Arts & Crafts
in Venice

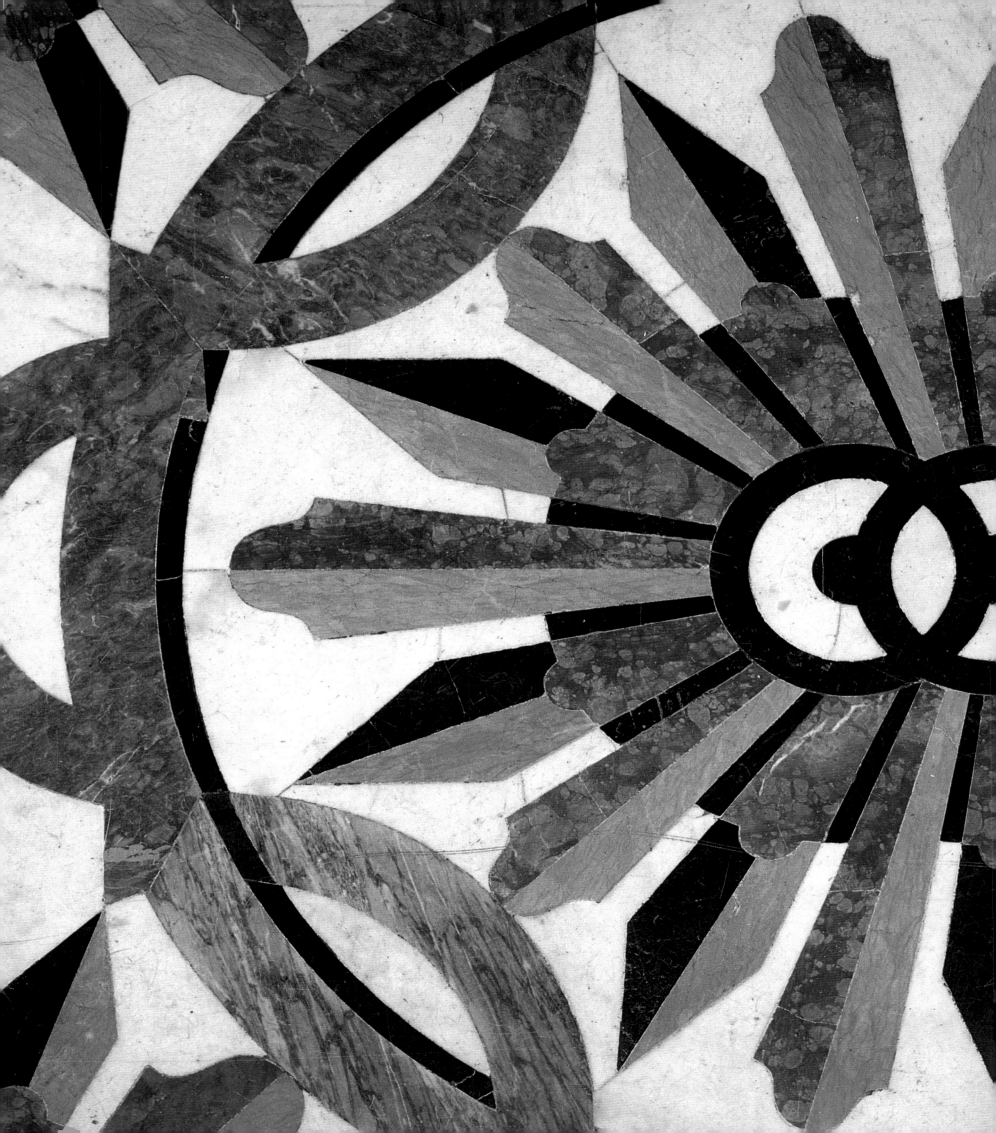

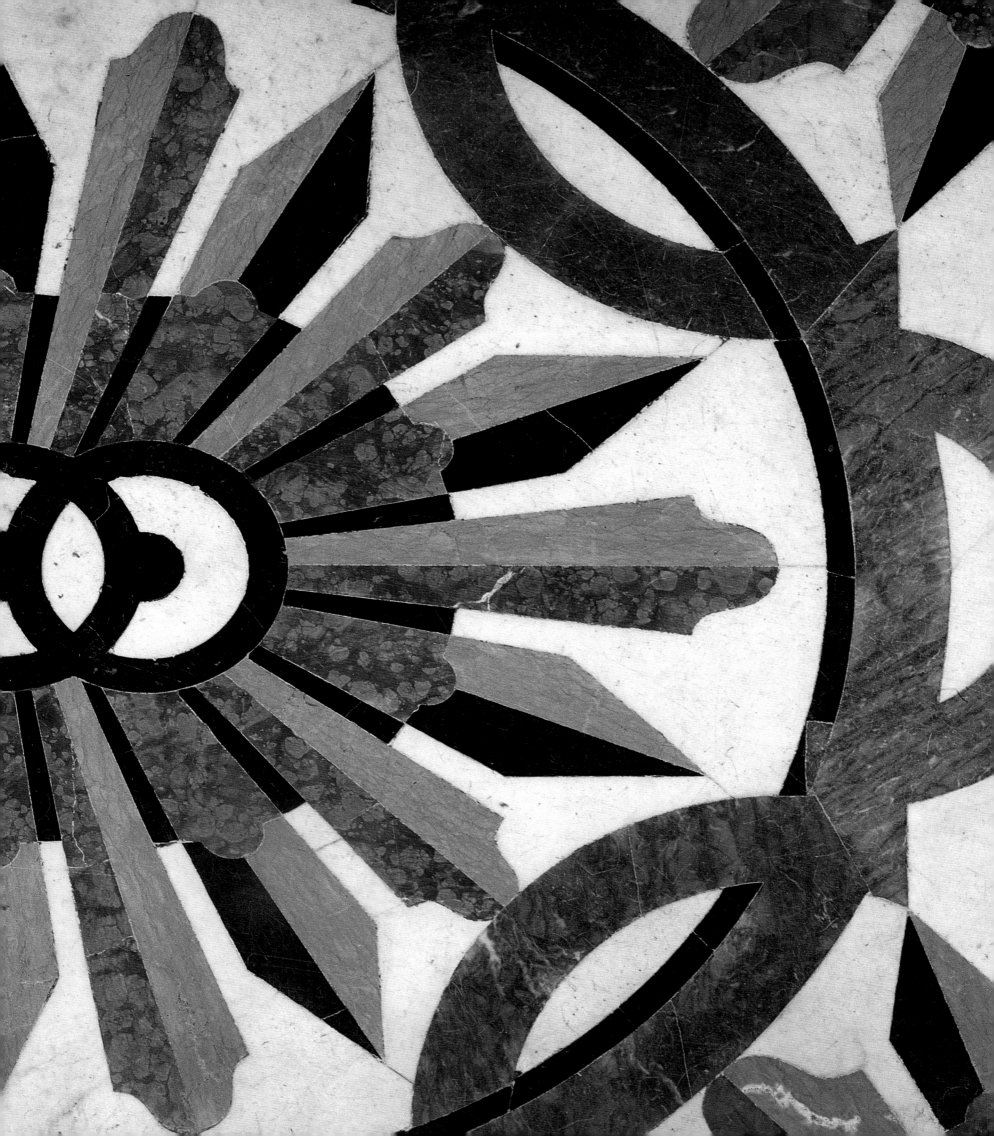

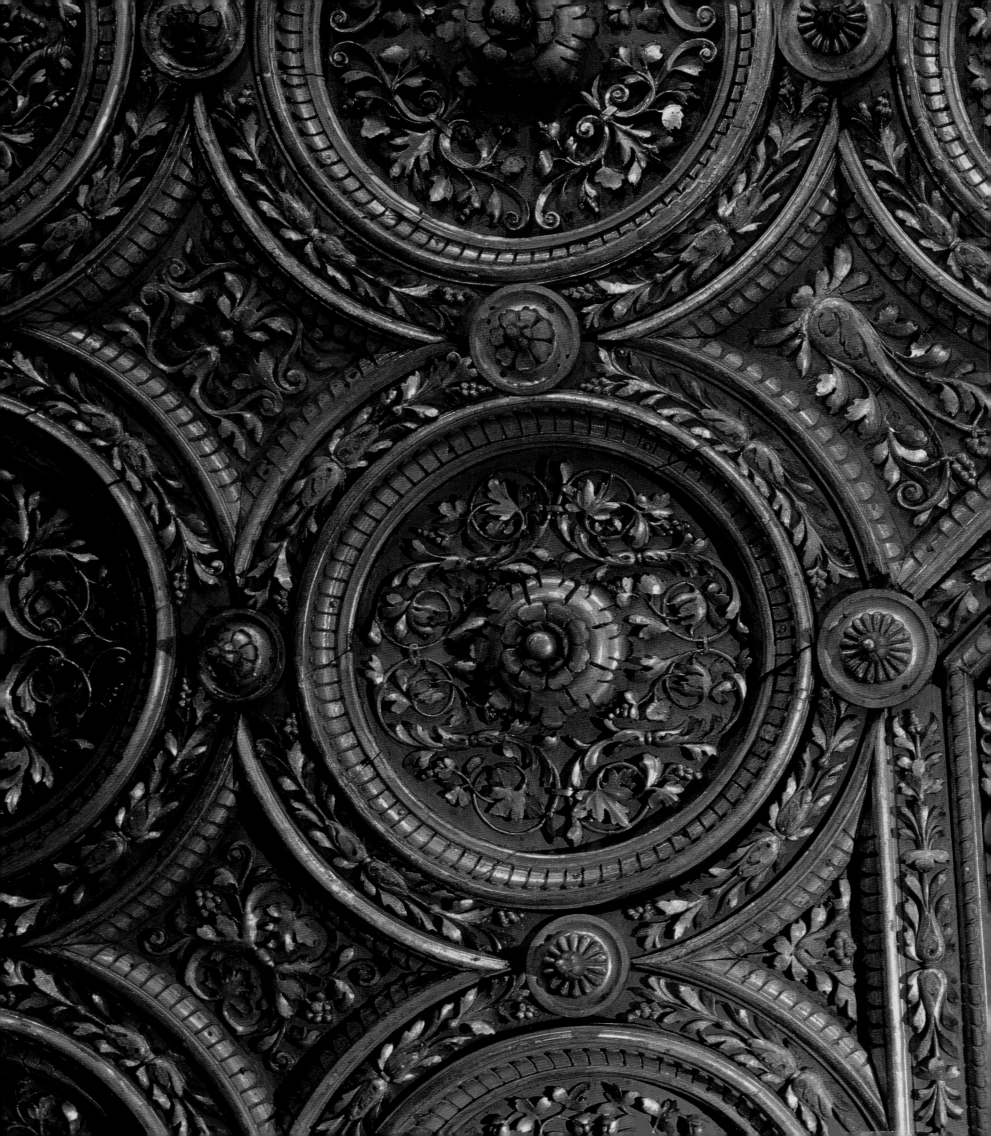

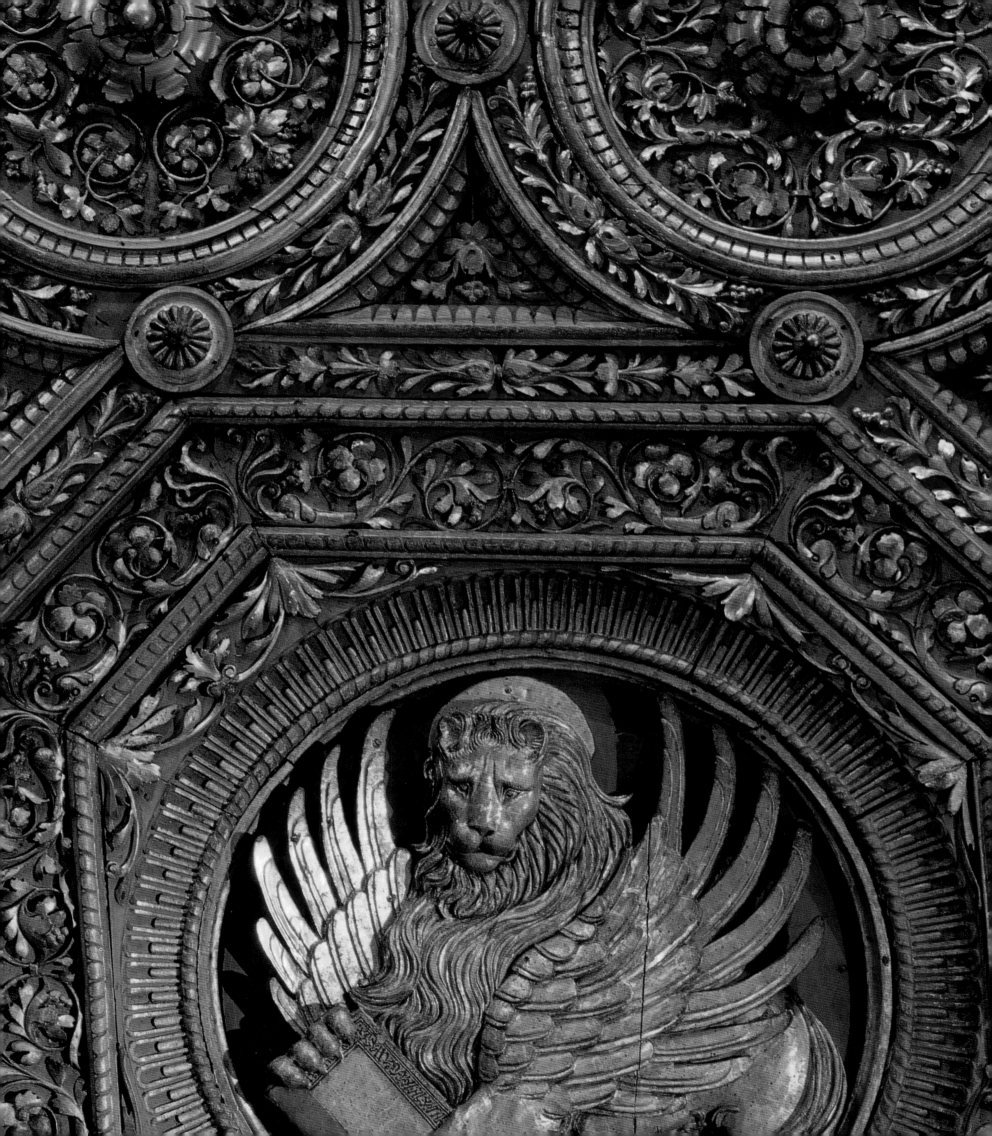

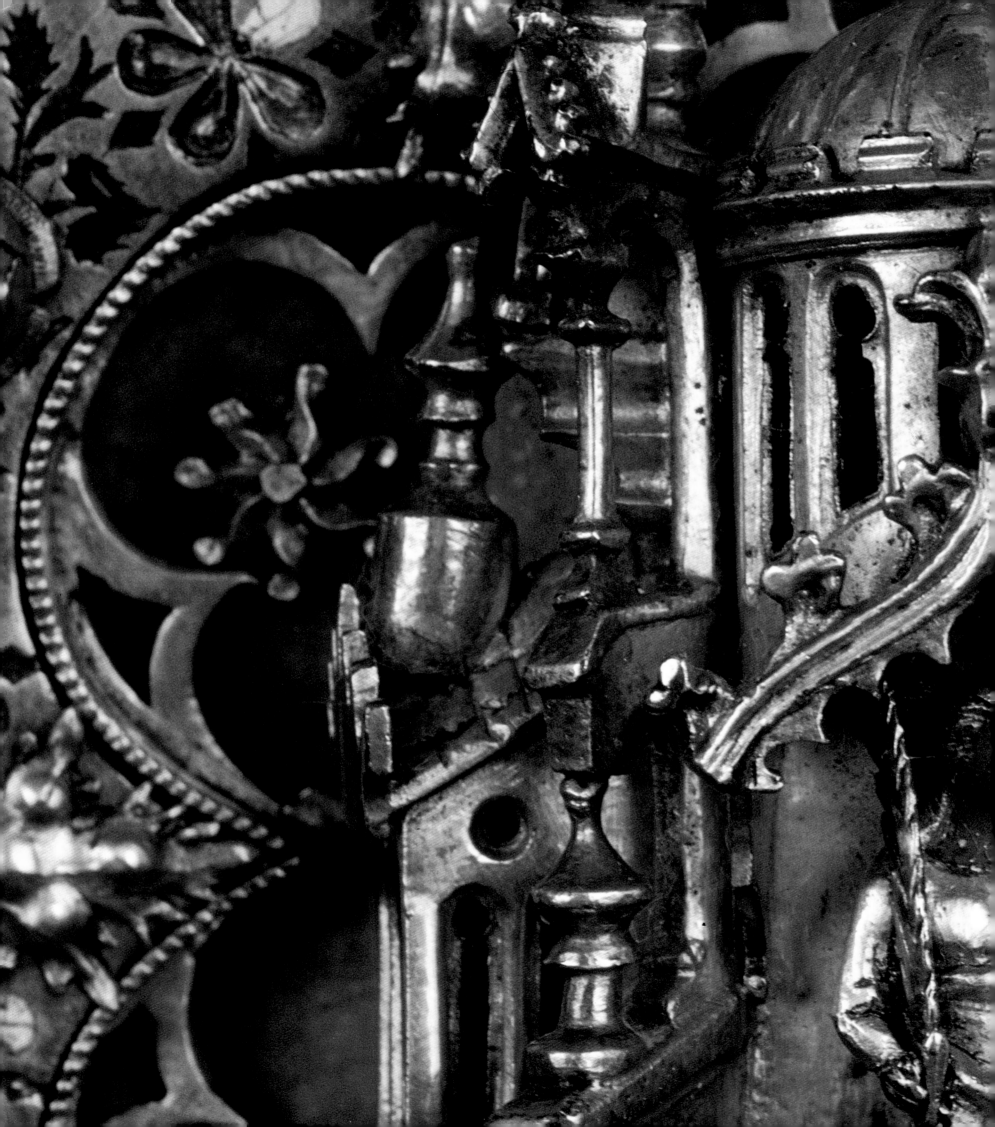

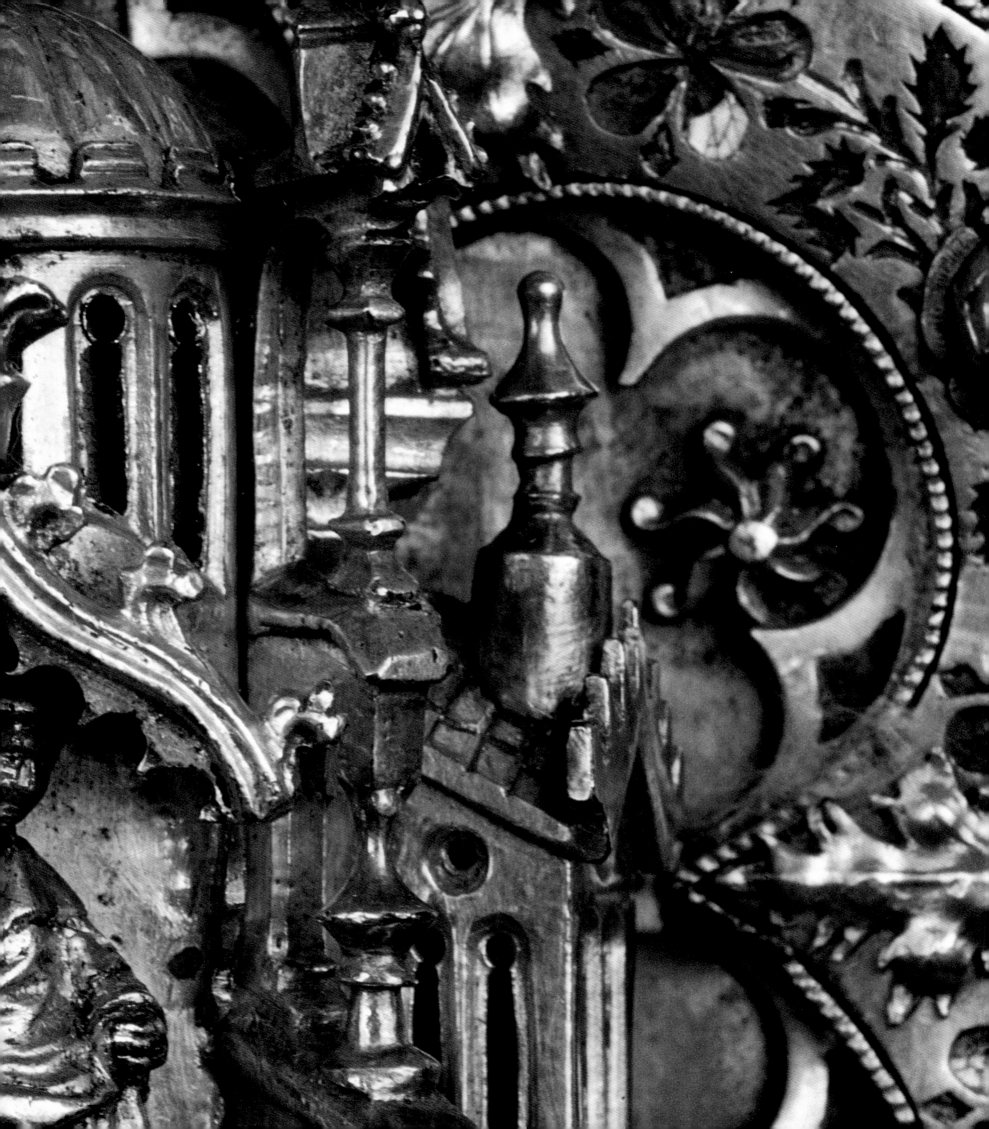

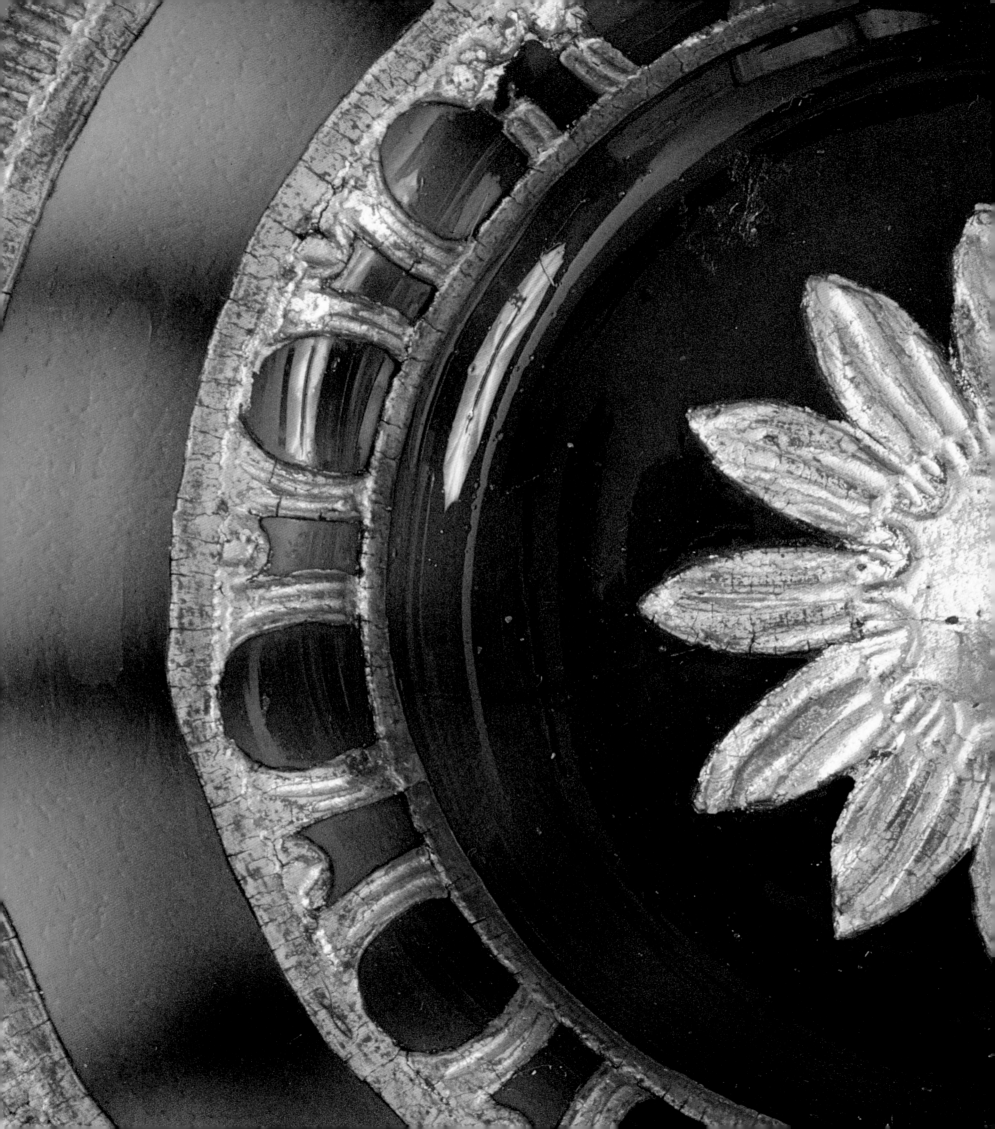

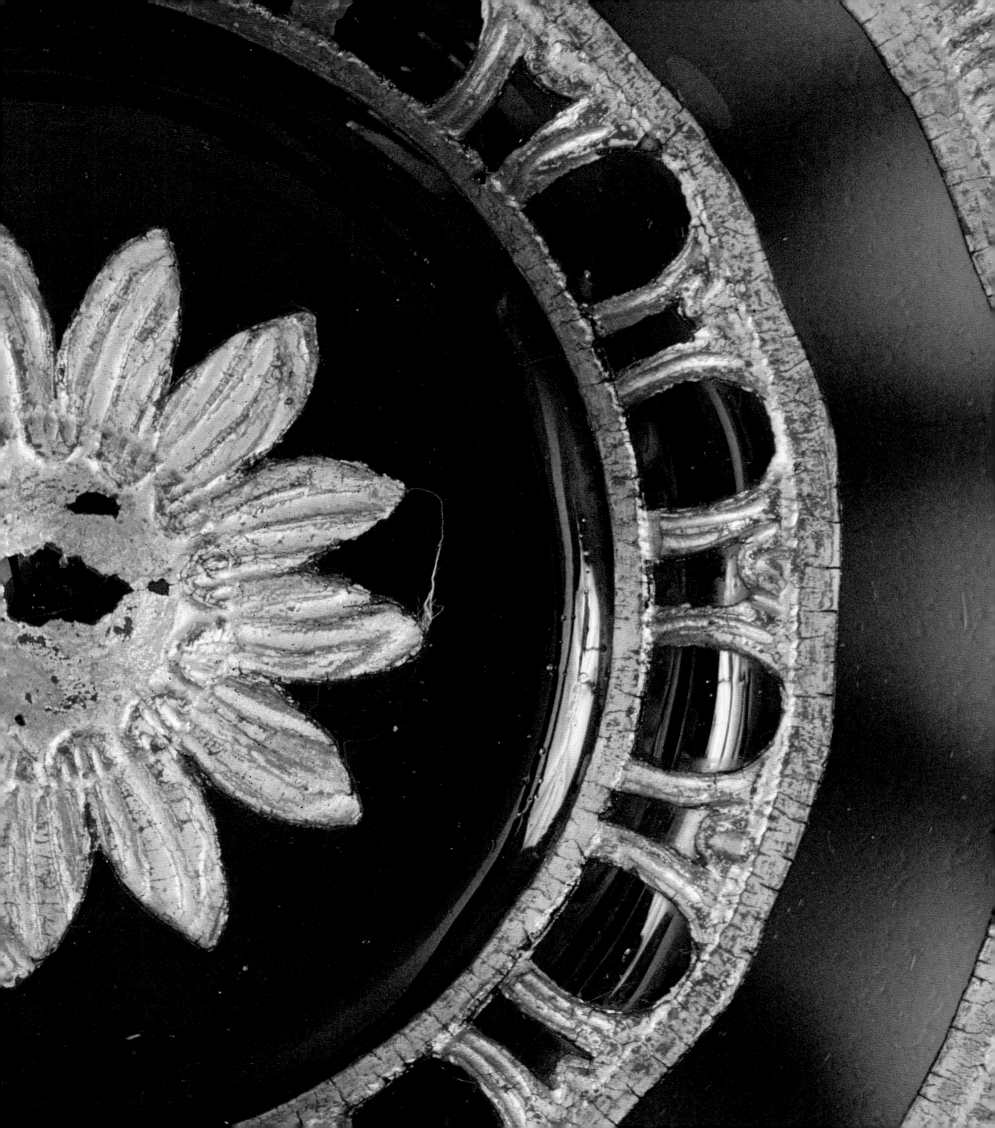

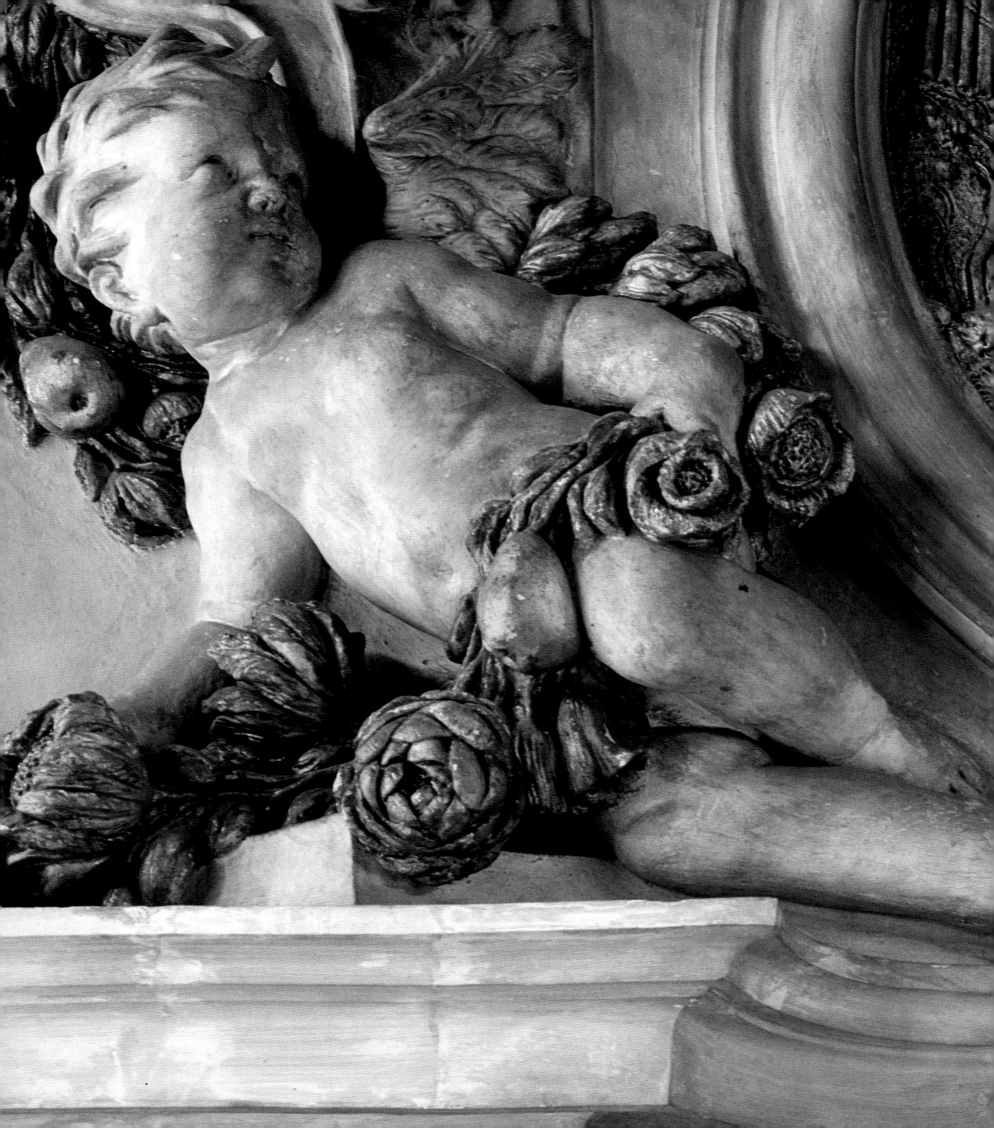

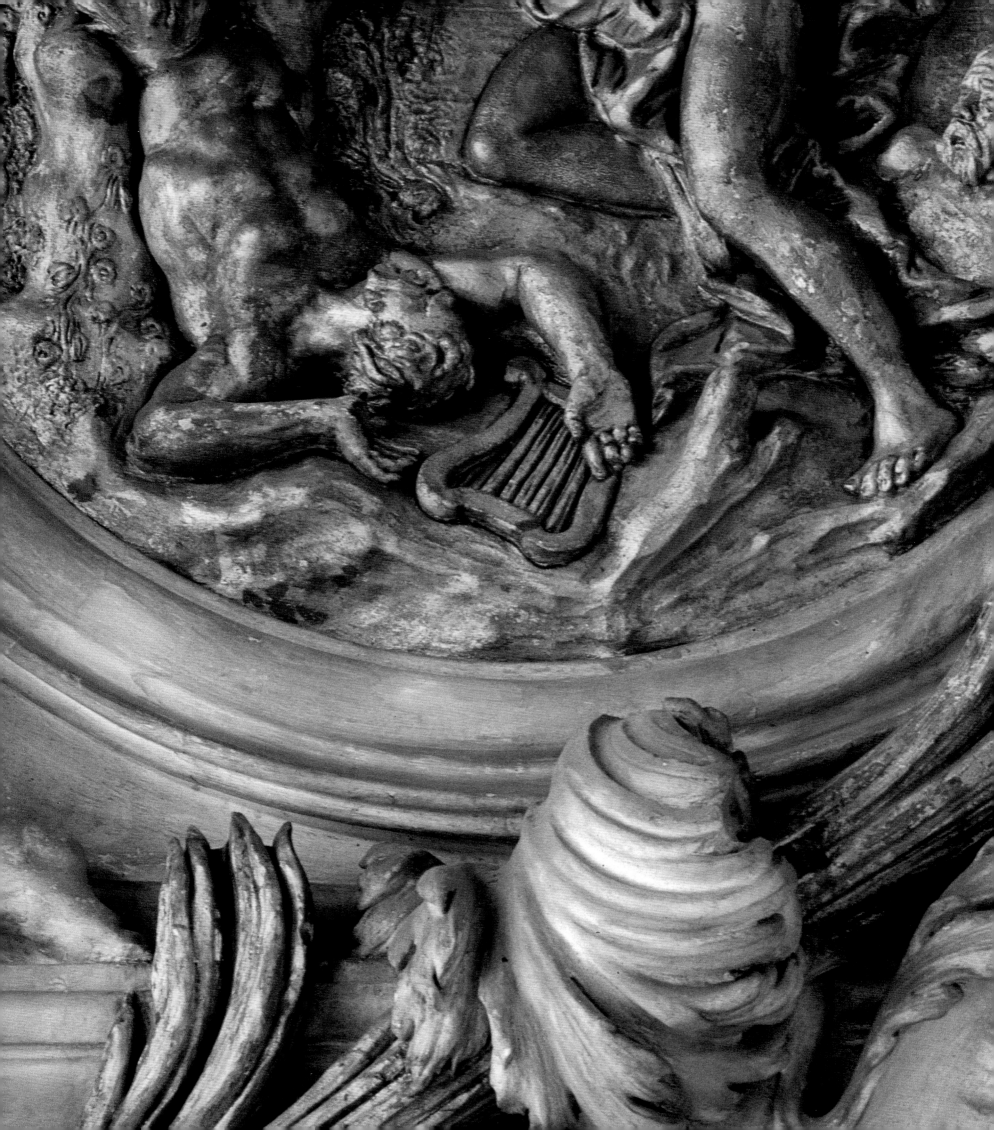

Doretta Davanzo Poli

Arts & Crafts in Venice

Photographs by
Mark E.Smith

KÖNEMANN

Copyright © 1999 for the original edition
Colophon srl, San Polo, 1978
30125 Venezia

Original title: *Le Arti Decorative a Venezia*

Project Coordinator: Andrea Grandese
Editors: Cinzia Boscolo and Massimo Chirivi
Research and Coordination: Lorenza A. Smith
Layout: Pietro Grandese
Reproduction: Fotolito Veneta, Verona

Captions for the preceding pages
pp. 2–3. Stone: floor in the Pisani Moretta Palace
pp. 4–5. Wood: gilt wooden ceiling in the Convento di San Domenico
pp. 6–7. Metal: railing in a private palace
pp. 8–9. Silver: cope pin from the church of S. Pantalon
pp. 10–11. Glass: dish with chalk decorations, private collection
pp. 12–12. Stucco: stucco decorations in the Ca' Zenobio
pp. 14–15. Tapestries: detail of the story of Semele, Palazzo Ducale

Copyright © 1999 for the English edition
Könemann Verlagsgesellschaft mbH
Bonner Str. 126, D-50968 Cologne

Translation from Italian: Janet Angelini, Peter Barton (captions), Paola Bortolotti, Jane Carroll, Liz Clegg, Sharon Herson, Caroline Higgitt and Elizabeth Howard in association with Goodfellow & Egan, Cambridge
Editor of the English-language edition: Shayne Mitchell in association with Goodfellow & Egan, Cambridge
Typesetting: Goodfellow & Egan, Cambridge
Project Management: Jackie Dobbyne in association with Goodfellow & Egan, Cambridge
Project Coordination: Kristin Zeier
Production: Ursula Schümer

Printing and Binding: Poligrafiche Bolis SpA, Azzano San Paolo
Printed in Italy

ISBN 3-8290-2908-X

10 9 8 7 6 5 4 3 2 1

Contents

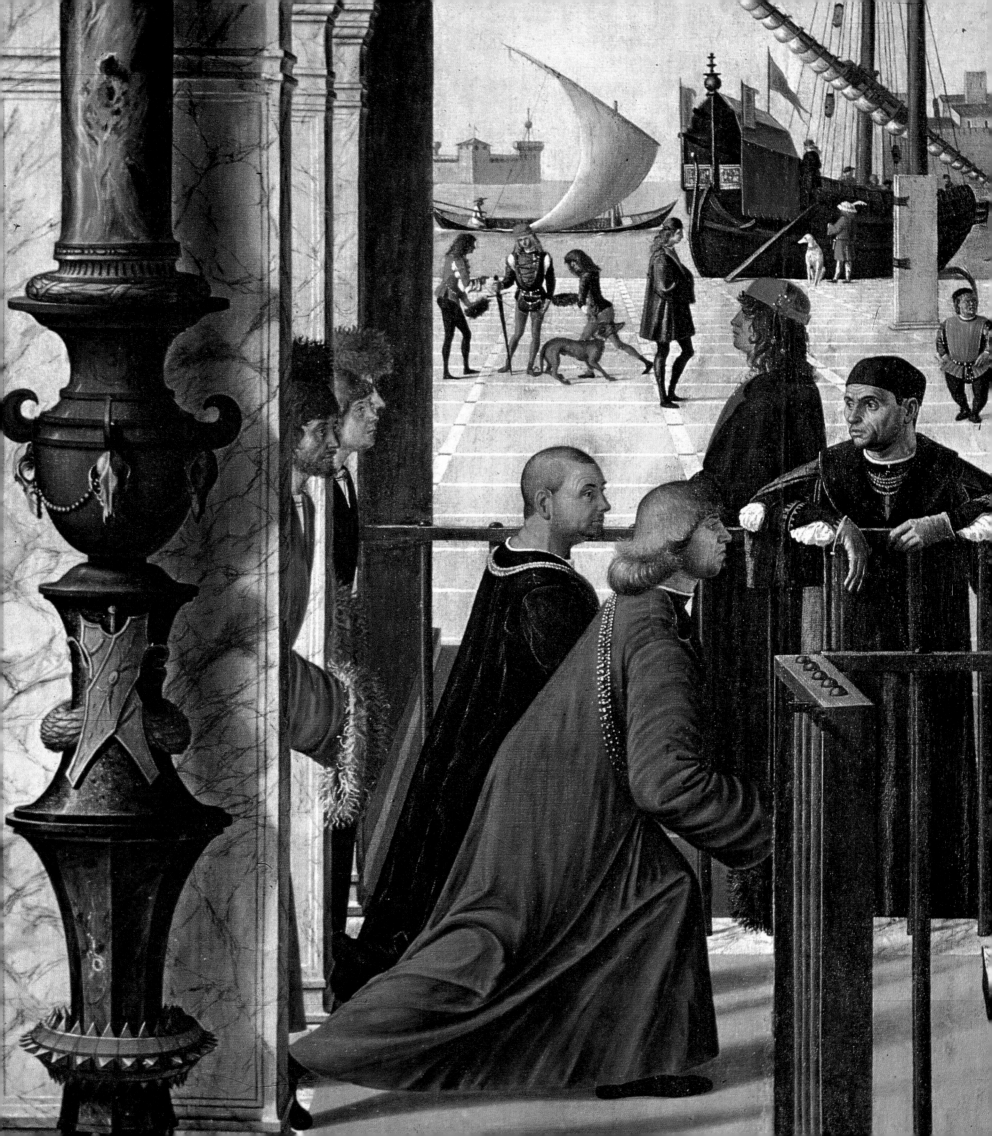

the Artist's Workshop

Venice is not lacking in wonderful talents.
In all arts, in all knowledge, she has always been happy,
And now
May beautiful souls, good taste and novelty flourish
More than ever in this lagoon…
Carlo Goldoni, *Una delle ultime sere di carnovale,*
Act II Scene I, 1762

Venice is a city born out of nothing. There was nothing but water and clay in the places where she rose up, and everything necessary for her construction had to be transported there: from wood for the foundations of the palafittes, to stone and marble to construct pavements, houses, and palaces; from iron for weapons, to fresh water to drink. If Venice is rather indebted to nature, she is even more indebted to man who, having laboriously gathered together the necessary materials, raised her up. Her own essence is not realistic, but scenographic, bounded as she is by scenery which looks like a theatrical backdrop. The most important and most representative places are a clear demonstration of this: the *Canal Grande* provides theatrical wings *par excellence*; the facades of the palaces appear slightly foreshortened and the side walls are sometimes projected diagonally mimicking the voids created by the brooks.

If we reflect in this way on Venice's nature we can understand the importance of manual labor in the evolution of the city until the time when great trading opportunities with the east diminished as profitable commercial routes moved to

Vittore Carpaccio
L'arrivo degli Ambasciatori
Venice, Galleria dell'Accademia.

Scuola del Longhi
Bottega-laboratorio da fabbro
18th century. Venice, Cassa
di Risparmio collection.

the west. At this point Venice discovered in herself and in her creative industries the basis of her economy. In seeking new sources of wealth, she found new aims for that industriousness for which she had always had great respect. Since ancient times, in fact, work and the quality of its products had allowed even the most humble of craftsmen to raise themselves to the nobility of Art.

At first glance the difference between the work of the craftsman and that of the artist seems to rest on the fact that the former is usually anonymous, while the latter is strongly linked to specific characters. But we only need to delve a little deeper to see that this is not true; many examples across the centuries confirm the quality and skill achieved in the applied arts. The craftsman's talent sometimes reached such a level that the products of his workshop were immediately recognizable, even without pointers like signatures, marks, or stamps. In this way we

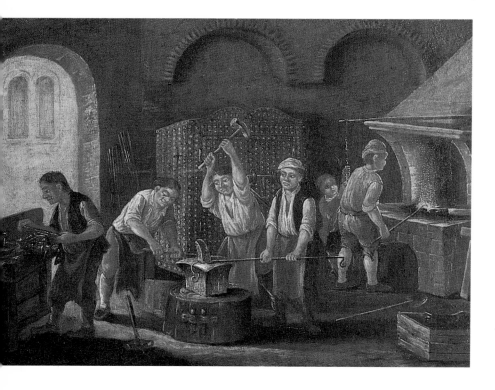

realize that there is no strict delineation between major and minor arts inasmuch as artists sometimes turned their hand to crafts, with extremely good results. One thinks of the architect who was also a stonecutter and blacksmith, or the painter who was stucco worker or weaver.

There are many illustrious examples of this. Andrea Palladio, as well as building churches and palaces, was also a woodcarver. Jacopo Sansovino, the architect of extraordinary historic buildings, was also a designer of

[22]

stuccoes and perhaps tapestries and the creator (with Vincenzo Scamozzi) of the fireplaces of the Zecca. Alessandro Vittoria, a very famous sculptor in stone, bronze, and wrought iron, also created stuccoes, gold leaf work, and the precious binding of the *Breviario Grimani*. Titian, Tintoretto, and Veronese, all renowned painters, also designed mosaics and tapestries; Aldo Manuzio, an extremely sophisticated printer-typographer, was a bookbinder. Abbondio Stazio was a stone-dresser, inlayer, and stucco worker; Giambattista Tiepolo was an artist much sought after throughout Europe, but, if needed, also a stucco worker and excavator. Francesco Guardi, "flower painter" and celebrated landscape artist, created the leather wall coverings in the Redentore. Giuseppe Borsato furnished a Venetian palace, planning every detail, from the stuccoes to the furniture, from the marbles for the fireplaces to the wrought iron for the chandeliers. Others, on the other hand, became famous precisely because of their specialty. One thinks of Angelo Barovier for glass, Francesco Vezzi for porcelain; Geminiano Cozzi for ceramics; the Cavenezias for velvet; the Dinis for tapestries and embroidery; the Franchinis, who invented *millefiori*, filigree, and miniature vases; and Giovanni Giacomuzzi for glass beads.

The artist, like the artisan, called his studio a *bottega* (workshop), and went easily from workstation base to another, developing the worker's taste through words but also by showing him practical examples. If we wish to define the boundary between art and craftsmanship, therefore, it is not enough to characterize the latter as the collective effort of a workshop and the

[23]

Giovanni Grevembroch *Terrazzaro*, in *Gli Abiti de Veneziani di quasi ogni età raccolti e dipinti nel secolo XVIII*, volume III. Venice, Museo Correr.

Insegna dell'Arte degli orefici Venice, Museo Correr.

former as an entirely personal creation, since the artisan himself also had clear creative autonomy.

Venice always specialized in the production of luxury items. She was well aware of the economic possibilities which could be gained from exclusive manufacture by fixed producers. Venetian craftsmanship had a clearly recognizable, defined style; it did not, however, remain unchanged and repetitive but evolved with changing fashions. In the beginning, Venetians were just merchants who imported rare, precious goods from the East and sold them in the West. In this way the city made its mark as a crucial link in the traffic of goods between East and West, and became the point of great international traffic and the port where

foreign merchants exchanged their goods for local ones.

People learnt early on in Venice how to work with primary materials. From the 12th century onwards the first manufacturing industries sprang up and developed; they were able to create prestigious finished products. The search for quality thus became the fundamental motor of wealth creation, which was a prerogative to safeguard and protect at all costs. Society was perfectly organized in guilds, which also allowed Venetians to preserve for centuries their inherited knowledge, which was jealously passed down from one generation to the next to the point of becoming inimitable.

In fact, it was with this aim in mind that from the 13th century onwards each group of people who were engaged in the same craft or who traded in the same specialty gathered together in associations, drawing up their own statutes in which rules were set out, and to which all members had to adhere. These regulations would be modified and updated over the centuries, but the objective was always to protect and improve the high quality of goods produced.

According to some historians the growth of guilds in the time of the Communes was based on the economic organization of the feudal *curtes*, but in fact today we can say that they were formed precisely when those systems were superseded thanks to the birth and development of an entrepreneurial, merchant, capitalist economy, based on autonomous work and free trade, and moved by a new spirit, which had developed with the religious-financial movements of the Crusades, pilgrimages, and great voyages. Guilds were therefore the result of two converging impulses: the need for a means of protecting the interests of craftsmen, and the intention of raising the quality of products, maintaining economic control within the guild and avoiding all political involvement. These associations had a primarily religious character at first, such that they identified themselves with devotional *Schole* (a word which means "union of people" in Greek); later, as their economic importance increased,

Mariegola dei tessitori di seta Mid 16th century. Venice, Museo Correr.

spiritual and secular aspects merged and the *Arte* (Guild) was instituted, regulated, in its various aspects as corporation and trade, by statutes—*capitolari* or *mariegole*. The texts of these, sometimes embellished with illuminated pages and extremely valuable bindings, have survived to this day.

The magistrature concerned with the guilds was that of the *Giustizieri*, instituted about 1173, with the task of protecting the consumer by watching over prices and avoiding fraud. From 1261 onwards this magistrature also approved regulations, settled disputes, and welcomed new members. At the head of each corporation sat a president or *gastaldo*, helped by a *vicario* and by a council of *bancali*, together with other figures such as *sindaci*, who were in charge of checks, *tansadori*, who divided up tax increases, an *esattore* (tax collector), a *cassiere* (cashier), a *scrivano* (secretary), and a *nonzolo* (messenger). No one could refuse election (the penalty being a fine). The *capitoli*, the general assemblies, were held in the *albergo*, the great hall of the building belonging to the guild called *Scuola*.

Any citizen or subject who had paid his taxes and was of proven honesty could join the guild once he had passed an aptitude test. The *garzone* (apprentice), who was officially supposed to be twelve years old but who was actually younger, had to follow an apprenticeship which lasted from five to seven years, depending on the trade; afterwards he became, for a minimum of two to three years, a *lavorante* (laborer). Once he had passed a new, more exacting test of his practical ability—the *prova d'arte*—he could take the title of *maestro*, and had the right to

[26]

open his own workshop and have his own apprentices and laborers. The government made sure that the relationship between *maestro* and workers was appropriate, to avoid exploitation and unjustified claims. It also legislated to avoid or limit pollution, and to defend workers' and citizens' health. Members were, moreover, insured throughout their lives, in case of sickness or death; their widows and children were provided for and, in order to safeguard businesses, licenses were even sometimes granted to women.

Skilled workers were strictly forbidden to emigrate, to avoid trade secrets being revealed thereby threatening the market. Foreign artisans were, however, warmly welcomed, if they could demonstrate particular abilities or skills, or if they had new knowledge or had invented unusual procedures. They were helped to settle in the Republic by being granted licenses, building areas and, sometimes, even by tax relief or exemption from duties.

Innumerable technical and artistic improvements resulted from the influence of immigrants. Weavers from Lucca brought their techniques and age-old professionalism to Venice in the 14th century, and contributed very importantly to the ascent of Venetian gold silk art. Itinerant Flemish tapestry-weavers arrived in the early 15th century. Tanners, first Hispano-Moorish, then German, came during the Renaissance. Potters from Faenza brought with them technical solutions and innovative decorations from the 16th century onwards.

[27]

Giovanni Grevembroch
Squerarolo, in *Gli Abiti de Veneziani di quasi ogni età raccolti e dipinti nel secolo XVIII,* volume III. Venice, Museo Correr.

What is more, guilds contributed to significant changes in the urban structure of the city. On the one hand, it was necessary to defend the normal path of citizens' lives, ensuring their security; on the other, it was important to respond to specific demands from producers, such as the need to make use of large spaces or of a great deal of running water. There are important examples of this. Glass factories were moved to Murano to avoid the danger of fire in a city which was at that time primarily built of wood. Tanneries were shifted to the Giudecca not only because of the noxious substances they discharged into the canals, but also because of the pestilential fumes produced by fleshed hides and the acids used.

The members of a particular guild were responsible for the furnishings of the altar or chapel which had been granted to them in various city churches. These were embellished with pictures, often commissioned from great artists like Tintoretto or Palma the Younger, and sculptures, or with the periodic hanging of altar frontals which were covered with gold silk fabrics, precious embroidery, goldsmithery, or gilded leather. The same schools were later noted for the accuracy of their architectural plans, their decorations in polychromic marble, in wrought iron, in carved wood and their ornaments such as *pàtere* (panels with reliefs mainly showing animals, placed on the outside walls of palaces and houses), memorial tablets, inscriptions, carvings, and bas-reliefs. Their subjects ranged from depictions of patron saints to more varied objects—from the tools of the trade to the finished product—mostly carved on architraves, pillars, pilaster strips, capitals, tombstones, or bands of parquetry. All religious or civic festivals were an opportunity for

displays of banners of the guilds, which competed against each other in splendor and richness during processions or official visits to the doge.

The artisans' pride is even demonstrated in toponymy: they gave the name of their trade to the places where they had their workshops or studios. One could go from Wool Square to Printer's, Carpenter's, or Blacksmith's Lane; from Glass Court to Dyer's Brook; from Mirror-maker's Street to Printed Leather Road; from Goldsmith's Way to Oarmaker's Alley.

From the economic point of view, Venice always relied on magnificent production based on high quality primary materials and exclusive manufacture, of which she quickly became the first great beneficiary. Such manufacture was initially oriented toward sales outside the city, given that a certain simplicity dominated the ducal court; from the 14th century onwards, however, internal

Insegna dell'Arte dei remeri
Venice, Museo Correr.

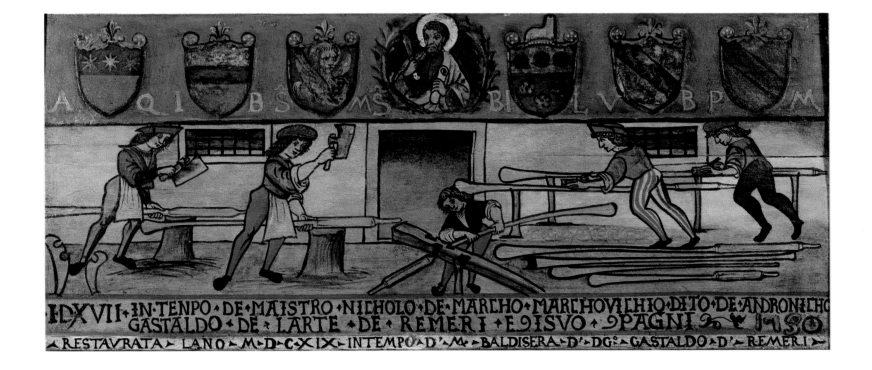

demand for luxury goods grew, as demonstrated by the promulgation of the first laws limiting excessive consumption of luxury goods. The appointment of a specific magistrature "*alle Pompe*" ("to Pomp and Circumstance") would only become necessary, however, in the 16th century, even if it is clear that excessive expenditure on clothing and furnishings was by then an established tradition. In 1466 a Bohemian traveler, Leo di Rozmital, described a Venetian bedroom which cost an estimated 24 000 ducats (equivalent to two million dollars today), with an alabaster floor, gold ceiling, sheets woven with silver and pillows decorated with jewels. The hugeness of this sum explains why a decree of 1476 made it illegal to spend more than 150 gold ducats on the decoration of a room. The decree was not, however, obeyed, given that in 1492 Jacopo di Porcia, in his operetta *De Reipublicae Venetae administratione*, claimed that the furnishings of an ordinary Venetian would be worthy of a royal palace.

Pictorial iconography confirms that the external walls of palaces were decorated with polychrome marble slabs and semiprecious stones, and sometimes covered with gold leaf; churches were splendid, glowing with luminous glass mosaics. The atmosphere was made magic and unreal by changing reflections (multiplied by the water in the canals) on ceilings, and in the wide central salon called the *portego*, in the series of adjacent rooms—embellished with frescoes, lace stuccoes, and enameled, gilded caissons which were embossed and inlaid. In such settings, from the lovely elastic floors, padded by coverings of upholstery and drapes in velvet, brocatel, or damask in refined dignity in which even tapestries would seem too

simple, warmed by great carved marble fireplaces, the light of enormous chande-liers colored by flowers was reflected in the numerous mirrors hung on the walls and interspersed with important paintings, placed within molded, gilded frames.

In order to increase the sumptuous impact of these interiors, all types and dimensions of furniture were produced in ever greater sizes, such as blacka-moors, brackets, little wall tables, corner shelves, and small sideboards, which were able to hold and display a new and superfluous collection of household objects of a purely decorative nature. Even fashion, ever more rich and magnifi-cent, helped give shape to furniture. Clothing was made extremely costly when

Venetian school
La bottega del tagliapietra
18th century. Venice, Cassa di
Risparmio collection.

Insegna dell'Arte del marangoni di nave, Venice, Museo Correr.

rare dyes were used for the first time on fabrics and, later, when it was made of complicated velvets and brocades; it was embellished with embroidery in precious metal, sequins, tassels, gilded studs, and lace, and was built on substructures which deformed anatomical lines. It called for seats, divans and armchairs of certain shapes and dimensions. Eighteenth-century "baskets" and farthingales, which made the sides swollen and voluminous, led to the abandonment of armrests. There was also the need to make clear one's personal power; this was an especially important factor in the Baroque era in the creation of unusual, luxurious items. Among the most showy examples of this were the show boats such

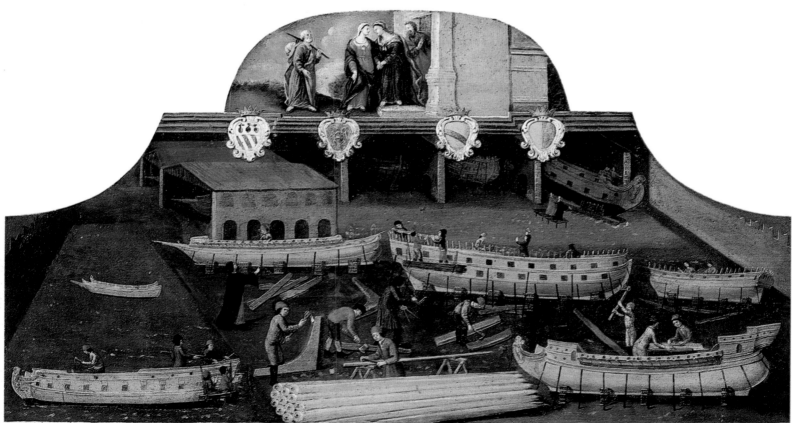

as the Bucintoro or the "household" gondolas, on which riches were lavished to a spectacular extent. Not only was there gold everywhere, on wood and metal, varnishing and pendentives, but also coverings and long trains in silk.

The instinct towards showiness, to "extravagant wastefulness," among the Venetian leisured classes was kept in check by the laws on spending of the Magistrate of Pomp, but it was impossible to limit the aspiration toward beauty and luxury which persisted in general among Venetian artisans, who were universally recognized as the best. It was not by chance that people referred to cloth "in the Venetian style" (which in the 16th century outclassed cloth "in the Florentine style"), "Venetian red" for dyeing, "Venetian point" for lace and embroidery, *façon de Venise* for glass, bookbinding, and lacquerware, *opus veneticum* for goldsmithery, and even *petite Venise* for table linen.

We have tried to summarize in this volume the history of decorative arts in Venice—solid, ductile, fragile, and soft—as a tribute to this aspiration. This is of course a complex enterprise, inasmuch as it overlaps with the city's history and the image it wished to give of itself, in the golden centuries and the periods of decadence, in the continual exchange between external and internal, public and private, without ever harboring any doubts about being able to achieve beauty.

Alongside and as a complement to the essential text, the high quality of the products, the magnificence of the objects, and the elegance of the finishings are splendidly apparent from the published images, which emerge from material transformed into decoration, whether stone or wood, iron or gold, silk or glass.

[33]

Solid Arts

Stone

*…the warning which seems to me to be uttered by every
one of the fast-gaining waves, that beat like passing bells,
against the stones of Venice…*
John Ruskin, *The Stones of Venice,* 1851–53

All stone in Venice comes from elsewhere, from other shores, from distant quarries; it therefore does not strictly belong to that city, which would have remained only brackish water, sand, and clay if man had not decided to take stone there. Perhaps this explains why the most important of all the guilds was that of the stone-masons, responsible for almost everything beautiful one sees as one crosses the city, from the *masegni* (the stones which form the pavements of *calli, campi,* and squares) to the bridges, from the wellheads to the chimneys, from the main entrances to the balconies, from the river banks to the palaces, from the churches to the bell towers. What stands out today, by its snowy whiteness on bricks and plaster is their work. Numerous building yards were scattered through all districts, and one, near the Accademia, was immortalized by Canaletto.

From a document dated 1781 from the *Inquisitorato alle Arti*—the magistrature in charge of craftsmen—we learn that only 200 workers in stone remained, 30 of whom were "owners of workshops" and the rest "working master craftsmen," without workshops or their own equipment, and one apprentice.

Ca' d'Oro
15th-century detail of the doorway. Designed by Lombard workmen, but completed and decorated by the Venetians Giovanni and Bartolomeo Bon, the Ca' d'Oro is the most famous palace on the Canal Grande, a typically Venetian work of Gothic art, completed in 1434. Its nickname comes from its abundant gilding and the luminous polychromy of its facade. The doorway, with its twisted vine shoots in white Istrian stone, is attributed to Matteo Raverti.

Previous pages
Internal wall of the Ca' d'Oro, 1487.

[37]

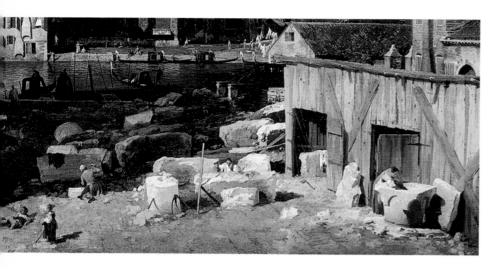

The Stone-mason's Yard Before 1741, Canaletto, London, National Gallery. In the stone-mason's yard, on the Canal Grande and opposite the church and the Scuola della Carità, note a nearly finished wellhead in the foreground on the right. The painting reminds us that the test of competence to become a stone-mason consisted of making the base of a column without the help of a design or a model.

Facade of the Doge's Palace facing the Piazzetta, 15th century. The walls are covered in red marble from Verona (nowadays pink), gray *bardiglio* and Istrian stone arranged in such a way as to create a pattern of small squares and diamonds with central crosses. The result is reminiscent of textiles, and is comparable to a "diamond" framework, or to embroidery made with little points or cross stitch.

The guild was divided into three *colonelli*: the *tagia-piera* or stone-dressers, the *fregadori* or polishers, and the *segadori* (sawyers). The *intagiadori*, those who carved leaves, flowers, or fruits in stone, formed another small *colonello* in the guild, joined with the college of sculptors by decree of the Senate in 1724. The *capitolare* (capitulary), approved in 1307 by the *Giustizieri Vecchi* was taken up and broadened at the beginning of the 16th century in the *mariegola* (a collection of regulations), which was updated periodically until 1799. Three *soprastanti* were in charge of the guild to regulate internal relationships among craftsmen and between craftsmen and clients, deliberating on the quality and type of materials used.

The *maestri* advised their clients on the nature, value, and price of stone; they also specified where it came from. For example, it was forbidden to use different types of stone in one job (except, obviously, if inlaying). The main quarries of Istrian stone, characterized by its tone—varying from snow white to ash colored —were in Pola, Parenzo, or Rovigno, in what is now Croatia. The harder, more consistent and rougher stone was used for doors, windows, sarcophaguses, sinks, gutters, and pipes; the softer and more friable were used only by express request of the client, who had to take full responsibility for the outcome by signing a sort of contract. The main preoccupation of the government was to protect Venetian artisans' work. From the 15th century onwards there were increasing numbers of

[38]

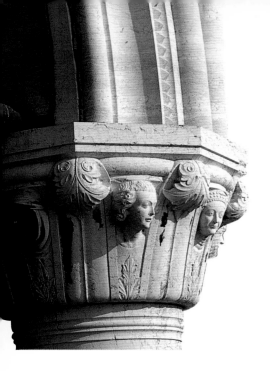

The variety of decorative motifs changed over the course of the centuries. The capitals of the portico and the balcony of the Doge's Palace have, between sparkling depictions of plants, the most varied of motifs: biblical or symbolic scenes, guilds and trades, animals, women's heads, and horses' heads.
The balcony of Palazzo Contarini Fasan, better known as Desdemona's balcony, is held up by four corbels depicting animals. It is an extraordinary example of Venetian flamboyant Gothic, with five circular tracery corollas placed between square frames sculpted with plant motifs.

Lombard workers in the city, necessitating regulations such that the latter were obliged to settle in Venice as a guarantee of their professionalism, an essential prerequisite of their admission to work in the city. The work which they left is, what is more, incontrovertible proof of this.

The Guild of stone-masons' was held in such esteem as to be depicted in the reliefs in S. Marco, among the trades on the main arch of the central doorway, as well as on two capitals in the Doge's Palace. Indeed, Venetians loved to beautify their palaces, on the inside and outside, both with frescoes and marble veneers. One thinks of the Doge's Palace, where the walls seem covered with "diamond" fabric, or embroidered with little points in white and pink; onto these walls open the chiseled windows of the balconies, embellished with Gothic pinnacles and encrustations, and the arches of the porticoes are completed by rows of fret-worked corollas or capitals on which, among luxuriant vegetation, human tales are depicted or local trades appear. One also thinks of the Ca' d'Oro, so named for the splendor of its polychromic marble and stone decorations which go from the crenelated coronation with fret-worked arabesques of the open galleries—

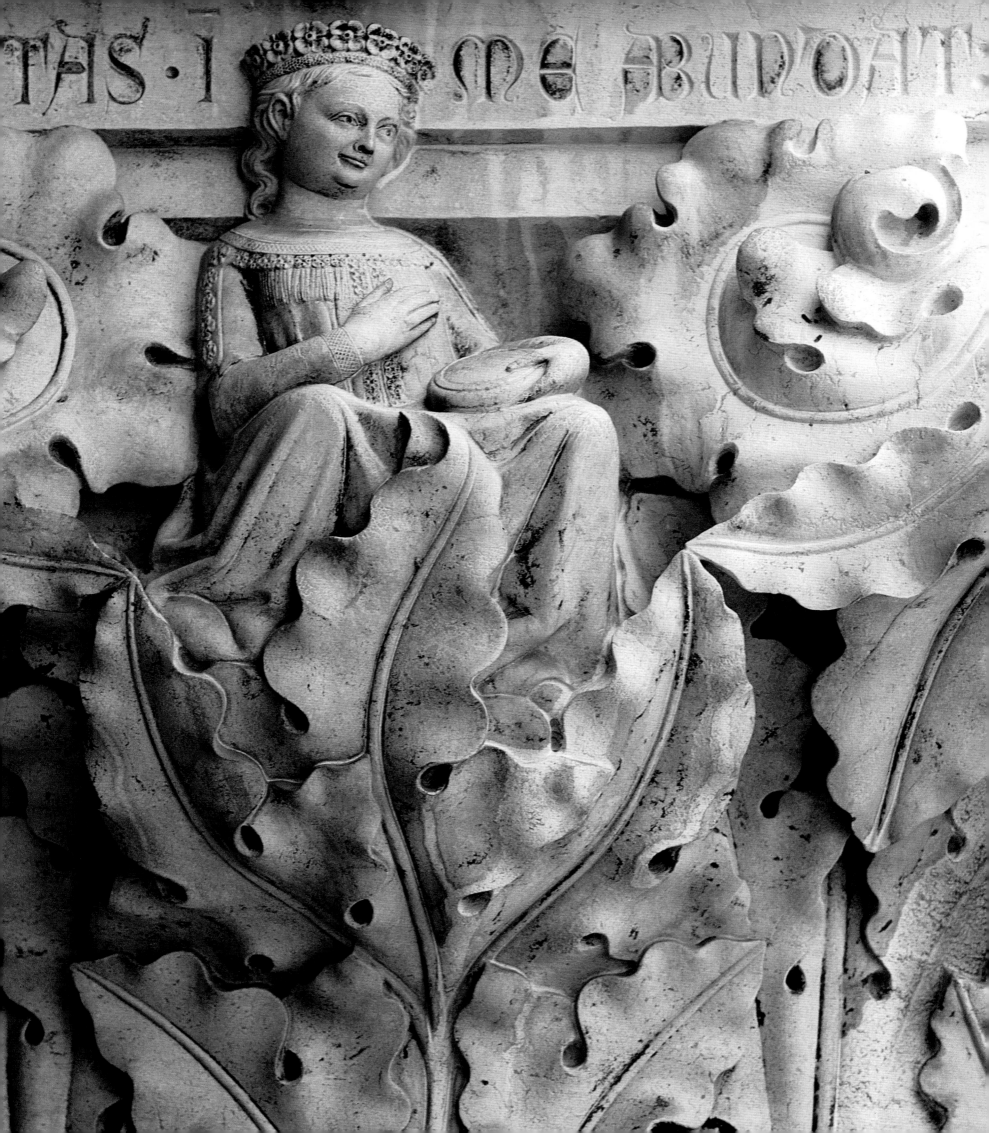

The warm gray-yellow tone of the stone becomes a decorative element in itself throughout the centuries. The patera in animal form (dating from the 11th century) is a typical expression of erratic art. It is perfectly linked to the sculpted baskets with fruit and flowers which catch the eye on the top of the pillars on the balustered staircase with thick marble gratings of Palazzo Loredan in S. Stefano. These are attributed to Antonio Abbondi, known as Lo Scarpagnino, who remodeled the palace in 1536.

the work of Lombard and Venetian stone-masons of the 15th century directed by Marco Raverti and the Bons —but also for the gold leaf which covered some of its surfaces. One thinks lastly of the facade of the Ca' Dario, a contemporaneous work of the Lombardos, full of precious polychrome marble encrustations in intertwined circles, rhombuses, and roses and finished off towards the sky by the magnificent architecture of the chimneys.

Even apparently trivial details confirm the high quality achieved by the guild. These include door and window frames, balustrades on balconies and both interior and exterior staircases, open arches over *calli* or capitals. The balcony in Palazzo Contarini Fasan, known as Desdemona's balcony, is comparable to the borders in lace needlework, just as the elaborate polypetal tracery of the windows, with one or more holes in flamboyant Gothic style, appear like lace borders. It appears that the art of lace was born in Venice in the Renaissance, drawing its inspiration from the city's architecture, and in particular from the crenelated copings with triangular or rounded points of Venetian palaces. Numerous examples stand out against the Venetian sky: from the above mentioned Palazzo Ducale and Ca' d'Oro to the Fondaco dei Tedeschi, from the Fondaco dei Turchi to the Procuratie Vecchie of the square of S. Marco.

There are also some very beautiful but little known internal staircases. The spiral staircase in Palazzo Contarini dal Bovolo, a late 15th-century work by Giovanni

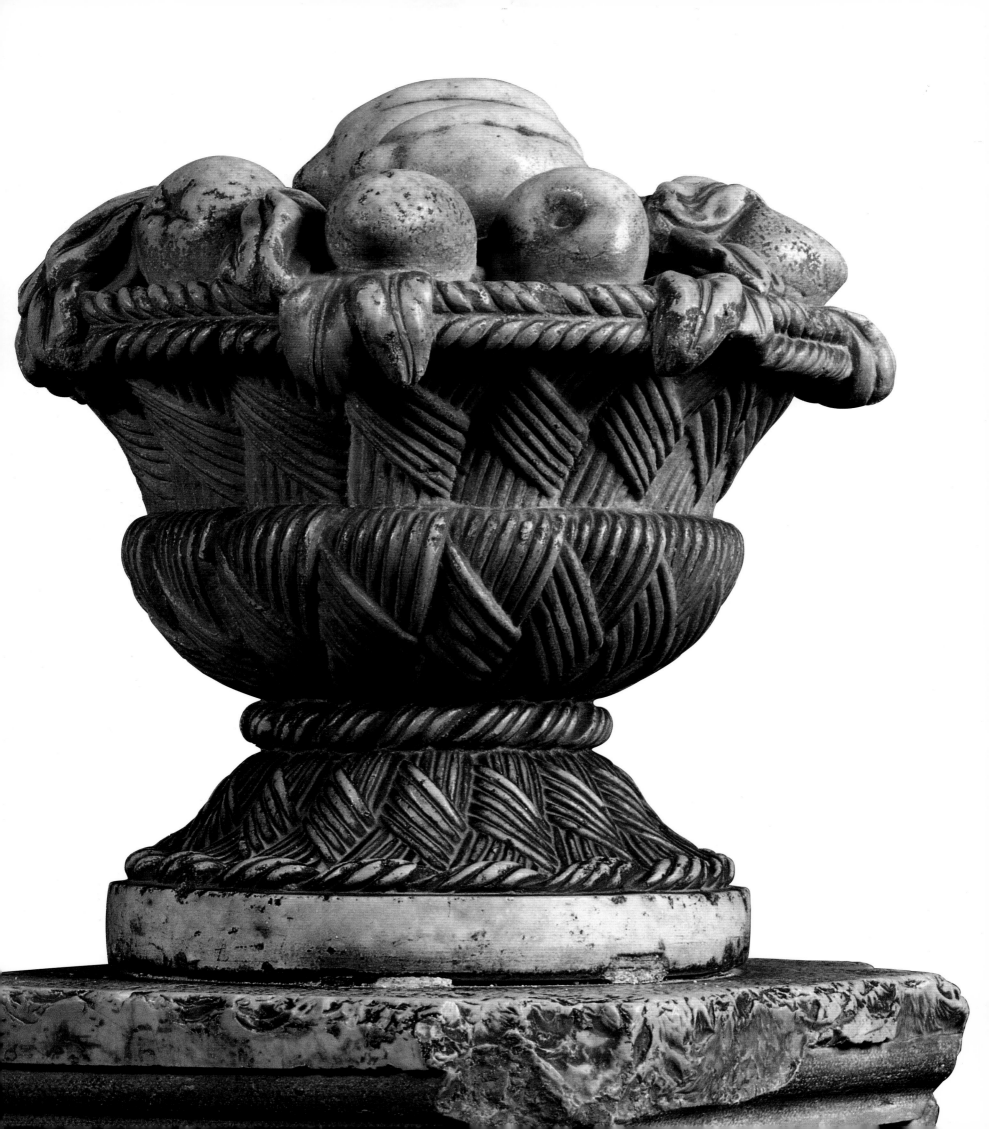

Marble decoration lends itself to Venetian fireplaces of every age. In the 16th century, we find this example, probably the work of Sansovino. A pair of classical telemons watch over an architrave-corbel decorated with quadrangular slabs sculpted with arms, amphoras, and loricas separated from triple vertical fluting and a short trapezoidal hood with mascaron framed by ribbons and garlands of fruit. The neoclassical fireplace, below is an integral part of a unified design by Giuseppe Borsato. It is sculpted with caryatids with baskets of fruit and is decorated by gilded bronze reliefs. At the front, there is a motif of scalloped garlands with shells. The cornices and firedogs in wrought iron from part of this homogenous whole, created for a unitary plan.

Candi, has steps which move away from the central load–bearing section, like the vertebrae of the backbone. The staircase in Palazzo Loredan was designed in the 16th century by Antonio Abbondi, known as Scarpagnino, and is characterized by thick marble gratings in the balusters, between pillars with baskets of fruit and flowers carved on the tops; there are also numerous external staircases, in private courtyards, with columned balusters and landings underlined by small lions, pinecones, or men's heads; there are also the great arches of doorways with volutes and vine tendrils among which hares and deer chase each other, topped by transoms and triangular or ogival niches. The expanse of the walls seems too simple and flat between the abundantly festooned spaces of the windows, and so it is decorated with precious sculptured fragments. These wall sculptures (known as "erratic") take many forms: there are thousands of *patera*—the round or square forms of Byzantine origin, sculpted with animals of the paleochristian tradition, such as eagles, lions, griffins, lambs, and peacocks, either alone or struggling with each other: real stone bestiaries—noble shields or "speaking" coats of arms, which reveal an identity or profession through allegory, niches with saints and symbolic characters, crosses, the signs of the workshop, and stones decorated with varied objects according to the different guilds.

Internal fireplaces deserve a separate mention. After their primitive beginnings, they became precise points of reference for the layout of the

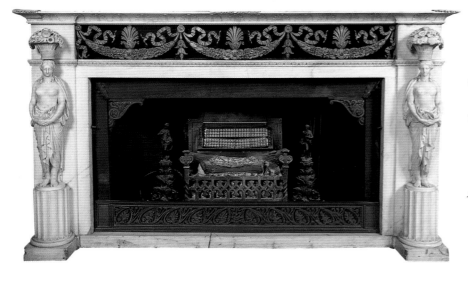

External decoration often becomes a means of communicating a variety of messages. The facade of the church of S. Maria del Giglio, built between 1678 and 1683 to a plan by Guiseppe Sardi, is decorated by relief plans of various cities and fortresses, among which that of Padua appears (reproduced here). This was included to extol the seafaring, civil, and political glories of the Barbaro family, which paid for its construction.

The violence expressed by this 17th-century mascaron, placed on the keystone of the arch of the entrance to the bell tower of S. Maria Formosa, is intended to act as a charm. It was supposed to scare away the devil so that he would not enter and ring the bells, creating confusion and panic in the city.

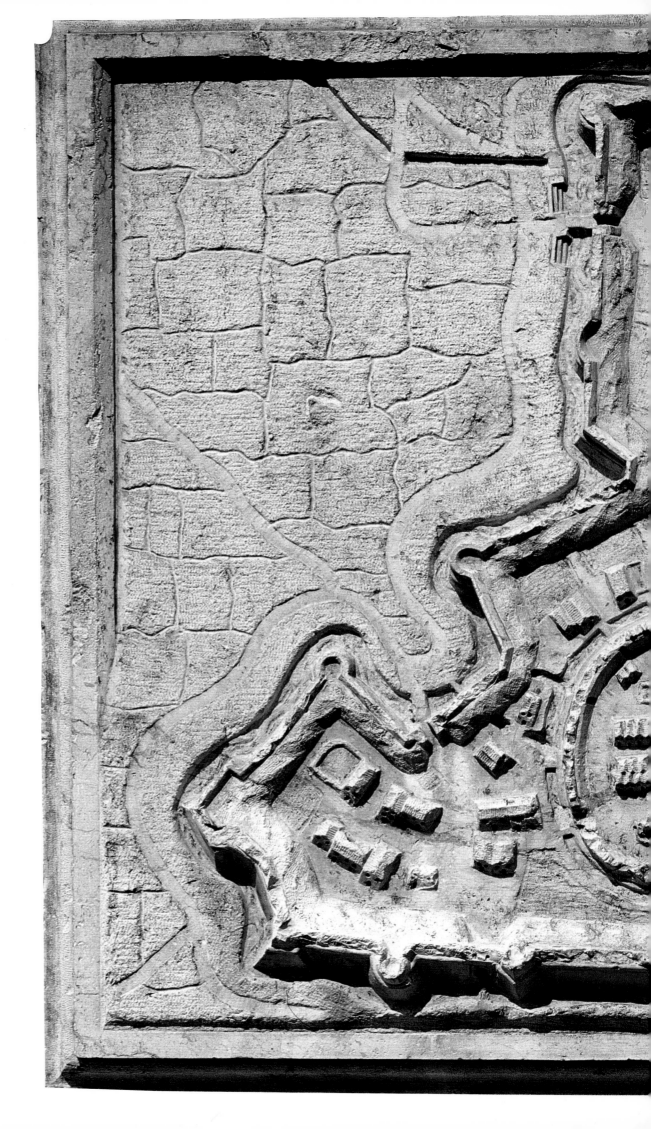

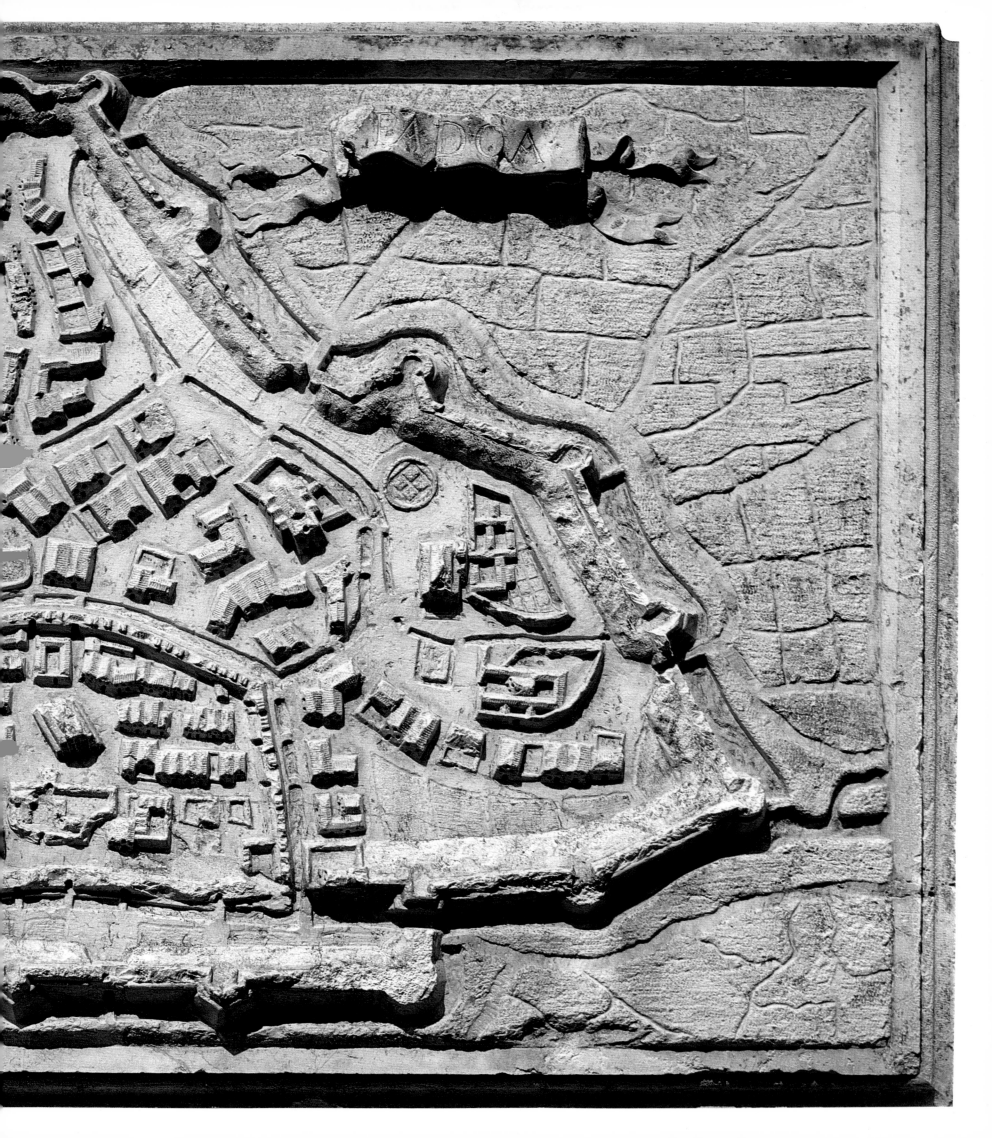

Pulpit and festoon in the church of the Gesuiti, 1729.

The church is the work of Domenico Rossi and was the home of the altars of the Guilds of silk weavers and tailors. Its interior is marked by extraordinary Baroque decoration with imitation wall hangings in *verde antica* on white. The decoration of huge, modular dimensions with plant elements which alternate vertically is extremely varied and covers every internal surface, from the pillars to the vaults and from the arches to the cornices, to the balusters.

We see typical motifs from furnishing fabrics from the 11th to the 18th centuries. This masterpiece may be by Abbondio Stazio, who was also responsible for the stuccoes on the ceiling.

plan and the furnishing of the home. However, it was only from the 14th century onwards that they have any interest from an artistic point of view. In the 15th century clear architectural rules were set out owing to a functional improvement: the hood was shorter and in pyramidal sections, and stood above an architrave supported by corbels on lateral pillars. The decorations were those of the classicizing Renaissance repertoire. In the 18th century, the fireplace was almost absorbed into the thickness of the wall, merging with the wall decorations and completed, in the internal niche, by coverings of ceramic tiles. Severe models were prevalent under Neoclassicism and Imperial style: there were reliefs and decorations derived from the Pompeian repertoire, often enriched with layers of gilded bronze.

Finally, the work of inlayers can also be considered part of the Guild of the stone-mason. Inlaying was derived directly from the ancient *opus sectile*, from which, however, it differs technically. The elements are cut according to a definite pattern, and placed between the deepest cavities obtained in the marble slabs. There is generally a strong contrast between the colors of the background material and the different materials (often very strong) which form the figures. The design is free from shadow thanks to clear chromatic matching, based on the decomposition of adjoining colors.

In Venice the largest inlaid surface is to be found in S. Maria Assunta, the so-called Jesuit church. Its internal walls and columns, up to the height of the capitals, are

[48]

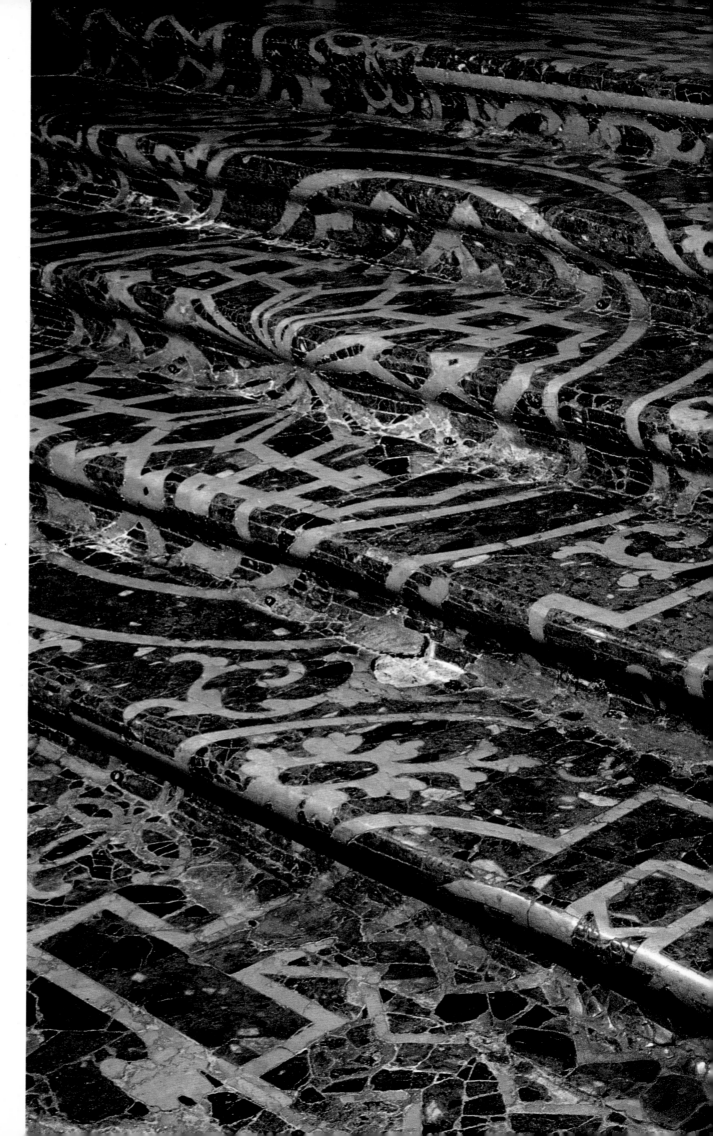

Step leading to the high altar in the church of the Gesuiti, 1729. The magnificent high altar was designed by Giuseppe Pozzo with a huge baldachin (inspired by Bernini) supported by ten spiral columns in *verde antica* marble. It is reached by five steps in *verde antica*, almost black, and yellow marble, in imitation of a covering in cloth. The overall effect is that of an enormous carpet with geometric-plant decorations, which has been spread out from the base of the altar over the steps and all round.

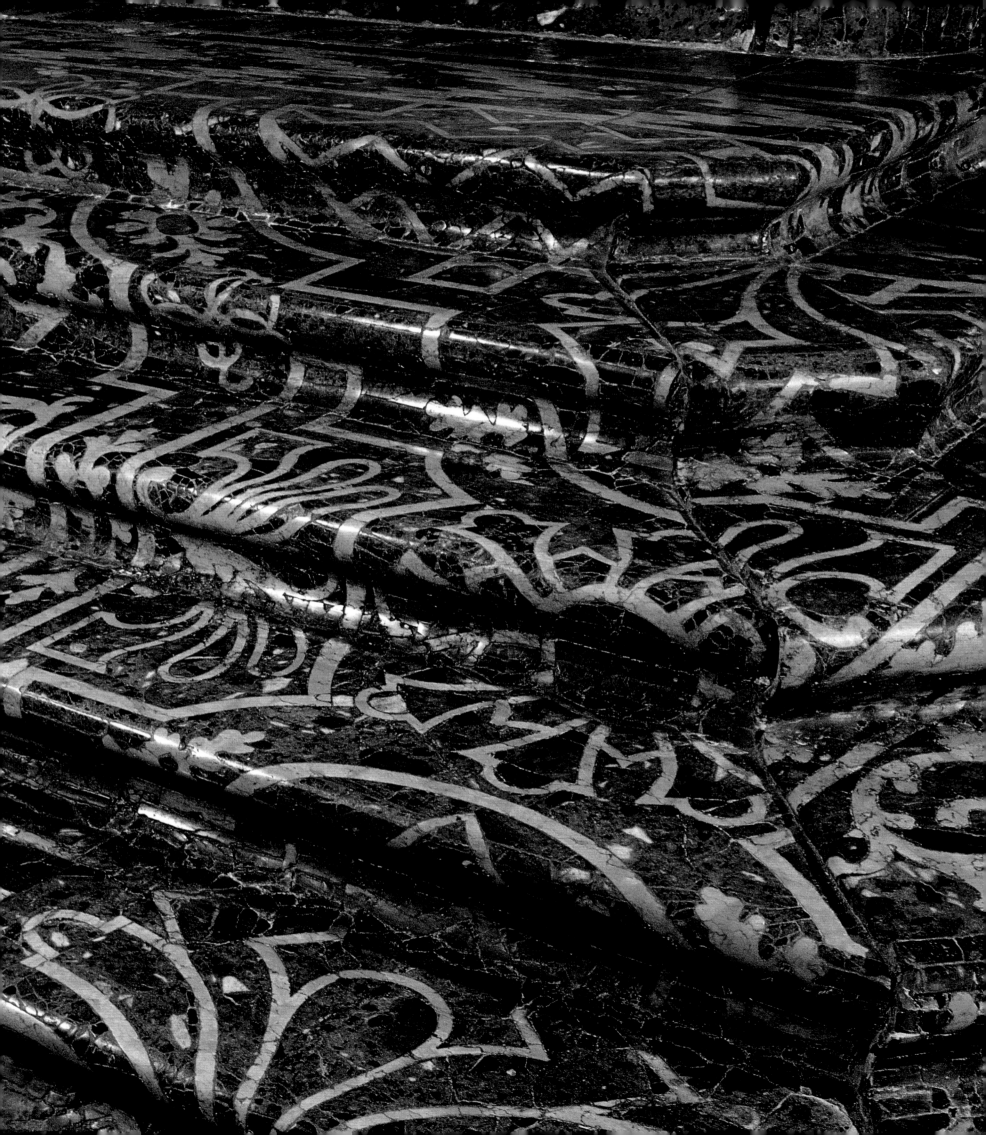

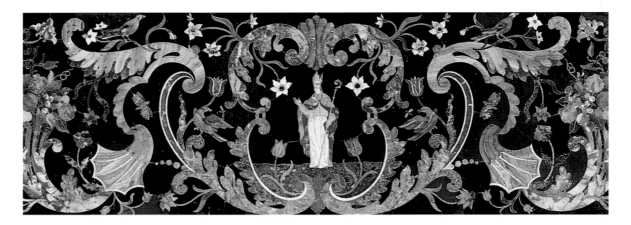

Parapet of the altar of the church of S. Francesco della Vigna, dating from the second half of the 17th century and attributed to Benedetto Corberelli. This magnificent inlaid work of rare marbles and polychrome semi-precious stones is to be found in the Bassi Sagredo chapel, remodeled in the 18th century by Tomaso Temanza.

The central medallion depicts the figure of a bishop saint. It is surrounded by cornucopias overflowing with flowers, lengthened and laciniated leaves, shells, shoots of flowers (among which narcissi and tulips can be made out), birds, and butterflies.

Opposite

In the central scroll, dated 1613, of the parapet of the altar of the church of S. Stefano, framed by botanical specialties which were fashionable at the time, the stoning of St. Stephen is depicted. Note the meticulous work of its creator, Giovanni Ferro, who managed faithfully to reproduce St. Mark's lion and the brocade velvet of martyr's dalmatic.

covered in white marble, on which, in *verde antica* breccia with the effect of inlaying in imitation of textile tapestry, appears a design of plant volutes. The steps of the high altar seem, however, to be covered with a huge carpet with green-black on yellow gold plant designs, obtained using the technique of *commesso* marble, also used in the "drapes" which embellish the pulpit. This church was the seat from 1643 onwards of the school of silk weavers and tailors, and its baroque design is perhaps the work of Abbondio Stazio, from Ticino, and his workshop, or perhaps the steps were by Giovanni Pozzo.

Between the second half of the 17th century and the first half of the 18th century there is evidence of a certain amount of activity by artisans specializing in work on semi-precious stones. This proves that glyptics, which emerged thanks to the humanist culture of the Renaissance, was not the exclusive territory of Florence and its factory of precious stones, founded in 1588 by Ferdinando de' Medici, but was also practised, with happy results, elsewhere. Important artistic examples of it remain, such as the pavement of the landings of the staircase of the priory of St. Dominic and the altar frontals in six Venetian churches. Giovanni

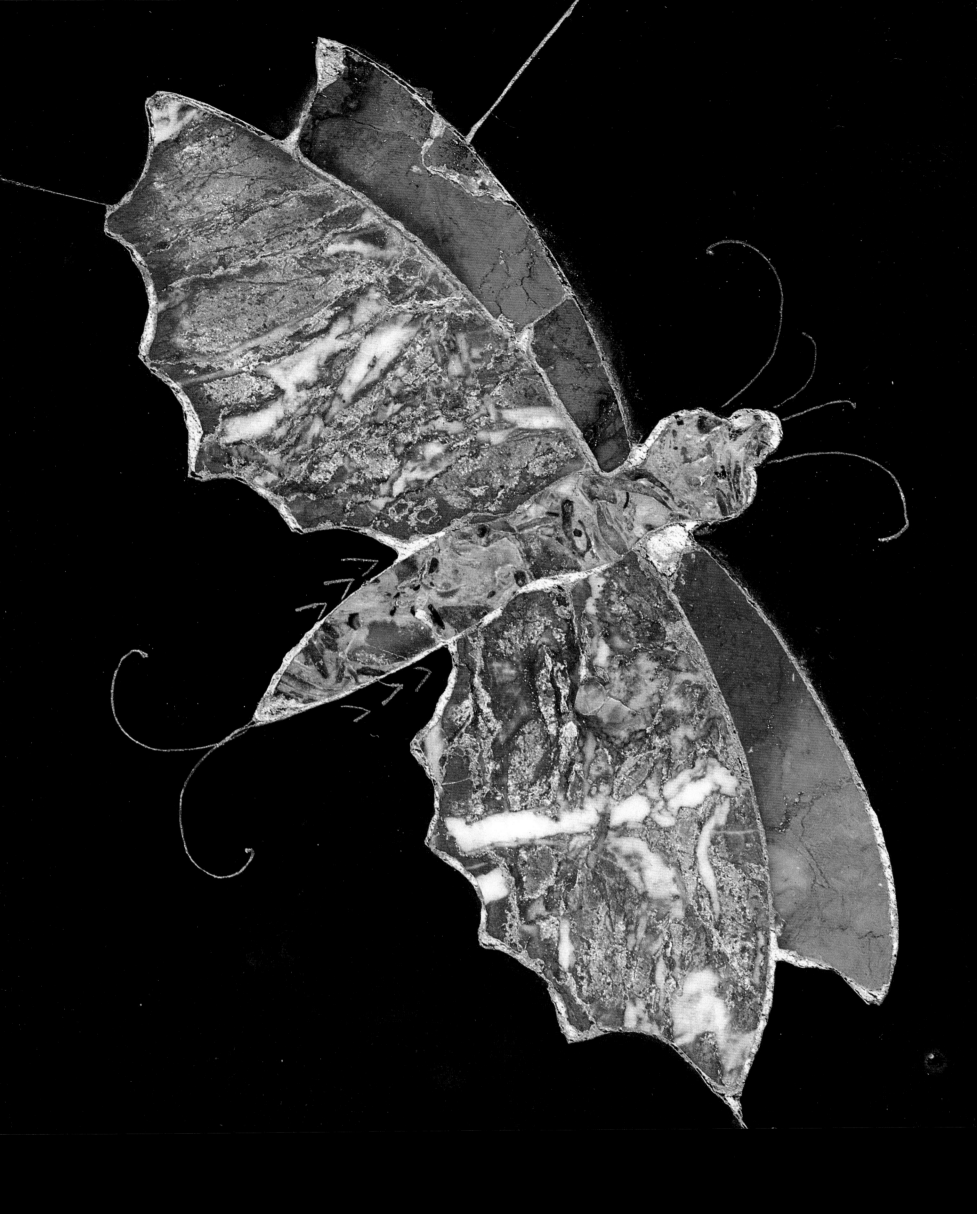

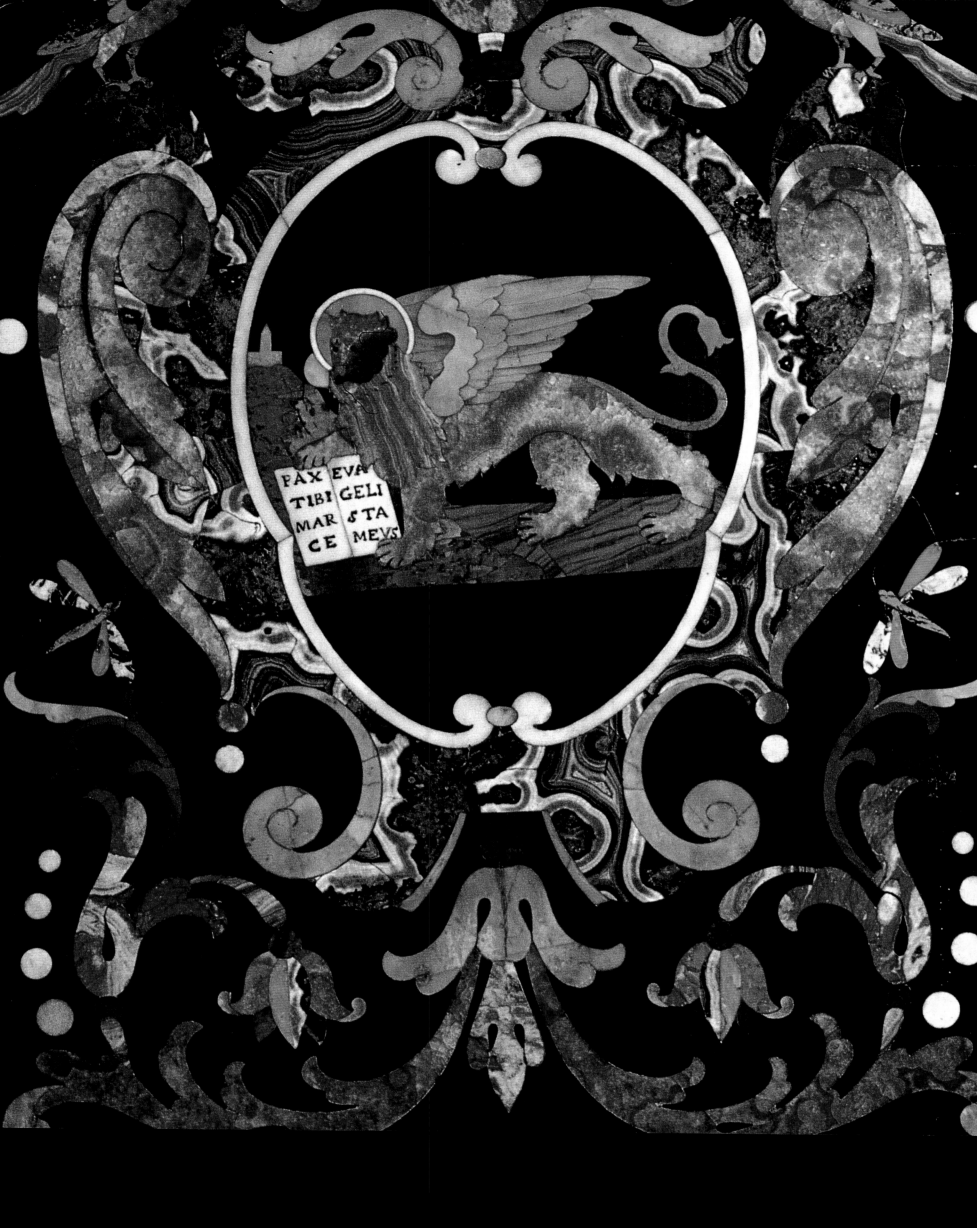

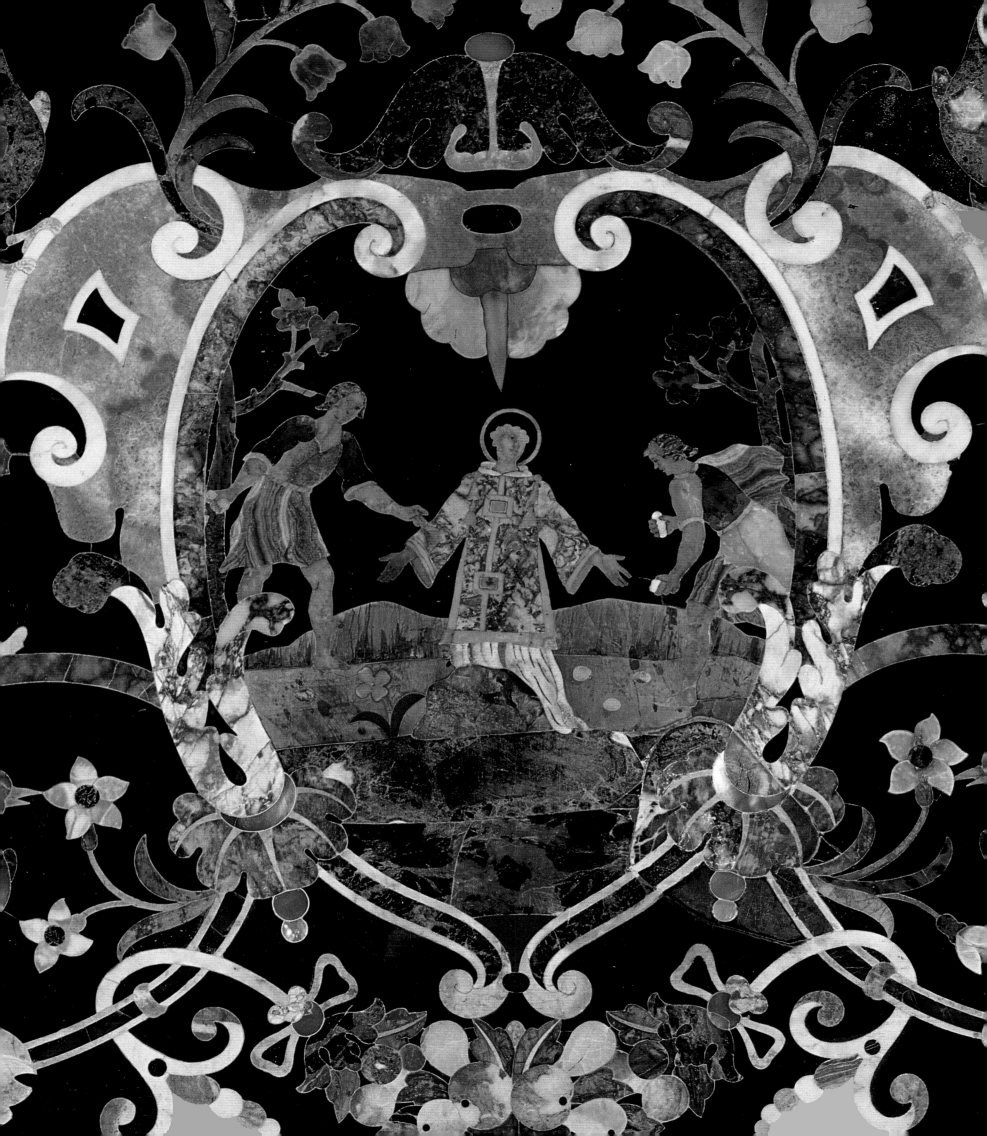

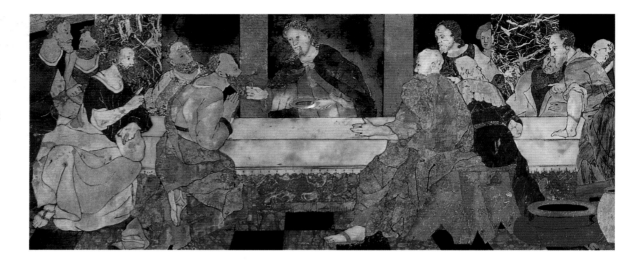

Parapet of the altar in the church of S. Maria del Giglio. The high altar is an elegant 17th-century work, embellished with sculptures by Arrigo Meyring. It is decorated with marble inlaid work depicting the Last Supper, created between 1683 and 1695 by Giovanni Comin.

Small table, probably made in Venice, 17th century.
Private collection.
This small table has four turned balustered legs, held by a crosspiece in the form of scissors. The top is inlaid with scagliola in imitation of marble and semi-precious stones. The decoration represents a *trompe l'œil* with musical instruments and scores, a map, a manuscript page, and playing cards which lead to the Venetian attribution.

Ferro created the *Stoning* of St. Stephen for the high altar of the church of the same name; it appears between a medallion supported by baroque floral polychrome volutes while, a few years later, Benedetto Corberelli was probably creator of an extraordinary triumph of plant and animal elements in S. Francesco della Vigna. Between 1683 and 1695 Giovanni Comin carved the *Last Supper* on the altar of the church of S. Maria del Giglio, in which the *commesso* marbles are ideally continued in the ornamentation of the floor, created using the same technique. But if the subject of the latter may seem empty of any symbolic meaning, this cannot be said of the *Stoning* in S. Stefano. The choice of subject is not limited to a mere reference to the saint to which the church is dedicated, but rather finds in the use of the marble a clear Christian symbolism in which stone is related to the death penalty of stoning by which Stephen became the first martyr.

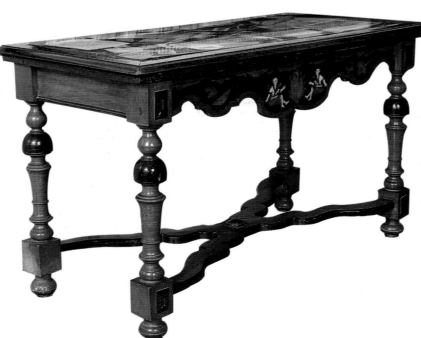

[56]

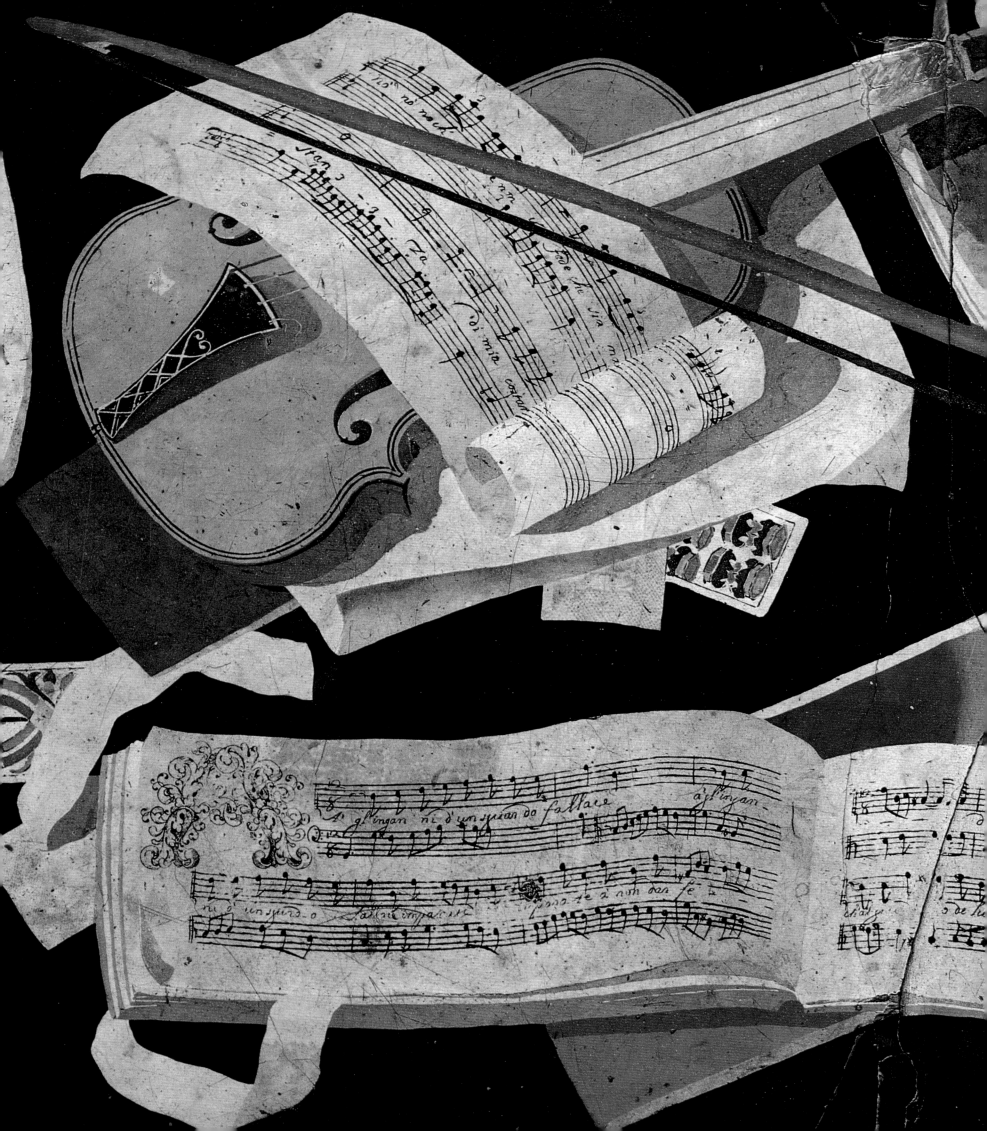

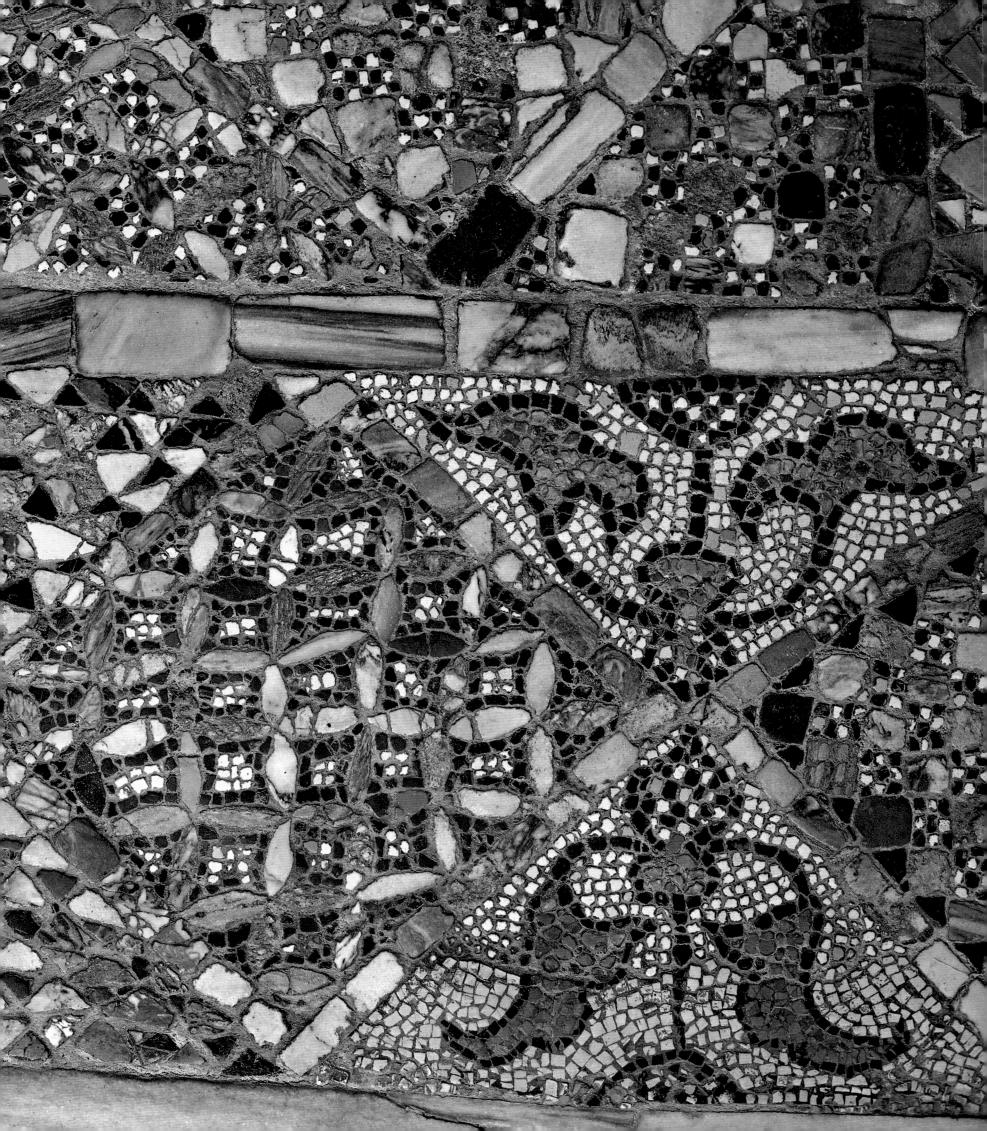

Tiles

The art, or rather the work, of Venetian *terazzeri* can actually be shown to go back to the *opus signinum* of Roman origins. This form of decoration, made up of marble and stone pieces cut into geometric shapes and brought together according to an imaginative, colored design, makes flat floor surfaces resemble rich oriental carpets.

The most ancient examples are to be found round Altino, but *opus sectile* is also visible in the church of S. Maria Assunta on Torcello, where the sunbeams and star corollas date back to the 9th–11th centuries, or in the church of S. Zaccaria (or rather in the remains of the 12th-century church) with the deer at the font, or in the fragment of an inscription between a series of arches in the primitive floor in S. Lorenzo. The original floor composition, dated 1141, still remains in the church of SS. Maria e Donato in Murano; here the *opus sectile* and *vermiculatum* give a geometric design, enlivened in the spaces in the composition by pairs of polychrome peacocks and griffins, which are very evocative. It is however in the marble carpets of the Basilica of S. Marco that one can admire the

Floor of the church of SS. Maria e Donato in Murano, 12th century. *Opus sectile* is obtained by bringing together high quality marble and stone blocks, especially porphyry and serpentine, of varying sizes, and different tones and geometric shapes, to form a decorative effect which is simple but nonetheless of great artistic interest.

The evolution of the technique of *opus tessellatum* is recognizable if we compare the primitive paleochristian floor of the church of S. Lorenzo—recovered in recent archaeological excavations—and this detail from the floor of the Basilica of S. Marco (12th–13th century). A pair of peacocks are separated by a vase with handles from which trail the shoots of lotus flowers.

Pages 62 and 63

This dodecahedron in a mosaic background with plant shoots is in *opus sectile*. It was inspired by the design of the same name in *De divina proportione* by Luca Pacioli and is traditionally attributed to Paolo Uccello. It was created between 1425 and 1430, again in the Basilica of S. Marco.

most skillful kaleidoscopes next to magically balanced compositions, even despite the stratification of refined wisdom in the course of many centuries (from the 11th to the 19th). Here, therefore, we find the "starry dodecahedron" of the door of S. Pietro, attributed to Paolo Uccello. In the south transept we see the concentric squares which inscribe a circle of crowns, hexagonal polyhedrons, pyramids, and parallelepipeds round a huge central lapis lazuli. There are also bands or passages in quadripetal or polylobate corollas, fanciful insertions of red and green porphyry, serpentines from Greece, colored breccias and ancient marbles embellished with even more minutely detailed spacings, which depict in *opus tessellatum* animals such as griffins, chickens, peacocks, eagles, and rhinoceroses. This typology differs from *opus sectile* insofar as it "weaves" in reduced dimensions and regular shapes. This weaving was fixed on a level surface, stretched over a plaster base, on which the motif to be depicted was carved or drawn. Once it had been leveled, it was sprinkled with a mixture of lime, marble dust, and sand which worked its way into the cracks, creating greater stability and solidity.

It is possible to follow the artistic development of this art in Venice, from the minute and meticulous design of the first *opus* to the geometric compositions with wide strips and broad squares of the 16th, 17th, and 18th centuries, which completed the buildings planned by Andrea Palladio, Baldassare Longhena, Antonio Gaspari, and Giorgio Massari. One thinks, for example, of the external

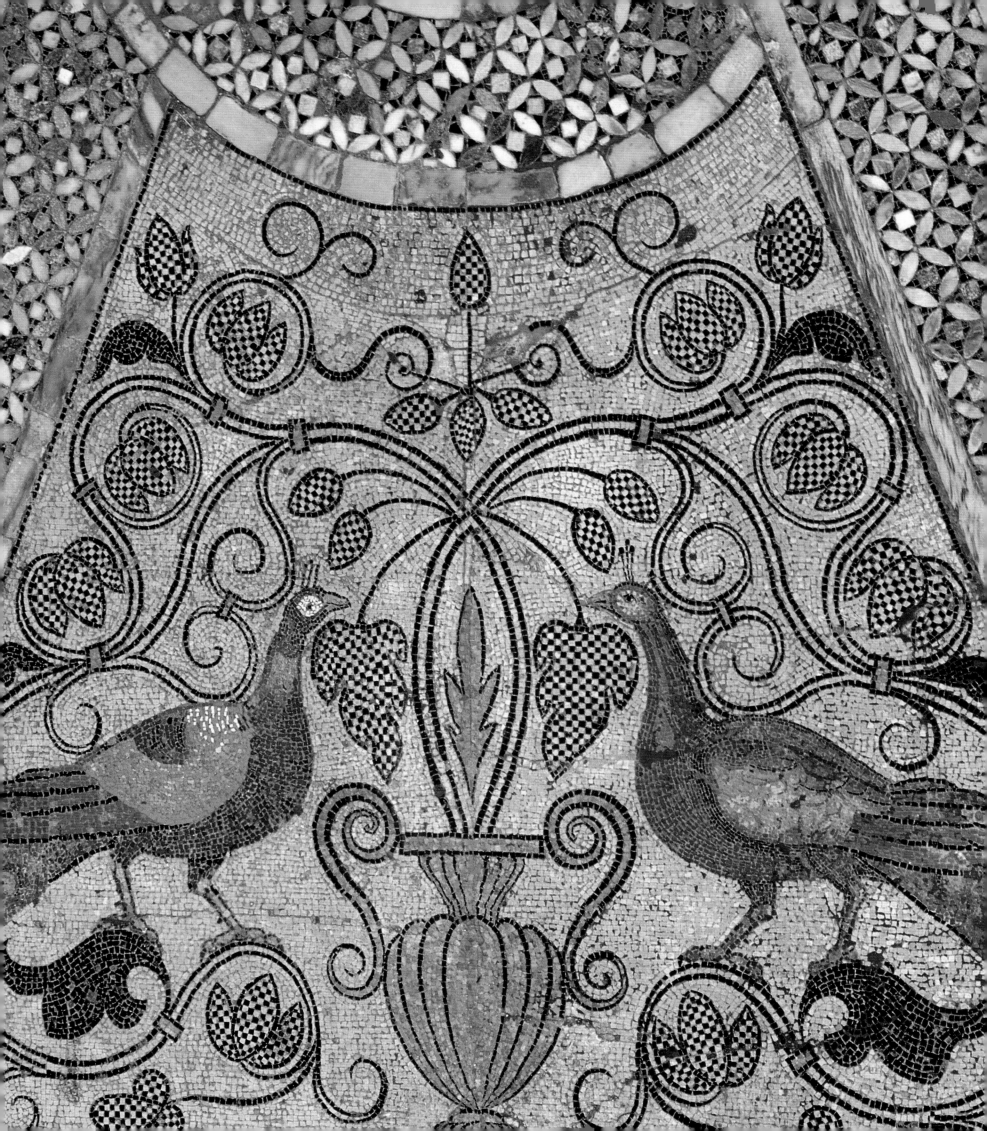

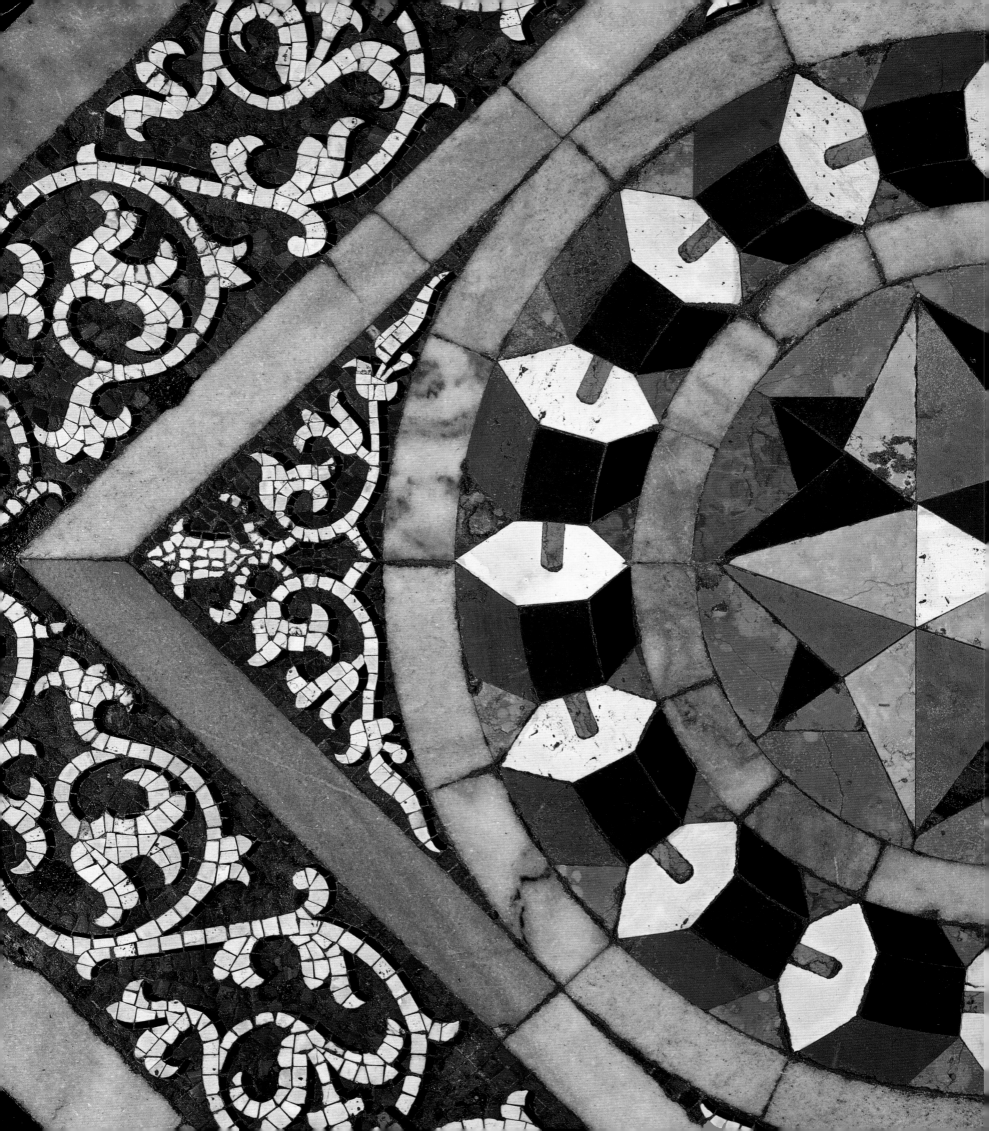

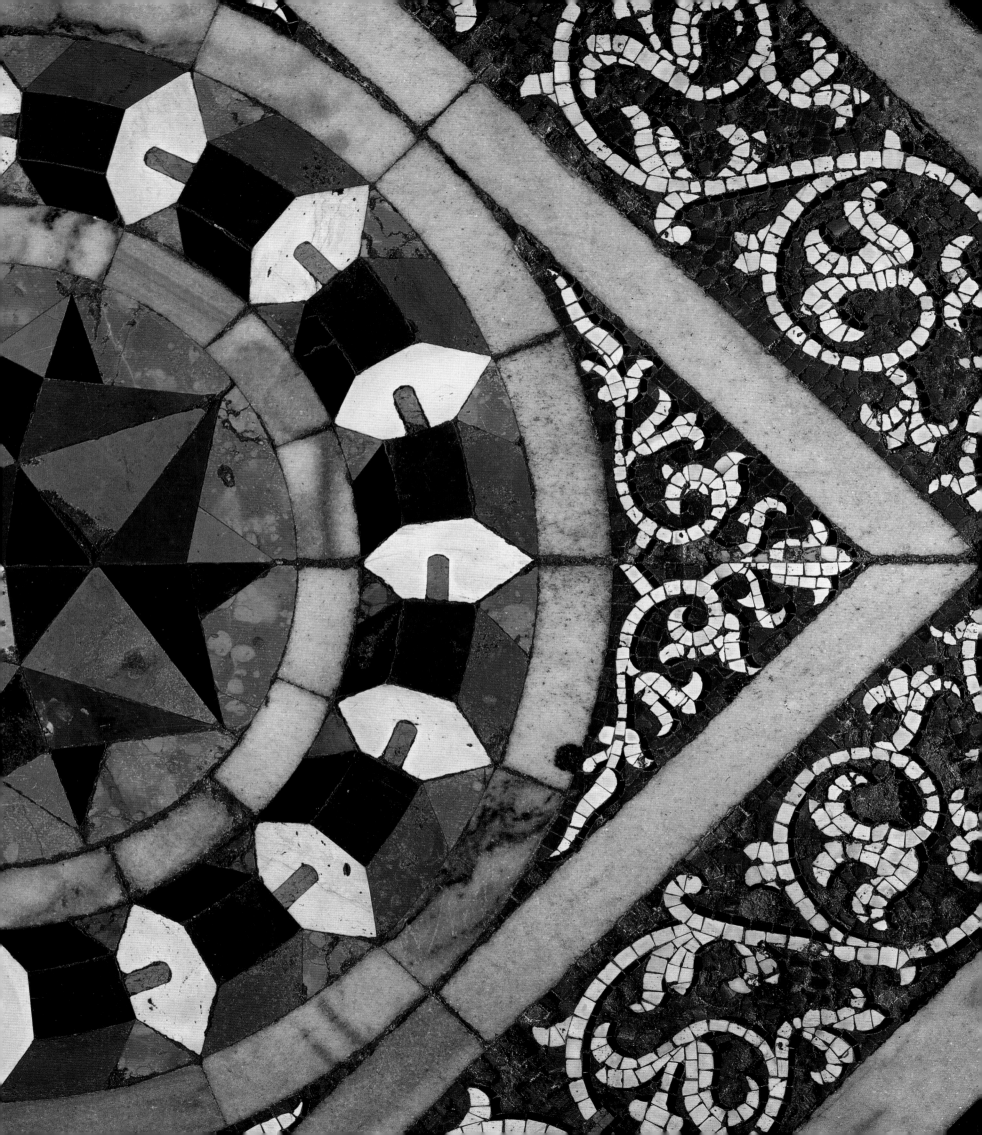

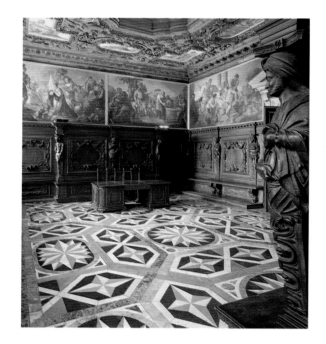

For the great architects of the past, the plans for the decorations of a room were as important as those for the building itself. For example, note the versatility of Baldassare Longhena, the greatest architect of Venetian Baroque. He not only designed the building of the Scuola Grande dei Carmini and the Chiesa della Salute, but also almost certainly designed the floors of the latter. The first, above, is attributed to Antonio Gaspari. It is in polychrome marbles and demonstrates perspective to great effect. It has star motifs between circular or hexagonal frames. The second, on the right, is characterized by strong Marian symbolism. It is realized with polychrome stones which form great concentric rings in which a round central medallion is enclosed. It has roses and buds and the inscription *unde origo, inde salus* (from the beginning, salvation).

floor, in trachyte and Istrian stone in rhombuses between octagons, which is a prelude to the internal floor, in white, gray, and black marble laid out to create three-dimensional optical effects, from the church of S. Giorgio Maggiore (by Palladio). There is also the spectacular perspective effect in the church of Madonna della Salute (by Longhena). This was created about the middle of the 17th century, perhaps to a design by Longhena himself, with red, pink, black, yellow, green, and white stone, culminating in the symbolic central crown with 33 rosebuds and shoots, which frame a nucleus with another five polychrome rose-peonies.

In another two buildings designed by Baldassare Longhena, the Scuola Grande dei Carmini and the priory of S. Domenico (both built in the second half of the 17th century), the floors of the Sala d'Archivio and the landings of the former are attributed to Antonio Gaspari and the great staircase of the latter to Antonio Bonini. Bonini is especially noteworthy for the quality of the inlaid work in mosaic as well as for the *opus tessellatum* on the ground floor, depicting colored birds, parrots, and doves between volutes of beaded acanthus with tulips and other exotic flowers. If we look carefully at the floors, from the earliest ones on a model from Byzantium or Ravenna to those from more recent centuries, we see that there is a relationship between the decoration of the ceilings and that of the floors, both in turn conditioned by the architectural structure of the buildings. It is therefore clear that, despite differences in style, inspiration and decoration, the

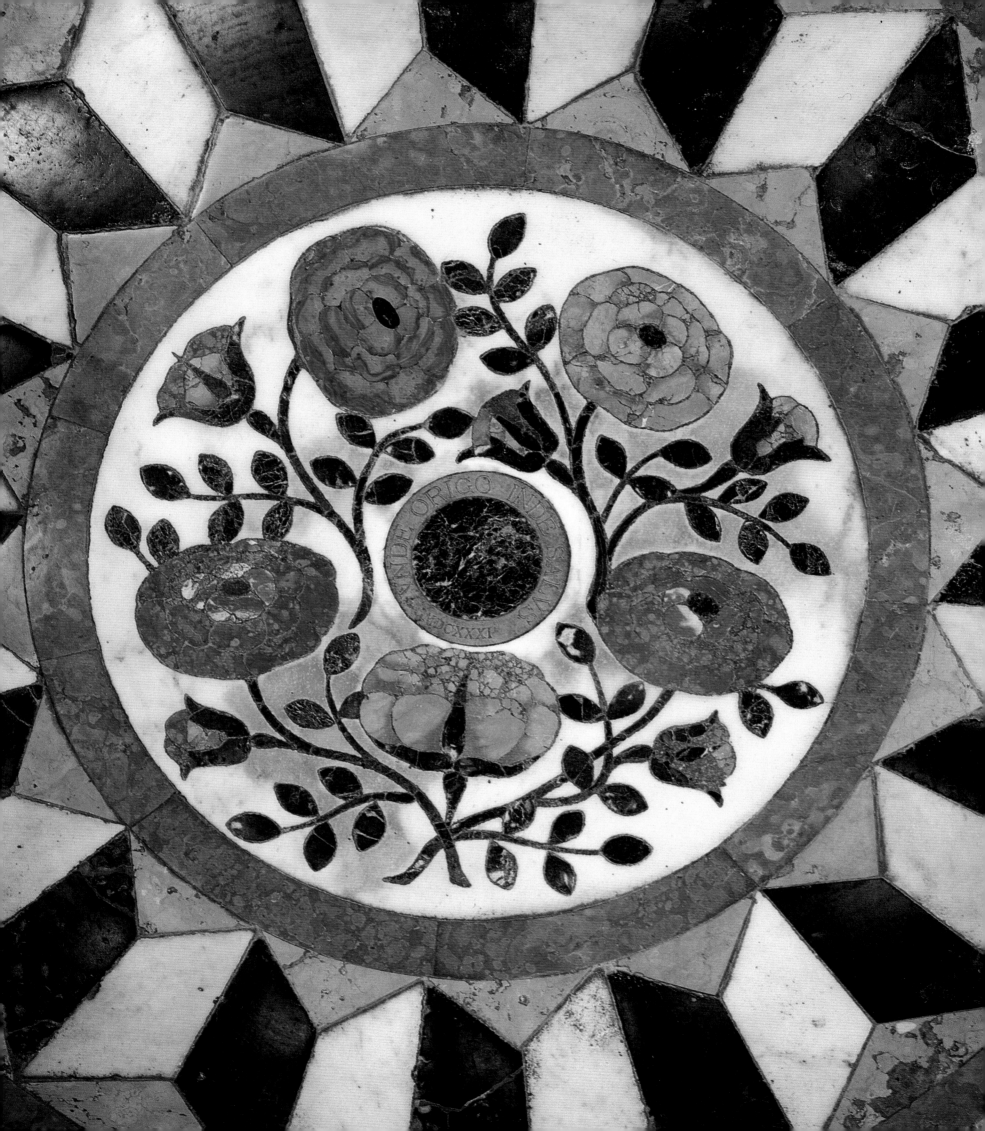

art of the *terazzeri* maintained throughout the centuries a clear point of reference in the *opus tessellatum* of the floor of the Basilica of S. Marco, a source of continual inspiration for all future city buildings.

From February 1583, thanks to the assent of the Consiglio dei Dieci, the guild was able to build itself a school, under the patronage of St. Florian. The 17 statutes of the *mariegola,* drawn up in 1586, concern as usual internal organization and rules of behavior based on mutual respect, as well as professional regulations. The trade, open only to Venetians or subjects of the State, was not allowed more than two apprentices, with an age limit of about fifteen years, established only from 1702 onwards. Once they were qualified workers, they had to do another three years in order to become master craftsmen, having naturally passed the "test of skill." Sons of master craftsmen were excused from this obligation; they had to pay the *benintrada* (entrance fee) and join the guild before they were 20 years old. In 1660 the technical test consisted of making a floor "of at least eight steps" (about six meters squared), later increased to "ten steps," well-hammered and leveled. They had to pay for materials out of their own pocket.

The complexity of the workmanship of a Venetian floor has been handed down to us by the architect Giovanni Vettori, writing in 1754. It can be summarized as

Only in a "floating" and aesthete city could a typology of floors be born which unites three indispensable qualities: elasticity, lightness, and decorativeness. This, in brief, is terrazzo in the Venetian style. A splendid example is that of the mezzanine of Palazzo Barbarigo. It was designed by Gerolamo Mengozzi, known as Il Colonna, in 1742, and presents a reticulate mosaic effect with a four-leafed flower placed between a small rhomboidal mesh. The one in the bedroom is livelier. In the center of a large medallion with concentric polylobate ovoidal corollas in pink Verona marble and an aster with twelve petals in yellow Torri marble, there is a red pierced heart on white *ciottolo* with scattered patches. Caterina Sagredo Barbarigo had this added after the death of her husband.

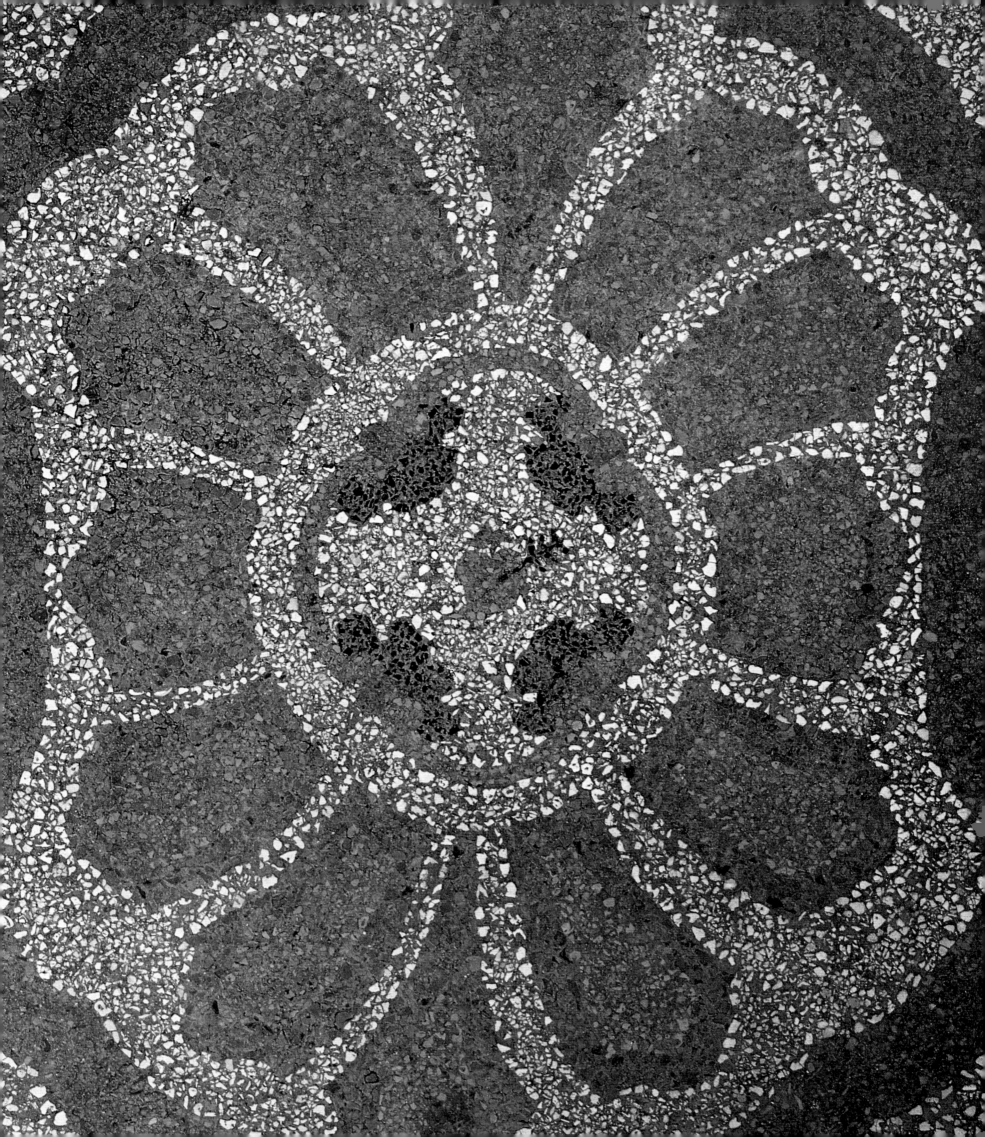

Different floor types are frequently combined in the same palace, such as in the Palazzo Pisani Moretta. In the large salons, Venetian *terazzeri* were used with circles, flowers and geometrical designs against a white background of crushed pebbles, while the stairways, (opposite and following pages) were done in high-quality marble. These floors, which Domenico and Giacomo Crovato laid following plans by Francesco Zanchi, show a vivid color combination achieved through the use of Sienna-yellow, Iseo-black, Cattaro-red and Verona-pink. The floor designs alternate between geometric figures and concentric garlands with flowers.

follows. First, lay out "well-hammered" boards on trusses; secondly, cover them with a layer of mixed materials made up of lime, strong, hard "splinters of rock from whatever source" mixed with bricks or well-crushed tiles, for a thickness and weight of about four ounces, well spread out, leveled and hammered; thirdly, once it has hardened place another layer on top, thinner and finer, called the "base cover" made up of lime made of pebbles, fine pieces of various dappled marbles, and ground brick dust. It was spread out and leveled on all surfaces, and had to be "vigorously" beaten and rebeaten once or twice a day for a month, using appropriate tools and uniformly in all directions. It was left to dry and harden, then leveled and smoothed with a special colored batter and finally oiled at least twice with linseed oil. There were three classes of floor quality: lowest or popular, medium, and of "strong and striking" quality.

In the 18th century the Guild of *terazzeri* found itself, like most of the other guilds, in serious difficulties. Their work was hard, demanded a lengthy apprenticeship and was poorly paid. The dearth of clients was combined with competition from more poorly qualified but less expensive workers from the mainland, in particular from Friuli, who came to the city for brief periods. Nevertheless a few exceptionally beautiful floors in Palazzo Pisani Moretta date from this period, and more precisely from 1742. They were the work of the *terrazzieri* Domenico and Giacomo Crovato, on the designs of Francesco Zanchi,

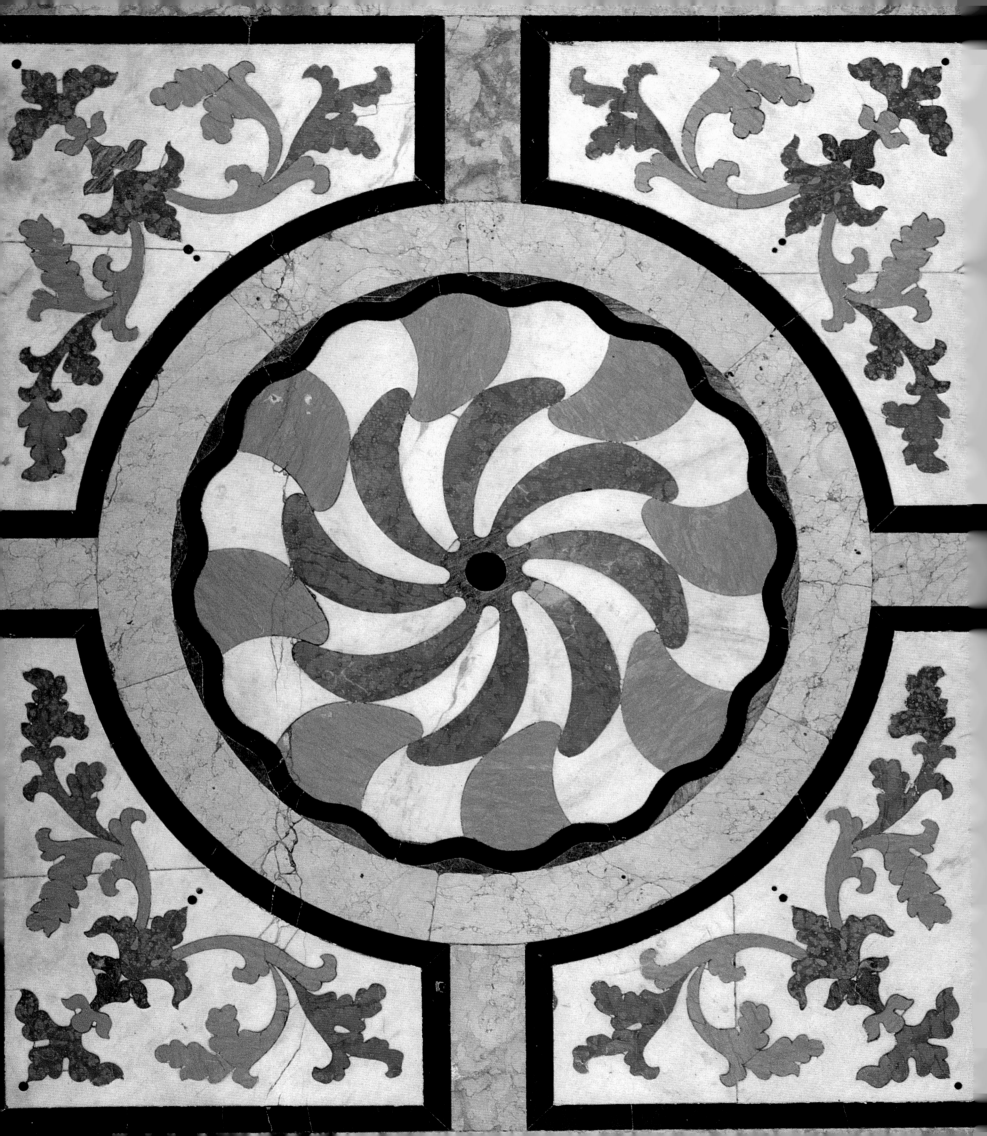

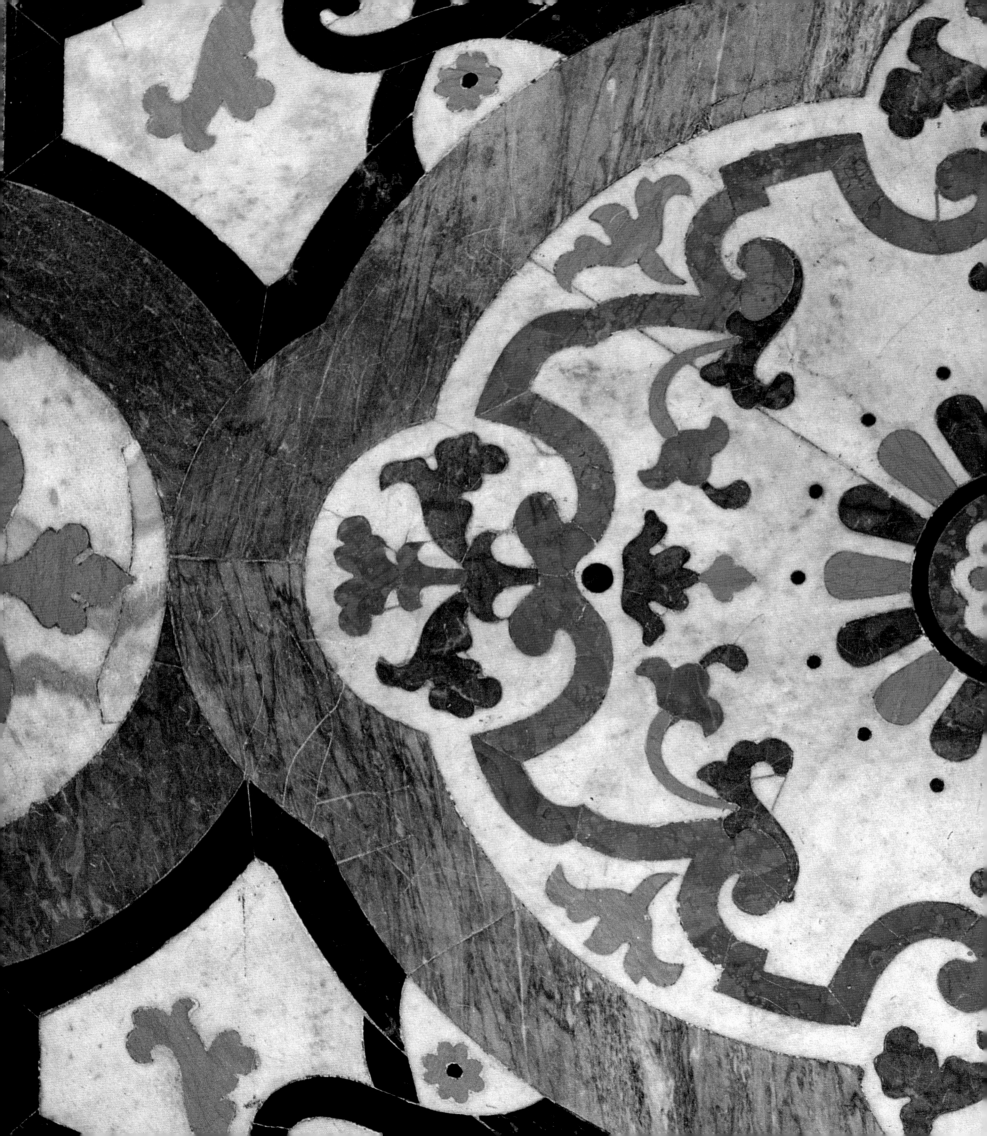

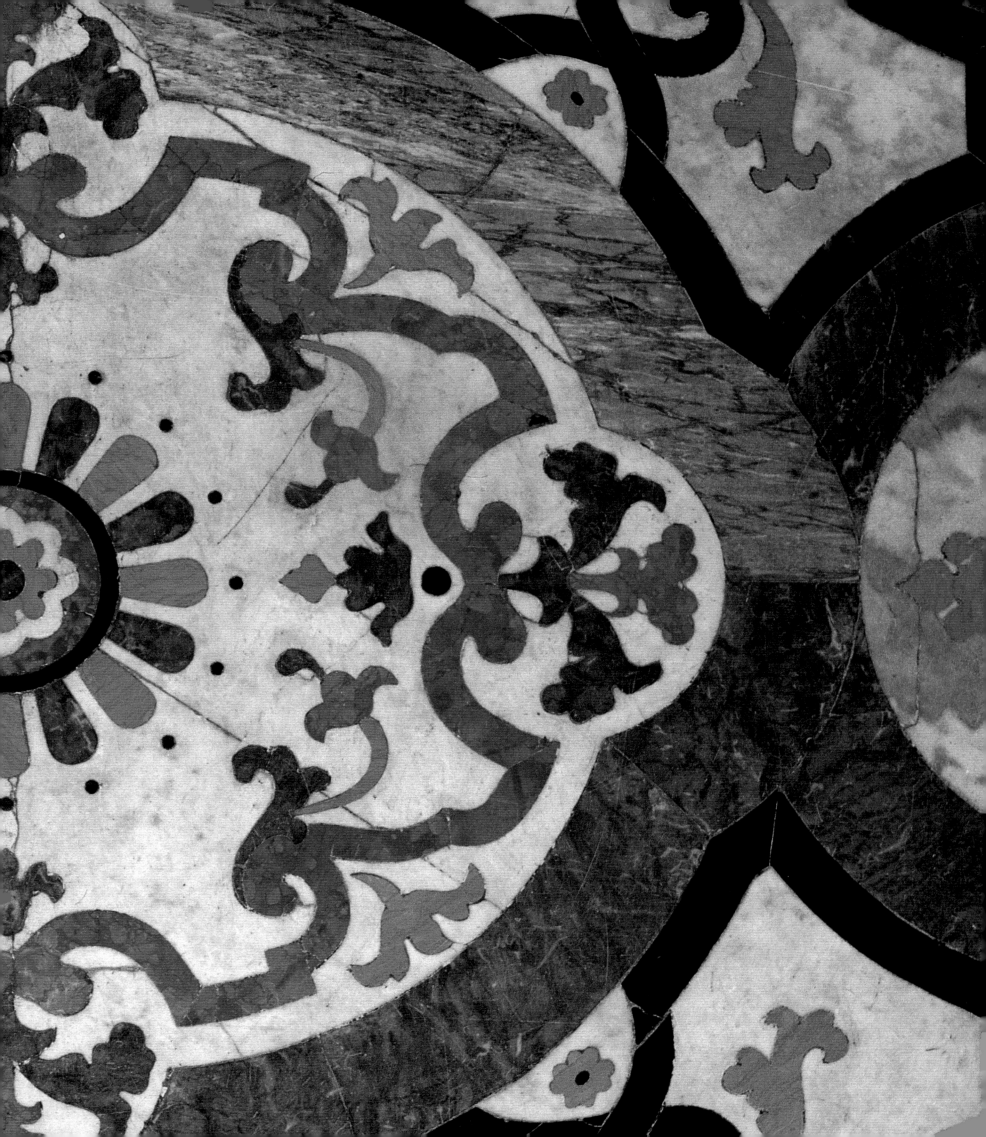

Ca' Tron gives us this elegant example, of which we see a detail. It may be dated to the last quarter of the 18th century. It has geometric frames which alternate with stylized corollas in a refined polychrome. Like a painter, the *terrazziere* paints floors drawing from a palette of marbles: *ciottolo* gives white, Cattaro marble red, lapis lazuli and *bardiglio* blue, Torri marble yellow and Alpi marble green.

and are very different from each other. Those in terrazzo are to be found in the salons of the *piani nobili*. They are of a traditional type, modestly decorated with arms and plant motifs, delicately framed by darker bands, while on the landings of the staircase they are executed in *opus sectile* or *intarsio*. They are of a different decorative style, and vary from a highly rigorous perspective geometrism to an airy, sunny naturalism. The floors of Palazzo Barbarigo are also documented: those of the mezzanine were completed in 1742 by the master craftsmen Antonio Tessa and Bortolo Cecchin to designs by Girolamo Mengozzi, known as Il Colonna. Garlands, medallions, arms, flowers, and pierced hearts appear in compositional contexts of large dimensions. The designs of the floors in the bedroom on the second floor of Palazzo Tiepolo Papadogli are attributed to none other than Giambattista Tiepolo, the fresco and stucco artist. They have *rocaille*, scroll, shell, and volute motifs. Meanwhile, the creator of the valuable terrazzo laid in the second half of the 18th century in Ca' Tron is not known. Ca' Tron is a 16th-century palace which underwent notable remodeling in the 18th century, and is now used as a university building.

The majority of Venetian floors are completely anonymous, but nevertheless inimitable, not only in their warm earthy tones but also in the uniformity and compactness of their surfaces. They needed careful maintenance. In 1585 Francesco Sansovino, who defined them as beautiful and durable, advised that they should be frequently cleaned with a cloth or sponge and covered with sheets to avoid stains and damage.

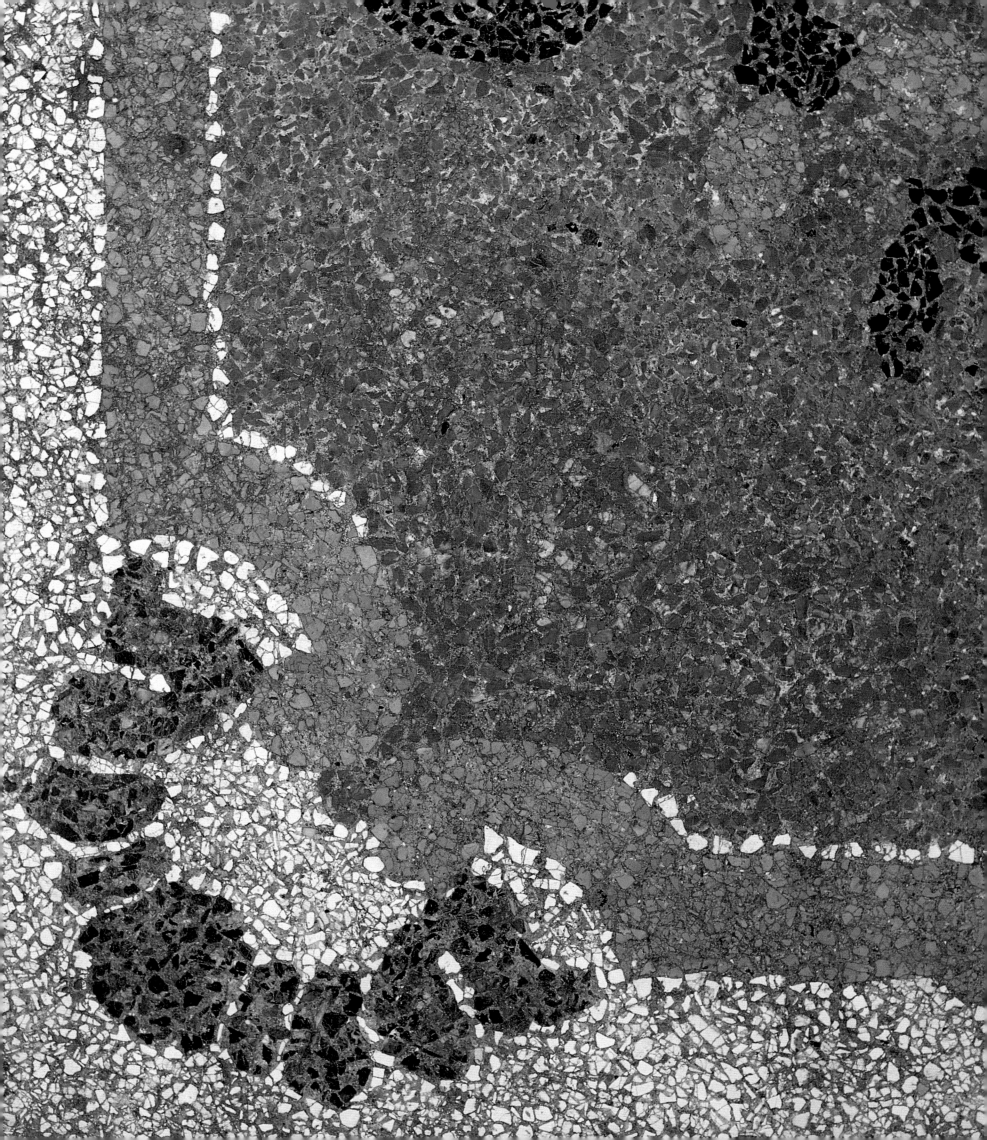

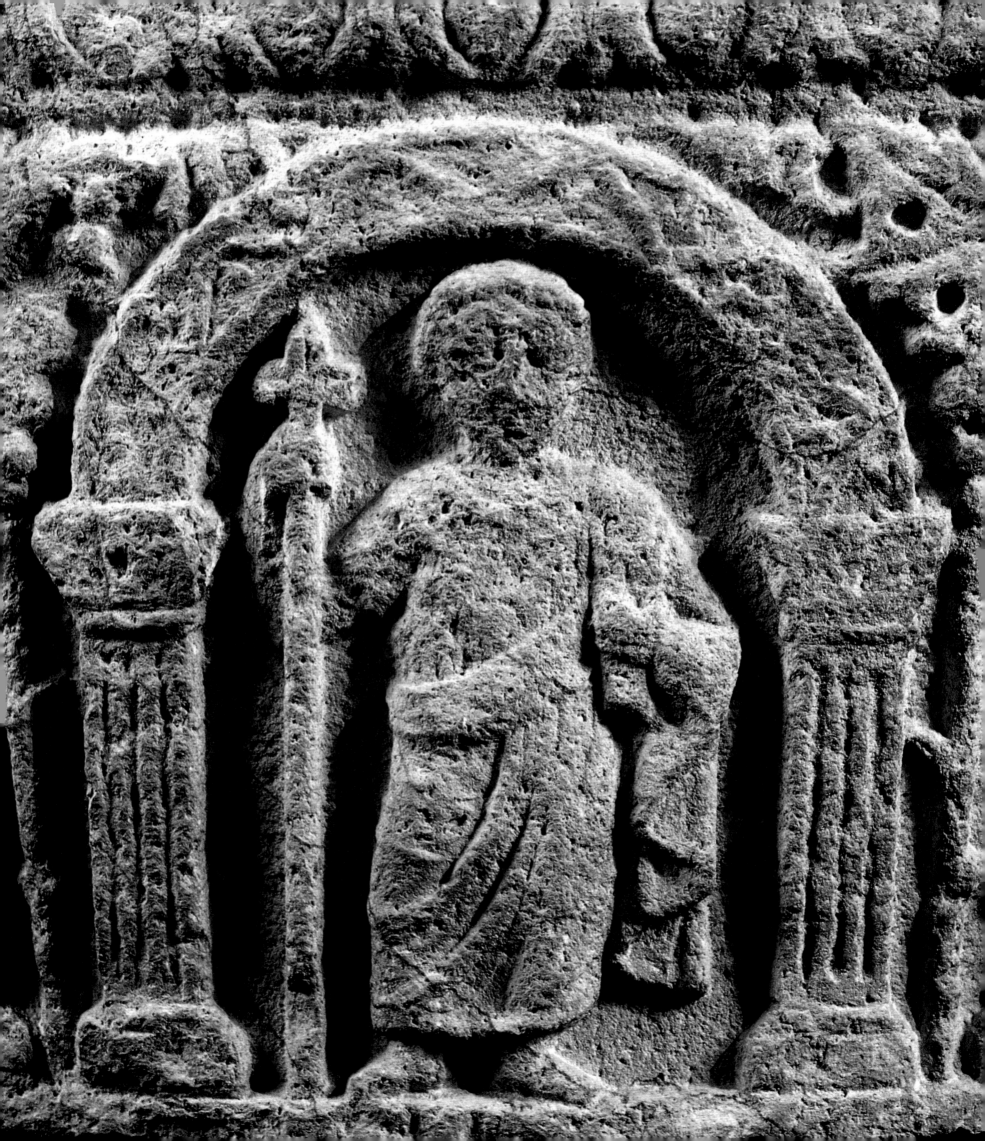

Wellheads and Chimneys

One of the most typical characteristics of Venice and its islands are the wellheads, or parapets, usually in stone, of the numerous wells scattered about the city. There were two guilds which were closely linked to wells: the *pozzeri* and the *acquaroli*. The former were skilled in excavation and in the construction of the shaft and supply basin of the well; they belonged to a *colonello* of the Guild of *mureri* (masons). The latter, together with the *burchieri* (owners of large boats known as *burchi*) were responsible for the supply of fresh water to a city defined by Sanudo as "in water but without water." Venetian wells were fed by rainwater or by water filtered through the sand of their own basin thanks to a hypogean structure carefully constructed following a technical procedure which was more than a 1 000 years old. Wellheads or puteals signaled their presence on the ground and protected them. They were also called *anelli, corone, sponde, cinte, parapetti, spallette,* or *bocche*; it

Wellhead, 950–80
Private collection.
This rare puteal comes from Altino or Aquileia. It is in trachyte from the Euganei hills and has a border decorated with a braid motif, while the central body has niches in which characters wearing a paludamentum alternate with animals of Christian symbolism, such as peacocks separated by the tree of life, an allegory of the immortality of the soul.

Wellhead of Campo SS. Giovanni e Paolo, from the first half of the 16th century, attributed to Jacopo Sansovino.
It came from Ca' Corner of the Ca' Grande in S. Maurizio and was placed in the *campo* in 1823 on the occasion of the construction of a new well, which was needed because of the dearth of water in the area. It is decorated with putti holding garlands of fruit, and culminates in an upper frieze with plant shoots. Its stylistic likeness to certain decorations in St. Mark's Library lead to it being attributed to Sansovino.
There is significant evidence that this well originated in the late 15th century. It is in Palazzo Loredan (S. Stefano) and was made by an anonymous stone-mason in a Lombardan workshop. It is octagonal and made of pink marble; it is bounded by a braided frame, under which there is a series of lion's heads alternating with plant clusters. Its sides have vine shoots tumbling out of amphoras, with bunches of grapes, garlands of fruit and laurel, heraldic shields, and lions.

appears that there were more than 7 000 of them, both private and public, in the city. Public wells were marked by symbolic jugs or amphoras and one or more St. Mark's lions walking or *in moleca*, a dialect term which means that the lion is squatting or seen from above with wings arranged like chelas, so as to make it seem like a *moleca* (crab). The wells were all made of stone (apart from the two in bronze in the Doge's Palace). They were completely plundered by the antiques trade in the 19th and 20th centuries; about 2 500 were recently counted. From the stylistic point of view there are several classifications. "Archaeological wells," taken from blocks carved with Christian figures or symbols date from the Roman or paleochristian era. "Carolingian wells," from the 8th to the 10th centuries, are in the form of parallelepipeds or cylinders, and are decorated with fantastic animals. "Veneto-Byzantine wells," from the 11th to the 13th centuries, are cylindrical or inserted in a bowed rectangle with little columns and spiral pillars intertwined, with depictions of animals between vine volutes. "Lombard wells," from the 15th century, have the structure of a Corinthian column with shields and arms. "Renaissance wells," from the end of the 15th century to the beginning of the 16th, are usually polygonal in shape, and have masks and animal heads, or are cup-shaped with complex scenes, with putti-telamons or in pink marble such as the well in the entrance to Palazzo Loredan. "Mannerist" or "Baroque" wells, until the middle

[76]

of the 18th century, are of notable architectural interest. Finally, "neoclassical wells," until the first half of the 19th century are of a simple, linear structure.

The most common traditional Venetian type, widespread until the 14th century in the least accessible courts of lesser Venice, is characterized by cylindrical lines, slightly tapered towards the base, with a square or polygonal part on top, with small curved arches (sometimes ogive) or little clawed vaults at the corners. But whatever the era and style of manufacture of the wellhead, and whether found in a huge *campo* or small courtyard, surrounded by imposing buildings or humble dwellings, in the courtyard of a mystical cloister or a shadowy *cavedio*, whether made of rough Curzola stone or noble Greek marble, it has a certain Venetian flavor, which imbues its surroundings. Wellheads have a part to play in underlining the color of the scenery of a place. Chimneys play an important part, too; they are authentic miniature masterpieces of engineering and imagination, and characterize the architectural profile silhouetted against the sunset.

The humble Guild of *mureri* was responsible for building chimneys. It codified its corporativist and professional rules in a capitulary of 1271. The tasks for which they were specifically responsible were: lowering balconies or enlarging doorways, maintaining foundations and banks, widening chimneys, making walls more solid by blocking up holes and cracks, remaking covered roof terraces,

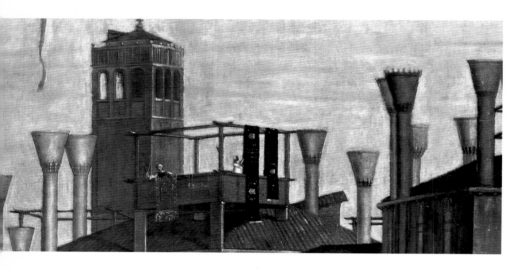

Vittore Carpaccio
Il miracolo della Croce al ponte di Rialto, 1494.
Venice, Gallerie dell'Accademia.
The different types of chimneys documented in this large canvas are still visible on the roofs of the city. An example is that of the early 16th century, the "bell" style where several chimneys are grouped together, placed on the roof of Ca' Vendramin Calergi.

[78]

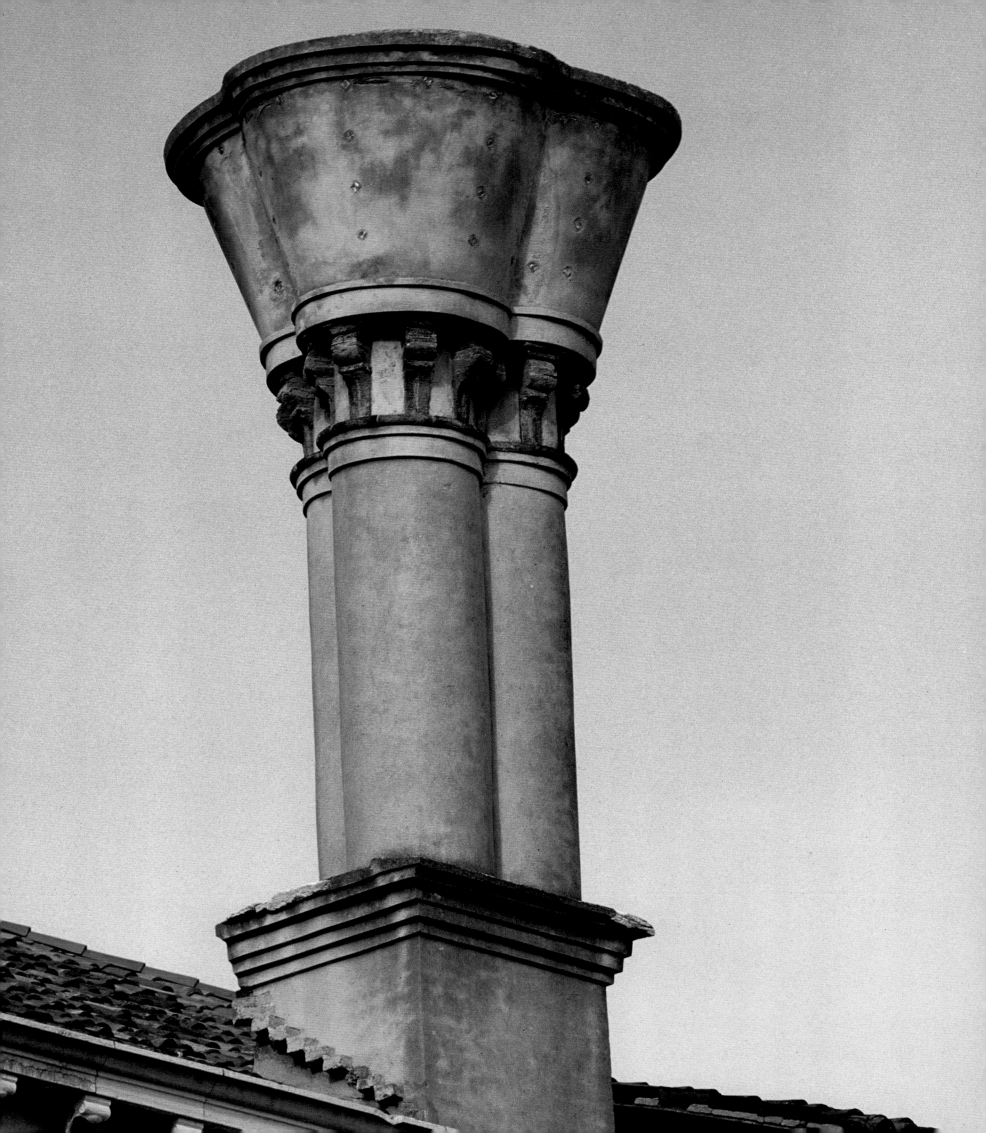

The most elegant of Venetian chimneys, is this from the old Zecca, celebrated by Palladio. It was enthusiastically planned by Jacopo Sansovino and Vincento Scamozzi in upside-down pyramid sections over a rectangular base. It is topped with moldings and a little pointed cupola which dominates the entire area of S. Marco.

changing the capitals on bridges, and tidying up gutters and recipients of rain and waste water. Unlike other guilds, foreign craftsmen were, from the earliest centuries, welcomed without much formality into the *ars murariorum*.

Those wishing to become master craftsmen served an apprenticeship of seven years, and were then tested making a plumb "column and its base" and a complete chimney with all its specific parts. Indeed, Venetian chimneys are not only extraordinary from the aesthetic point of view, but also in their ingenious and complex internal construction. Their architectural form can be "bell tower," "fork," "obelisk," "bell," "casket," "needle case," or "urn," and sometimes even stranger, more indefinable forms if different elements are combined.

Important artists, such as Raphael, Leon Battista Alberti, and Vincenzo Scamozzi, from Vicenza, were interested in the aesthetics, as well as the structure of chimneys. The latter lived in Venice, where he planned the Procuratie Nuove and completed the Libreria Sansoviniana. In his *Regole* he included a chapter on the construction of chimneys, in which he advised that their shafts be built straight and of medium size, to avoid smoke lingering in them. He was also the creator, with Sansovino, of the chimneys of the Zecca. Their shape—obelisk on a pedestal—pleased him so much that he judged them among the best. Later graceful and imaginative creations were not lacking, as for example the chimneys of Palazzo Albrizzi and Palazzo Vendramin Calergi, with shafts coupled and joined together almost like Gothic columns or those on the roofs of SS. Giovanni e Paolo, where three overturned bells form a single body, like a trefoil.

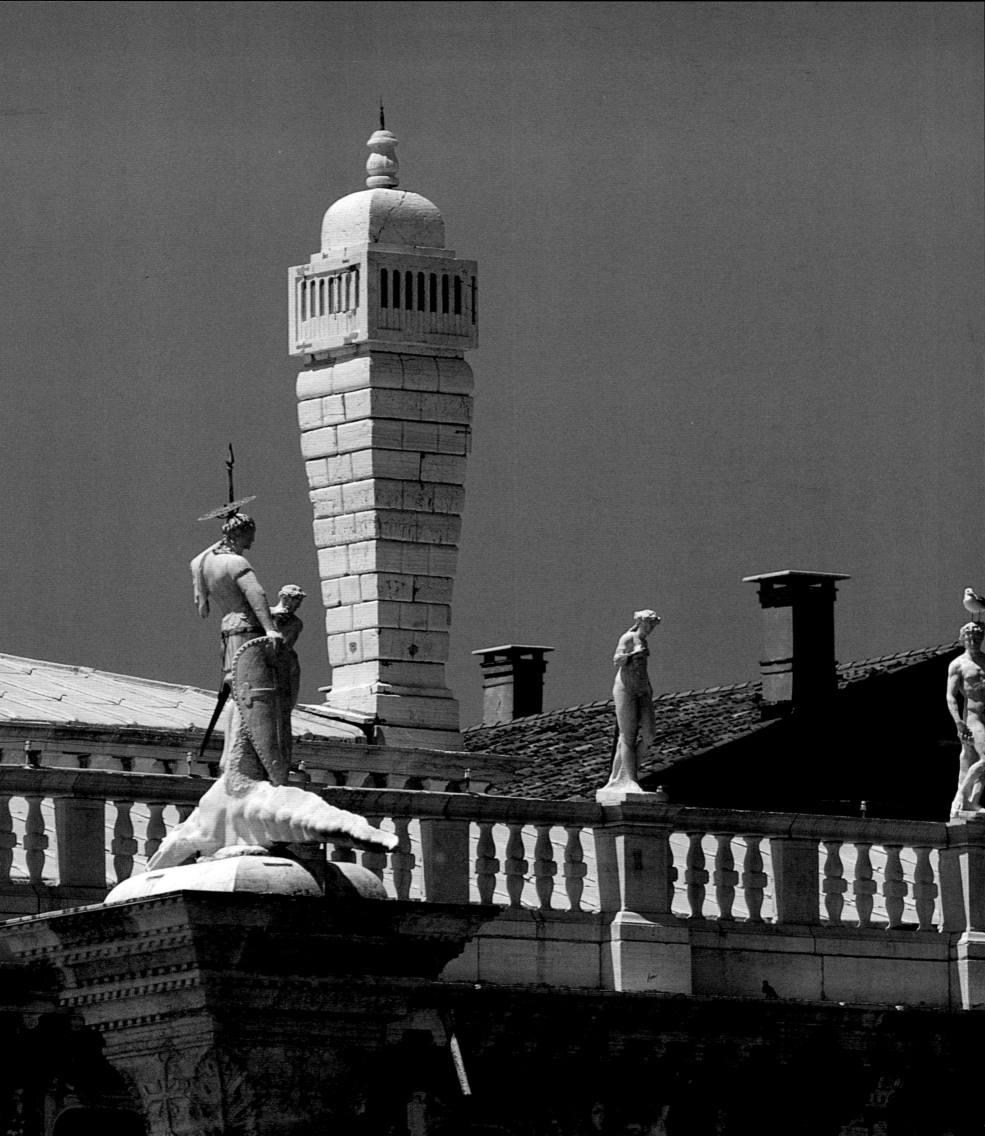

Malleable Arts

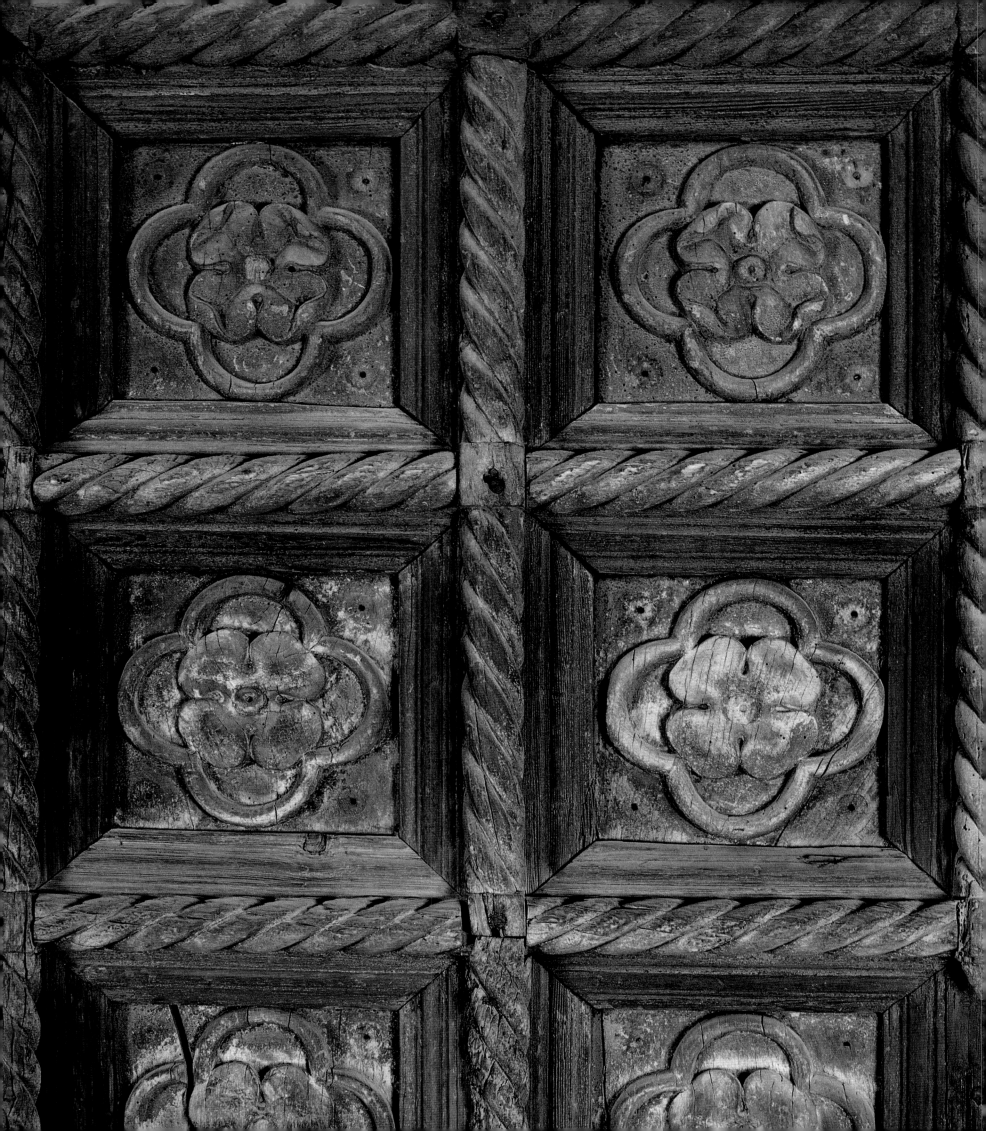

Wood

This kind of art bears great similarity with that of the smith,
So much…that there is the ancient question
Of which came first, the hammer or the handle?
Tommaso Garzoni, *La piazza universale di tutte le professioni*, 1585

Originally, Venice was completely built of wood: from the wooden piles of the foundations stuck in the mud to the roofs of .the houses made of wooden boards, the so-called *scandole*.

The art of the *marangoni*, woodworkers, originated and developed alongside the city itself. At first the craft of these artisans was limited to assembling the rough boards used in the construction of the first houses around Rialto, but the woodworkers gradually increased in number and importance as more and more palaces and churches were built on the lagoon. In 944, one specialized branch, the so-called *casselleri*, builders of nuptial chests, participated so actively in the liberation of the girls abducted by Slavic pirates during a collective wedding that was being celebrated in the church of S. Pietro di Castello (Venice's first cathedral)—an event that would later be commemorated with the Feast of the Marie and with the procession of bejeweled wooden icons—that they obtained the privilege of the annual visit of the doge to the altar dedicated to them in the church of S. Maria Formosa.

Original examples of 15th-century fixtures are rare. One of these is the door from the portal of S. Maria dei Servi, in the Museo Correr. Sectioned into squares, each compartment contains a quatrefoil within a quadrilobate frame.

Previous pages
Coffered ceiling found in a private palace.

Engraved cypress wood nuptial chest. Middle of the 15th century, Treviso, Museo Civico Ballo Among the foliate volutes with serrate leaves and berries, two male figures move towards a couple of girls dressed in flounced gowns; such garments, along with the hairstyles allow the dating of the piece and its certain ascription to Venetian craftsmanship.

The art of wood inlay produced, between the end of the 15th century and the beginning of the 16th, extraordinary examples in the armoires of the sacristy of the Basilica of S. Marco (see following pages). The chair back on the left, shows an inlaid urban view, an imaginary Venetian scene ascribed to Antonio and Paolo Mola. A door from a chest of drawers, on the right, shows a perspective view of a small cabinet containing various objects. Produced with various types of wood, it has been attributed to Vincenzo da Verona and Pietro da Padova.

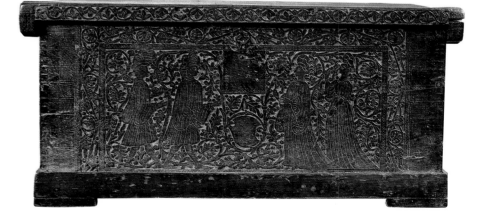

In 1271, the *marangoni* were issued a statute and in the early 14th century were included in the bas-reliefs of the allegory of professions on the third arch of the central portal of the Basilica of S. Marco. In the 18th century wood artisans were still distinguished into four categories (*colonelli*): *fabrica*, *noghera*, *soaze*, and *remessi*. The *fabrica* artisans provided the structure of the house—they built the doors and windows, fixtures and staircases—and other elements of soft, inexpensive wood. The *noghera* craftsmen, more refined, worked with walnut or other hard woods, to produce plain, unveneered furniture. The *soazeri* specialized in the creation of frames and worked with gondola craftsmen to provide wooden decorations for the *felze*, the typical gondola coverings, today no longer used. The above net distinction in four different sectors did·not exclude the occasional combination of the various specialties, except for the art of the *remesseri*, who were exclusively appointed to the technique of veneering and inlay.

The Guild of the *marangoni* accepted not only Venetian citizens or subjects from the mainland, but also foreigners—a right that was withdrawn in 1767—as long as they followed the regular procedures of apprenticeship and paid their dues. The four-year period of *garzonato* (apprenticeship) could begin at the age of thirteen, followed by a period of five years, later two, the so-called *lavorantia* (period of specialization). In order to reach the level necessary to open one's own workshop,

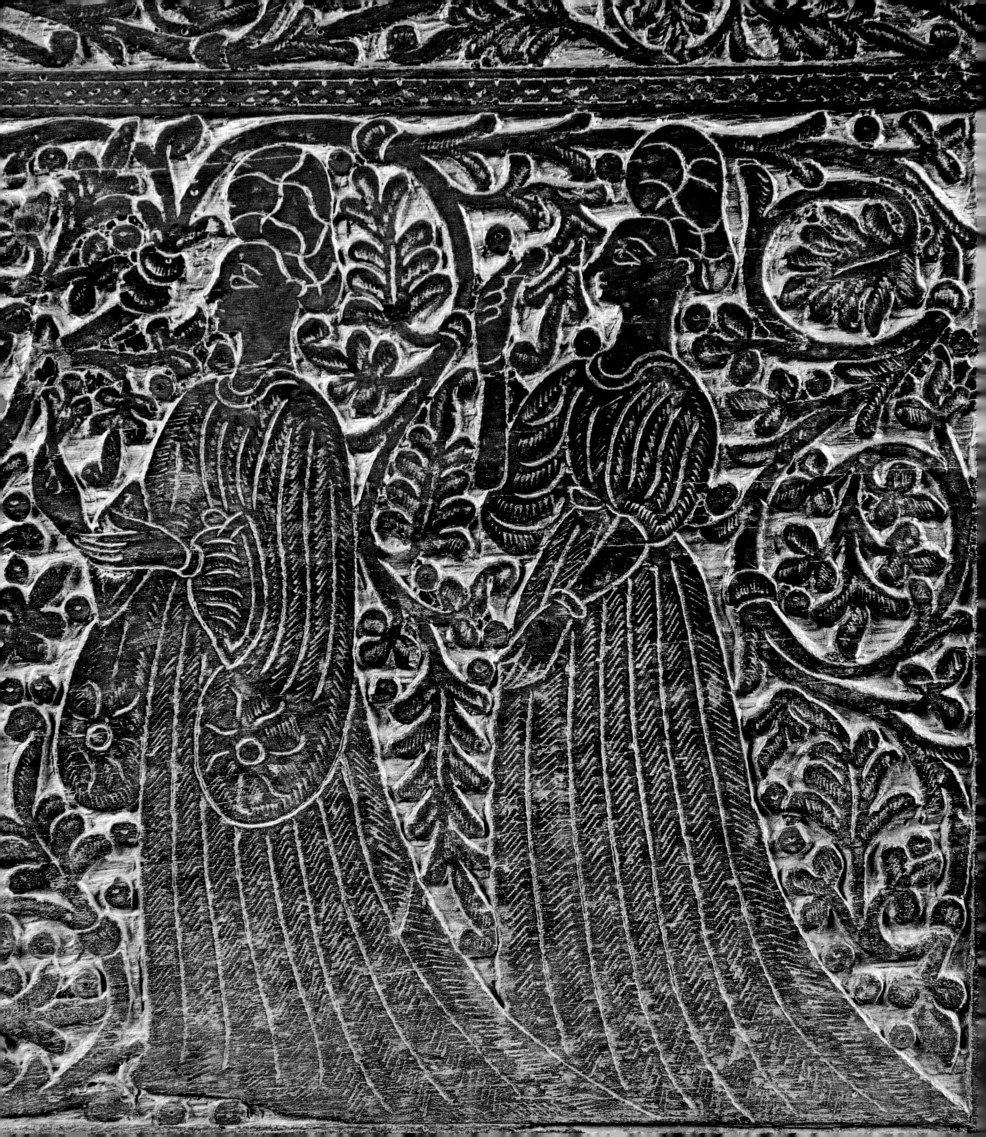

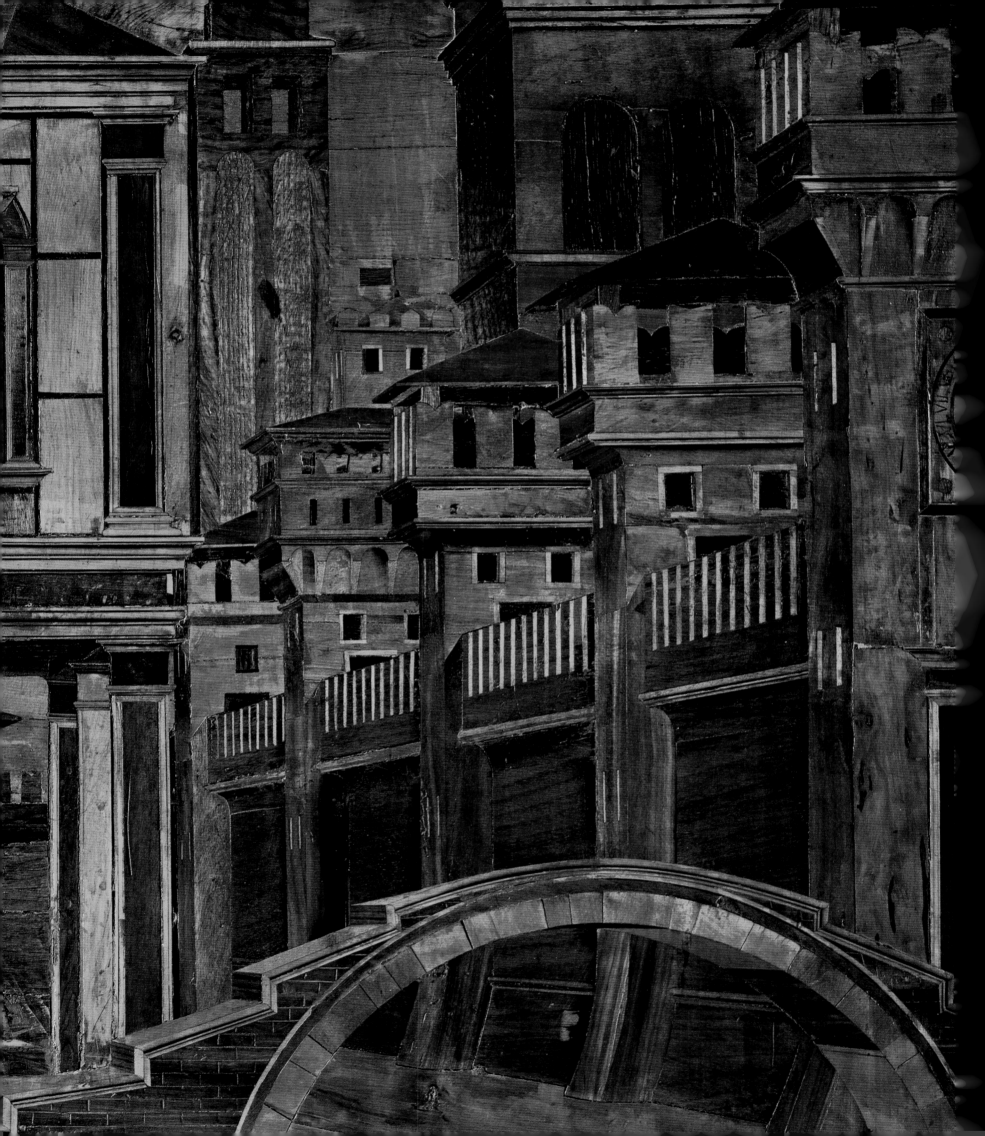

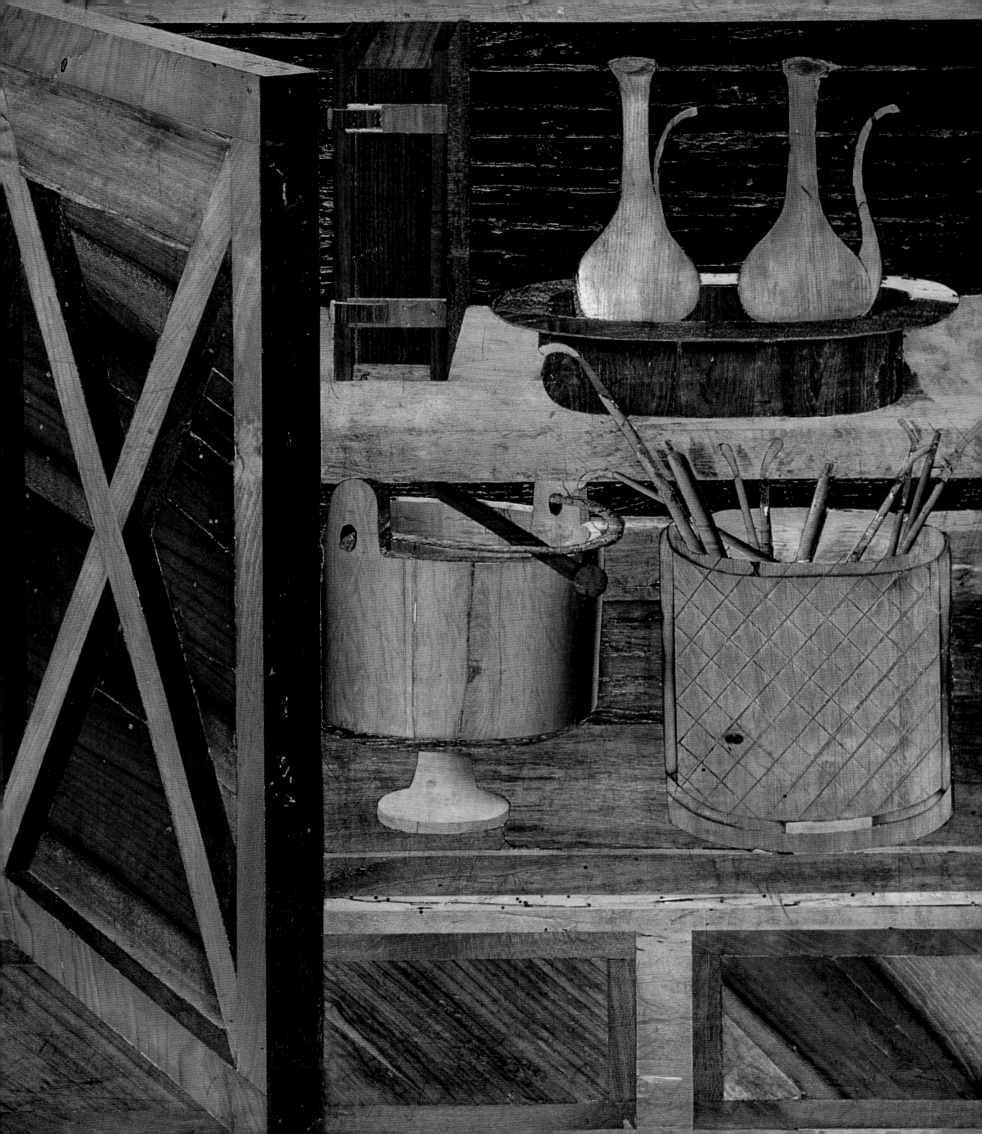

The close link between gold and Venice is as ancient as the city itself. Pressed into extremely thin leaves and properly laid, gold transformed the plainest of woods, conferring a precious touch and refined elegance to domestic objects. From frames, like this exquisite example from a private collection of the second half of the 15th century decorated in the *pastiglia* technique (a mixture of chalk and glue) on blue background to the door leaves like the ones of Palazzo Corner Spinelli of inlaid wood on blue background with foliate volutes and dolphins that frame the head of the Medusa. But perhaps it is in the coffered ceilings that the gilding, along with extraordinary wood carvings, produce exceptional ornamental effects. In the pages that follow, the 1547 ceiling from the Palazzo Corner Spinelli remains perhaps the most spectacular example, in addition to being one of the few still left in its original location.

teach apprentices and participate in the *capitolo* (general committee) which allowed access to the highest positions in the artisans' hierarchy, artisans were required to take an examination in order to demonstrate their technical ability.

For the *marangoni da fabrica* the exam involved drafting a stairwell and the perfect square cutting and polishing of a board, while the *noghera* craftsmen had to manufacture either a walnut chest with a partitioned front or a plain high chair, without any carving or decoration. The *soazeri* were asked to produce a mirror frame (*soaza* in Venetian dialect) or a gondola fixture. More precious types of wood were reserved for the *remesseri*, whose exam consisted of creating a small ivory-inlaid altar, then a cabinet. In the second half of the 18th century they would attend an academy in order to specialize in drawing and architecture.

No examples of Venetian furniture remain from the 13th century, though an idea of their appearance can be gathered from the mosaics in S. Marco (depicting the high-backed chairs of the saints and evangelists, or the beds on which lie Eve or Mary). By contrast, from the centuries that followed remain a large quantity of inlays, door ornamentation, frames, and ceiling beams, such as the door of the Palazzo Bernardo in S. Polo, or the doors of the Church of the Servi, now in the Museo Correr, or the original frame of the altarpiece by Lorenzo Venziano at the Gallerie dell'Accademia, signed and dated by the carving artist of the fantastic ornaments: *MCCCLVII Laurentium Caninum sculptorem.* It is possible that

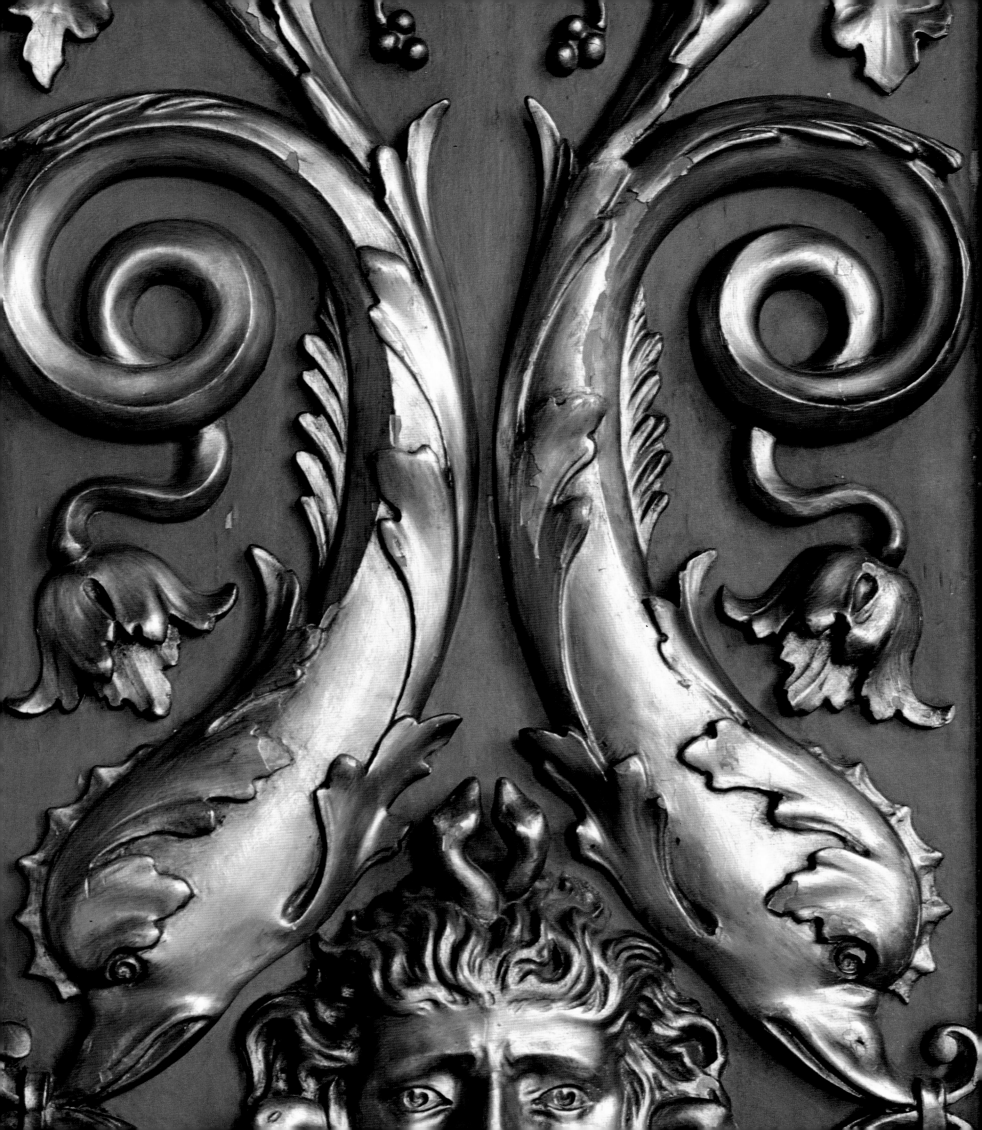

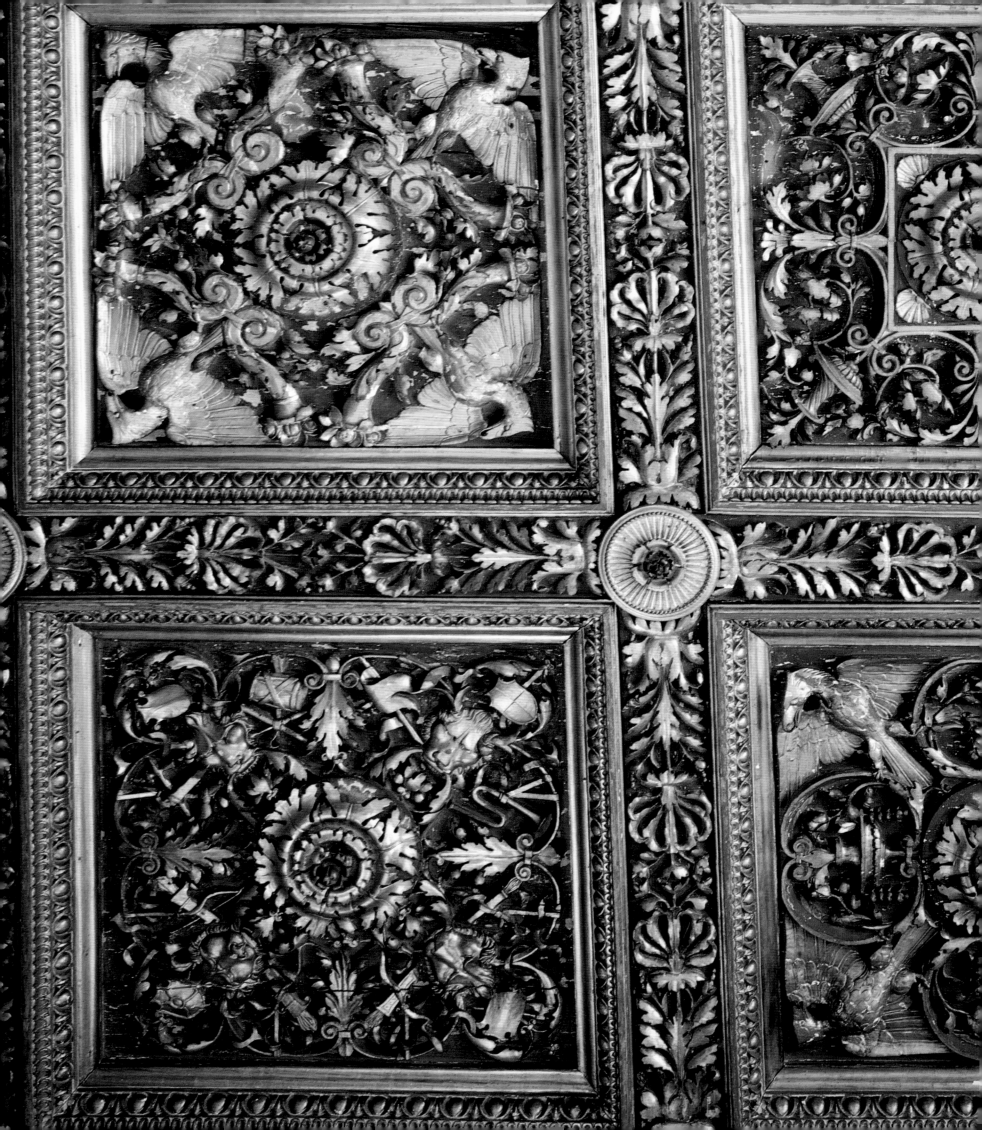

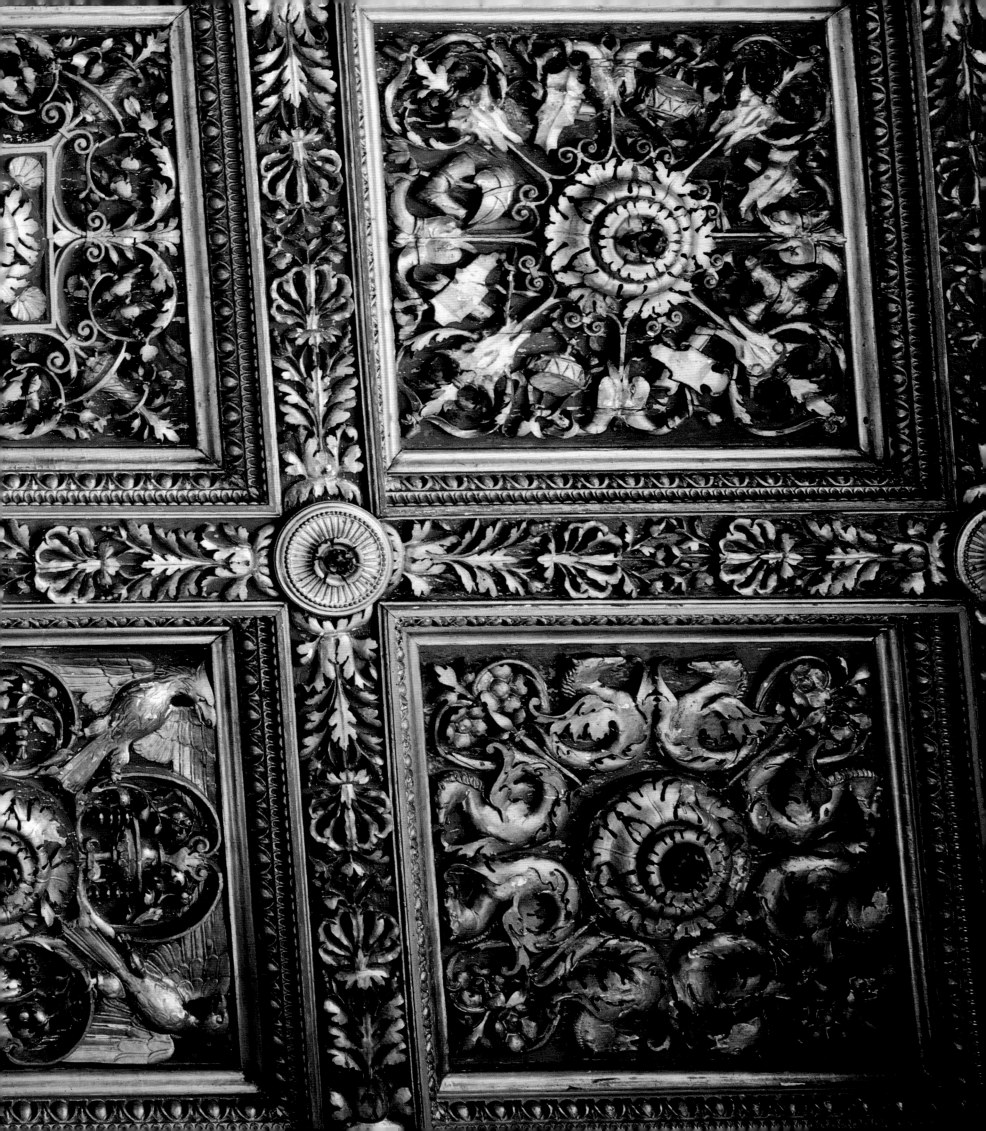

Completely inlaid with polychrome woods and datable to the 16th century, this cabinet with drawers shows a hinged shelf decorated with flower motifs, which hides ten small drawers arranged around a central door decorated with imaginary urban scenes of oriental taste.

Following pages
Disquieting scenes and irreverent poses animate a console table in the Palazzo Pisani Moretta and the boiserie of a beautiful palace on the Canal Grande. The first satyr's head of carved and gilt wood from the early 17th century functions as a supporting feature to the green marble top. The second foliate mask, typical of the so-called "grotesque" decoration, is a carved sculpture, again from the 17th century, of wood shaped as if it were a malleable material.

in the city, as elsewhere, the main pieces of furniture were the plain chest, the rectangular tables, the seats and benches with supporting structures that were either straight or gracefully molded and frames, with ogee arches and tracery carvings inspired by nordic architectural motifs. The armoires possibly resembled the ones in the Cappella degli Scrovegni in Padua, with their overlapping Gothic pointed arches, intersected with rosettes and palmettes of oriental influence.

Of the many wood carvers of the time, especially of altarpieces, remain the names inscribed in the *mariegola* of S. Caterina. From the 15th century onwards, records pertaining to furniture become more accurate and complete. From the pieces remaining can be inferred that furnishings, no longer limited to the necessities of domestic life now assume an aesthetic role as well. Hutches and library tables make their appearance, while the chests, sculpted or decorated with stucco and painted, become increasingly elaborate. Furniture designs develop alongside architectural styles: simple and linear, with thin ridges which frame mirror panels harmoniously arranged according to the Lombard models of the early Venetian Renaissance. This period sees the arrival in Venice of Francesco and Marco Cozzi from Vicenza who, in 1468, designed the triple register stalls of the 124-seat choir in the Chiesa dei Frari, a masterpiece of wood carving and inlay. From Lendinara came the artists Lorenzo Canozi and his son Giovan Marco, who carved the altar fronts and pews in the sacristy of S. Marco. From Mantua came Antonio and Paolo Mola, sons of Vincenzo, *faber*

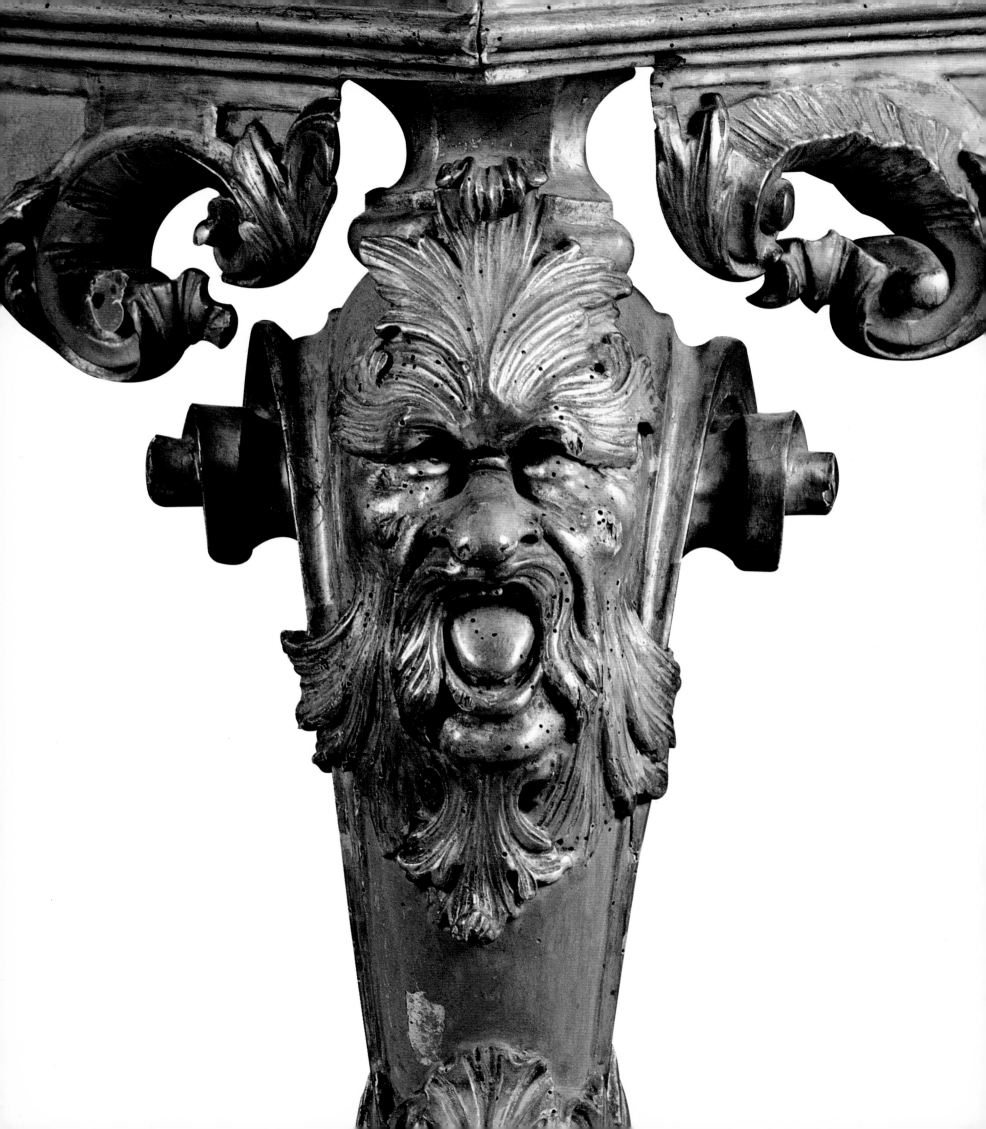

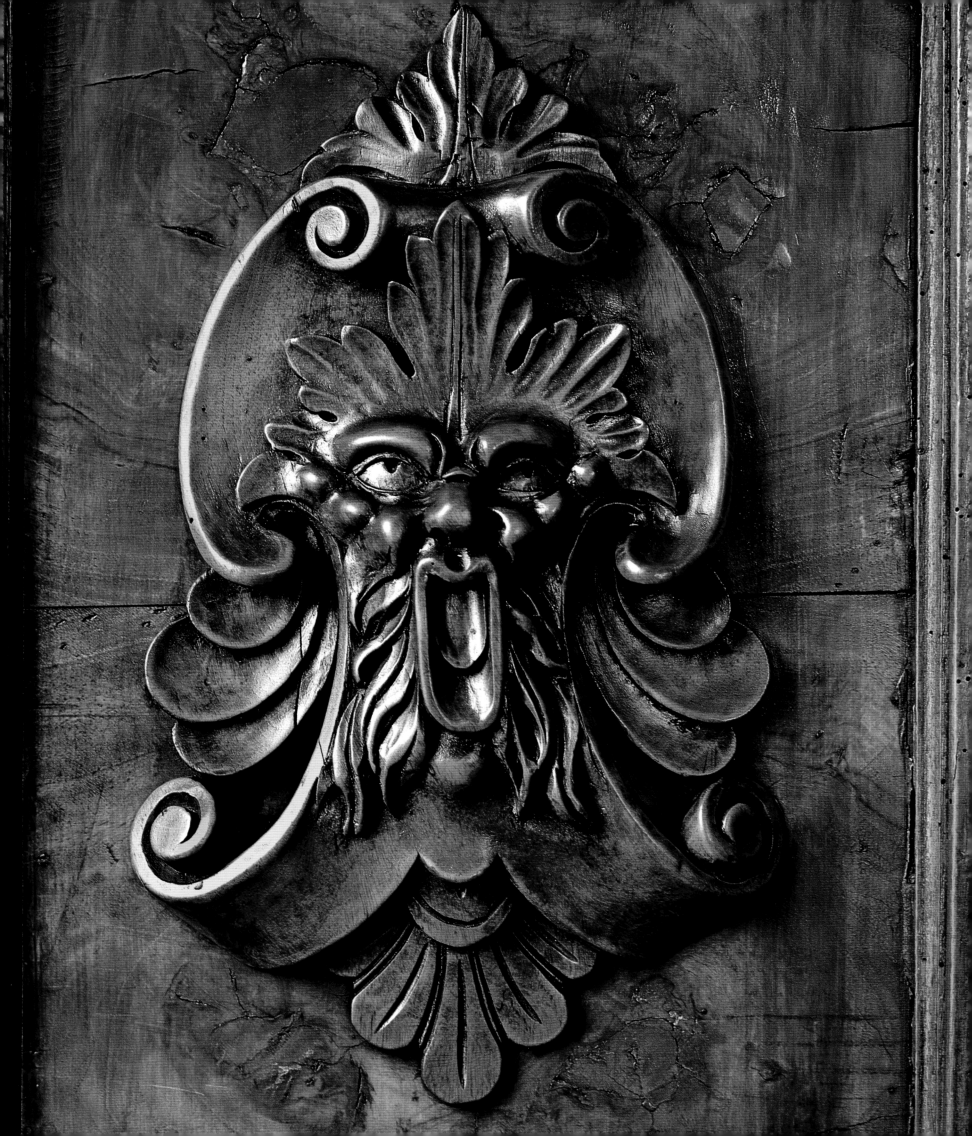

An exquisite example of polychromatic inlaid work of wood, ivory, gold and silver plated metals is the cabinet-medal cupboard from the second half of the 17th century, from a private collection. Articulated in two sections, the armoire features a table-like lower portion on spiral turned legs linked by a scissors-shaped joint cross and topped with a chest of ten drawers arranged on each side of a central door decorated with two allegorical female figures.

In the same palace and from the same period, is the corner cupboard in olive wood with ivory and ebony inlays and mother-of-pearl details. Standing on onion-shaped feet it features a central door framed by thin pillars topped with gilded bronze capitals.

Following pages

The table top that complements the harmonious inlay style décor is probably of later manufacture.

lignarius ("woodsmith"), carvers of the choir of the church of SS. Giovanni e Paolo—destroyed in 1683. As evidence of the choir's opulent Gothic style, somewhat revised by the rational vision of the Renaissance, remain the seats from the choir of S. Zaccaria, of similar manufacture. They also created, between 1498 and 1502, the wood marquetry of urban scenes on the armoires of the S. Marco sacristy, produced with the collaboration of Bernardino Ferrante and Sebastiano Schiavone. The latter, a monk from Oliveta, is remembered for his remarkable work in the S. Elena convent, a magnificent choir, now lost, but described by Francesco Sansovino in 1581 as being manufactured "with much artistry and imagination," in which were depicted the 34 most important cities in the world at the time. Partly designed by Antonio da Verona and Pietro da Padova, the lower doors of the drawer chests in S. Marco which hold the liturgical garments, are inlaid with a perspective view of a cabinet with its doors opened to reveal objects of sacral décor, musical instruments, fruits, and small animals.

From the 16th century remain many precious lacunar ceilings, carved, gilded, and painted like the ones in the so-called Albergo and in the Sala Capitolare of the Scuola Grande di S. Marco (which today houses the Ospedale Civile), produced in 1504 and 1519, or the one in the hall of the Collegio di Palazzo Ducale, made in 1577 by Francesco Bello and Andrea

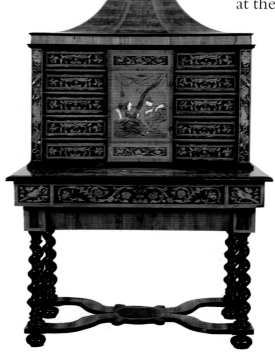

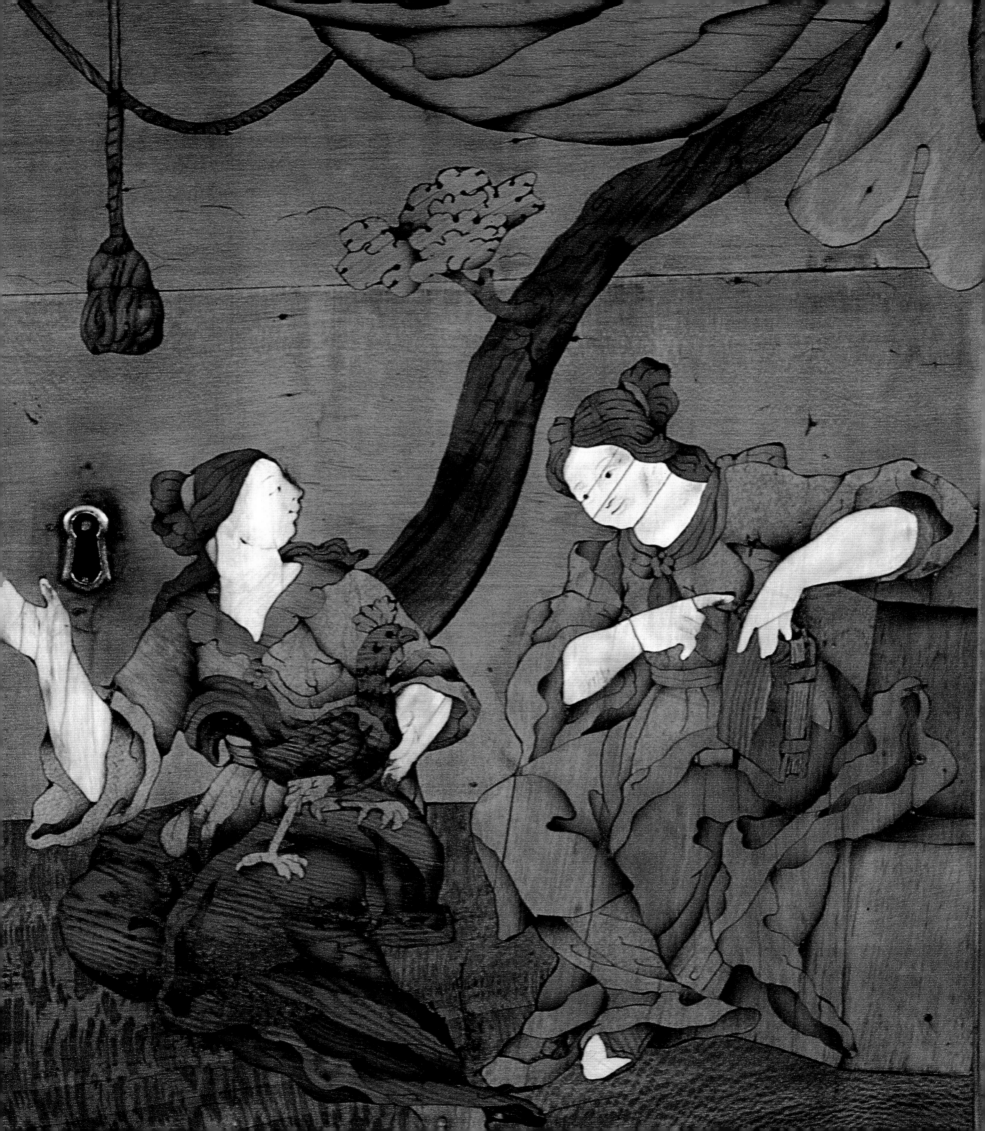

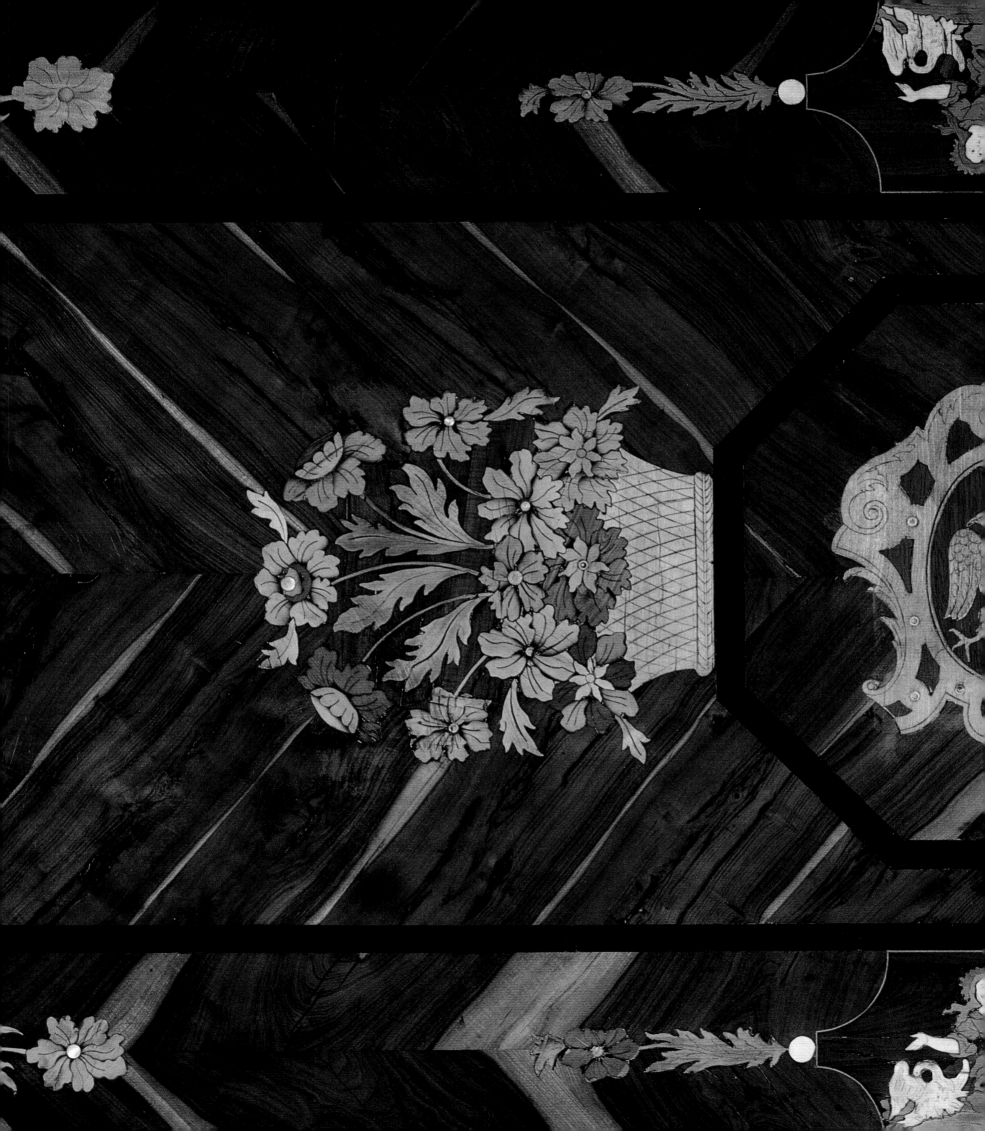

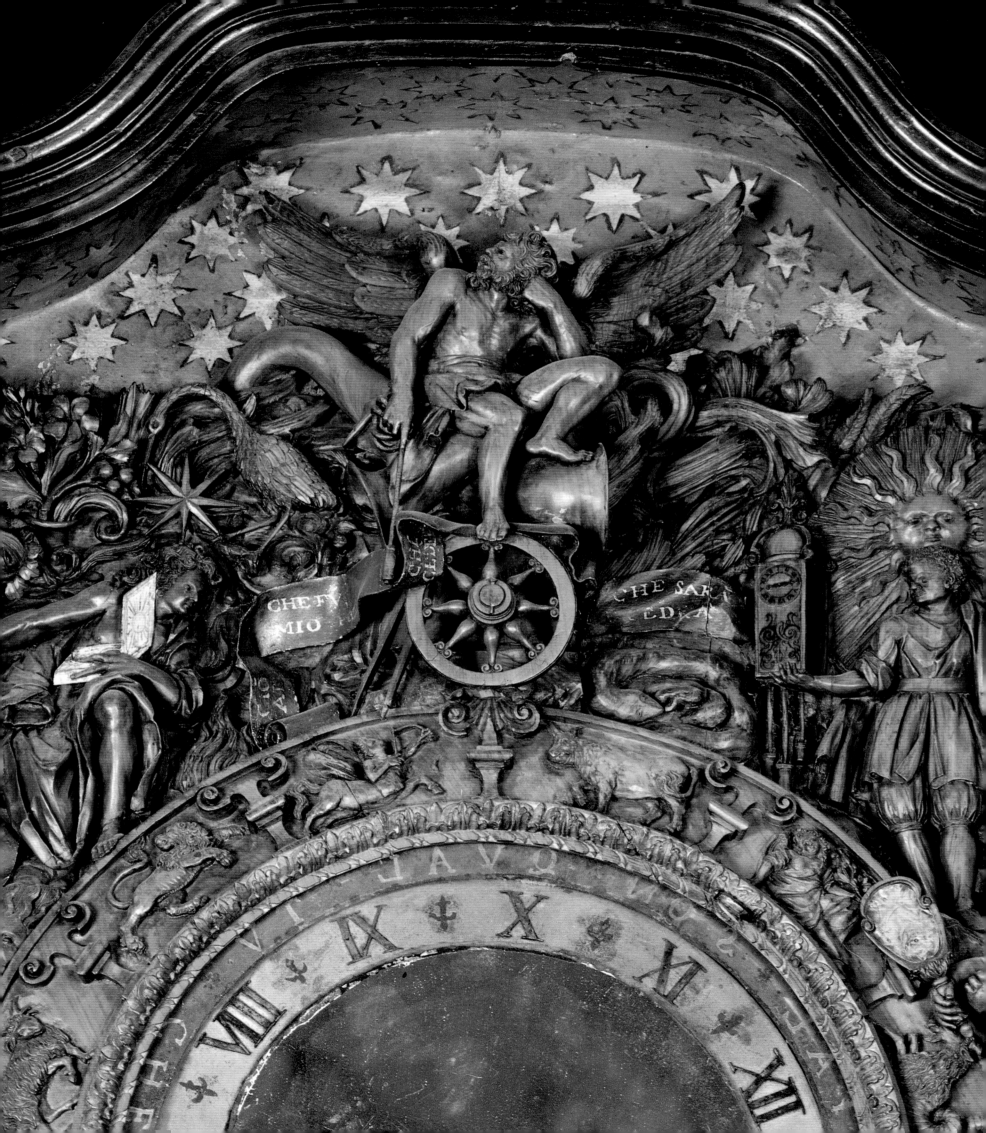

Faentin possibly after a drawing by Palladio, who supposedly collaborated in the realization of the wooden wall decoration and trabeation of the Tribunale and the doge's throne. Alongside these important creations was a proliferation of more or less elaborate wooden objects: from the extremely intricate ornaments for parade ships to the emblems, affixed to the coffers of aristocratic families, to the frames carved with superb artistry from precious woods.

The 17th century was characterized, to a higher degree than previous centuries, by the need to display the power not only of the court or State but also of individuals. Therefore, the wealthy home, where such need was particularly felt, would see a multiplication of its spaces and a change in the arrangement of the public reception rooms, with a transformation of even the private rooms, like the bedroom, into show and reception rooms. The interdependence of the spaces was emphasized through the stylistic continuity of the wooden ceilings, all of which feature the same harmonious carvings and gilding, stucco framed wall surfaces covered with tapestries or sumptuous fabrics, dominated by large paintings within lavish and extravagant frames and mirrors. The furniture, characterized by sculptural exuberance to the point of compromising its functionality, is sculpted, carved, painted, gilded, and lacquered, then complemented with glass, porcelain, and mirror elements. In the armoires, the applied cymae are replaced with cornices that confer elegance and lightness on the piece: the cabinet, which in its simplest form appears as a small chest with handles sitting on supports becomes

A clock by Francesco Pianta il Giovane, from the sacristy of the Chiesa dei Frari. Crafted of boxwood in the 17th century, the face is richly decorated with a myriad allegorical personages related to the representation of the passing of time, created in a sort of aversion of empty space.
A sculpted and gilded siren/caryatid datable to around the early 18th century supports the molded top surface of a table ascribed to Antonio Corradini, from a private collection.

[103]

almost a console table decorated with inlays, carvings, and marquetry of semi-precious stones, ivory, and mother-of-pearl. It appears that the drawer chest with folding top and raised hutch—known as *bureau trumeau*—that would enjoy enormous popularity from the end of the 17th century throughout the 18th century derived from the cabinet or desk with hinged top.

In the last quarter of the 17th century, among the numerous wood artisans, a few distinguished themselves for their outstanding artistry. In 1682 Jacopo Piazzetta created a large complex in the library of the Dominicans of the SS. Giovanni e Paolo, animated by statues of doctors and saints in triumphant poses on heretical figures, among animals, foliage, and ornamentation that complemented the symbolic composition. After 1680 and for the first 20 years of the 18th century Andrea Brustolon created furniture and other ornamental objects (often in precious woods such as ebony) that exceeded their practical function to become proper sculptures. He produced console tables, complex anthropomorphic vase holders, tray holders, and candelabra, armchairs in boxwood on legs shaped like knotted branches and armrests supported by *moretti* (blackamoors), chairs shaped like female nudes or fruits and flowers alluding to the 12 months of the year, frames with putti bearing coats of arms. Other remarkable artists were Antonio Gai, founder of a family of inlayers and from 1696 apprentice in the workshop of Ottavio Calderon, Giovanni Marchiori, a pupil of

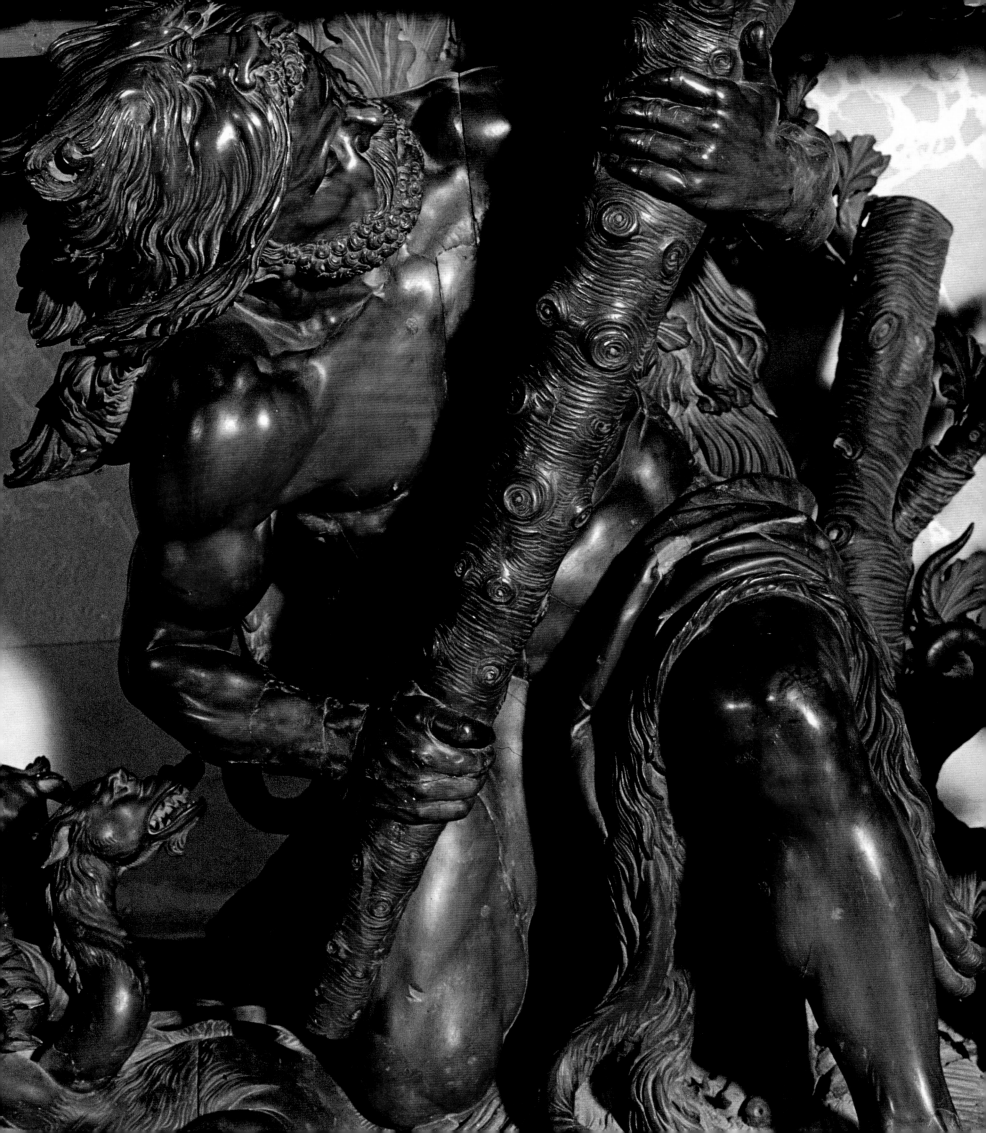

The lacquering of wood represents the glorious tradition of Venetian wood artistry. The mirrored door on the ground floor of Palazzo Pisani Moretta, from the middle of the 18th century is a splendid example. On the polychromatic decorations on green background, in the middle of foliate scrollwork, a vase containing a large bouquet of flowers stands out.

Brustolon's, Fasoli, remembered by Temanza as the artist of sumptuous armchairs, and Antonio Corradini, who was active throughout the early 18th century.

The wood carver of the 18th century favored svelte and thin shapes, soft volutes, sinuous lines, exuberant motifs; the furniture, though coordinated to fit within the same décor, was never identical. New types of furniture were invented: console and game tables, mirrors of all sizes and shapes, mantelpieces, stands, shelves, screens and fireguards, backdrops for halls, sofas, armchairs, and small chairs free of angular lines, light, easy to handle, and comfortable. In the luxury furniture, sculptured in bas-relief and usually gilt, the capricious evolutions of blossoming branches, the soft drop of medallions, which in the first half of the 18th century were almost always framed within ribbons that defined various sections, revealed the total mastery of the drawing and a secure hand that, though carving only the surface, could very effectively render a range of chiaroscuri, comparable to the creations of goldsmiths. In order to render the pictorial effect, even when following the capricious and triumphant transformations of the rococo style, with its multifarious scrolls, volutes, moldings, festoons, braids, and sinuous profiles punctuated with blossoming branches, shells, fruits, fantastic creatures, masks, putti, fusaroles, and more, the craftsman's chisel was never limited by sketches but kept the freshness of improvization intact. Antonio Corradini, who, unlike Brustolon, ignored the rustic style, preoccupied as he was with all that was solemn, around 1730 created that regal furniture in the Ca' Rezzonico, in which he reveals and reiterates his sculptor origins in the well-

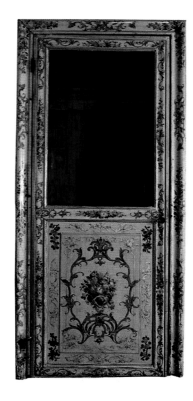

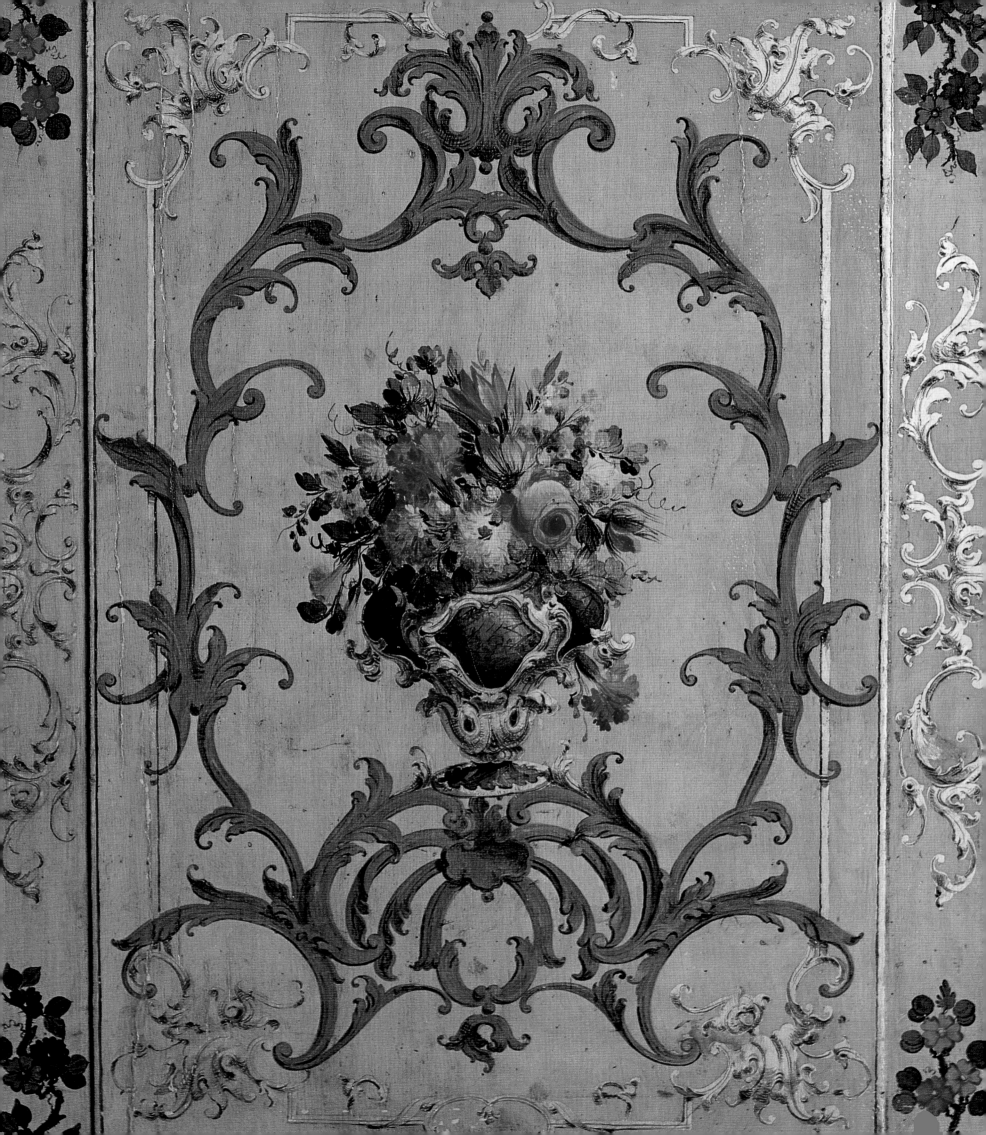

Floral motifs, often accompanied by mythological themes are the favorite type of lacquered wood decoration in the 18th century. Evidence of this taste is provided by coffers, which were extremely popular in the 18th century and used to hold toiletry items, jewels, and sometimes tea leaves, and by the decoration on the front of the console table of carved wood, sculptured and lacquered in various colors on a light blue background that depicts Venus and Cupid framed within the scrollwork.

shaped and chaste nudes, in classical drapery in the preference given to the human figure over the vegetal elements, scrollwork, and volutes.

These are the years in which Corradini also supervises the decoration of the last splendid Bucintoro of the Republic.

The production of inlaid furniture, on the other hand, is not as plentiful, due to the lack of exotic raw materials, which had become expensive as a consequence of the diminished mercantile traffic, and the competition from the *depentori* (painters) who created beautiful lacquered furniture. Rarely did the Venetian *remesser* follow the example set by his foreign colleagues, who conferred preciousness to their polychromatic floral compositions with rare exotic woods. Rather, he limited himself to the use of woods such as boxwood, maple, and rosewood. Remarkable examples of "superb wooden inlays" remain, however, in the sacristies of S. Eufemia, S. Antonino, and the furnishings of some Venetian palaces.

The *depentori* on the other hand were extremely successful. They were the leaders in Europe in the imitation of oriental lacquers, and were responsible for chromatically harmonizing the new furniture with the stuccoes and the wall coverings of the scaled down but graceful and cozy spaces that contemporary society preferred. The smooth working surface was prepared by first laying an extremely thin layer of *pastiglia* (obtained by dissolving extremely fine chalk in glue) to eliminate the smallest gaps in the wood grain, preferably stone pine. The surface was sanded with paper and agate, then a very thin layer of linen cloth was glued onto it to

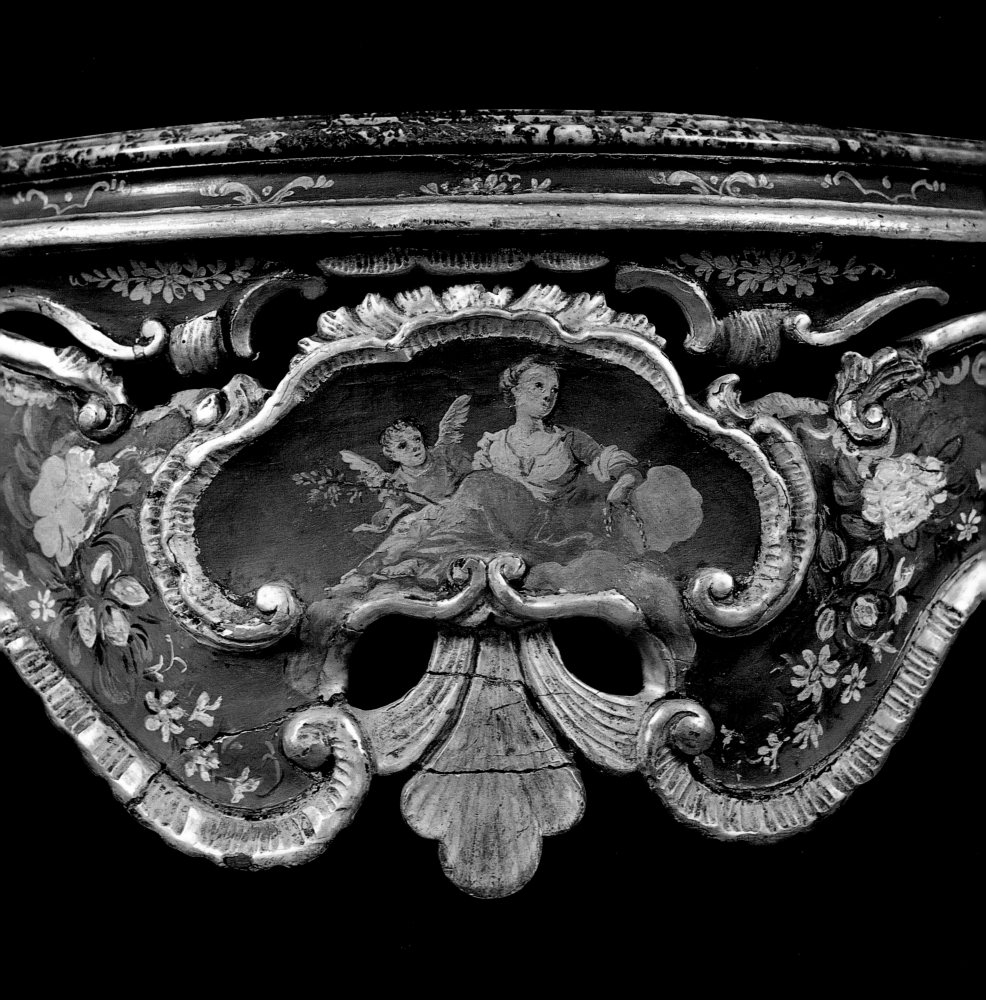

A curious example of a table clock stand from a private collection. The object, wood lacquered in burnt hues, represents a male figure elegantly dressed according to the late 18th century fashion.
Slightly older is the chest with folding top and hutch, also from a private collection. Made of inlaid wood, sculpted and lacquered, unusually supported by only two legs, it is decorated with polychrome flowers and Chinese figures against a dark red background.

prevent deformations due to climatic variations. It would then be given a layer of background color and the design motifs would be traced with tempera, followed by up to 18 layers of varnish. In order to obtain the raised decorations, a combination of molding and painting techniques was used: following the contours of the drawing underneath, the fluid *pastiglia* was dropped from the brush, so as to obtain a thin raised work a few millimeters thick, which would subsequently be painted in various colors or gilded. The Martin brothers became famous for their reproductions of mandarins, pagodas, boats, minute umbrellas, and landscapes in unusual perspectives, "the whole work would be painted gold on a black, red, or green background," not just on flat surfaces, but on concave or convex ones as well. Typical are the chests of drawers with a hinged surface, with or without a hutch on top, sometimes of remarkable dimensions.

Around the middle of the 18th century, the Chinese style of decoration evolves into an exoticism which becomes more formal than substantial, representing a fantastic world where characters still have oriental somatic features but whose stance and demeanor are typically Venetian. Alongside this style, two different genres developed just as successfully: the floral and the figurative style. The latter was inspired by the Arcadian concept of nature—such as found in the figurative arts, in the theater, and in poetry—with idyllic, bucolic scenes as featured in the paintings of Ricci, Zais, and Zuccarelli. As far as the floral is concerned, all kinds of botanical forms are represented—from simple daisies and

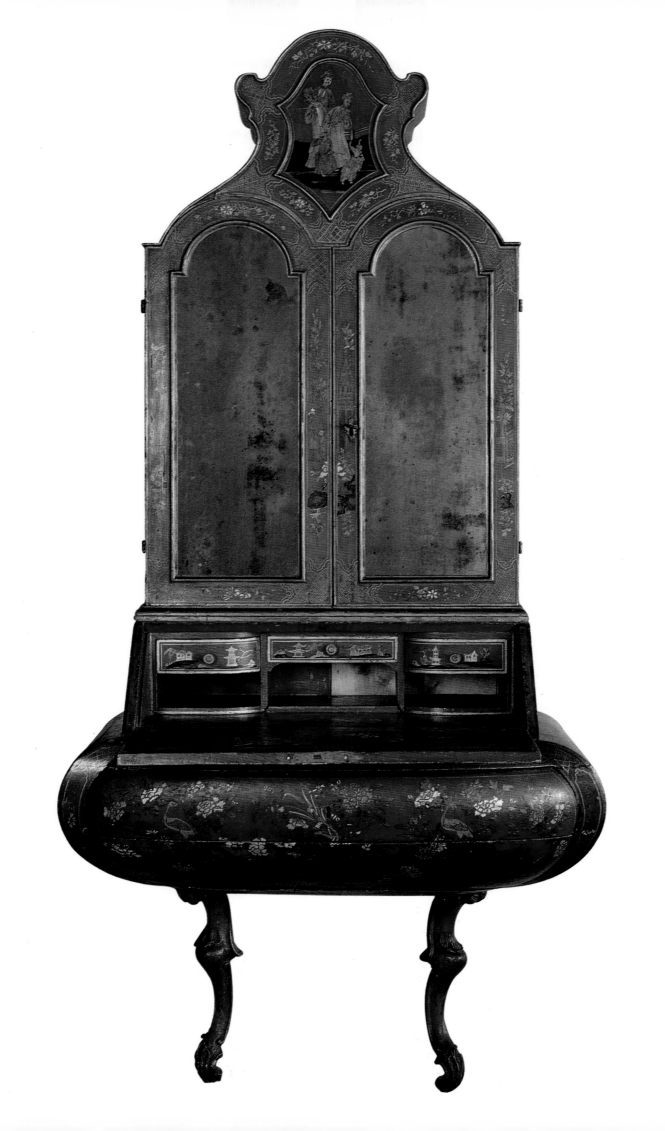

Previous pages

Molded frames with quatrefoils associated with some personages of the Commedia dell'Arte characterize the decoration of the lively polychrome lacquered wood doors of the dining room in a prestigious Venetian palace.

A typical 18th-century Venetian character, the black boy, in sculpted and gilded wood, with a short feather skirt, holds a large cornucopia filled with glass bead flowers. Of the same period is the *bureau trumeau*, from Ca' Rezzonico, in walnut root, a monumental structure consisting of a base element with three drawers and hinged top with small compartments. The hutch, transformed into a showcase with molded doors, is crowned by a scalloped cornice with shaped mirror.

poppies to more refined lilies, tulips, or roses—often scattered with butterflies, small birds, and beetles. The strong background colors are gradually replaced with more delicate and cheerful hues: bright red, pink in all its subtlest nuances, olive green, indigo or slate blue, light yellow, delineated by the thin and intricate interlacing of gold or white lace framing. At the end of the century, a rediscovered graceful composure of lines was matched by a more delicate use of colors: white, light blue, green, pink, and yellow would suffice to intertwine festoons and garlands alternated to symbolical medallions. In order to satisfy the clientele, drawn from the new small bourgeoisie, the *depentor* would sometimes work in collaboration with the chalcographer who would paste onto the wooden surface various engravings—obtained from local printing presses, and from the Remondinis in Bassano—on which he then layers *sandracca*, an economical type of lacquer obtained by dissolving lacquer gum in alcohol. This technique would then be known as "humble art."

In Venice, the rigid subdivision of every form of art into sections that leads to continuous conflicts between specific competencies, determines a series of disputes between the *depentori* and the *indoradori* (gilders), especially in the second half of the 18th century, for the strong demand of objects both lacquered and gilded. For the high quality of the gilding, both glossy

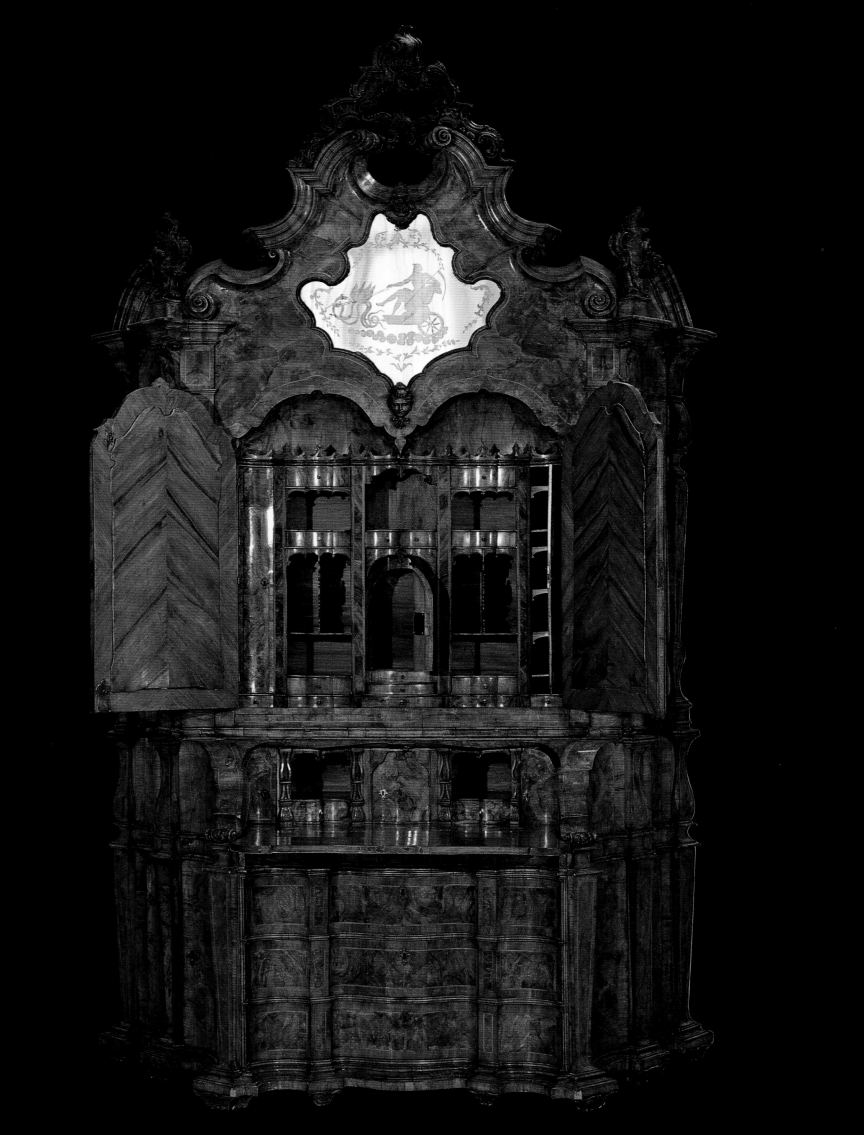

and matte, featuring a range of chromatic gradations from red to green, from orange to pale yellow, "but always of the highest quality," thanks were due also to the *battioro*, artisans who reduced pure gold to extremely thin foils. Also noteworthy was the collaboration between the wood artists and the artisans of glass, mirrors, and ceramics, for the production of furniture. Giuseppe Briati was a virtuoso of glass fixtures and details set in wood like gemstones, while Geminiano Cozzi was a master of inserting white porcelain flowers in opulent console tables.

Furniture was largely responsible for representing power in interiors, while outside, on the streets—which at the time in Venice corresponded with the canals—this important function was linked to urban transport or parade boats. The art of the builders of these means of transport—the coaches of the Venetians—traceable to the *fabri navales* (boat builders) of Aquileia and Ravenna, was organized as a guild from the 13th century. The special statutes of all guilds relative to ship building can be traced to the same period. Among them the *marangoni da nave* (naval carpenters), the *calafai*, *segatori*, and *remeri* were the main categories well distinguished according to their competence.

In the beginning they all were appointed to maintain the Bucintoro—the most important official vessel of the doges—later exclusive prerogative of the *arsenalotti* (workers of the Arsenal) in charge of rowing on Ascension day, during the ceremony of the marriage of Venice to the sea, which

Carved and gilded wood night table from Ca' Rezzonico, in the typical bombé shape of 18th-century Venetian style. Decorated with thin blossoming tendrils, it is complemented by a green marble top.

Following pages
Richly sculptured and carved, the gilded andiron of the middle 18th century represents a small island with trees and little Chinese figures. The opulent gilt frame around a large mirror, a work from the first half of the 18th century, is complemented by a precious and elaborate molded cornice featuring a small female figure holding a mask and a basket of pomegranates under a triple arch.

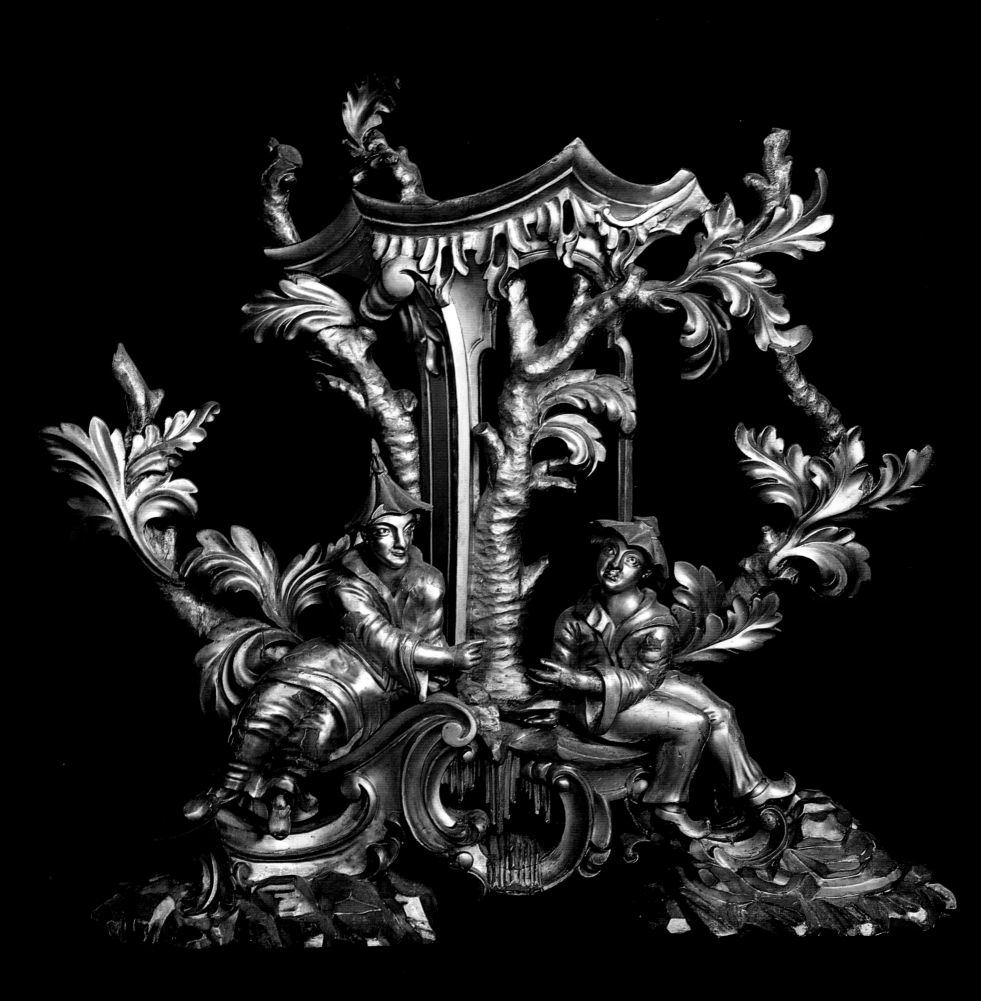

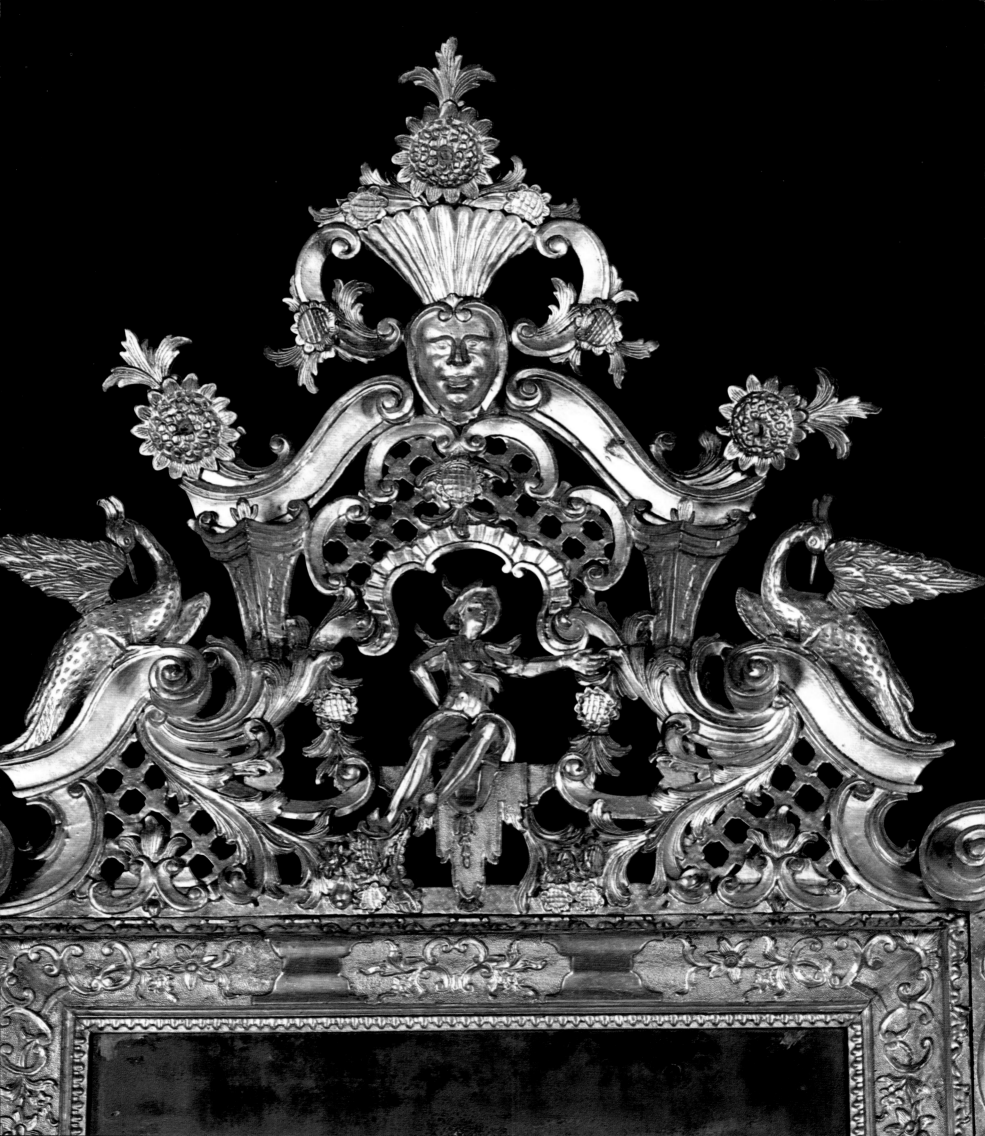

The honor of being in charge of the decoration of the last splendid Bucintoro of the Republic was held by the renowned sculptor Antonio Corradini in 1730. The splendid outer ornamentation, with alternating bands featuring telamones, caryatids, shells, arches, and sirens was matched by the internal décor and furnishings, in a profusion of gold and crimson. This faithful scaled down reproduction from the Museo Navale goes back to the beginning of the 19th century.

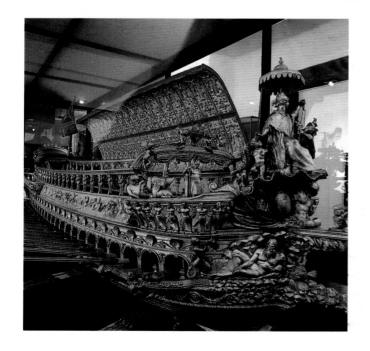

earned them the prize of participating in an opulent banquet in Palazzo Ducale.

Some of the most notable Venetian churches feature ceilings *a carena di nave* (shaped like the hull of a ship), an extraordinary work produced exclusively by naval craftsmen: for instance the churches of S. Caterina, datable to the 14th century, was destroyed in a relatively recent fire, or that of S. Stefano and S. Giacomo dell'Orio, both from the 15th century.

The *remeri*, organized in a guild since 1307, do not just build oars, but also rudders, futtocks, and crutches that go beyond their functional role with their highly original shapes to the point that they become proper sculptures.

In 1607 the art of the *squeraroli* was founded and comprised the categories of *da grosso,* which specialized in vessels of medium to large tonnage, and *da sotil*, for flat-based vessels and gondolas. The *squeri* (shipyards) of the first type were located at the edges of the city and in the Giudecca canal, while the workshops of the second were uniformly distributed along the internal canals. The gondola, that most typical of Venetian vessels, begins already in the 16th century to take that appearance that will make it so characteristic by curving the profile of the vessel, decorating the stern (which curls with gold and silver vine volutes) and adding a cabin called *felze*. In order to limit the numerous expenditures involved in the decoration of vessels and gondolas in particular, which were gilt and enriched with *felzi* of colored silk, adorned with oriental

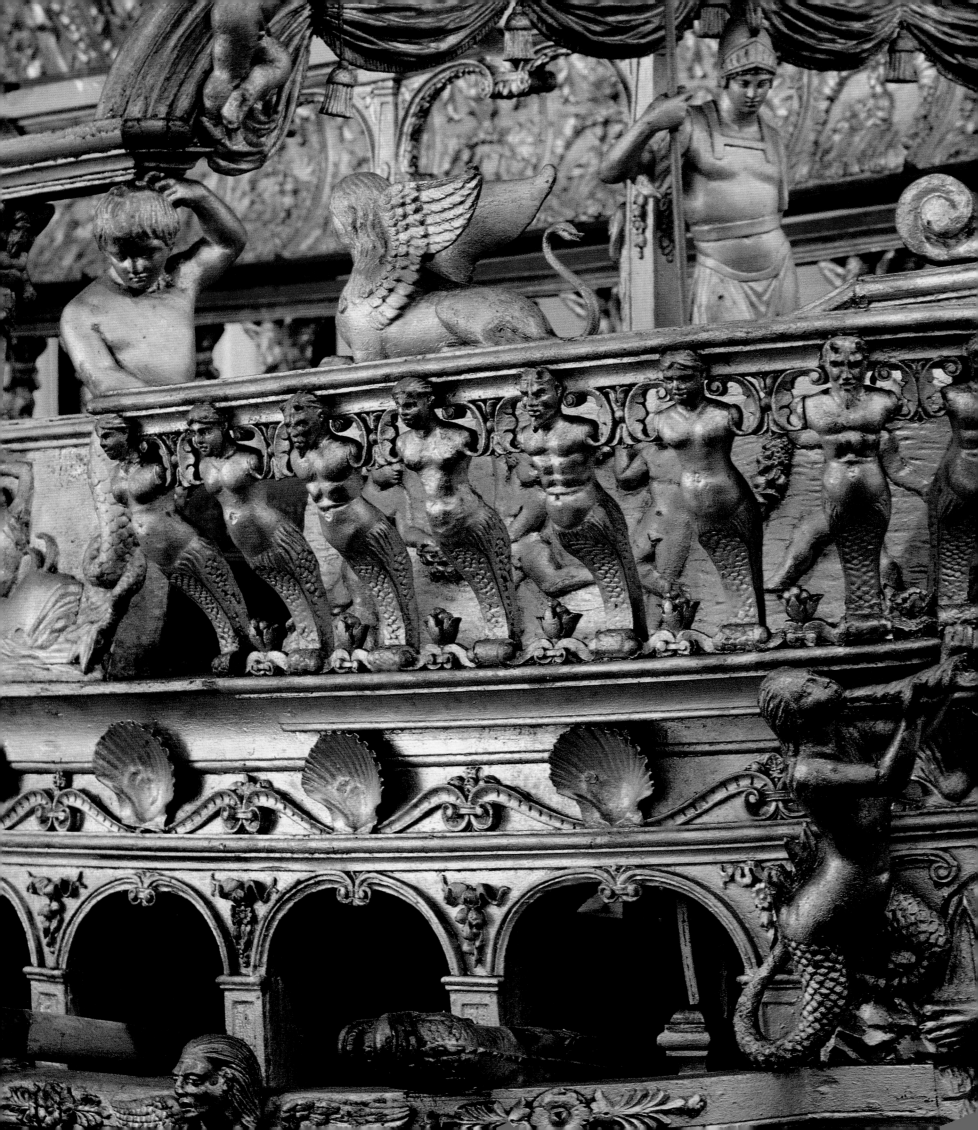

An essential part of the gondola and of all Venetian vessels, the use of the crutch was documented from the 14th century. Its practical function is complemented with a remarkable aesthetic freedom. The *felza*, the covering of the gondola that protected it from adverse weather conditions, was mostly there to guarantee a certain privacy; it went out of fashion a century ago. Black, of carved and painted wood, the *felza* was created by the *soazeri*, the framing craftsmen. The example shown below can be dated to the 19th century.

rugs, satin and lace, in 1633 the Magistrato alle Pompe decrees as mandatory the color black and the *rascia*, a rough woollen fabric for the inside of the cabin. However, the period between the end of the 17th century and the beginning of the 18th saw the production of the most sumptuous vessels, decorated with figureheads and other life-size wooden sculptures. At times, the vessel disappears under the overwhelming ornamentation and becomes a marine monster, a giant cornucopia, a floating theatrical "machine."

The Mauro brothers, Gaspare, Pietro, and Domenico, among the most active in the design and construction of parade vessels, who began their activity around 1680 were responsible for the *bissone* vessel designs of which numerous engravings can be seen in the Museo Correr. A vague idea of what they were like can be gained from the annual pageant of the Regata Storica on the first Sunday in September. The Mauros' contemporaries were Marc'Antonio and Agostino Vanini, sculptors renowned for their creation, in collaboration with Corradini, of "extremely exquisite figures and magnificent ornamentations"—as recorded by Morazzoni—for the Bucintoro. In the Museo Navale, there remains the precious small-scale model, produced at the time of the 1824 dismantling of the great ship, which had been stripped of all its ornaments and even reduced to a simple prison.

Metals

Hearing the ancient sound of the bells of S. Marco ringing out together at midnight, in the deep silence of the city, one is magically transported back in time. During the brief time span of the echoing sounds one is almost aware of feeling, to a certain extent, the same sensation felt by the Venetians from centuries past and to be united with them in history. That sound, more imposing and severe than the architectural and artistic vision of the city, instantly makes us grasp the greatness and power of the Serenissima. In actual fact, of all the original bells of the historic bell tower, which unfortunately toppled and crashed to pieces in 1902, only one is left—the

External door of the Basilica of S. Marco, 14th century. Dated and signed "MCCC Magister Bertuclus aurifex venetus," the bronze door features rows of small superimposed arches decorated with little spheres at the junction points. Inspired by Roman patterns of the Augustan period, this design appears to be stylistically anachronistic for the time.

The bell of the Clock Tower on S. Marco's Square, by Ambrogio Da Le Anchore, cast in 1497, features a lower band decorated with motifs of amphorae and floral and foliate vines.

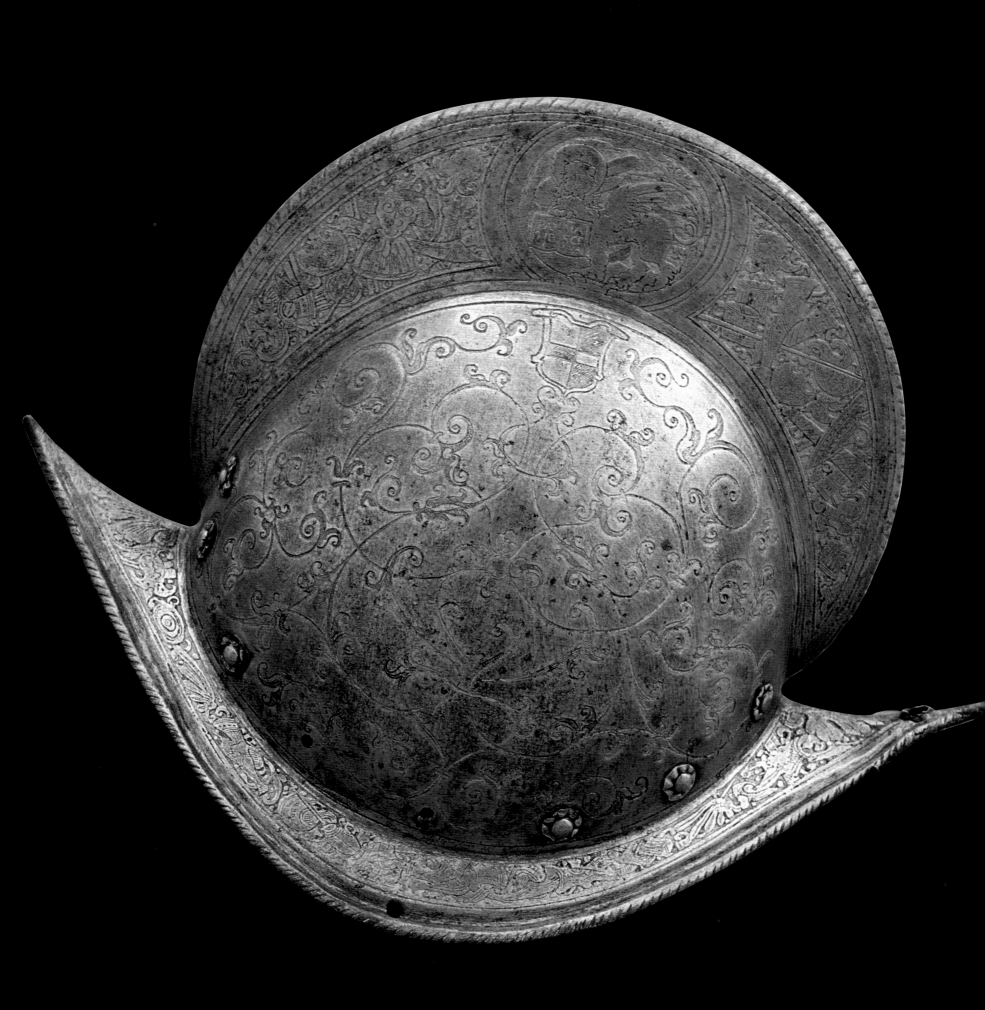

marangona—the largest, the one which signaled the start of the working day for all the various artists and craftsmen and whose peculiar timbre can still today inspire the shivers. The other bells—the *trottiera* (trotter), that hastened the steps of the patricians on their way to meetings held at Palazzo Ducale; the *nona* that rang at noon; the *mezza terza* or *dei Pregadi*, that announced the Senate sessions; the *renghiera* or *del maleficio*, which signaled a capital execution—broke when they fell and were melted down at the expense of Pope Pius X, who was then patriarch of Venice. At the beginning of the century there were still some foundries in the city, like the one of the Munaretti; it was here that the ancient embossed and gilded copper statue of the archangel Gabriel that still dominates the city from the bell tower top was re-cast.

The Guild of the *favri* (smiths), whose statute goes back to 1271, with church and school in S. Moisè, comprised the *colonelli* (categories) of the *lavoranti di armi* (weapon craftsmen), the *stadieri* (scale makers), and the *calderai* (makers of cauldrons and bronze containers). According to Tommaso Garzoni, the guild was subdivided in many other minor crafts, such as the *magnani*, in charge of placing raw iron on the fire with large tongs. Then there were artisans specialized in

[127]

The gilded steel helmet from the armory of the Palazzo Ducale was manufactured in the 16th century. Better defined as a crested morion for its pointed arch shape with a curved brim, it is of clear Spanish inspiration. The helmet is exquisitely etched and chased, and features foliate motifs and the ever-present lion of St. Mark.

A 17th-century hilt, from a private collection. At one end of the branches, two gilded bronze intertwined serpents curve until they join the lion head of the knob. The element that joins the handle to the blade is decorated with burnished metal and engraved, at the base of the mother-of-pearl handle, with the words *viribus unitis*. The projecting tracery medallion is emblazoned with the imperial double-eagle of the Giustinians, who by tradition were descendants of Giustinian, emperor of the east.

In the houses of wealthy merchants and bankers, the heavy wrought iron keys and armored wooden safes were the items most trusted to keep their riches. The 17th-century locker below (in the Istituto di Ricovero e di Educazione) in wrought iron adorned with burnished steel, features, on the inside, the original lock still perfectly intact.

An example of utilitarian decoration is the group of gilt bronze keyholes from a private collection covering various periods datable from the 16th to the 18th centuries.

producing or working with "knives, swords, weapons, keys, scissors, sharpening, tin or pewter, lanterns, bellows, pins, and needles, *conzavalezi* (repairers of pots and pans), mortars, *rigattinieri*, *strengari* or *ferrastringhe*, ironsmiths and farriers." Garzoni then goes on to explain that the *chiavari*, besides producing keys of all shapes and sizes decorated with rings in various patterns—hearts, stars, crosses, and buttons, with arabesque traceries—also produced locks, keyholes, latches, and padlocks. The *cortellari* made knives, shears, small scissors of excellent quality and with elaborate handles; the *rigattinieri* specialized in metal hinged closures for bags, while the *strengari* sold fashionable metal tipped strings, thimbles, spectacles, small mirrors, bells, earrings, buttons, and even combs. The *spadari* specialized in the production of swords for cutting and for wearing, scimitars, poniards, daggers, and stilettoes. Among the renowned 16th-century *spadari* were the brothers Andrea and Giandonato Ferrara and Giorgio Gargiutti, to whom has been attributed most of the weaponry of Palazzo Ducale. To the category of the *calderai* or *fabriramarii* (producers of vases, large and small cauldrons, "pails, tubs, bedwarmers, *frissore*, *cuoccome*, skillets, pans, strainers, ladles, soup pots, and other items") also belonged the *campaneri*, makers of bells, which were often adorned with inscriptions and figures. Giovanni Grevenbroch in his *Gli abiti de' Veneziani* reports that in S. Pietro di Castello two orphaned sisters, Caterina and Anna Cossali, ran an all-women workshop

which produced bronze bells, highly prized for their excellent quality and harmonious timbre.

Bronze is a metal alloy of copper and tin—the proportion is ten to one—with a small quantity of lead to confer a particular strength and hardness. Since prehistoric times, bronze has been used to produce weaponry and a variety of items, and the taste for miniature bronze figures experienced a revival in the second half of the 15th century, especially in Tuscany and Veneto. One of the earliest Venetian bronze items is the large door in the vestibule of S. Marco, with two leaves, inlaid with various metals and decorated with small figures of saints, crafted according to Byzantine technique by order of the procurator Leone da Molin in the first half of the 12th century. The two external doors of the same basilica, with small superimposed arches that create a sort of grille, bear the date 1300 and the signature *Magister Bertucius aurifex venetus*.

Donatello's sojourn in Padua was a determining factor for sculptural art in general and for bronze in particular, as it gave new impetus not only to the creation of statues, but also to the production of objects of common use, to the point that it becomes difficult to differentiate between artistic objects and artisan products. Someone who was undoubtedly a sculptor besides being a smith was Alessandro Leopardi, named "of the Horse" for his creation at the death of Verrocchio of the horse for the famous monument to Colleoni. He was

One of the two wellheads from the courtyard of Palazzo Ducale, made by Alfonso Alberghetti and Niccolò dei Conti, datable to between 1556 and 1559. The massive, extremely ornate casting, with a diameter of 195 cm, features eight sides decorated with allegorical scenes, emblazoned and inscribed, while on the corner edges satyrs alternate with harpies holding garlands.

Still in bronze are the beautiful castings at the base of the three pylons that support the banners in Piazza S. Marco, by Alessandro Leopardi from the beginning of the 16th century. They are partitioned and decorated with vegetal friezes, allegorical and mythological scenes such as satyrs and nymphs, Nereids and tritons bearing fruits of both land and sea.

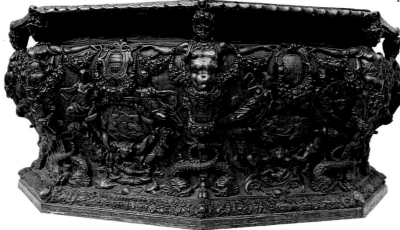

responsible for the three bronze bases of the flag poles in Piazza S. Marco, erected in 1505 under the Doge Leonardo Loredan. As a weapon craftsman and master of artilleries, he was involved in the decoration of the cannon mouths of the Arsenal.

Artillery masters Alfonso Alberghetti and Niccolò dei Conti, were creators of the two massive and extremely ornate bronze wellheads from the courtyard of Palazzo Ducale, cast around the middle of the 16th century. Particularly renowned for the production of objects with a practical as well as decorative function was Andrea Briosco, called *il Riccio*, who left oil lamps made out of fantastic masks, crab or tortoise shaped caskets or boxes, lanterns, inkwells, and anthropomorphic candleholders featuring sphinxes, two-tailed sirens, and satyrs.

Certainly not belonging to the guild of the smiths, are outstanding artists like Jacopo Sansovino, creator of numerous bronze collection artifacts of various sizes, or Alessandro Vittoria, artist of objets d'art, inkwells, holy water font, medals, braziers, and doorknockers, like the one with Neptune on a shell between facing sea horses from the Palazzo Loredan. The sculptor Tiziano Aspetti created the doorknocker with Venus at the Kunstgewerbemuseum of Berlin, while Gerolamo Campagna made the couple of andirons, surmounted by the mythological figures of Venus and Adonis in the Ca' d'Oro, the two angel-

Girolamo Campagna, andiron base, Ca' d'Oro.
The mythological figure is supported by cupids, chimeras, and satyrs.
Another cupid holds a shell in the inkwell of Nicolò Roccatagliata, a 17th-century piece, also in the Ca' d'Oro.

Portal doorknocker, around 1560, Palazzo Loredan and S. Stefano, by Alessandro Vittoria. Of outstanding quality for the modeling and fine detailed chiseling of the burnished bronze. The mythological scene depicts Neptune with the trident, standing on a shell and flanked by two winged sea horses, who sinuously arch to form a lyre shaped frame.

From the 17th century, hot chocolate and coffee added pleasure to sitting room conversations or just to gossiping. The first was served in the chocolate pots that, as in the 17th and 18th-century example below, were made of pewter on elegant feet. Copper coffeepots, on the other hand, were placed directly on the flame, and to reflect their function, the larger ones were called "*conversazione*" (conversations) and the smaller ones were mischievously called "*pettegole*" (gossips). The peculiar shape of the spout also gave them the name "*baffone*" (mustaches).

candleholders in the third altar of the right-hand side nave of the church of the Carmini, and a saltcellar, also in Berlin.

Bronze decorations were everywhere: on balustrades and cornices, gates and railings in the elaborate shapes of the Baroque age, largely employed as appliqués on furniture and door ornaments, as rope holders on the gondolas in the shape of sea horses or monsters. The use of bronzes declined as industrial techniques became widespread. The whole 19th century sees a good production of chandeliers, street lamps, clocks, fireplace items, table centerpieces, and vases.

Unlike the *favri*, the *peltrari* work with a mixture of lead, tin, and copper that is hammered like gold to produce paper-thin foils, sometimes gilt. Among the most common artifacts, stained with Tripoli's earth and hallmarked with the crown or the lion of St. Mark are flat and shallow plates, small and large bowls, mugs, flasks, chalices, basins, trays, saltcellars, and other objects. According to the 1480 regulations, now lost, for the prevention of adulterations, metal alloys were checked to ensure they had been made according to a precise formula. The use of pewter spread in Italy around the end of the 16th century, and Venice was the first to realize the commercial potential of this material by welcoming and hiring numerous specialized artisans from Flanders, after 1550. In the first instance, the production, which was still limited to containers for domestic use, was very plain, but it later became so embellished with friezes, arabesques and chisel work that

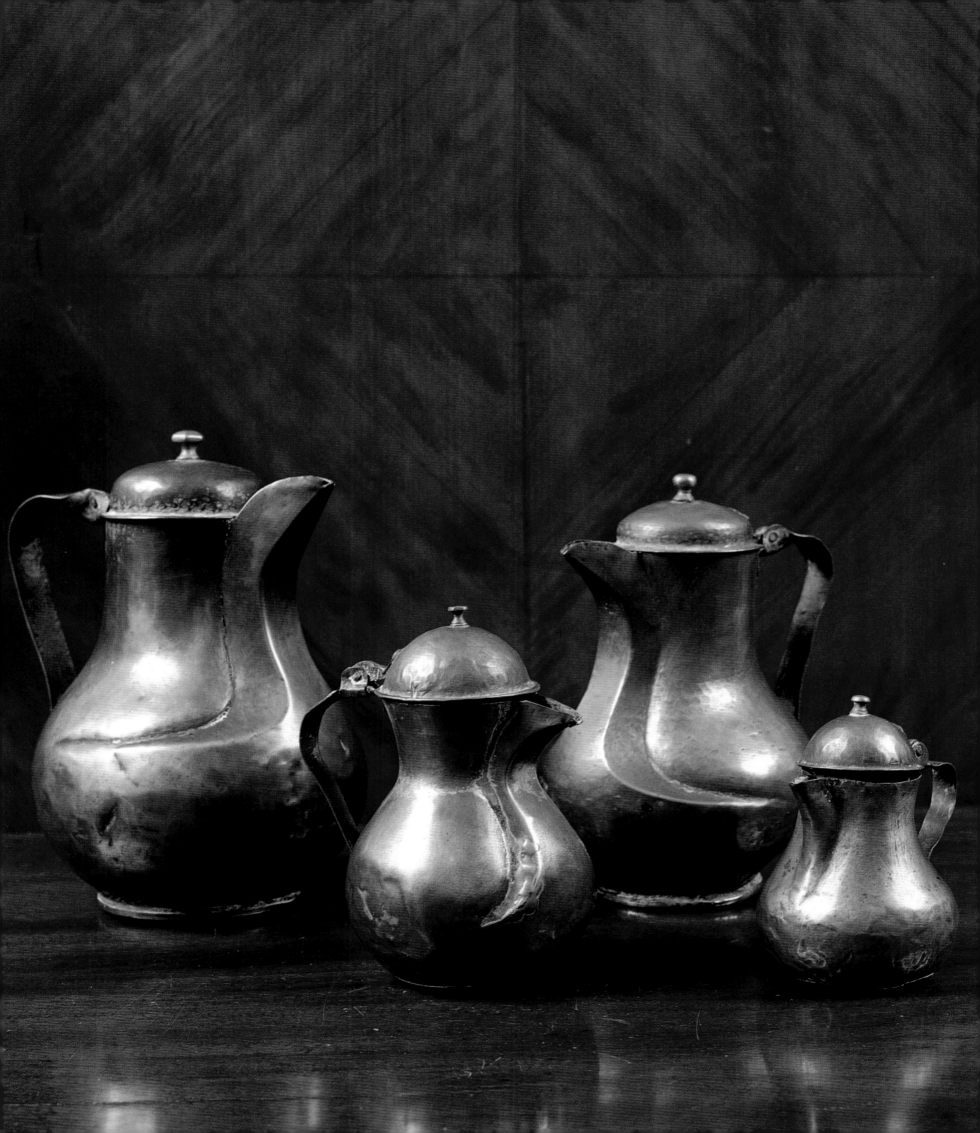

The lively imagination of Venetian ironsmiths found its freedom of expression in the decoration of lesser objects, such as window grids or the wrought iron grillwork of large doors (previous pages). The decorations go from simple intersecting circles in a large variety of geometric shapes to the most sophisticated motifs, like the quadrilobate elements with lilies arranged in parallel rows and joined with double lozenges.

Held by a wooden arm and fixed to a wall of the entrance hall of a prestigious palace on the Canal Grande, this bronze lantern is an exquisite 18th-century artifact which features detailed chisel work and a bombé shape. It is still used today to light the entrance from the canal.

it would compete with the creations of silver and goldsmiths. The production would include elegant platters with embossed rims, of shapes similar to the ones manufactured in Germany but more balanced in the decoration and essential in shape.

The making of wrought iron, that required melting in crucibles with either natural draft or bellows, or even, in the late Middle Ages with hydraulic machines, required more space and plenty of water. The raw material, shaped in bars, was forged, that is, heated until white hot, then made malleable and hammered with mallet and anvil until the desired shape. The first productions, aimed at practical objects for daily use in homes, workshops, and boats, were very simple; but artistic intentions became manifest early on in the decorations and elaborate fixings of large doors, weather vanes, spouts, and coffer lockers. The Gothic style promoted a splendid flourishing characterized by a technique that developed to increasingly advanced stages and ornamental elements that became thinner and more refined. Metal gates were enriched by cusps, pinnacles, and quadrilobate sections, like the railings around the Scaligeri graves in Verona.

The Renaissance represents the golden period for iron artisans who created torch holders, lanterns, flag poles, braziers, carts, and andirons, as well as shop and inn signs. In that period, the bi-dimensional railings featured spirals, volutes, braids, and pointed leaves. Later, the flat grillwork was enriched with ornaments in the round like shoots, spindle tree flowers, herms, and molded figures. The individual parts, at first held together by bands or joints, were then welded and sometimes painted in bright colors.

[138]

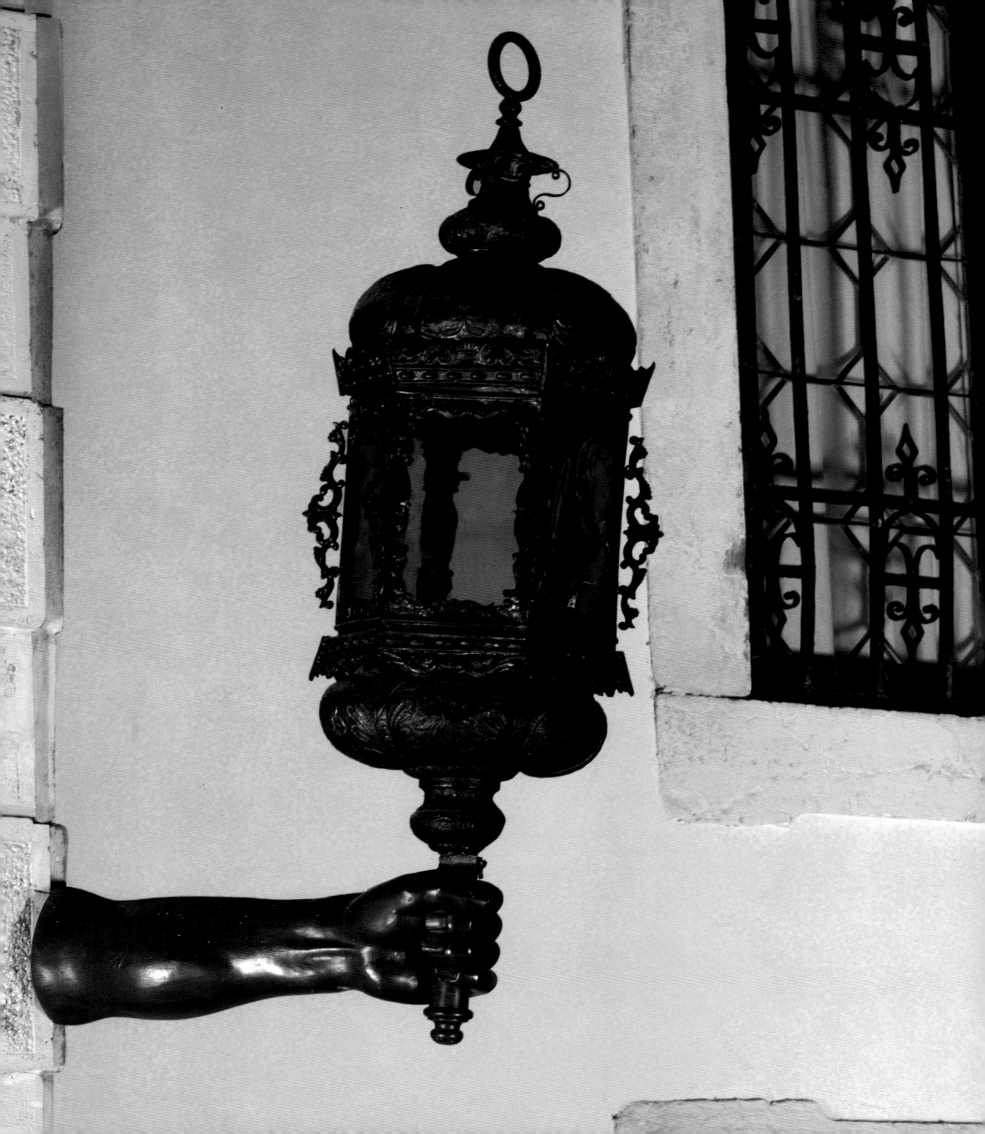

The year 1530 saw the publication in Venice of the book *Pirotechnia* by Vannoccio Biringuccio, a work which became a classic in the metal and mineral arts. It was widely studied in the centuries that followed, as shown by the repeated subsequent editions. It contained the records of methods and formulas, knowledge drawn from direct experience for the preparation of many metal alloys for the melting of large castings, like those needed for the construction of bells and artillery pieces. The Baroque period also brought movement and fantasy to grillwork and railing, sometimes decorated with heraldic emblems emerging from acanthus or vine branches, palmettes and scroll-work, and even to boat decorations. The bow iron of the gondola ends with a fringed floral and foliate voluta, almost like a curled feather. The virtuosity of Rococo style would lighten the metal decorations yet further, treating them almost like filigree.

The use of iron melted into shapes is very limited, at least until the 18th century, due to the difficulty in obtaining the high temperatures needed to cast the molten metal into shapes, but it would become widespread during the neoclassical age. The new criteria of formal rigor and inspiration from a classical age lead to the adoption of purely graphic schemes and sober motifs. The development of melting techniques

In a city whose main street is the Canal Grande, the entry doors which open onto the canal represent the first impression of a palace. Therefore the great importance given to their decoration should not be a surprise. The pointed arch of the entry door of Palazzo Barbaro, decorated with windmill rosettes with quatrefoil motifs, is a wrought iron version of the stone-work motifs on the contemporaneous Desdemona balcony in Palazzo Contarini Fasan.

[140]

Despite the abundant use of stone and bronze in this early 19th-century chandelier, the overall effect is one of extreme lightness. Securely attached to the ceiling with precious composite golden chains, it is made of a central cobalt blue stone corolla with golden bronze friezes from which originate six pairs of arched griffins that hold the candles. On the lower portion, the shaped surface culminates in a star-shaped plaque decorated with a golden pinecone.

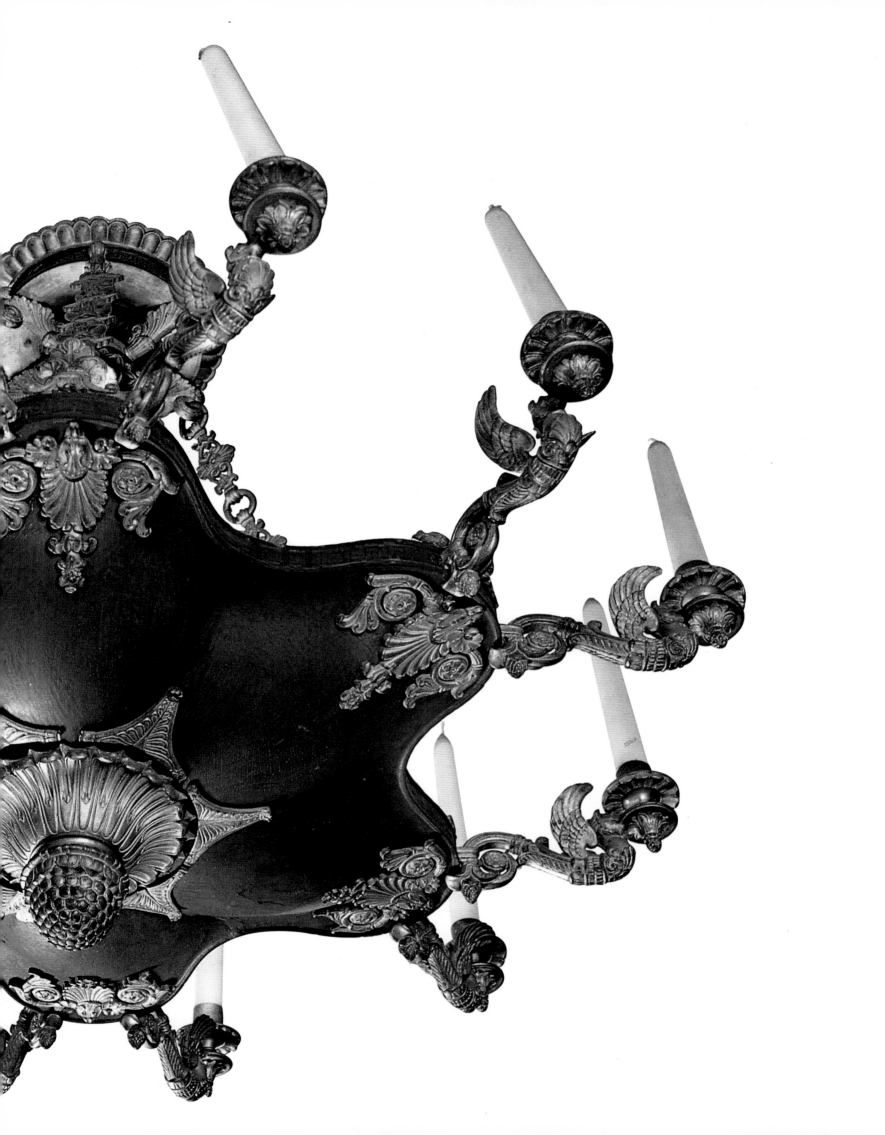

The 14th-century pattern of the small superimposed arches on the portal of the Basilica of S. Marco inspired the design of the wrought iron gate before the tomb of Daniele Manin in the adjacent Piazzetta dei Leoncini. The railing was created by the pupils of the homonymous institute on a sketch by Luigi Borro in the middle of the 19th century. The balustrade of an interior staircase of the headquarters of the Chamber of Commerce was crafted in 1927 by Umberto Bellotto. Inspired by Art Nouveau, Bellotto was an outstanding iron artist who produced a row of large thistle flowers with central spiral elements with intertwining snake-like dragon figures in the corners.

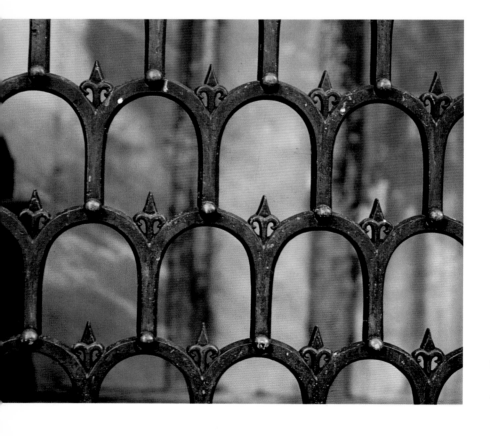

allows for an increase in the practical use of the metal, especially to produce gates for villas and gardens, balustrades for staircases and balconies, while fan windows and lanterns are still produced in the traditional way.

During the 19th century the use of cast iron becomes common in the construction of pavilions, religious niches, and bridges. In Venice, the Istituto Manin, whose function among others was to teach orphans professions, distinguished itself by the valuable practical subjects taught, which produced outstanding artistic results, such as the railing around the tomb of Daniele Manin placed in the Piazzetta dei Leoncini, on the left-hand side of the Basilica of S. Marco.

Among the last iron artists is Umberto Bellotto (1882–1940), born of an artistic family, who participated in the Venice and Monza Biennali d'Arte exhibitions between 1924 and 1925 and was the curator of the iron ornamentation (gates, balustrades, fan windows of doors and railings) of the buildings which today house the Stock Exchange, the Chamber of Commerce, and the Banca d'Italia. Called "the wizard" for his incredible ability to shape iron into the most bizarre and harmonious forms, he was inspired by the stylistic features of Art Nouveau, but went beyond them, to express his own innovative and personal style; he also dedicated himself to the art of glass and to that of textiles and laces.

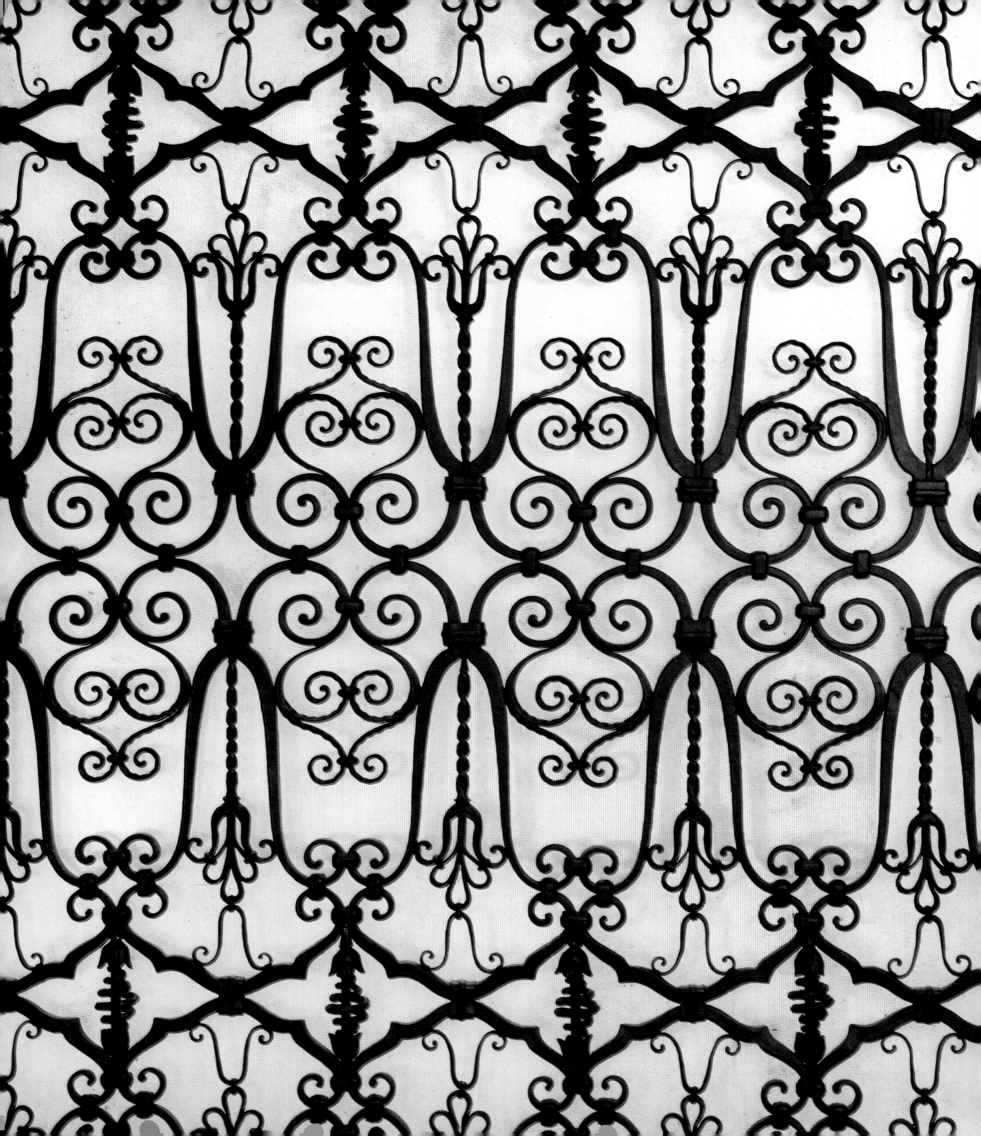

Gold and Silver

The first Venetian jewelers, recorded as early as 1015, followed the canons of Byzantine art in the silver and gold tracery and embossing techniques, with the application of polychromatic enamels and the setting of precious stones. The techniques invented by those artists for the setting of the 1470 stones and pearls and 84 enamels which decorated the Pala d'Oro, the golden altarpiece of the Treasury of S. Marco represented a strong long-term influence on the European artistry of jewel making and goldsmithing in the 14th and 15th centuries. The pyramidal pearl encrusted collets, the large triple and quadruple claws, the raised stone settings and the small leaf motifs would actually spread throughout Europe, and the few jewelry pieces remaining from that period provide the evidence. Later, Venetian jewelers favored an oriental inspiration, especially when filigree, which was introduced at the end of the 13th century would become characteristic of the Venetian Gothic-Romanesque art of gold-smithing with the name *opus veneticum* (Venetian work). This technique consisted of preparing thin strips of silver and gold, reduced to tiny beads, then twisted and

A detail from the Pala d'Oro in the Basilica of S. Marco. Placed on the main altar in 1105, the Pala d'Oro underwent in the two centuries that followed various rearrangements and additions until the definitive version in 1345 by Giampaolo Boninsegna. The blessing Pantocrator Christ, exquisite goldsmithing work in Byzantine enamel on a gold background adorned with pearls and gems, is part of the original nucleus.

Gold star-shaped brooch. Early 14th century. Verona, Museo di Castelvecchio. Serendipitously found during excavations, this brooch is one of the most spectacular examples of Venetian jewel making art of the early 14th century. Featuring an outline finely incrusted with pearls, it is adorned with standard size pearls, large cabochon cut rubies and emeralds.

Saltcellar, Museo Correr. In gilt bronze, probably by Gerolamo Campagna, second half of the 16th century, the object represents Neptune kneeling on a dolphin, holding the shell-saltcellar on his head with his hands.

wound to form small spirals or other ornamental motifs with flowers, foliage, and rosettes, arabesques and figures of animals with tracery work on the decorated object. The talent of Venetian artists however lies in the skilled combination and fusion of various techniques.

The first records of a jewelers' school date from 1213, with S. Antonio Abate as the patron saint and an altar first in the church of S. Silvestro then in S. Giacomo di Rialto, the area with the highest concentration of their shops and workshops. In the *ruga granda* (lit. main lane) vessels, pots, and pans were sold, while jewels could be found in the *ruga degli anelli* (lane of rings). The first statute of regulations, dated 1233, was transcribed and reviewed between 1278 and 1297. The guild was divided into various *colonelli*, that is, groups of artisans who specialized in the various stages of jewelry making. There were craftsmen who produced chains called *manini* or *entrecosei* (that is, "intricate" because they were made of thin gold links which tangled easily) of filigree, massive gold chains in the "Spanish fashion," chiseled, embossed, enameled, or crafted with various casting techniques, kitchenware, sacral or laic silver items, and buttons. Others specialized in diamond cutting (*da duro*, hard [technique]), precious stone cutting (*da tenero*, soft [technique]), the mounting of the *zoie* (jewels) in either Venetian or French fashion, or the cutting of rock crystal; the latter moved on to create a separate category, the *cristalleri*, not to be confused with glass artists.

[148]

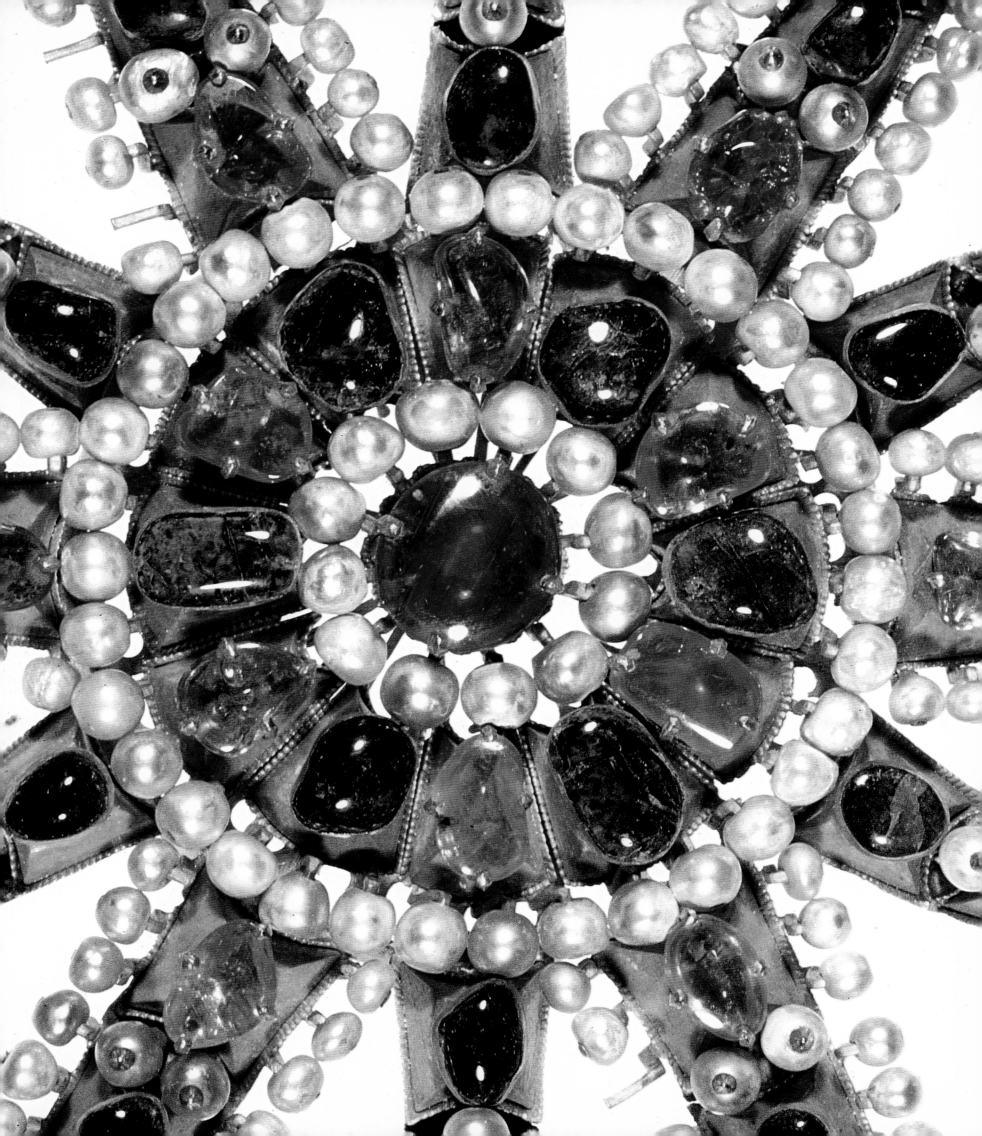

Devotional pendant, 16th century. Padua. Private collection.

In gold and enamels, the jewel is a small but precious showcase which can be opened to reveal the images of St. Paul in the background and S. Caterina on the back of the lid. The garb of S. Caterina itself helps date the object to the beginning of the 16th century.

Another religious subject for the cope pin from the church of S. Pantalon. Within the polylobate frame, decorated with branches of roses and lilies, is enclosed a small temple and a niche which contains the statue of a female saint. Of gilt silver, sculpted, chiseled, and enameled, this is one of the most interesting Venetian Gothic jewels.

The Venetian *diamanteri da duro* would become the creators of renowned cut diamonds, such as the Gran Mogol or the Farnese, inventing, in the last quarter of the 17th century, the technique so-called *a brillante*, which is a fundamental cutting technique from which modern gem cutting criteria were developed. The *da falso* (fake) jewel makers, that is, faux jewelry artisans also belonged to the Jewelers' School; for this reason, starting from the 15th century the *banca* (the Art committee) appointed officials, the *toccadori* (touchers), to inspect the artifacts in order to test the quality of the metals used. The test consisted of rubbing the object on the *pietra da paragone* (testing stone) and subsequently comparing the color of the mark left with that left by the precious metal.

Apprenticeship for boys from the age of seven to eighteen lasted four years, followed by a further two years' training, after which they could become heads of workshops, and possibly open their own shop, but only after passing the practical skills exam. The test was different for each specialization, but all candidates had to recognize precious metals and various alloys.

From the beginning of the 13th century, the creations of Venetian jewel craftsmen were sought abroad and the proliferation of workshops in that period stands as evidence of the increased demand for jewelry. In the 14th century, following the Byzantine style, the activity of jewelers begins to feel the Gothic influence. Laic specimens of the period are rather rare (some are kept in the Museo di Castelvecchio in Verona), while there are a considerable number of ecclesiastical

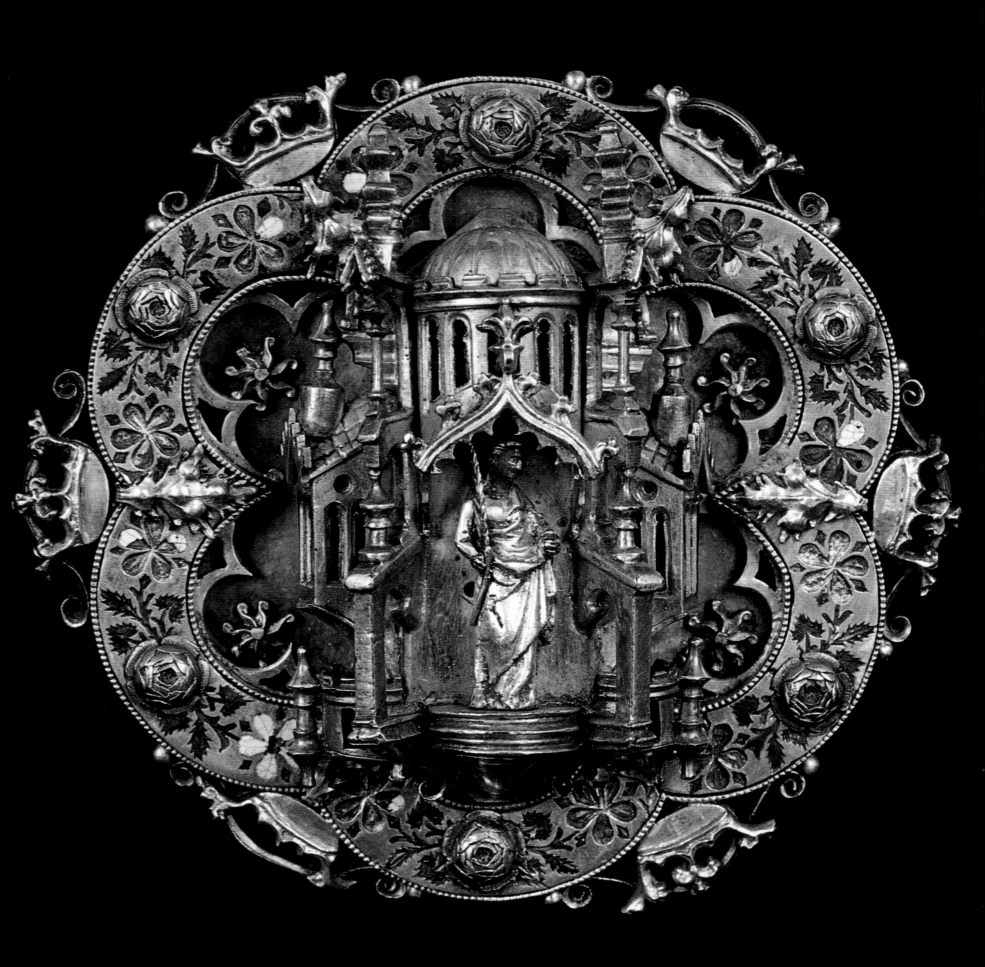

pieces remaining, as they were less exposed to dispersion. An example is the reliquaries of Chioggia cathedral, whose Byzantine style, still dominating, incorporates nordic influences in a harmonious fusion of styles.

The definitive transition to Gothic design is evident in those altarpieces called *pale d'oro* (gold altarpieces). Records tell of the Da Sestos, creators of the astylar silver cross in the church of the Salute and the golden altar panel in S. Marco, donated by Gregorio XII to the church of S. Pietro di Castello in 1408. From then on, enamels on gold and silver became increasingly used along with the technique of precious stones, and extremely fine nielli decorated chalices, trays, bowls, and nuptial chests, with allusions to the never quite forgotten oriental style.

Later than anywhere else, the first signs of an artistic renaissance appeared in Venice only during the final 20 years of the 15th century, with the influence of the Lombard style. With Valerio Belli, the art of Venetian jewelry would definitely adapt to the new artistic canons of the Renaissance. Valerio, known by the nickname of Vicentino, was a master of gem and crystal cutting, chisel, work and niello decoration of vases and gilt silver bowls, according to what was later called "Venetian technique." Gerolamo Campagna created the gilt bronze saltcellar in the Museo Correr, while Alessandro Vittoria, better known as a sculptor, crafted the precious binding of the *Breviario Grimani*, in the Biblioteca Marciana, made of embossed gilt silver, chased and beautifully highlighted by the contrast with the red velvet background.

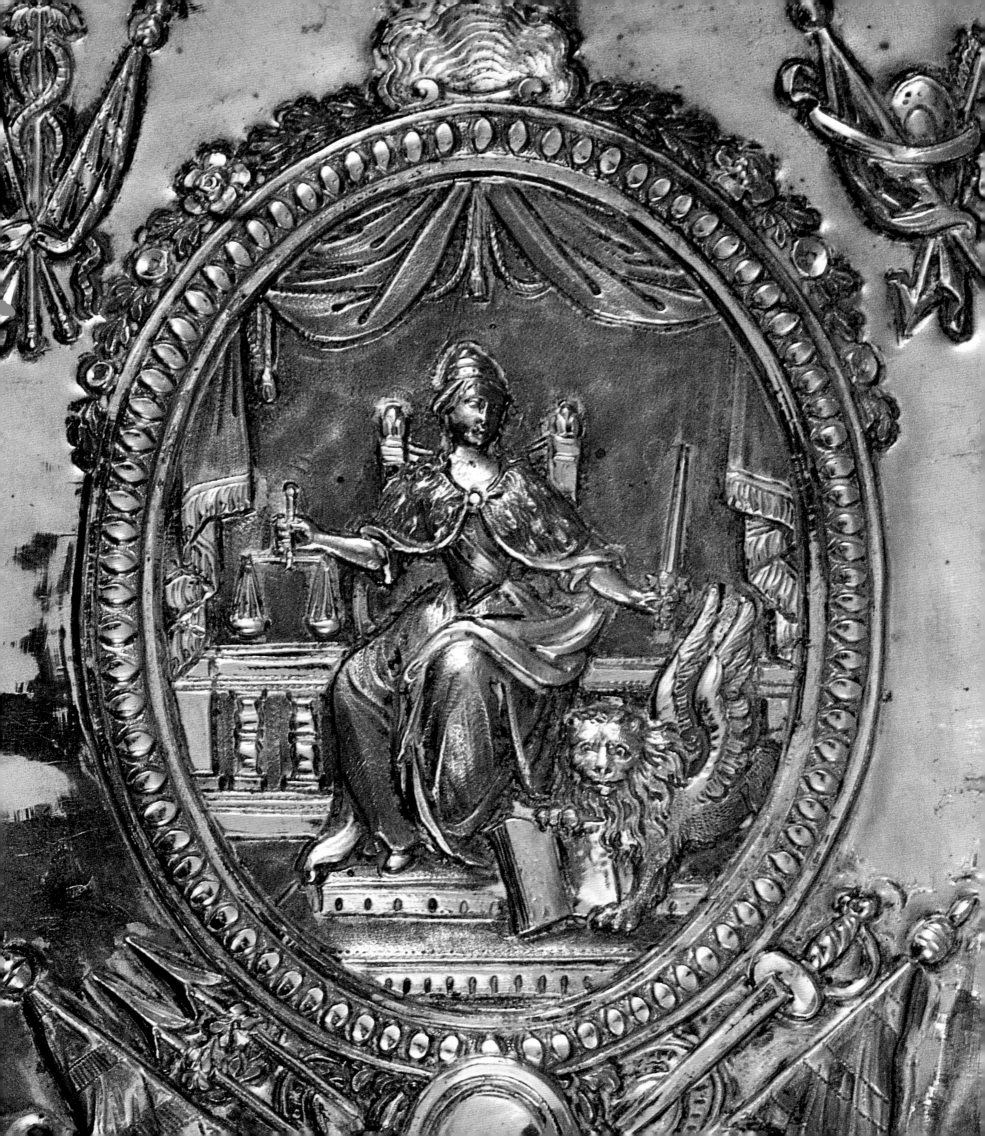

Reliquary of the Madonna of
Loreto, 17th century, church
of S. Stefano.
In embossed silver and gilt rays,
the reliquary is topped with a small
statue of the Virgin and in the center
a glass showcase surrounded by a
ring of diamonds. Inside the
showcase, the container of the
precious relic is shaped like a
branch with two buds and a rose,
Mary's symbol *par excellence*.

Some jewelry artists, Paolo Rizzo amongst them, stand out for the technique of damascening, that is, the application of etched metals in various colors on a different, also metallic background. Also called damask technique (from the homonymous city where this technique had originated) it is particularly appreciated in the crafting of weapons and armor. Some jewel makers were actually also weapon makers and their workshops also produced cuirasses, damascened helmets and shields, chiseled spears, daggers and swords decorated with floral friezes on blades and hilts, poniards with gem encrusted ivory handles, velvet sheaths with gold rings and pearls, armors with chiseled reliefs on lowered etched backgrounds, and sallets lined with crimson fabric and decorated with gilt bronze ornaments.

From the middle of the 16th century, the Venetian jewel craftsmanship production would begin to acknowledge German and generally European design influences. It dates back to this century, and more precisely to 1557, the completion of the fourth horn of the doge, the last public crown of Venice, called, for its preciousness, simply *zogia*, that is, the jewel *par excellence*. The shape of the doge's headdress, at first similar to a miter, had gradually developed into a very peculiar design, with a protuberance at the back. The updating of the headpiece, the main symbol of the doge, involved a committee of jewelers and goldsmiths of the city among whom were Marc'Antonio Benzon and Alessandro Caravia. The old one was disassembled, the mediocre pearls

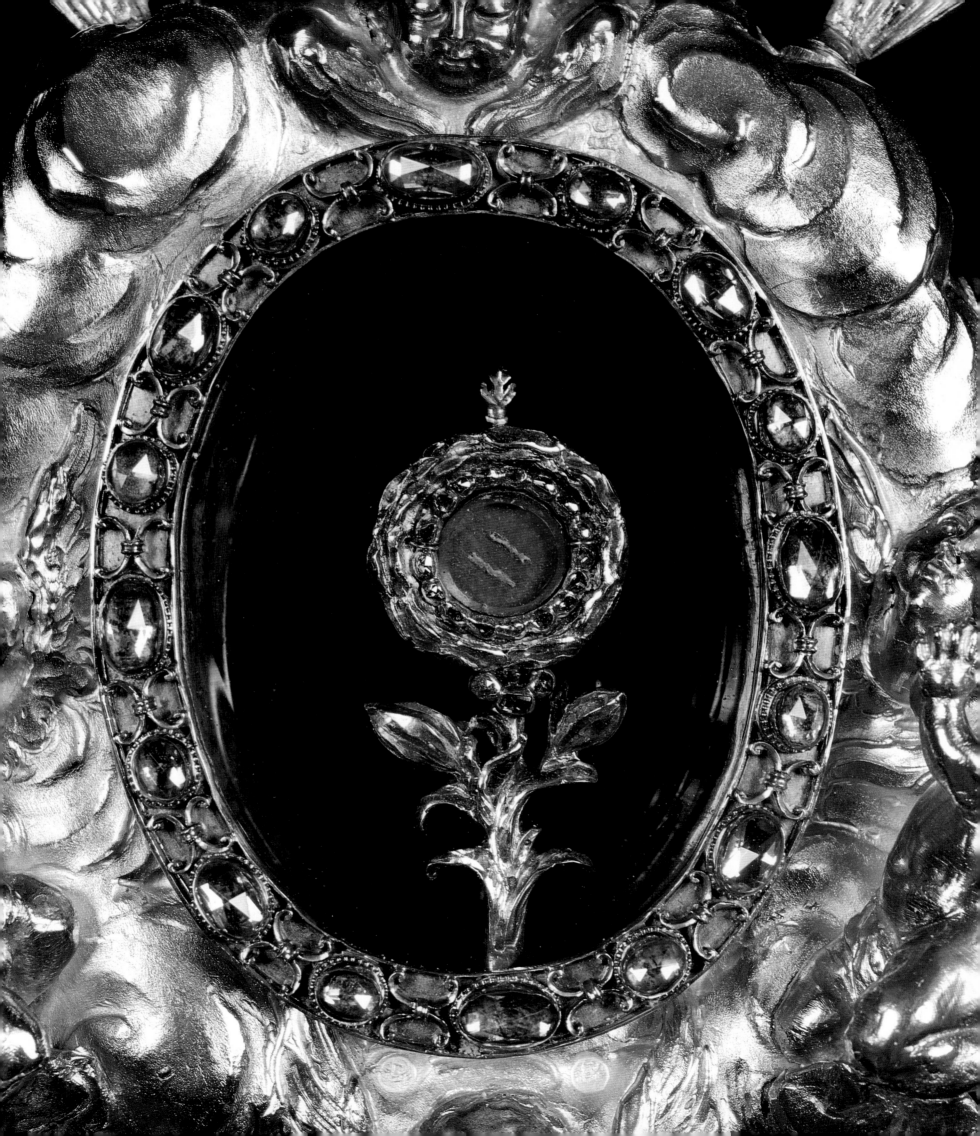

This flashy jewel, which belonged
to the Pisani family, dates back to
the middle of the 18th century and
is today part of a private collection.
In silver and diamonds, it represents
a bouquet of flowers that,
according to a particular need,
could be taken apart and pinned on
the headdress and on the
décolletage, as shown in many
portraits of that time.

replaced and prestigious gems were added after being removed from the "breast pieces of the Marie" (processional statues that commemorated a legendary abduction), and a total of 27 teardrop shaped pearls, 28 emeralds, 24 balases, 66 gems, a pebble-shaped ruby, and an enormous diamond on top, for a total cost of over 194 000 ducats (equivalent to nearly 15 million dollars today). The artists were Filippo Cordon, a Flemish jewel artist and Zuanne Alla Speranza; the result was a jewel of extraordinary splendor and magnificence, as well as great originality and uniqueness that, nonetheless, the Temporary Council with lack of consideration had stripped in order to put the precious gems to public use. Sold in several stages (the last auction took place in 1819), the revenues allegedly were used to finance the repair work urgently needed in the Basilica of S. Marco. This was certainly a noble intent, but one that deprived us of an artifact of enormous value, of which only a watercolor reproduction remains in the British Museum.

The commerce of Venetian jewelry flourished in Asia. Marin Sanudo tells of the sale in Constantinople of a horse saddle adorned with jewels valued at 100 000 ducats, and of a gold helmet encrusted with diamonds, rubies, emeralds, and turquoises with an exotic plume, of enormous value and bought by Suleiman. Among the artists who created the piece was one Ludovico Caorlino, who belonged to a renowned family of jewel makers and goldsmiths, extremely ingenious builders of automatons among which was a walking doll, presented to the doge on 16 December 1532.

Of the doge's headdress, the Venetian jewel *par excellence*, only the watercolor drawing in the British Museum, London, remains.

Part of an album consisting of 23 pages printed in Venice in 1751 by an artist who signed the piece with his initials only, D.M.T. The drawing depicts a *parure*, that is, a coordinated set of chest brooches made of gems and pearls.

Venetian noblewomen preferred jewelry made with large pearls, while the courtesans, who were not allowed to wear pearls, substituted little rounds of silver or mother-of-pearl. The courtesans often wore beaded belts, so-called *paternosters* with an end pendant containing perfume and wore rings on the index, ring, and little fingers. The fur hand mitt or shoulder shawl made of squirrel, sable, or fox is hung onto the large gold chain of the belt by a small chain attached to the small muzzle of the animal, covered with a gilt and gem encrusted mask. Pictorial documentation also shows earrings with coral bows, small boats, and small mythological figures composed from large baroque pearls.

The first woman in Venice to wear earrings seems to have been, in December 1525, during a solemn banquet, a relative of Marin Sanudo's, who describes her in his *Diarii* as having earlobes pierced with small thin rings from which hung large pearls, "according to the Moorish style." Sanudo looks upon this fashion with scorn and shame.

Seventeenth-century noblewomen, besides sticking in their gathered hair *spuntoni* and *tramoli*—jewels shaped like small swords and flower bouquets respectively—also arranged on their dresses or shawl, brooches of various sizes and matching design. Earrings became larger and featured clusters of pearls and set gems and pendants that created *rocaille* shapes, would later be scaled down to the small enameled bow design, adorned with tiny set pearls, in the so-called "dauphine fashion" after Marianna Cristina of Baviera, dauphine of France, who wore them

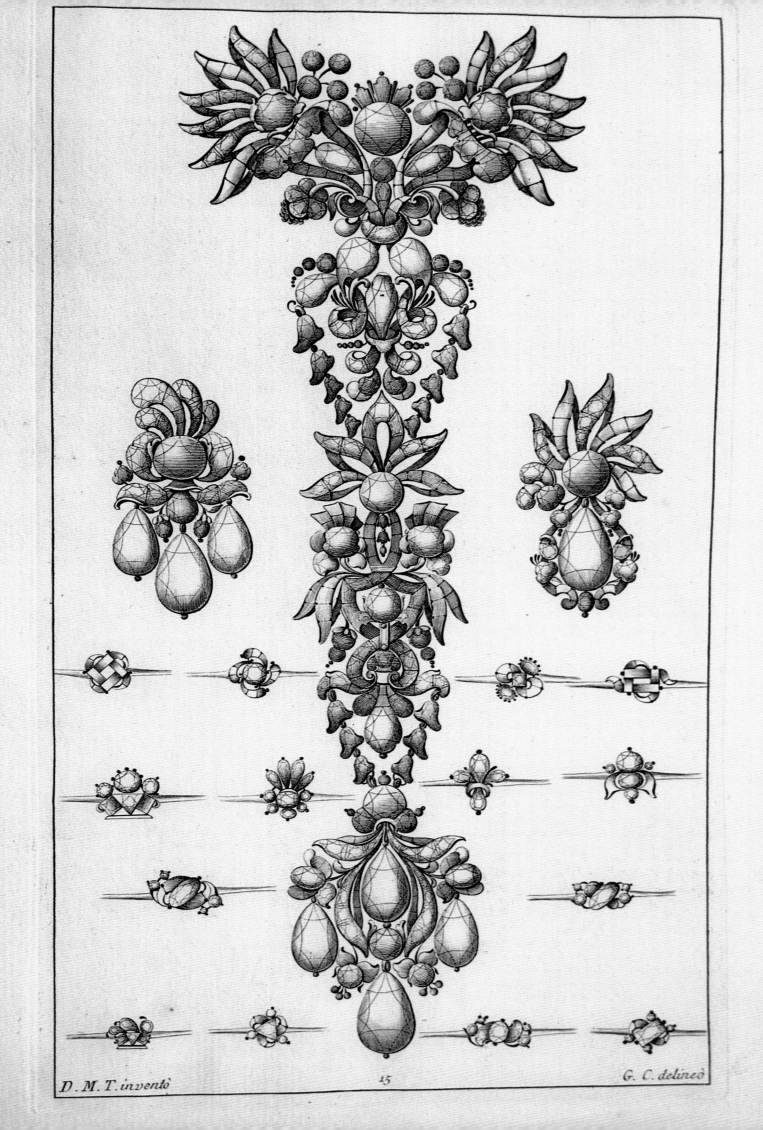

for the first time. The ladies also wore the *goliè* around their necks, a velvet or lace ribbon decorated with a jewel in the middle. Also called *esclavazzo*, it was sometimes matched with a similar bracelet called *polsetto*. Very popular were the *moretti*, miniature blackamoors head and bust jewels, made of ebony and stained metal, dressed in exotic costume, and headpieces rendered in enamels or colored metals encrusted with gems and pearls. Perhaps of Istrian-Dalmatian origin, such figures are used to make earrings, brooches, buckles, pins, and stick handles, or are strung together in necklaces and bracelets. It is possible that the presence in Venice of black slaves introduced them also as a motif in jewelry, making them the exotic element *par excellence*.

Clocks, at first used as niche shaped decorative objects placed atop furniture, through the centuries became an item preferably worn upon garments. It is interesting to note how, as early as 1531, the internal mechanisms underwent such a miniaturization that they could actually be set in rings and worn as such. Saludo again provides a record of a "sior Francesco Zen—wearing a gold ring topped with a beautiful watch" that even tolls the hours. Already onion shaped by the 17th century, but also round and oval, they would become so popular in the last quarter of the 18th century that men and women would wear at least two, hanging from the waist belt along with the minute tools that ensured the watches' perfect functioning. The trend to bejewel objects did not spare toiletry or embroidery cases, which contained tiny scissors, thimbles, needle cases, tobacco boxes, boxes for beauty spots, rhinestone encrusted buckles and buttons.

Chateleine, 18th century, Museo Correr.
Hooked on the waist belt or pocket, better known by its French name of *chateleine*, it was used to hang the watch and its tiny maintenance tools, the perfume vial, or any other precious item. With its hints at oriental designs, this specimen, in gilded metal with fine filigree and crystal reveals the fashion in Venice at the end of the 18th century.

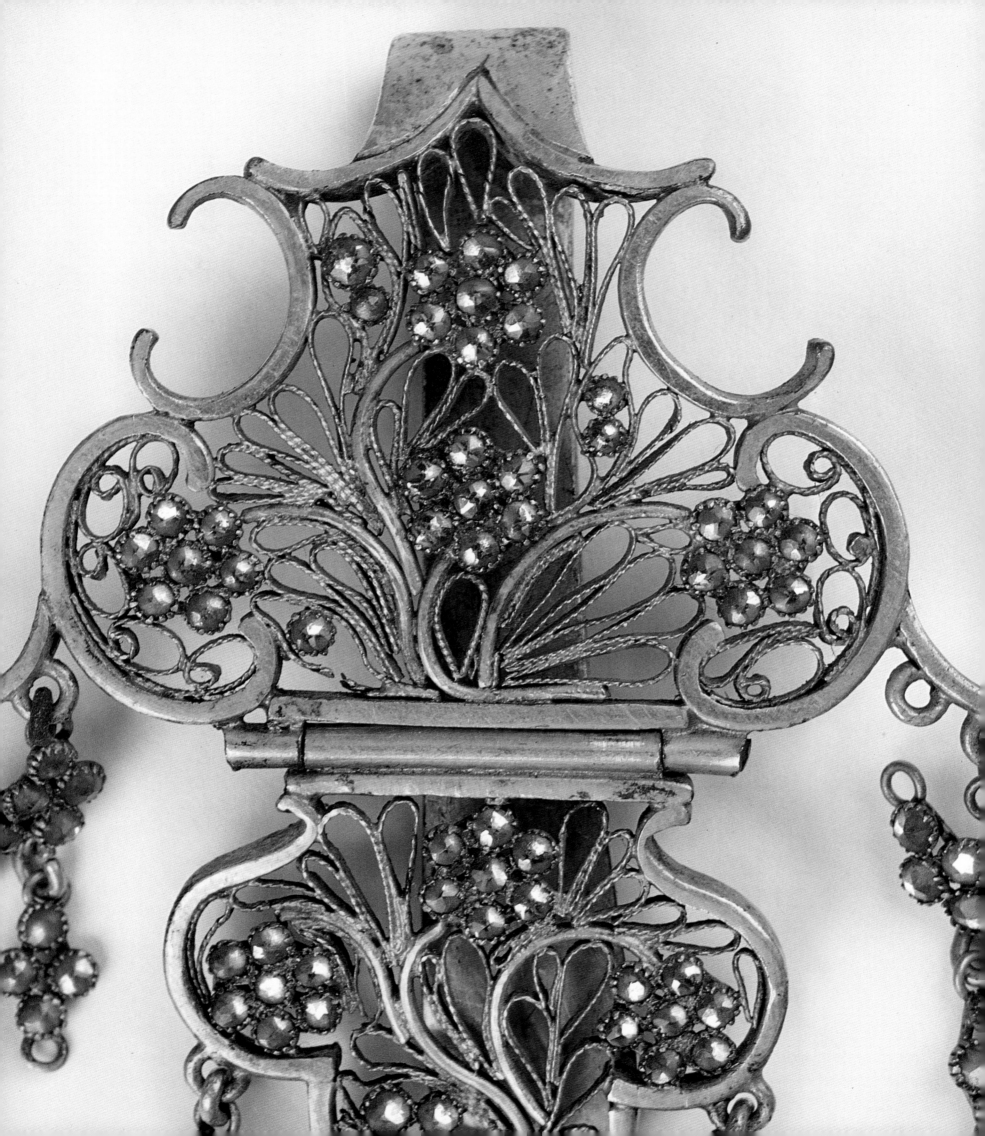

Pendant, middle of the 18th century. Private collection.
The jewel, silver with gilt sections consists of an oval medallion with a miniature of the Madonna—ascribed to Rosalba Carriera—framed within a thin loose spiral motif with leaves, buttercups, and buds.
Flourishing rose branches twist around the small bottle, in the Palazzo Pisani Moretta, made of green matte glass, gilt metal, and semi-precious stones, sitting on an elaborate pedestal. Used to hold liquor substances, essences, and perfumes, it is datable to the 18th century.

The most popular ones are made of balsa wood, covered with gold and silver threads and sequins arranged so as to create refined patterns with rays, fishbones, checker, and concentric circle designs.

Between the 16th and 17th centuries, silverware, large food serving platters and vessels, underwent various influences—from Germany through Augusta, then Spain thanks to Milan—eventually they would develop their own style, so-called "S. Marco," characterized by large wavy bands that run lengthwise through the object, decorated with a rope along the festooned edges. Little remains of the table silverware, documented in detail by the pictorial iconography of the time, which adorned the tables of the wealthy, lost to frequent meltings through the centuries. Very common were the large platters for serving food, the fruit stands, and the glove holders, trays kept in the hall for holding gloves. More numerous are the objects which survived made of less precious metals, such as silverplated copper, brass, pewter, or bronze. Indispensable on the banquet table was the saltcellar, which takes on a boat shape in the 16th century. Camouflaged within theatrical sculptural groups in the Baroque age, it changes into a shell shape in the centuries that followed. Finally, from the end of the 17th throughout the 18th century, there is a proliferation of jugs and teapots, coffeepots and hot chocolate jugs, which featured bizarre and graceful shapes with prominent embossed bellies.

[162]

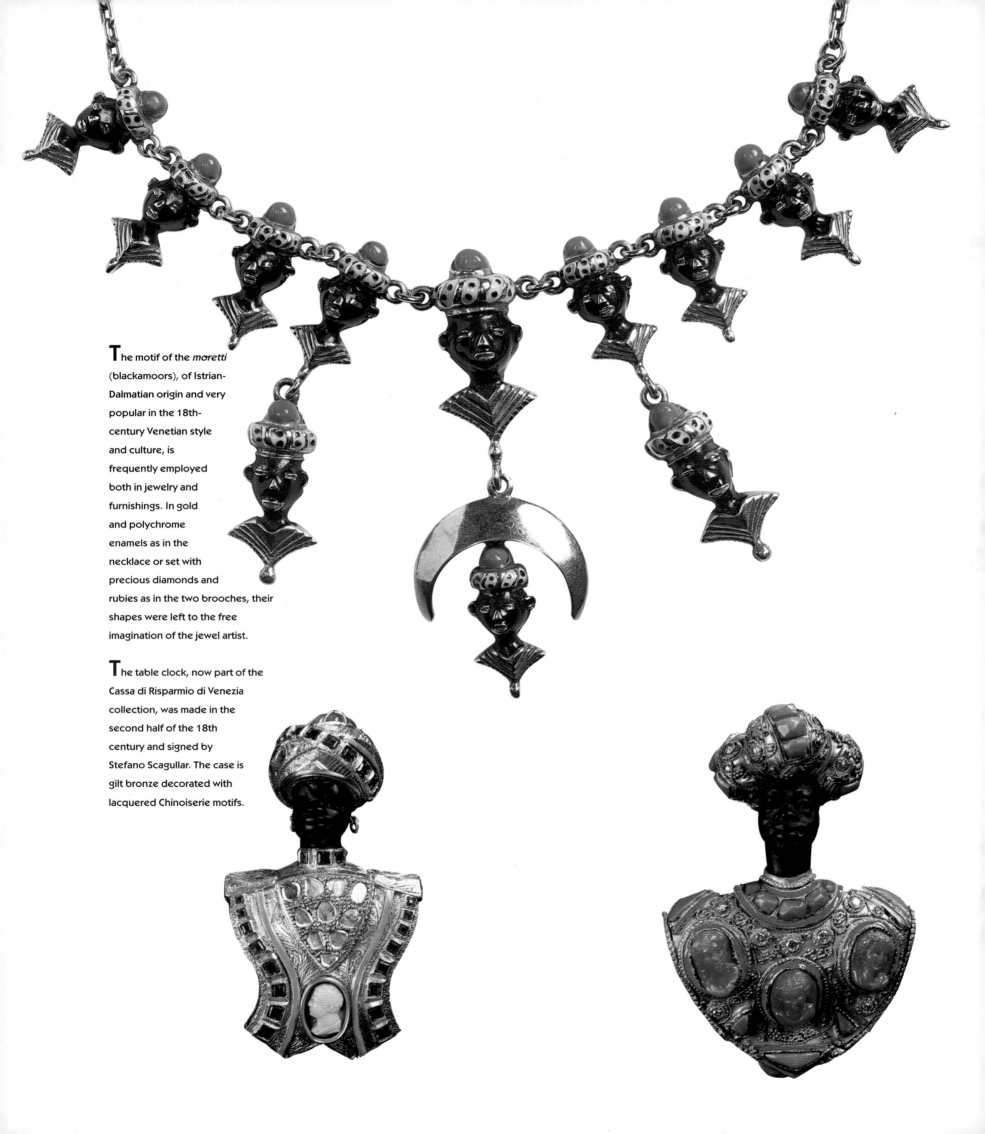

The motif of the *moretti* (blackamoors), of Istrian-Dalmatian origin and very popular in the 18th-century Venetian style and culture, is frequently employed both in jewelry and furnishings. In gold and polychrome enamels as in the necklace or set with precious diamonds and rubies as in the two brooches, their shapes were left to the free imagination of the jewel artist.

The table clock, now part of the Cassa di Risparmio di Venezia collection, was made in the second half of the 18th century and signed by Stefano Scagullar. The case is gilt bronze decorated with lacquered Chinoiserie motifs.

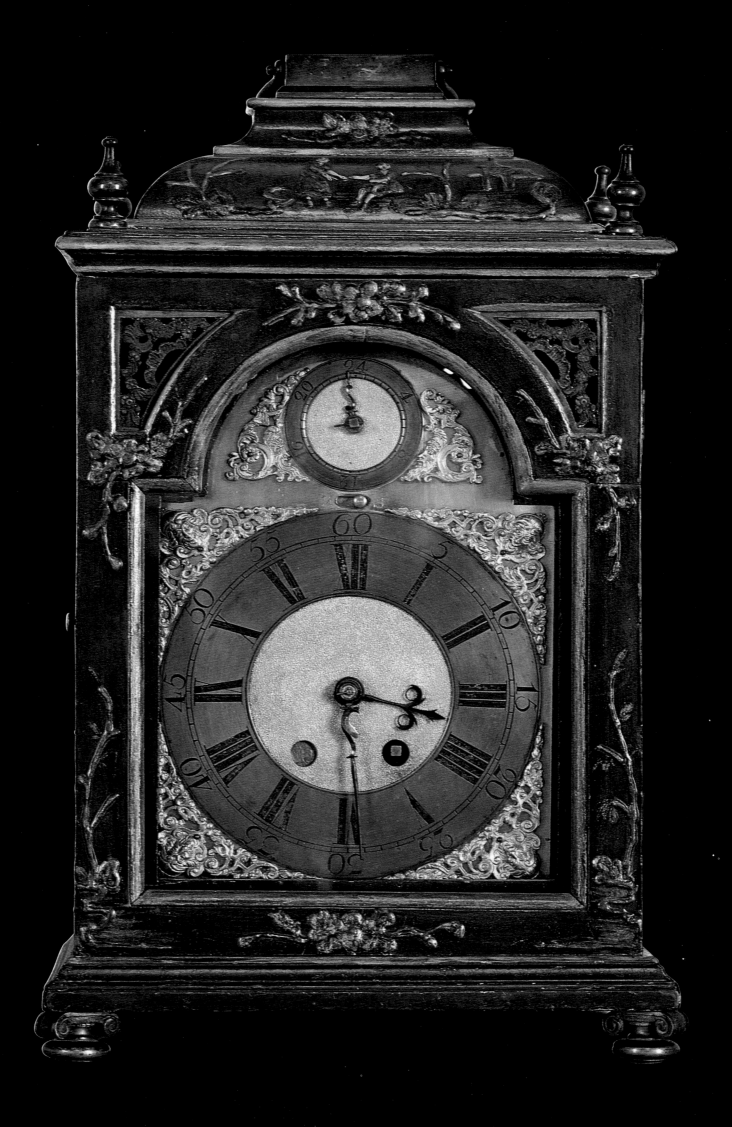

The coffeepot, reflecting a style datable to the first half of the 18th century, from a private collection is made of silver, engraved with the St. Mark's lion. With the body marked by curved lines and camel shaped spout, the domed lid is completely covered with leaves and berries, and the handle is made of ebony-like wood to prevent it from overheating.

The *tiraoro* and *battioro* (goldsmiths) worked with both gold and silver. They organized themselves into a single guild in 1576, which originally only accepted Venetian artists, but was subsequently opened in 1720 to foreign artisans as well. The *tiraoro* worked with gold in tube shape, pulling it through the holes of a *trafila* (draw plate) to the point of hair-like thickness—so thin that a thread measuring between seven and nine meters weighs no more than a single carat.

The *battioro* beat the gold, reducing it to flexible thin plates of various thicknesses and widths, using two steel wheels placed one against the other so that the metal would be well pressed. The two specializations were well distinguished because each was forbidden to practice the other's expertise. The products—foils and metal threads—mostly wound around a raw thread of smooth or wavy silk, in a tight or loose spiral, were employed mainly by the "soft arts," silk weaving of fabrics, haberdashery and braid, embroidery and lace making, as will be seen later.

The reduction of precious metal to foils was the duty of the German *battioro*, organized into a guild from 1582. The artisan, after separating the thin gold poles with sheets of parchment derived from the intestines of sheep and oxen, wound them in a double sheath of thick parchment which was then sewn up and hammered repeatedly with mallets of decreasing weight until they obtained extremely thin sheets. Such foils were then used for the gilding of wood and for the *cuoridoro*, but more about this later.

[166]

Fragile Arts

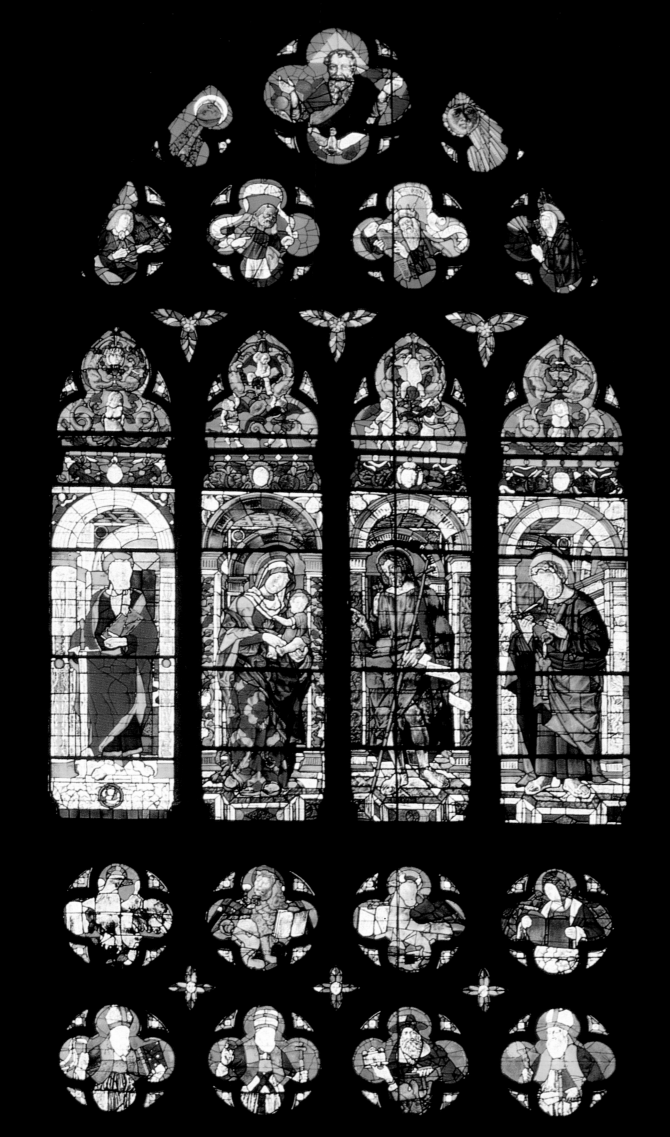

Glass

A thin glass reed was spun before me, just as time spins out our fragile life; and from that glass was made a bead which hung from the nose of the little Cherokee girl from the Niagara falls; a Venetian hand had fashioned the ornament of a savage girl.
Chateaubriand, *Mémoires d'outre-tombe,* 1848–50

hilst Venice inherited the art of the mosaic from Ravenna and Byzantium, it probably learnt the art of glassmaking from the Romans, through the glass blowing centers of Altino and, later, Torcello. It seems in any case that its origins were due to the presence in the area, from at least the 10th century onwards, of Benedictine craftsmen who used to decorate churches with mosaics and who therefore needed a local source of enameled glass tiles. There is written evidence of the existence in 932 of the *phiolarius* (manufacturer of phials and small bottles in blown glass) Domenico Veneziano, whose name appears in the deed of donation of the island of S. Giorgio from Doge Tribuno Memmo to the Benedictines. Teofilo, a Benedictine monk, had listed the art of glassmaking in his *Schedula diversarum artium.* There is later evidence of links and exchanges between this order and Murano glass-makers, who were evolving and progressing thanks in part to expertise and deco-rative techniques learned from the Islamic world. From 1271, workmen producing *lastre* (window panes), *quari* (mirrors), *canna* (glass beads or *conterie*),

The vivid color typical of the Venetian artistic milieu at the end of the 15th century is exemplified in the glass of the large ogival window in the church of SS. Giovanni e Paolo. Started following cartoons, perhaps by Bartolomeo Vivarini or Cima da Conegliano, in 1496, it was completed by Gerolamo Moccetto in 1515 with the help of the master glassmaker Giannantonio Licinio. Fifty years older, the dark blue glass Barovier wedding cup, decorated in enamel, is now in the Museo Vetrario in Murano.

Previous pages
A 19th-century processional baldachin. Church of SS. Giovanni and Paolo.

suppiadi (blown glass), joined the Guild of *fiolieri* and *vereri* (phial and glass-smakers), while in 1284 the *cristaleri* (producers of glasses, cups, buttons, and spectacle lenses) were joined by the *paternostreri, margaritieri,* and *perleri* (makers of rosaries, glass flowers, and beads). From 1528 the latter were subdivided into a further category, of *supialume,* who worked glass rods and enamels by oil lamp. The test which had to be undergone to become a craftsman in the above-mentioned specialties, and which remained unaltered from 1346 to the end of the 18th century, consisted in making a double glass rose, an octagonal piece of glass and two beads or faceted *paternostri,* one rounded and one oblong.

This guild, considered to be one of the most important ones, was subject to extremely strict rules and constraints: anyone who was not a full member was forbidden from practicing the craft, and it was also absolutely forbidden to take materials or tools relating to the art outside the Venice lagoon area. A Murano glassmaker who abandoned his native area was considered a traitor and as such could face the death penalty. On the other hand, the profession enjoyed special privileges; a boy born of a liaison between a patrician and the daughter of a master glassmaker could be a member of the *Maggior Consiglio,* as if he were of noble descent.

The great majority of glassmakers were resident in Murano in the 13th century, and this became compulsory in

[172]

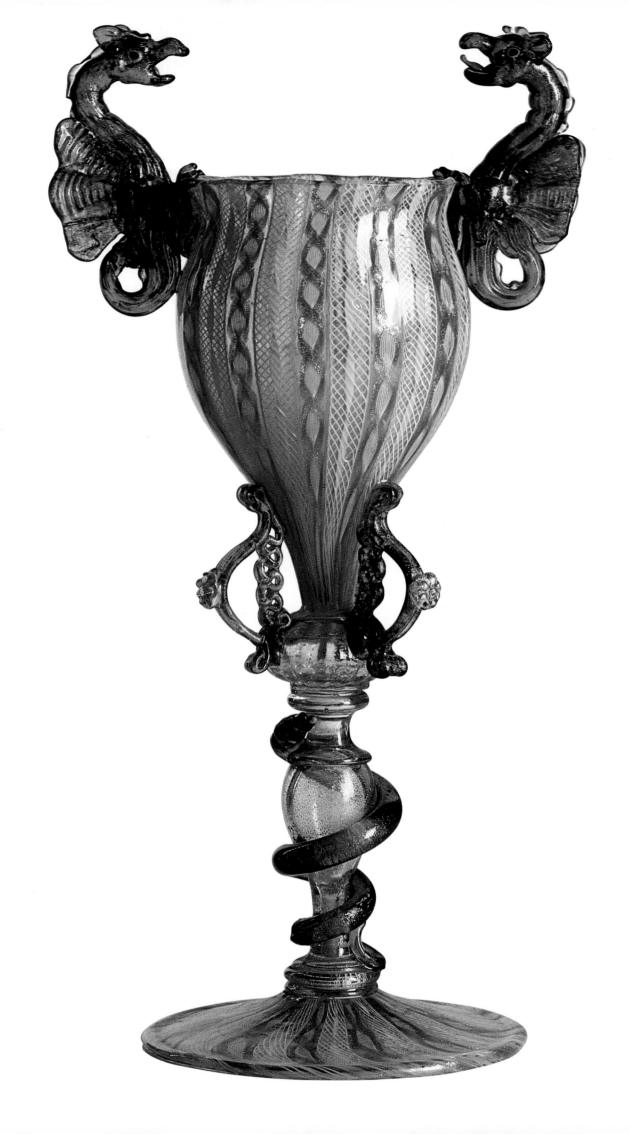

Probably a 19th-century copy of a Renaissance original in *lattimo* glass, this "pilgrim's flask," decorated while hot in polychrome enamels, depicts a naked woman with a soldier.

The slightly concave dish in transparent blown glass with a *lattimo* filigree, similar to the 16th-century examples, was made by Antonio Salviati between 1866 and 1877.

1291, when the *Maggior Consiglio* ordered the transfer of Venice's furnaces to the island, to minimize the risk of fires in the city—at that time built mainly of wood.

Glassworks normally had three furnaces. The first was for melting down raw materials: white silicon sand, pebbles from the river Ticino (quartzite) which had been ground and mixed with *rocchetta del Levante*, the ash obtained from plants which were rich in sodium carbonate. The *fritta* (a rough glass full of impurities) obtained by this process was then cooled, broken up, and melted once again in crucibles in the second furnace, then poured through water several times to purify it. It was then made into blocks and, after a slight cooling, it reached the ideal consistency to be worked on. A certain quantity of glass paste would be taken on the end of a blowing tube and brought to a smooth surface to "marbleize" it, then it would be enlarged by blowing. The bubble obtained in this way, either still suspended on the end of the blowing tube or transferred onto an iron rod, would then be squashed, twisted, pinched with pliers and tongs, etched, and cut until it took on the desired shape before finally being put in the third furnace to cook and stabilize.

In the 14th century there was a marked increase in the production of great multicolored, artistic stained glass windows, thanks to the contribution of Paolo Godj, an alchemist and rector of the church of SS. Giovanni e Paolo, who came from the Ancona region, and that of Giovanni Deola, who employed two master glassmakers from Murano to help him make *vitra colorata et apta fenestris* (colored glass suitable for

[174]

There is a wide variety of glass decoration, from the simple late-18th-century emerald green plate decorated with gilded chalk on a red background and a central daisy, to the decoration in enamels and etching on gold leaf of this beautiful example of blue and ivory blown glass from the second half of the 19th century. Signed "Salviati e C., Venezia," it reproduces mythological scenes.

windows). This production stopped in 1515 after completion of the sectioned ogival window of SS. Giovanni e Paolo which was made and signed by Gerolamo Mocetto following cartoons by Bartolomeo Vivarini or Cima da Conegliano. The first experiments with glass mirrors instead of metal ones were also being carried out during this period, and there was much imitation with glass paste of gemstones such as veined or marbled chalcedony, agate, jasper, and onyx.

The Barovier family was famous among the Murano glassmakers; they started their activity in the 13th century with Antonio, the *fiolario*, but they owed their fame to Angelo, who was active until 1461, and his daughter Maria. Their extraordinary production includes works in exceedingly clear glass, whose intense tones (blue, green, dark red, blood red, purple, and golden yellow) are as rich as jewels (rubies, emeralds, sapphires, and turquoises), decorated with gold, graffito designs, enamels, and miniatures. Praised by Filarete in his *Trattato de architettura*, Angelo's workshop produced the famous nuptial cup known as the Barovier Cup and now in the Museo Vetrarioin Murano. It is a precious object in dark turquoise glass, with multicolored enamel portraits of bride and groom separating a group of ladies on horseback and a fountain of eternal youth. In 1469 it was prescribed that the work of enameling and gilding, which had previously been carried out in separate workshops, would henceforth be the responsibility of the *cristaleri*.

[176]

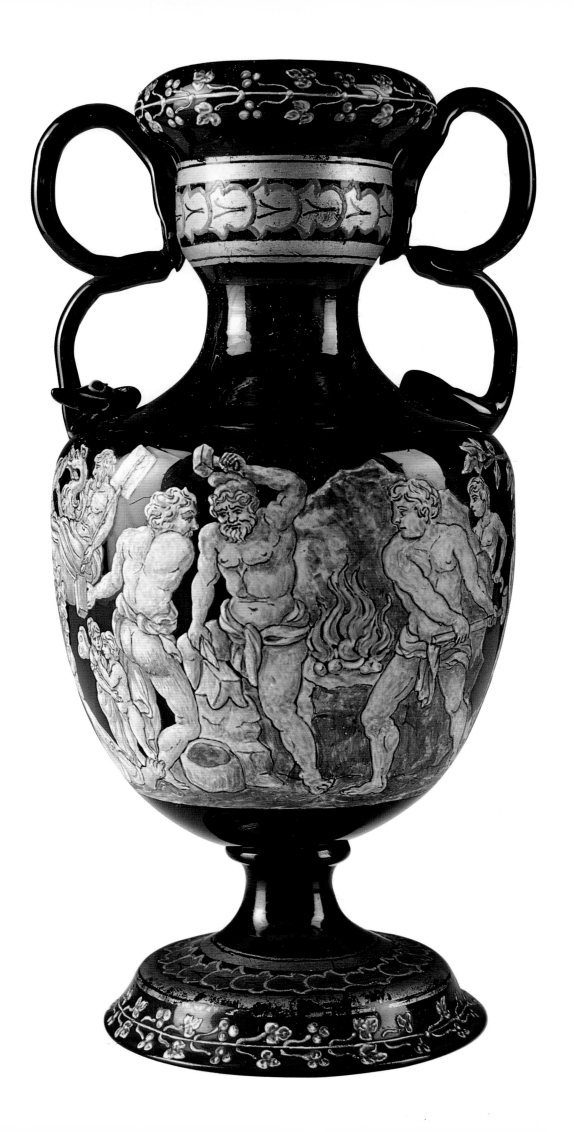

The small amphora in blown glass *a ghiaccio* with gold leaf, the work of Antonio Salviati between 1877 and 1890, is completed with looped handles and *morise*, particular glass applications whose undulating shape is obtained by pinching them with pliers. The special effect of cracking the glass *a ghiaccio*, which is visible in the detail opposite, is due to the sudden change of temperature which the glass undergoes when it is immersed in cold water.

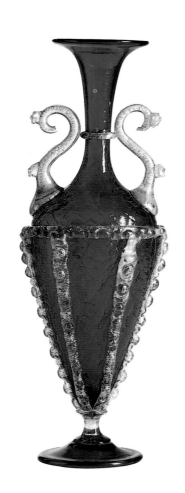

In 1475, the Barovier workshop produced a new type of glass, named *lattimo* because of its milky white opacity, which could compete with Chinese porcelain.

Despite the fact that the Murano glassmakers' skill was recognized, it is worth noting that the *Hypnerotomachia Poliphili* (one of the most fascinating illustrated texts of the Renaissance, published in Venice for the first time in 1499 by Aldo Manuzio) describes a glass garden edged by jasper colored glass columns, with bases, pillars, and trabeation in gold-streaked glass and with box, cypress, and other trees covered in a great variety of colored flowers, all of it so beautiful and precious that even Murano could not imitate it.

Two new techniques were adopted in the first half of the 16th century. The first, a type of glass called *a filigrana*, was obtained by incorporating lengths of *lattimo*, either straight or twisted, into the glass and blowing it, and the second, called *a redexelo*, had glass rods bent in opposite directions in order to produce a lattice effect. The second half of the century witnessed the production of glass called *a ghiaccio*, which has a cracked effect obtained by immersing the object in cold water and then slowly reheating it. Another noteworthy technique was that of engraving with a diamond point, which creates very delicate, lace-like designs, or regular lines which look like woven cloth. Moreover, glassmakers preferred blowing glass "free hand" which, though requiring extreme dexterity, allowed greater creative freedom. To this they added decorations in relief—especially flowers and animals—which were to be developed further in the centuries to come.

The ancient technique of carving with a diamond point, widely used until the 18th century, became fashionable again only in the 20th century. To this period belongs the fruit stand in blown glass on which an aquamarine-colored chain was applied with heat. Etching cold glass around the dish creates a lacy effect and it looks as if a doily had been placed on the surface.

The mirror with an etched, silvery glass frame belongs to the 18th century. The application of small panes produces an effect of greater brightness and luminosity. The two little birds on the top of the mirror and the flower motifs all around were etched with a copper wheel and abrasive dust.

Considerable achievements were also made in producing "Venetian style" mirrors; the technique, started by the Dal Gallo brothers, consisted of making a glass sphere, slicing it into panes, smoothing down the surface of each one, then covering it with tin amalgam. In his essay *Dello specchio di scientia universale*, published in Venice in 1572, Leonardo Fioravanti describes this process clearly, but obviously not in enough detail to divulge its secrets. First, a glass sphere was formed in a furnace, then cut with special scissors into square shapes of various sizes, according to need. These were pressed with an iron spatula and placed in a furnace to spread them out, before being covered with ash and put in another special kiln to finish firing. After cooling they would be polished with a particular sand from Vicenza, on a special iron slab. At last they were slowly pushed onto a large sheet of tin covered in quicksilver, thus becoming "the most beautiful" glass mirrors "ever made." In his previously quoted work on the world's professions, Tommaso Garzoni speaks specifically of Murano mirrors in similar terms, yet this is not enough to describe their true originality. Indeed, they were framed with other mirrors, enriched with multicolored glass and enamels, with bunches of flowers, etched or inlaid with gold bas-relief, or even inset among marble or stucco work.

In the 17th century, a century of great splendor and ostentatious luxury, there was a demand for glass objects which would be immediately

The *Guggenheim Cup,* 1875
Salviati, Private collection.
Copy of a 17th-century example,
the stem and the handle of the
lid are made of small glass chains
and buttresses linked to large
crystal beads.
Also by Salviati is the stylized dragon
cup made in *rigadin* crystal with gold
leaf. The object, known as a
galanteria, is purely decorative and
thus has no practical function.

identifiable as status symbols, because their extravagant shape demanded considerable technical skill, or because they were impractical and difficult to use. The tall-stemmed, lidded goblet seems to be the object most worthy of magnificent decoration, so much so that it is the epitome of baroque glass work. In *gotti con bisse* (glasses with little snakes), the stem is transformed into a complex braiding of slender glass tubes, edged with scalloping and crests. Two other types of glass objects, very sought after in the 17th century, were the *zuccarino,* a bottle in the shape of a stylized gourd which was used as a perfume spray or *rosolio* container, and the table lamp or oil lamp, sometimes modeled in grotesque zoomorphic shapes which some historians like Gasparetto have traced back to designs from the *Libro del Serenissimo Principe d'Este,* now kept in the *Archivio di Stato* in Venice. Most unusual are the ones in the shape of a rabbit or a musical instrument with horses' heads now in the *Museo di Capodimonte* in Naples, or the ones in the shape of a sea horse or a dragon.

Venetian quality and creativity, which were naturally sought after in all the courts of Europe, were

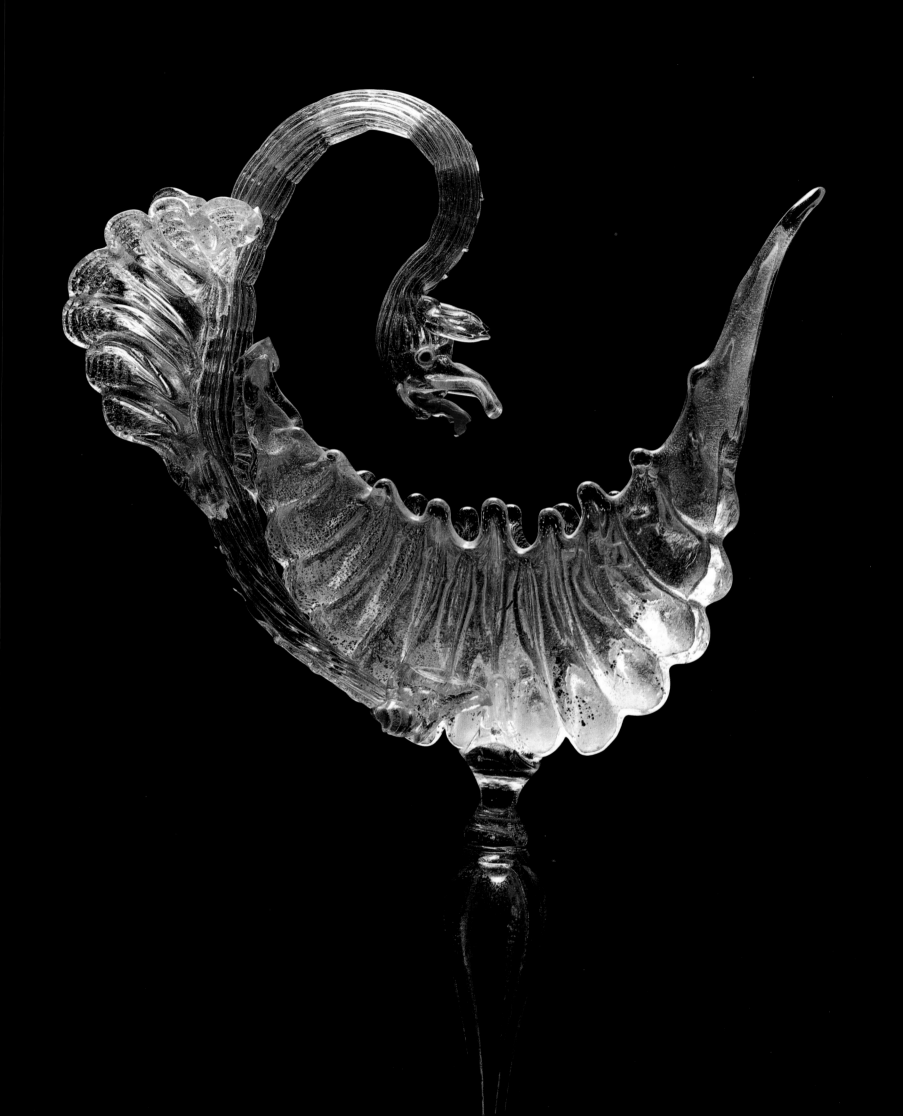

With their reflecting action, mirrors helped to diffuse and increase light in rooms. Made of small fragments of mirror side by side, this example from the first half of the 18th century shows an unusual decorative motif. It is conceivable that the sobriety and rationality of the architectural design of the palazzo's facade are a symbolic reference to the distinctive characteristics of the Enlightenment, which was spreading in Venice during those years.

exported and greatly benefited Venice's economy. Louis XIV's shrewd minister Colbert tried to control this situation as far as France was concerned; if the king's principal expenses were in buying lace, fabrics, and mirrors from Venice, all he needed to do was attract Venetian lace-makers, weavers, and glassmakers to France with tempting job offers. In a few years, from 1665 to 1670, Colbert managed not only to equal Venice's production, but to surpass it, with new inventions such as a system of casting which allowed the production of bigger and cheaper mirrors.

The glass paste known as *avventurina* or *stellaria* because of its characteristic golden and sparkling specks, normally used in costume jewelry, was now employed in furnishings, to make table tops and to decorate divans and armchairs.

Other technological innovations introduced in England and Bohemia were to bring about a final crisis in the Murano industry which, in order to be competitive, was obliged, in the 18th century, to produce imitations of foreign products such as *Bohemian-style* crystal. It is true that part of the blame rests with the Murano glass-makers for their intolerance to innovation, which went so far as to obstruct whoever tried to forsake traditional techniques and methods to adopt the new. Glass blowing was by now becoming obsolete and being replaced by casting and rolling and so the Venetian industry, which still employed 340 workers in 1766, was wretchedly beaten by the competition of countless foreign workshops.

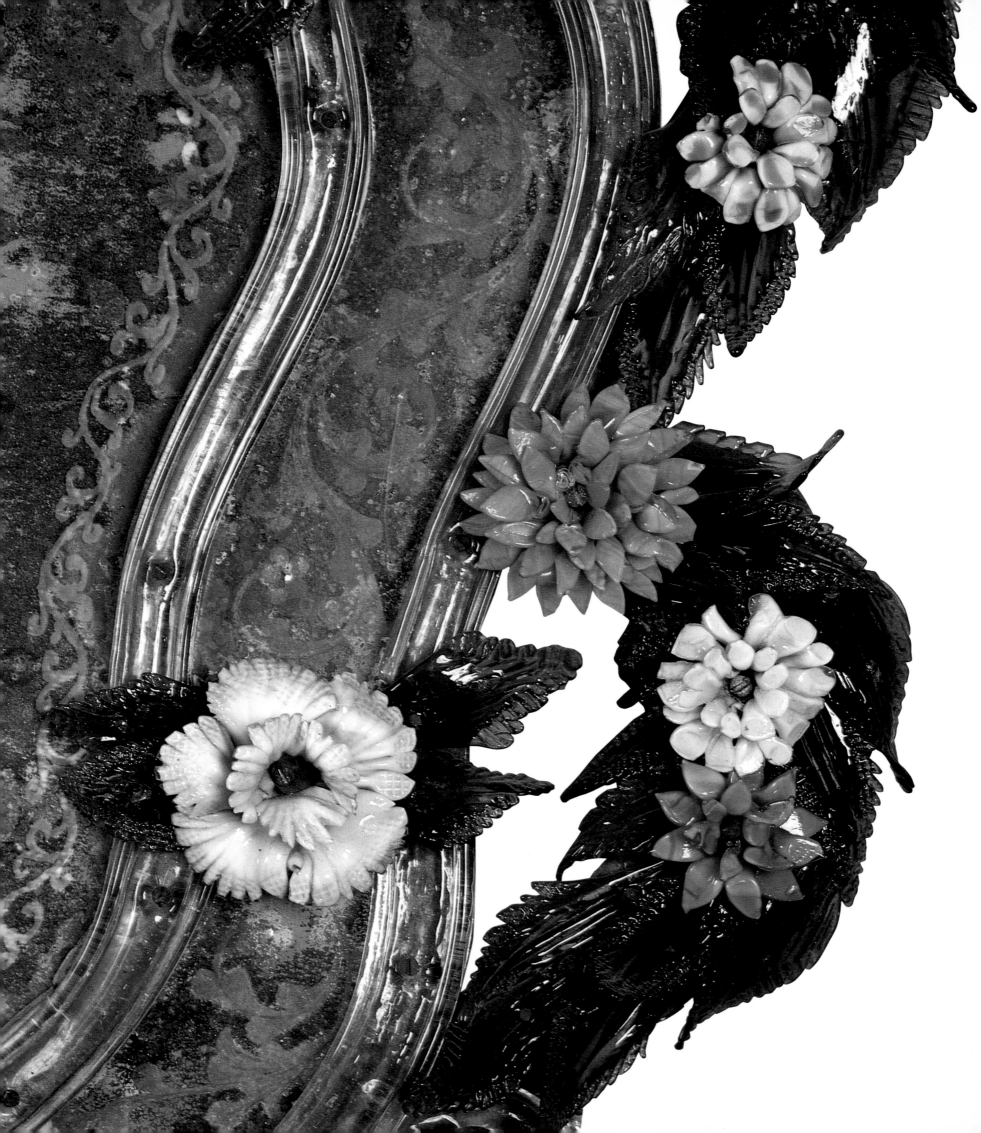

Nevertheless, the major merit of Murano in the 18th century was that of elevating the average standard of production to a degree of sophistication and elegance which had never been reached before, thus also making such products available to the emerging classes. Moreover, they tried to satisfy changing consumer demands which depended on new lifestyles, by creating more functional table lamps, snuffboxes, holders for patches and other ornaments, phials and little bottles for essential oils and perfumes, candlestick holders, salt cellars, jam dishes, baskets, bowls, and drinking glasses. Giuseppe Briati (1686–1772), who was so hated for his innovations that he had to move his furnace from Murano to the Carmini area in Venice, created sumptuous table decorations known as *desser*, which looked like real miniature scenes in glass, for the doge and for great banquets. The craftsmen, aiming above all for glorious color, covered their work, especially mirrors and chandeliers, with polychrome flowers and leaves, which became the main decorative elements in furnishing. Light literally became more important in the century of "Enlightenment," so the numbers of candles were increased and their brightness improved when they were multiplied in a series of reflections. Mirrors therefore gained a primary importance in the 18th century, framed in a variety of materials, such as ebony and walnut which had been carved, gilded, lacquered, made in ceramic, or, more often, in glass tiles, rods, and petals. They were often engraved with allegorical figures, pastoral scenes and characters in fashionable costume, not only on the frame and the edges but also on the mirror face.

Very frivolous, and definitely less ideologically-loaded, is this 19th-century mirror with its elegant many lobed shape. Surrounded by a frame fashioned out of etched glass plates, it is decorated with colorful three-dimensional applications in the shape of leaves and flowers whose species are readily recognizable.

Light played an absolutely central part in the century of the "Enlightenment" and chandeliers, like mirrors, became a crucial feature in fashionable interiors. In the greatest variety of shapes—the one below is boat-shaped—they are a veritable triumph of color and light, amplified by the widespread use of transparent glass. Often large—the one opposite, manufactured by Briati of the Fondazione Querini Stampalia, is over two meters in height—they were made up of thousands of pieces. Like fireworks, these chandeliers seem to defy the force of gravity in an explosion of colored flowers, leaves, and chains.

Lights and chandeliers made largely of glass, with a French-style metal structure and covered in exuberant Venetian drops and pendants, had first made their appearance in Venice at the beginning of the 18th century. However, it was certainly Giuseppe Briati (who also made the two precious colored glass reliquaries in the church of the Redentore) who introduced the great innovation of covering the metal support and the arched side branches with pieces of hollow glass arranged on different tiers, and of decorating them with polychrome glass pendants, curls, and flowers. These chandeliers, known as *cioche*, are up to two and a half meters tall and can be in the shape of a pillar or a boat, or "Chinese style." With their arms outstretched almost in a declamatory stance and their candles never straight, they give a feeling of giddy elation.

The end of the Republic in 1797, successive foreign rulers, and the abolition of the guilds in 1806 decimated glass production, which by 1820 was carried out by only sixteen glassworks, with five of these making blown glass and crystal.

However from 1830 there was a gradual revival; a 1700-piece *cioca* was made in the Toso brothers' furnace, while Pietro Cozzato and Angelo Fuga resumed the art of engraving with a wheel-shaped implement. The abbot Vincenzo Zanetti's work continued to be very important. He founded a glass museum on the island of Murano in 1861, opened a design school and organized exhibitions and events which helped maintain the glassmakers' interest in their craft by stimulating their creativity. In

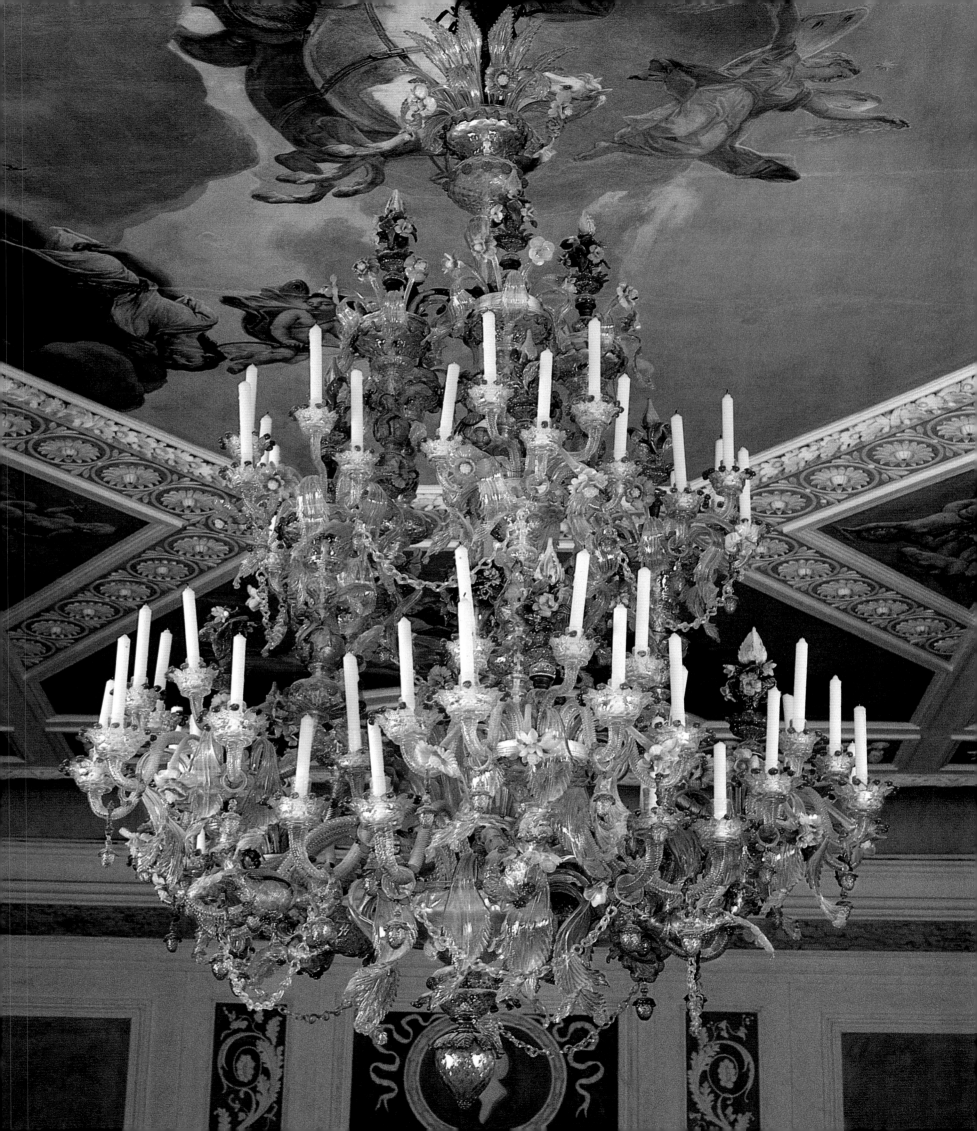

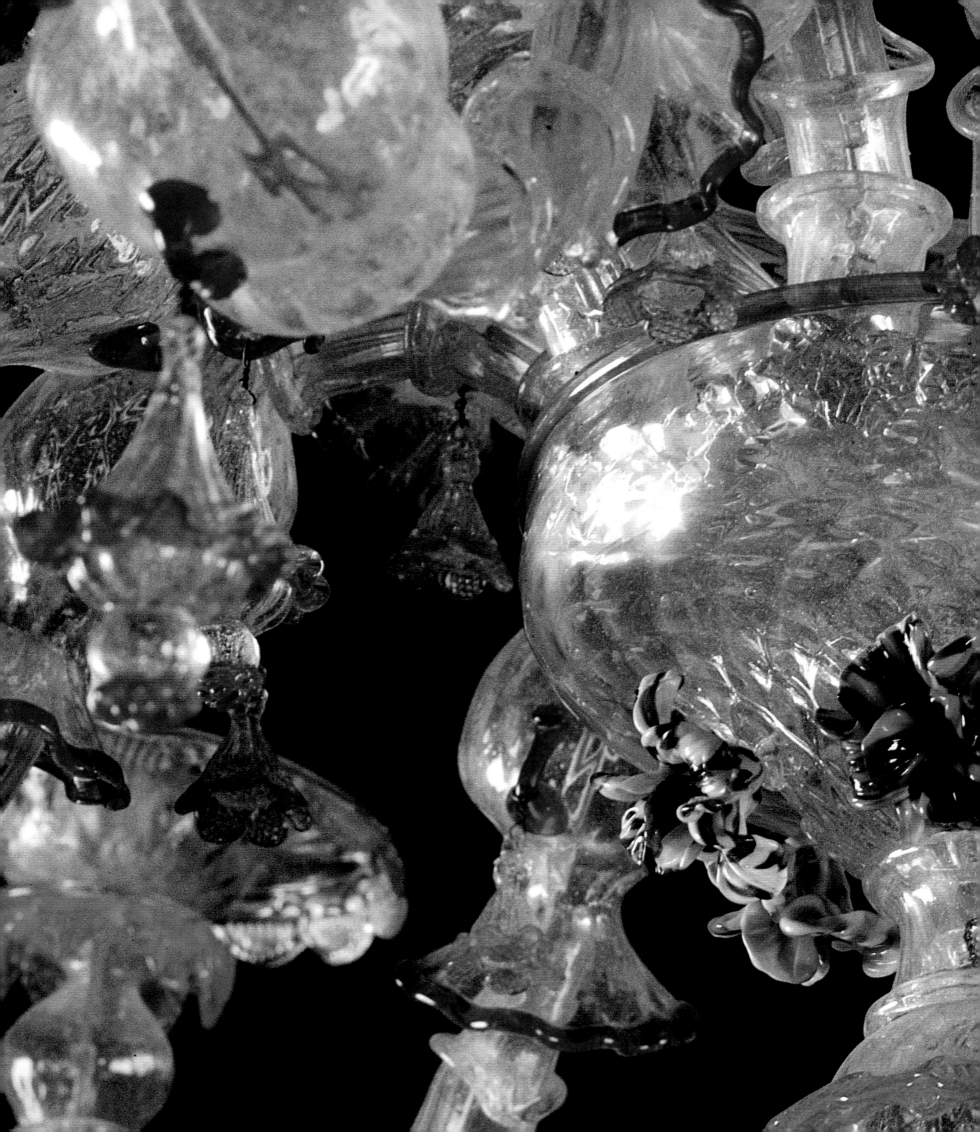

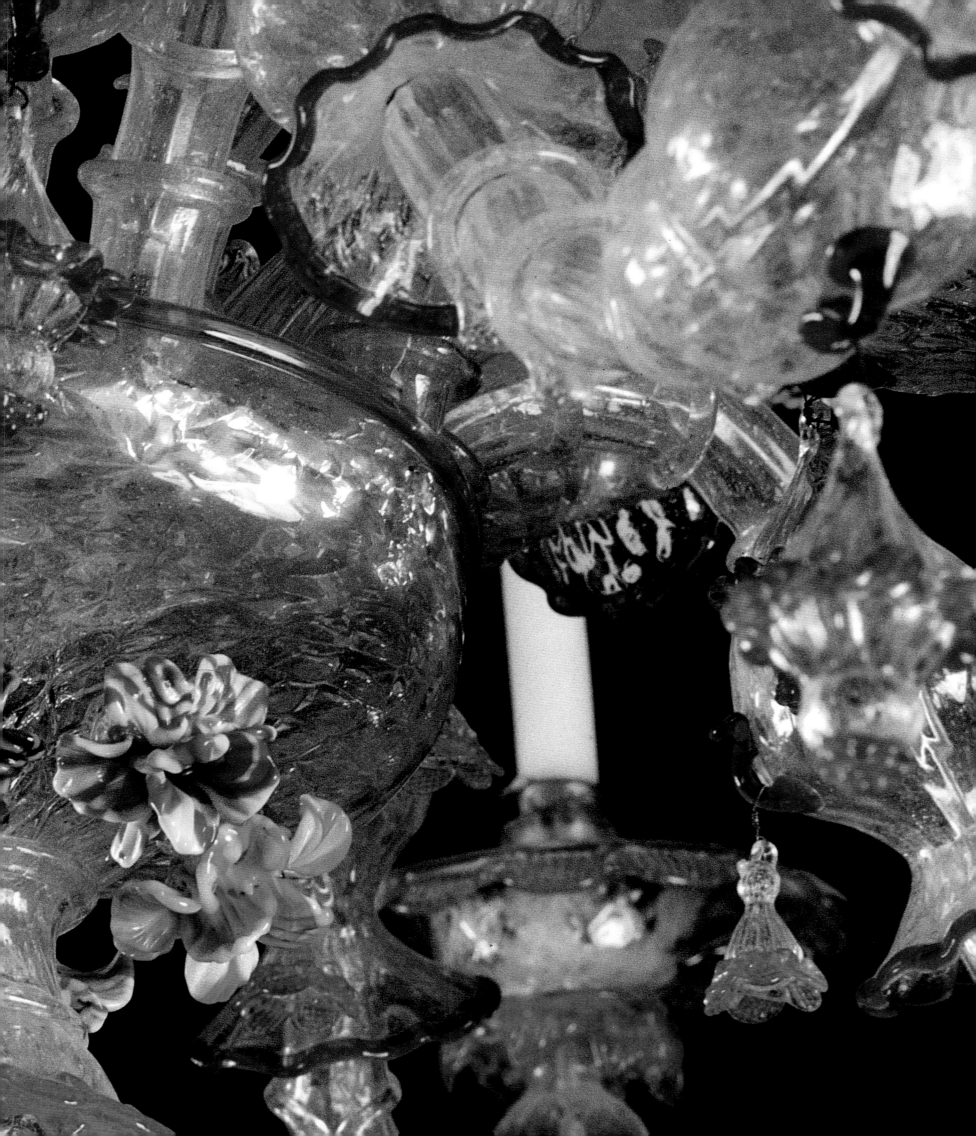

The size of a hand, this small colorful pane representing an archer was made by Vittorio Zecchin at the beginning of the 20th century. An artist who came to glassmaking from painting, his works are permeated by the influence of contemporary painters of the Art Nouveau and Viennese secessionist movements. In this pane one can notice echoes of Gustav Klimt, even if they are interpreted in a more fairy tale, naive mood.
Technically, the pane is made of *murrine* and glass powder assembled into the design while cold and then fused together by heat.

those years Antonio Salviati, a lawyer from Vicenza, having recovered a considerable capital, founded the glassworks Salviati & Co., recruiting the most able glassmakers, decorators, technicians, and promising apprentices. The latter were obliged to attend drawing lessons in order to both develop their manual skill and acquire artistic knowledge.

Especially noteworthy among the main exponents of early-20th-century glassmaking are the Toso and the Barovier workshops for their translucent glasses with the thinnest of stems and, in the second case, for the invention of *vetri a piume*, obtained by applying glass filaments on an opaque surface at high temperature. Then there is Umberto Bellotto for his ingenious marriages between glass and wrought iron, Teodoro Wolf-Ferrari with his flowery leaded glass, and Vittorio Zecchin. The latter two artists produced that murrhine glassware which, exhibited at the Venice Biennale in 1914, marked the definitive success of the new Murano glassmaking style. Furthermore, we are indebted to Zecchin for a decisive renewal of the art, first for the creation of featherweight blown glass decorated in enamel and gold with delicate designs, then, when artistic director of the Cappellin & Venini glass factory, for works devoid of any decoration. Influenced by Rationalism and also drawing inspiration from the Renaissance, he produced both copies and original pieces, lightly colored in amethyst, light yellow, and sky blue. Described by Giulia Veronesi as "light as soap bubbles, fragile and supremely non-utilitarian," they enjoyed a huge success at the Universal Exhibition of Decorative Arts in Monza in 1923 and in Paris in 1925.

Ever since antiquity, the Murano glass industry has specialized in making beads. The fruit of specific technical procedures, the beads are called *margarite* when obtained in great quantities by cutting a hollow thin glass rod, or *a lume* when they are individually made, shaping the glass in the flame of an oil lamp. The small size of the *margarite* allow for the most diverse uses, including the artistic creation of multicolored flowers. A suggestive and representative visual survey of these is given in the sample book reproduced on the next few pages. Inside Domenico Bussolin's *Guida alle fabbriche veterarie di Murano che contiene la descrizione dei lavori che si fanno… (Guide to the glass factories of Murano containing a description of the work done there…),* published in Venice in 1842, we find *margarita* beads illustrated on the left and *a lume* beads on the right.

Still made of glass, but with a historical and technical development of their own, *conterie* (beads) derive their name from the Latin *comptus* (adornment). This term at first included only *perle a lume* beads, then it came to mean beads of any color and shape, from the tiniest ones, the size of grains of sand, to the most precious, with decorations in enamel, gold, and silver. The etymology of *counting*, suggested by the monetary use made of them in the past, is tempting but wrong.

Of very ancient origin (they were used as ornaments by dignitaries, priests, and women in Egyptian, Phoenician, and Etruscan societies) they only become popular in Venice in the 16th century, and tradition even attributes their import to Marco Polo, even if they were in fact reinvented by two Murano glassmakers, Domenico Miotti and Cristoforo Briani.

The Guild of the *contereri*, with its chapel in the church of S. Francesco della Vigna, became independent in 1308 after splitting from the more important and very large Guild of the *vereri*, yet it remained one of its *colonelli*.

The *margarite*, made by a process which had remained unchanged for centuries, were among the most important products. The glass paste, made red hot by the master, was pulled into very long and thin hollow rods which were sorted according to their thickness by the *cernitrici* and cut, by the *tagliadori*, into little tubes called *pivette*. These were sorted again by the *schizzadori*, who eliminated the faulty ones, then put in a container called *siribiti* where their hollow was filled with a mixture of sand, lime, and coal which prevented it from getting blocked when they were made to rotate again and again in a

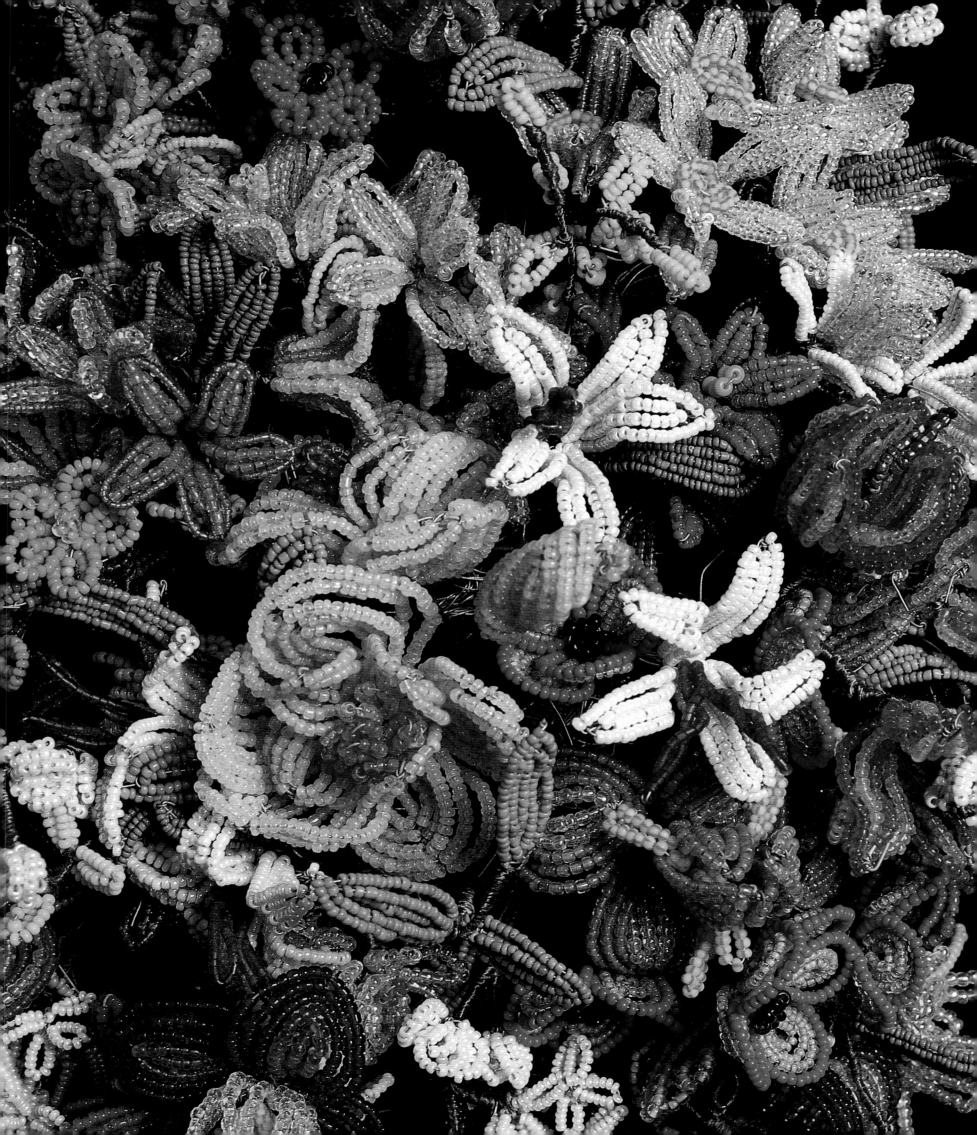

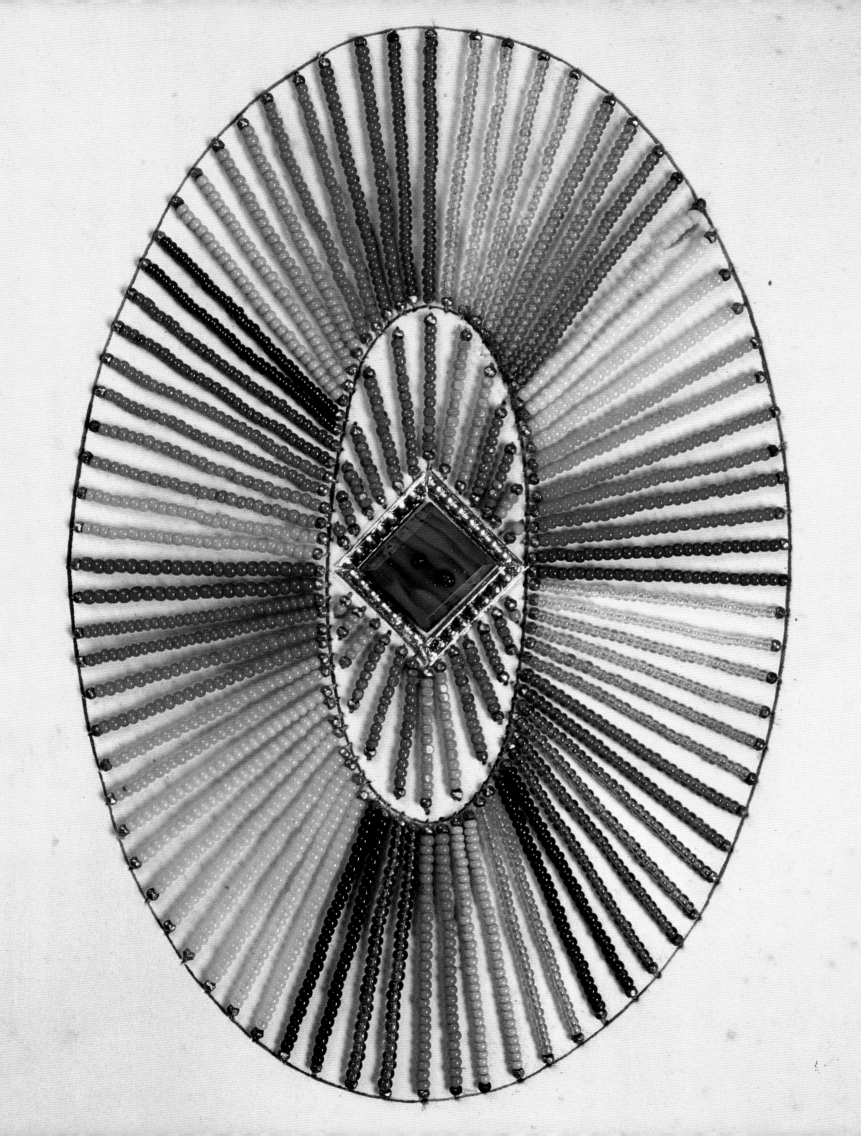

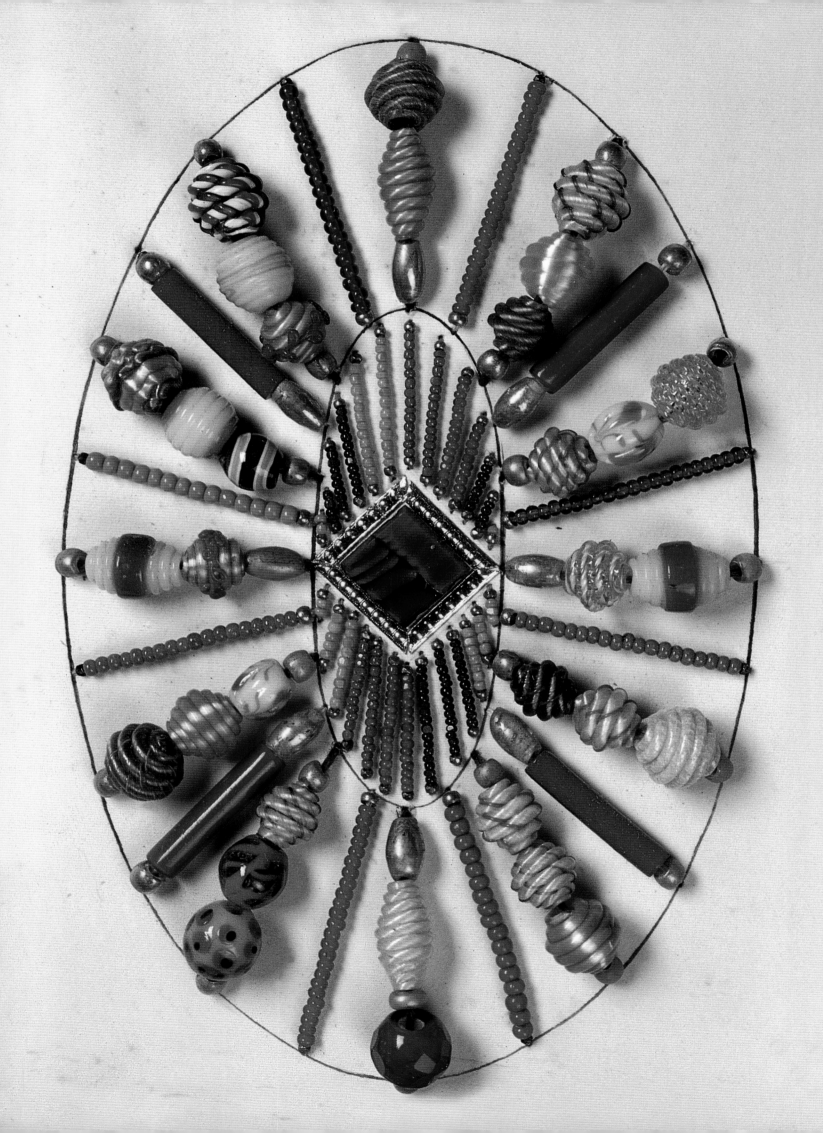

container called a *turbante*, and, still warm, they were put in a furnace. They took on a spherical shape during this phase and were then separated from the blocked ones, *ballottini* (which were used in furnishing and to make decorative pictures), before being sent, through the *macchina degli orbi*, into barrels full of oiled bran by the *lustradori* (polishers). Now clean and sparkling, they were ready to be threaded, a task at one time undertaken by women called *impiaresse* who, having put a certain quantity of beads on a wooden tray (*sessola*) on their lap, would quickly and rhythmically plunge 40 to 60 very thin needles into them. These needles were linked to the same number of threads and held fanned out between the first three fingers of the right hand. The strings obtained in this way were used to make necklaces and to complete embroidery or in special weaving.

Another type of *conterie* were the *perle a lume*. Their manufacture dates back to the 15th century and consisted in threading a piece of glass tubing, cut to the required thickness, onto an iron wire and heating it in the flame of an oil lamp which was kept burning by small bellows. It was then energetically blown on to swell it and filled with a special gold and silver paste before being painted on the outside with colored enamels. It has already been mentioned that *avventurina* was among the most prized types of glass, a cinnamon colored or amber glass incorporating thousands of glittering specks which looked like gold. Once the procedure had been rediscovered in 1650 in the recipe book of the Muranese Giovanni Darduin, it was produced exclusively by the Miotti workshop. Fallen

Beads blown *a lume* and *alla lucerna* both indicate the same technique which can, however, obtain a huge variety of results. Archaeological finds have shown us that all that was needed for the most ancient branch of glassmaking, was a heat source and a piece of glass tubing, which could take on different shapes and sizes.

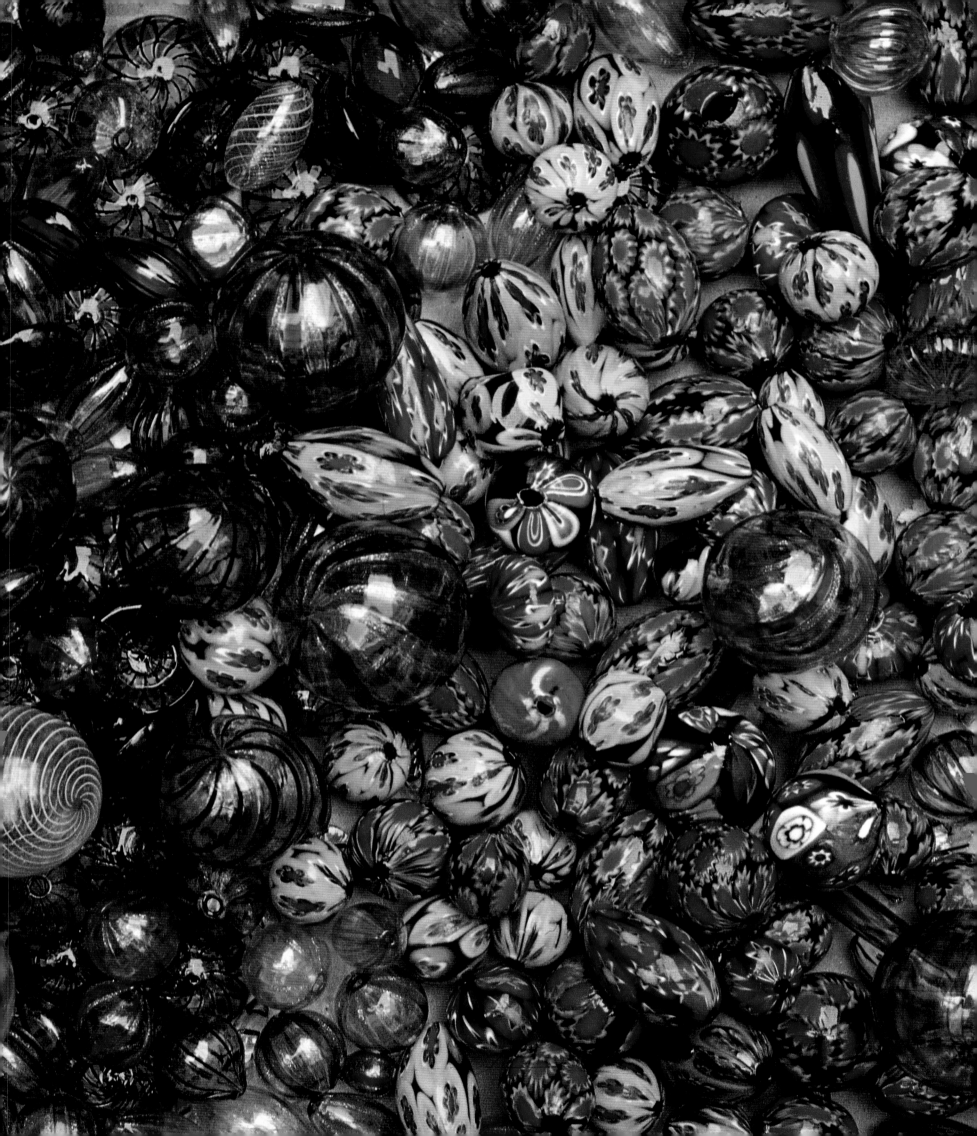

into disuse, it was then relaunched and perfected by Pietro Bigaglia in the first half of the 19th century.

However, it is the *margarite* which were always the main export, in large quantities, to the most faraway countries of the world. These *conterie* were found in an archaeological dig in San Salvador, at the spot where Christopher Columbus is presumed to have landed, and they were then used habitually for centuries by explorers and travelers as goods for barter. It should be borne in mind that the above-mentioned *Hypnerotomachia Poliphili* describes a silk garden whose walls, made with remarkable skill and at considerable expense, were covered in glass beads, all of the same size. The work goes on to describe flower beds and gazebos in sumptuous silk fabrics, enriched with embroidery, and pergolas made of gold thread, covered in roses with silk leaves and flowers made of *conterie*.

As for the 16th century, Morazzoni and Pasquato write that the Milanese were also seized by a passion for *margarite*, with which they decorated clothes, covers, and ornaments, and that Neapolitan noblewomen in the 17th century adorned their precious aprons with little pendants and fringes in Murano beadwork. They also relate that the *paternostreri*, makers of rosaries, belts, and necklaces, collaborated closely with dressmakers to make women's clothing embroidered so densely with *conterie* that they looked like mosaics "there being interspersed little variously shaped pieces of glass, and gold and silver enamels." On January 20 1594 or 1595, however, the Senate banned such adornments, limiting them to hairstyles and headdresses.

Beaded accessories were very popular between the end of the 19th century and the beginning of the 20th. Embroidered with a particular technique, similar to weaving, they were wildly fashionable until the 1920's. The decoration was extremely varied, from reproductions from previous centuries reproduced on handbags to ethnic motifs on belt-like necklaces. Both from private collections.

[200]

Embroidery using glass beads was fostered during the 16th century in Venice by the publication of numerous manuals of patterns; because of the geometrical precision required, those suitable for cross-stitching, with counted threads and drawn stitch, were also suitable for embroidering with small beads, which was to become very successful for a short time in the second half of the 17th century. The grandeur of baroque style was perfectly matched by the opulent splendor of glass, while its taste for three dimensional decoration was ideally met by the texture of the beads. They were used on cushions, baskets, caskets, frames, altar frontals, and canopies. Flowers made of beads threaded onto metal wires made up compositions which jutted out of amphorae and glass vases. Writing about artificial flowers, then very popular, Francesco Griselini, in his *Dizionario delle Arti e de' mestieri* of 1768, also states that there was an industry in Vicenza making flowers out of wire and Venetian beads.

Top and sides of the 19th-century processional baldachin from the church of SS. Giovanni e Paolo were made out of Murano *conterie* (glass beads). Some round, some tubular, in a huge palette of colors, they have been threaded onto a thin copper wire and fixed onto strong gauze. The decorative motifs of this extraordinary artifact are scroll shapes filled with checkered patterns in perspective, frames of varied outlines, even ribbon-shaped, garlands of plants, great bunches of flowers. It is highly unusual and can be considered half mosaic, half embroidery.

Conterie and *perle a lume* were the only two branches of glassmaking which did not collapse after the fall of the Republic or suffer from foreign rule. In the period between Empire and Restoration, purses and handbags made of *margarite* became fashionable again; bunches of flowers and pictorial compositions were embroidered against a pastel background with extraordinary skill, such that they were likened to graceful mosaics by Renier Michiel; in fact, they look like the more common petit point works. Between 1822 and 1826, Giovanni Battista Franchini and his son managed to produce a

[202]

realistic imitation of coral and pink mother-of-pearl and from 1843 onwards they perfected the *millefiori*, while in those same years, Peruzzi obtained perfect reproductions of the human eye with enamels processed in the flame of oil lamps, which were widely used as prostheses.

Even spun glass, known as early as the 18th century and used to make "plumes," employed in futuristic applications in tapestry weaving and for wig making, was abandoned because of its fragility and consequent danger. In 1866 Giovanni Giacomuzzi invented a type of yellowish-gold bead which was to be widely applied in quilted embroidery. At the *Esposizione industriale* at Palazzo Ducale two years later, when "braiding made with our conterie was still used," being indispensable for fashionable female clothing, the maestro presented a sample book of fringes and braids which surpassed the French-made products.

The column coverings for the Madonna altar and the 14 festoons for a chapel in the church of S. Pietro Martire, the patron saint of glassmakers, in Murano, all date back to this period. In crimson velvet, they are embroidered and quilted with floss silk, in relief, with horizontal bands of carnations enclosed in garlanded drapery and surmounted by a Greek cross. Other altar frontals for the churches of the city (S. Trovaso and Redentore) were made with the same golden beads, as well as column covers and altar veils for the church of the Pietà, embroidery for garments and furnishings for the Jesurum company, and the magnificent curtain for the Teatro Comunale in Treviso. As a gift for the empress of France, Eugenia de Montijo on the occasion of her visit to Murano, Abbot Zanetti had an artistic

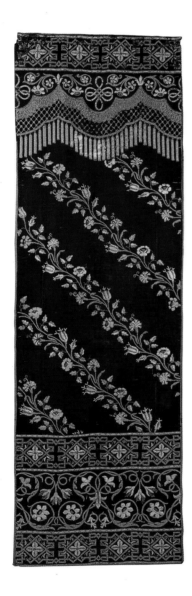

Column cover from the church of S. Pietro Martire. In crimson velvet and embroidered with golden-yellow beads in floral motifs with drapery, it was made, with others, in 1868 in Giovanni Giacomuzzi's workshop, on a commission from the parish priest, to cover the columns of the Virgin's altar.

We are indebted to Vincenzo Moretti for his splendid miniatures of flowers, (tulips, daisies, and tuberoses) which were used to make plates and cups. The perfection of detail and the vividness of color in a few millimeters' diameter are incredible. The early-20th-century paperweight, from a private collection, is not made of *murrine* but of glass rods.

The *redexelo* basket, containing a great variety of flowers, is skillfully encased in glass like a soap bubble.

guidebook of the island covered in velvet and quilted with little gold beads, which was so beautiful that it started a new fashion.

There was widespread use of *conterie* in this century, both in clothing for trimmings, fringes, buttons, purses, and dress panels and in furnishing for bell-pulls, cushions, footstools, pelmets, and fireguards, not only in Europe, but also around the Asiatic and the African shores of the Red Sea and in Abyssinia. Indeed, these peoples not only adopted them as ornaments to wear around their necks, in their ears, and on their clothing, but also to adorn their rooms and to cover the remains of the dead in their graves, according to ancient custom. Even Chinese Mandarins and Tartars wore buttons of Venetian glass paste on their garments and ornaments of *margarite* as symbols of status and office. It is affecting to think that Venetian beads adorned the footwear of native Americans, African headdresses, and even Inuit furs.

A more specialized branch of the industry, which had an extraordinary revival in the 19th century and was distinguished by a rather kitsch virtuosity, is that of *murrine*. This term refers to a glass rod, either hollow or solid, which contains a pattern which repeats itself constantly throughout its entire length and which is cut into identical portions. Each little disc, a few millimeters thick and wide can contain very varied patterns, from the simplest to the most kaleidoscopic geometric whole, as well as representations of flowers, animals, and people. Such glass miniatures, which were the product of a complex technical procedure, date back to the Alexandrian and Roman glasmaking industries of the 1st century BC.

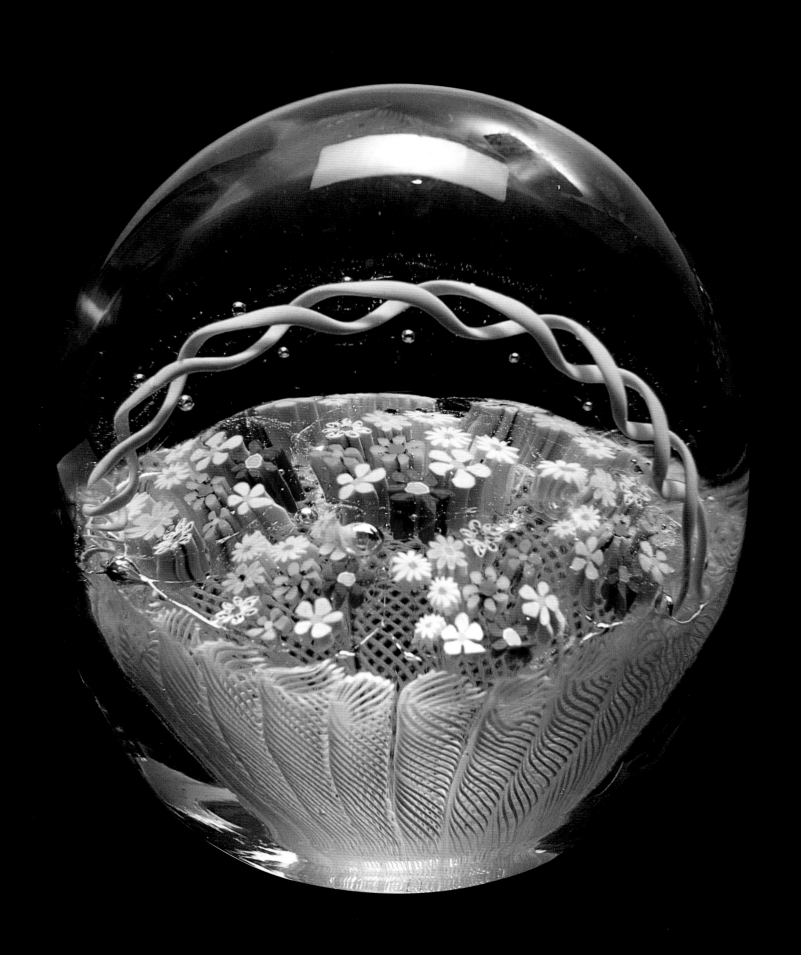

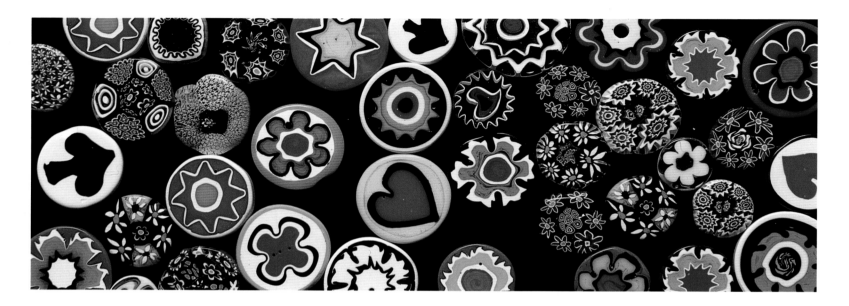

By putting together a certain number of colored glass rods of various sizes according to a specific decorative plan and fusing them together by firing, a single rod is obtained which can be reduced into many little slices. These are then made into beads and beautiful objects such as bowls, small plates, or vases, but also wall decorations. The invention of the blowing tube in the first half of the 1st century AD brought this laborious technique into decline, which only reappeared in Venice, but without much success, at the end of the 15th century. The *rosetta* bead (linked with the name of Marietta Barovier, Angelo's daughter) from this period is remarkable; made up of six superimposed layers, it is milky-white in the center and this is then followed by a blue indented circle, edged in white, followed by another red and white zigzag and a blue band.

The real rediscovery of *murrine* happened much later, from the first half of the 19th century onwards, thanks to Domenico Bussolin who invented the *canna millefiori* in 1836. In order to understand the technical complexity of the task it is

T hese modern examples of glass rod sections, all of them a few millimeters in diameter, show the variety of the motifs that can be obtained by arranging glass of different colors.
This same technique, but demanding even greater skill, is the basis of *murrina* making. Giacomo Franchini first applied the technique to making complex miniature panoramic views or miniature portraits of famous people such as the French emperor Napoleon III.

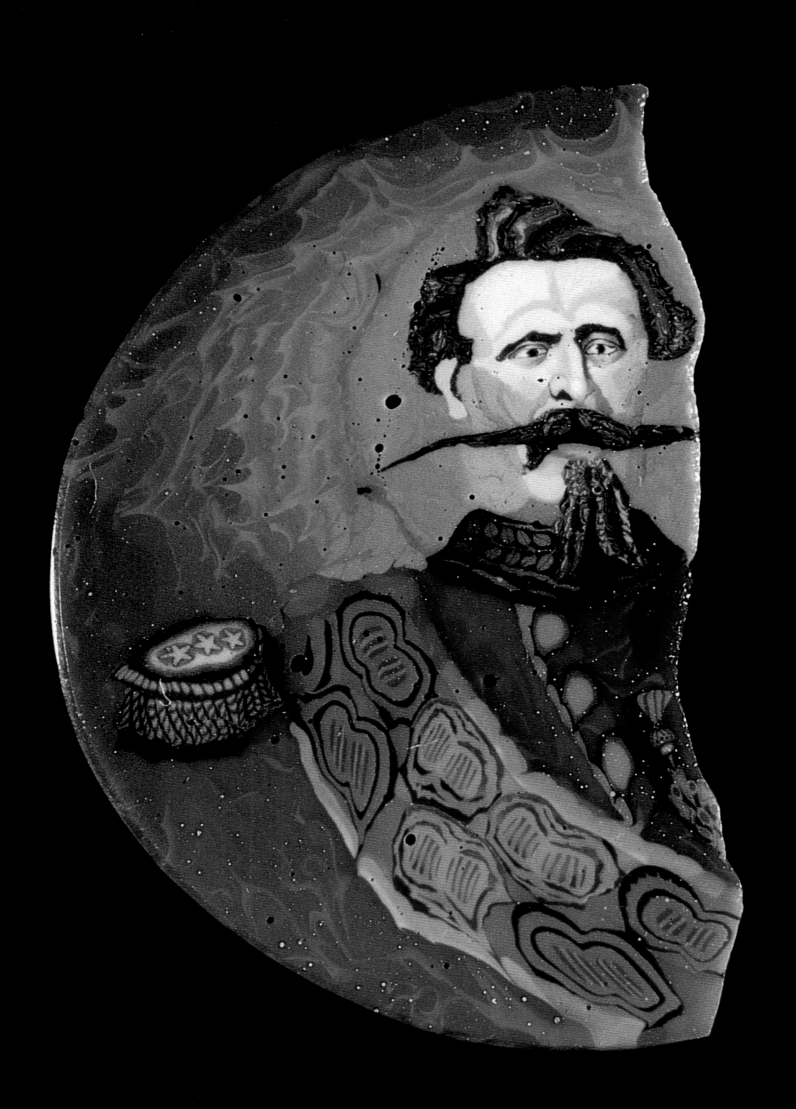

While *murrine* were obtained by putting together several glass rods, *rosetta* beads, created in the 16th century by Angelo Barovier, were made with a cylindrical rod with six layers. Through a process of abrasion, the beads took on their characteristic ovoid shape, which clearly shows the various layers at its ends.

The famous peacock *murrina*, considered the loveliest of those made between 1800 and 1900, was the work of Giuseppe Barovier. Inserted over a black background, the peacock shows variegated feathers which are shaded with a mellow subtlety rarely seen in images of similar artifacts.

enough to remember that to make a *murrina* with a very simple flower one must prepare the same number of glass rods as there will be petals in each section, a stalk section and others for leaves, then arrange them next to each other and solder them one by one. The interstices are then filled with glass of the same colors to form a cylinder which, stretched, is then reduced to a single rod of the required diameter.

It is necessary to work with hot, and therefore soft, glass which is kept at a constant temperature, with the risk of incorporating very visible air bubbles each time that smaller bubbles merge. When the pattern is complex, many rods are prepared which contain part of the design and are then fused around a central nucleus to which is added, whenever necessary, new glass taken directly from the kiln.

It was Giovanni Battista Franchini who created very delicate and complex *millefiori*, obtained thanks in part to new technologies such as Bussolin's gas burners, while his son Giacomo conceived writing using glass rods and portraits in miniature. Between 1843 and 1845 the former managed to make "rods of rods," in which it is difficult to distinguish the initial number of rods used. As regards the portraits made by Giacomo, Abbot Zanetti relates that it took four years of endless experiments to achieve that first portrait of a lady, dated 1845, contained in a *murrina* with a six millimeter diameter. This was followed by portraits of Pope Pius IX (1848), Garibaldi, Napoleon III, Victor Emanuel II (1860), and Franz Joseph, as well as many other historical personages and private persons. Giacomo also succeeded in producing a set of elaborate images,

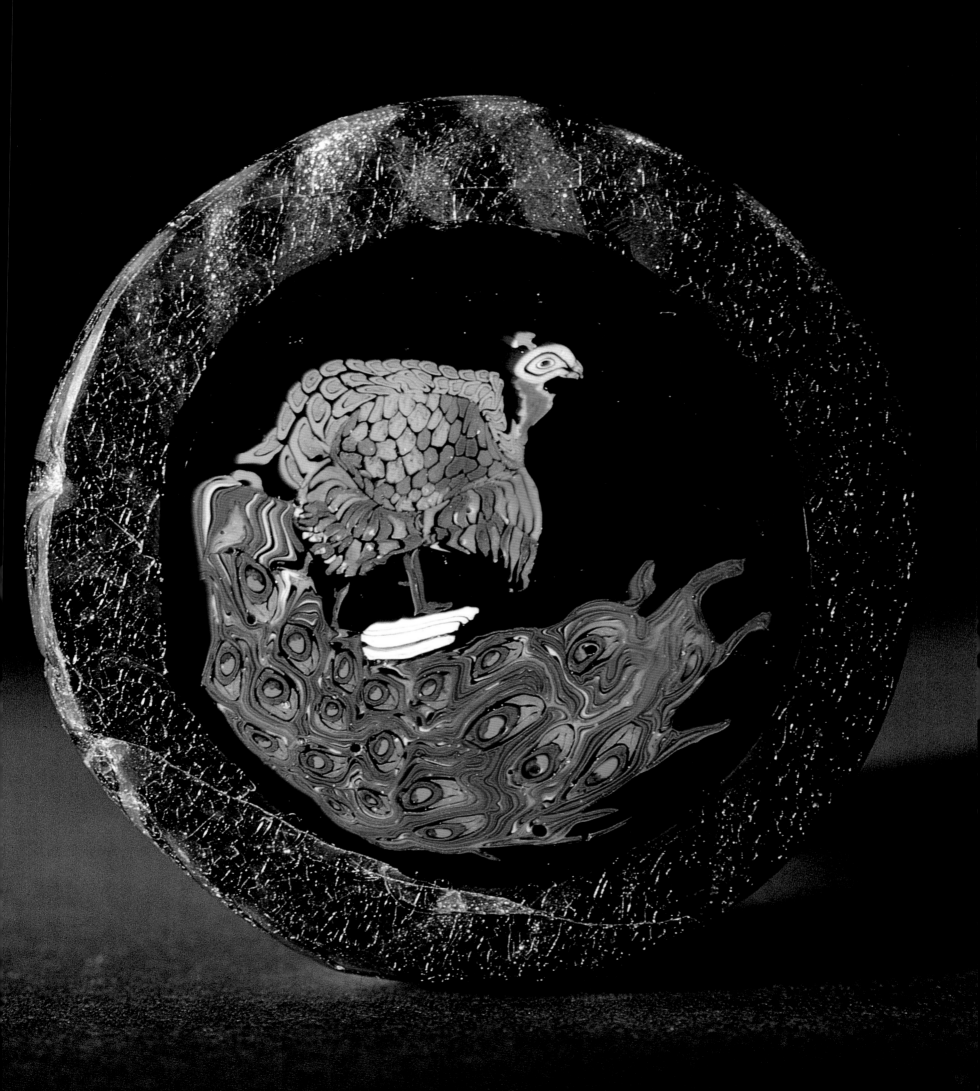

Agony in the garden, 13th century. Southern wall of the Basilica of S. Marco. The sharpness of the drawing, the brilliance of the colors on their gold background and its naturalistic flavor make this a masterpiece of Romanesque style leaning towards Gothic. Among the botanical species one can recognize small palms, banana trees, bushes with berries, and thistles.

Rialto Bridge, contained within a *murrina* of only seven millimeters' diameter, being of particular importance.

Between 1871 and 1878 Vincenzo Moretti reproduced *Roman murrine* in the Murano furnaces, thus starting production of objects which are still much in demand, while his son tried to pursue the work of portraits in miniature started by Franchini. With this technique, the Barovier family succeeded in making early-20th-century masterpieces, inspired by Art Nouveau, among which were *peacock murrine*, examples of artistic skill and sensitivity never since matched.

We shall conclude with some considerations of the art of mosaics, since these were mostly made from glass tiles. Indeed, mosaics bring Venice immediately to mind, even now that they remain almost exclusively an ornament for churches, foremost the Basilica of S. Marco, having disappeared from the facades of palazzos.

The term, which literally means "work of the muses," relates to *opus musivum*, that is the decoration of walls, and is distinct from *opus tesseratum* which relates to flooring. Indeed, the *musivarius* carried out mural work while the *tessellarius* was the person who made the floor decorations.

Mosaics became an art form in their own right in the early Christian era and reached perfection in the 6th to 7th centuries. Although there were a few glass workshops in Roman times, it is generally thought that glassmaking was introduced to Venice around the first millennium by Byzantine craftsmen, because of their need for vast quantities of multicolored glass tiles with which to decorate the churches around the lagoon and S. Marco. The *imaginarius* was in charge of

The small mosaic panel, about half a meter across, represents the bucolic scene of a shepherd among sheep and cows. It was made in the mid 16th century as an artist's proof in the Zuccato works, based on a cartoon by Jacopo Bassano, probably for the Basilica of S. Marco and is a rare example of a sample from outside the St. Mark's works.

creating the design and the *pictor parietarius* transferred it from the cartoon to the wall. The cutting of the tiles (these were one centimeter cubed) was also the responsibility of skilled workers, and was done with a little hammer and chisel and a special cutter which made their surface irregular, thus encouraging a varied refraction of light and unusual chromatic effects. The technique of positioning the tiles remained essentially unchanged through the centuries: two layers of plaster between one and four centimeters thick were spread on the surface of the wall, the first with coarser texture and the second smoother, both of them made of pozzolana, slaked lime, marble dust, and straw. The design was transferred onto both layers from a pricked cartoon with the technique of "*spolvero*," but on the second layer it was completed by a drawing in yellow, black, and light brown called *sinopia* after the colored earth used which was imported from Sinope, a city on the Red Sea. A very thin base was then applied, frescoed in full color, into which the tiles were then inserted. This procedure, called *a diritto* (right way up) was substituted in the 19th century by the *a rovescio* technique which is still used today, and consists in painting a mirror image of the subject of the mosaic on the cartoon and then sticking the tiles on it upside down. A scratched wooden support, brushed with glue, is then prepared, with a double thickness of lime, cement, and sand. The mosaic is applied, pressed and moistened over the uppermost layer which has been applied using water, even on the tiles which have previously been covered in sand to keep the gaps intact. Once the cartoon has been removed and the mosaic cleaned, the design appears, the right way up, in all its glory.

The side table in dark wood, with slim turned legs, has a rectangular mosaic surface. This artifact, made in the 19th century, is characterized on the outside by a decoration comprising a series of small frames, adorned with chain, cross, and notch motifs separated by a black line against a yellow background; on the inside there are two wide bands with colorful truncated pyramid motifs which show an exaggerated perspective.

Since there has never been the continuity of a "school" of mosaic making, there have been consequent temporary losses of knowledge of practical procedures, and the art suffered various crises such as one in the 15th century when, following the loss of status of mosaic workers compared with painters, the artistic part of the process was dissociated from the actual manufacture of the work. In the 16th century the art, dismissed almost everywhere else, remained alive in Venice for the basic requirements of maintaining and completing the Basilica of S. Marco. The mosaic workers of S. Marco could count on cartoons by the greatest Venetian masters, from Mantegna to Tintoretto, but there were also artists of very great value and prestige among their own number. Worthy of note are Silvestro and Antonio, who in 1458 put their name to the four saints in the transept, and the workshops of De Zorzi, Barbetta, Rizzo, Bianchini, Sebastiani, Crisogono, and the Zuccatos. The latter family, especially Valerio and Arminio and their best pupil Lorenzo de Battista, translated paintings by Titian, Tintoretto, and Palma the Younger into mosaic. For his part, Bartolomeo Bozza used works by Salviati, Veronese, and Tintoretto, and this latter artist also provided models for Domenico Bianchini. Giacomo Pasterini, who worked on cartoons by Padovanino, is considered the last great mosaic artist of the Venetian school. The decline which followed was compounded by 19th-century industrialization, promoted by Antonio Salviati who, from 1859, had improved the paper method according to which the mosaic

A masterpiece of virtuosity, the micro-mosaic was an attempt, in the 18th and 19th centuries, to counteract the decline of mosaic-making. It was particularly appreciated by elite tourists and mainly adorned small objects such as the 18th-century gilt bronze brooch which depicts a parrot perched on a broken tree-trunk, intent on pecking a colorful flower. Other examples are the late-18th-century brooch with diamonds, which depicts a small city square, and the late-19th-century portrait frame, finely decorated with colorful flowers and the usual lion of S. Marco.

was made in the workshop and then transported and fixed anywhere. In this way it was possible to export mosaics, as for example those for the altar frontals in Westminster Cathedral in 1867, those for the Palatine chapel in Aachen, between 1870 and 1875 and then the Orsoni pieces for the Basilica of the Madonna in Lourdes.

The so-called *micromosaico*, that is the manufacture of objects with miniature decorations, obtained with minute glass tiles of various shapes, deserves special mention. This form of craftsmanship, born in Naples in the 18th century after the archaeological discoveries at the feet of Vesuvius, spread to Rome where it became extremely fashionable, and finally reached Venice, where it was not quite so popular. It was especially used to make less important jewelry, brooches, pendants, rings, earrings, inserts for bracelets and necklaces, buttons, thimbles, and snuff-boxes. The favored motifs are those beloved by the neoclassical style with views of archaeological ruins, Arcadian landscapes, and architectural follies, but also natural subjects like flowers, animals, and small figures. Venetians preferred views of the lagoon, city monuments, exotic multicolored birds, and especially the lion of St. Mark. During the 19th century they gradually began to take on the more modest role of souvenirs and the range of articles increased, from inkwells to pill-boxes, from mirrors to a whole series of frames, in varied shapes and sizes.

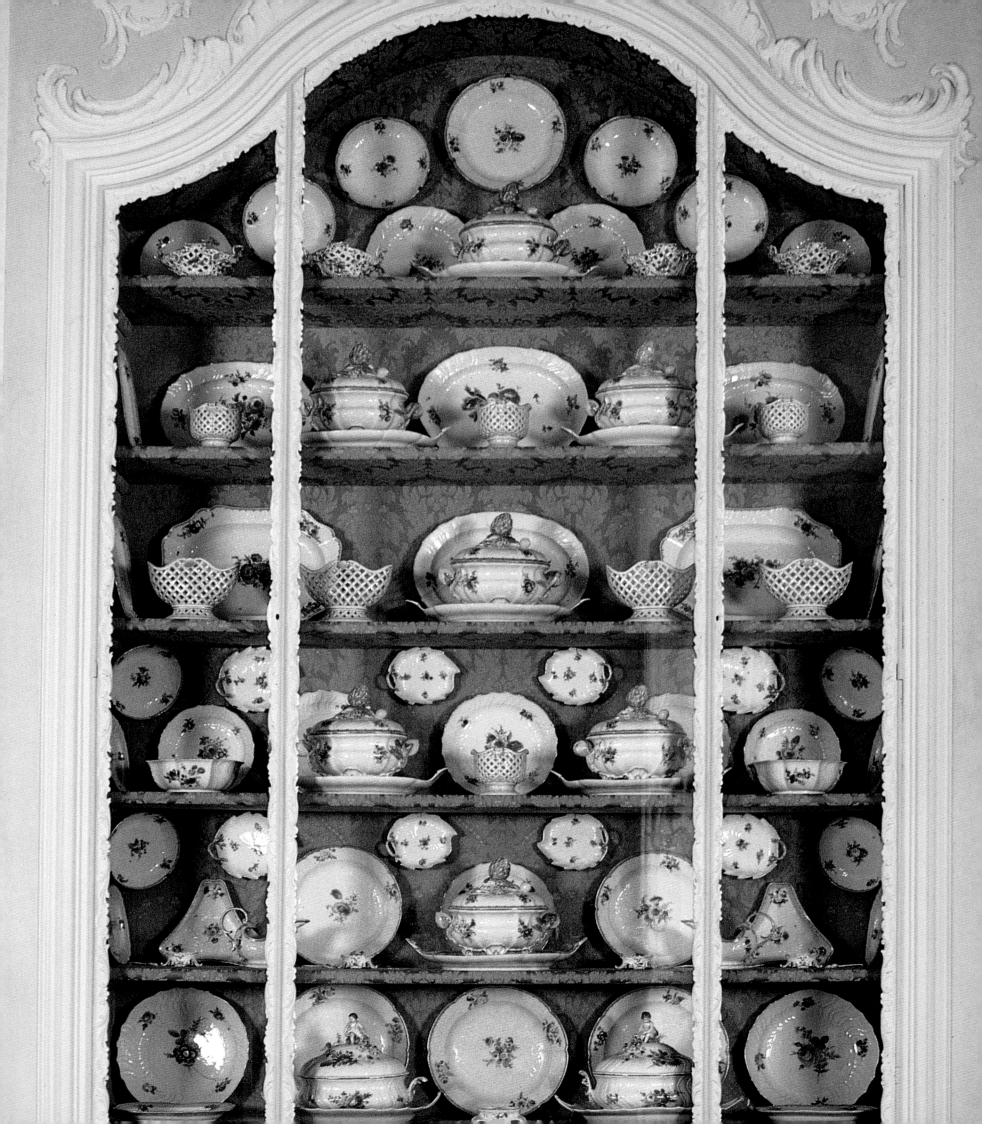

Ceramics

The term "ceramics" defines a range of wares obtained with a mixture of clay and water, shaped by hand, dried, and then fired. They differ from each other in terms of the level of purity of materials used, the type of covering and the method of firing, including therefore both simple porous terracotta as well as majolica (which takes its name from the island of Maioreca or Majorca) covered with colored or transparent glazes, and also porcelain, made of a nonporous body which is itself glossy.

This work originally belonged to the Guild of *fornaseri* (artisans who worked with ovens), with a capitulary of 1231, from which the *colonelli* of *scudeleri* (bowl makers), *bocaleri* (jug makers), and *pignateri* broke off in 1301. St. Michael was the patron saint of them all, and they shared the altar of the church of S. Maria Gloriosa dei Frari. The master in these crafts could only have one apprentice, paying him simply *ad panem et vinum*, that is with food alone, but after 1304 he was allowed to take on up to four workers.

Set in the wall and decorated with stuccoes, the cupboard of this private Venetian residence still holds a precious service in porcelain from the second half of the 18th century, manufactured by the Cozzi factory. The service is decorated with polychrome enamels with plant and flower reliefs, and includes tureens, large serving dishes, trays, sauce boats, plates of various sizes, and a series of baskets with pierced decorations, with scalloped rim. They are 12 centimeters high, and are used for holding bread, biscuits, and sweetmeats.

This soup tureen, with cover and stand, is part of the service shown on the preceding pages. It is decorated with polychrome enamels with flowers and artichokes in relief. On the base, a little red anchor is the mark of Geminiano Cozzi's factory.

Also from Cozzi's factory, but with motifs and colors typical of Francesco Vezzi's production, is this porcelain tureen cover from the end of the 18th century (opposite). It is bordered in blue and gilt like the flower sprays which decorate it, and its finial has a three-dimensional depiction of a posy of polychrome enameled roses, poppies, convolvulus, and lily of the valley, rendered with great naturalism.

In the beginning, terracotta was used to decorate architecture with molded elements like ovolos, dentils, and fusaroles. Originally, these were put in place to decorate archivolts in Romano–Byzantine buildings, and later also those in Gothic churches. Plain terracotta was used to decorate surrounding walls and the upper storys of palaces. From the 13th century it was covered with greenish glazes containing copper and lead. It seems that a considerable number of potteries were concentrated in the area round the Campiello degli Squelini, near S. Barbara, defined by Sabellico as *figulorum area*, that is the zone of the potters. The 15th century sees the beginning of the Hispano–Moresque influence in the technique of glazing and in the enriching of decorative motifs with geometric or anthropomorphic designs and graffiti later colored with manganese. Unfortunately, nothing remains of the majolica floor which the Giustinian family had laid about 1450 in the sacristy of the church of S. Elena, which was destroyed in the Napoleonic era. A heraldic device of a blue eagle upon a white ground formed the decoration.

Toward the end of the 15th century a new type of pottery, still *sgraffito*, became widespread. It had oriental inspired designs in three or four colors on a background with polychrome patches or with arabesques painted in deep blue on a background of *ingobbio* (slip)—a solution of white earth from Vicenza—imitating Chinese or Islamic porcelain. From the same period

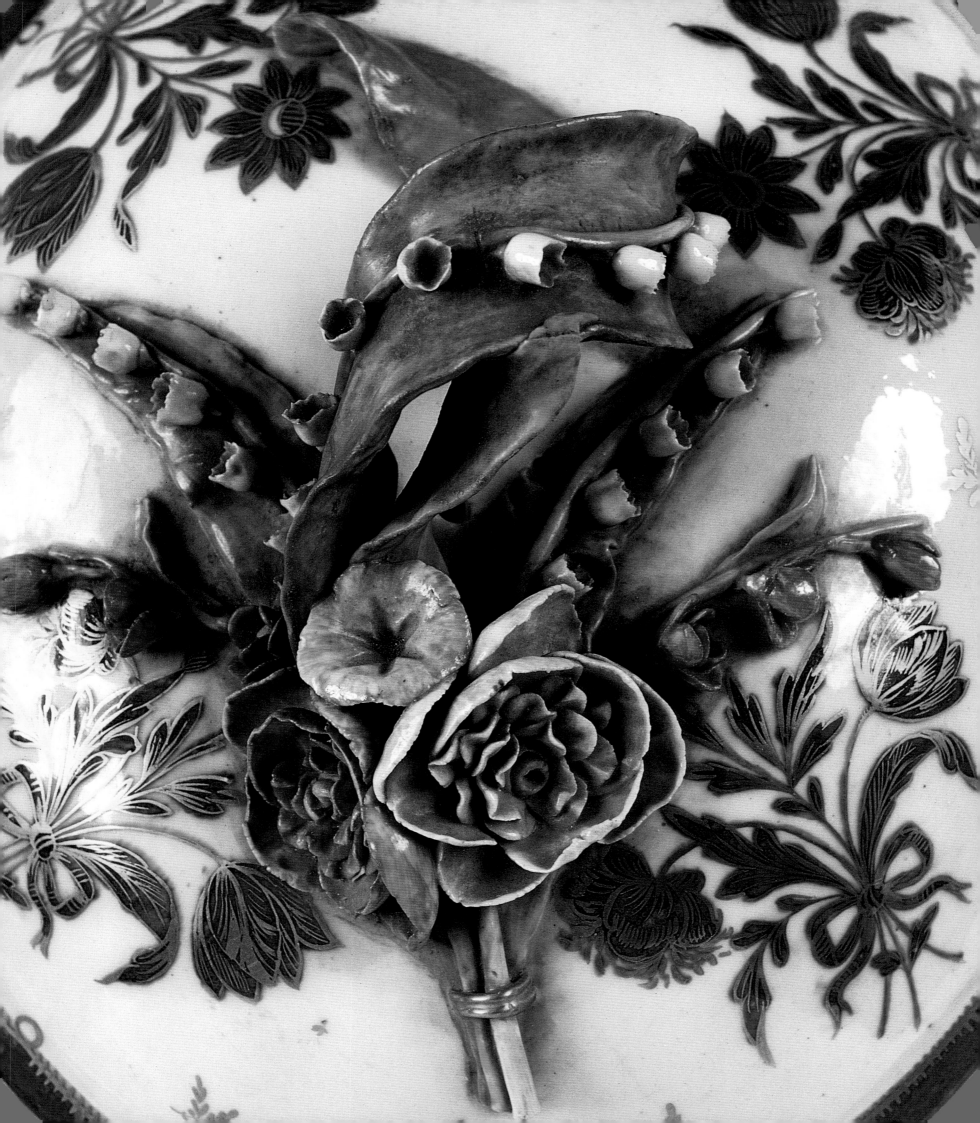

come those artistic graffiti which depict busts (especially of women) taken in profile, or architecture or landscape.

At the beginning of the 16th century the new technique of majolica came to be used. The terracotta body was covered with a thick glaze containing a great quantity of tin, called stanniferous enamel. Wares were produced with a compact, white and sturdy surface which could afterward be covered (or not) with an iridescent glaze. From this period dates the tile floor of the capella Lando in the church of S. Sebastiano, which is decorated with polychrome plant and animal motifs with a uniform bluish luster, derived from *berettino* enamel, which is typical of Venetian production.

Cipriano Piccolpasso's *I tre libri dell'arte del vasaio*, published in 1548, includes a chapter dedicated to "colors in the Venetian style." This confirms that Venetians used a different recipe for the preparation of *marzacotto* (the final glaze, made up of fine white sand, salt, and wine lees, substituted in Venice by Levant ash). It also reveals that characteristic colors were *zallolino*, a light, brilliant golden yellow, and *berettino*, a grayish blue. There were numerous important commissions by famous personalities of the day, demonstrating that these wares had a certain original character. For example, in 1518 Isabella Gonzaga, duchess of Mantua, ordered several *piedenelle de preta*, that is, plates of Venetian or Faenzan pottery, while in 1520 Alfonso I, the duke of Ferrara, charged Titian with having a certain quantity of earthenware vases made in Venice, destined for the ducal pharmacy.

These two porcelain spoons are pierced like strainers. They are about 26 centimeters long and decorated in polychrome enamel with little floral motifs. They bear no mark, but are nevertheless attributable to Venetian manufacture, and may be dated to the last quarter of the 18th century.

In the first half of the 16th century artists from Pesaro, Urbino, and Faenza were active in the city. The latter were favored by the brief annexation of Romagna to Venice, which undoubtedly influenced local craftsmen. Among them we should note Domenico Da Venezia, a *bocaler* or *depentor* who had a very personal style, free from outside influences. He had a workshop, as we read on the back of his wares, "on the stonemason's bridge on the way to S. Polo." Coloristic effects dominate the design of his creations, which are datable to the second half of the 16th century. Cobalt tones, which lend themselves so well to a monochrome palette, are substituted by intense ochers, soft yellow, and gradations of green.

The 17th century was to be a time of experimentation in porcelain, and not just in Venice. Porcelain's milky whiteness was imitated by majolica itself. Production was repetitive, continuing to present antique devices, historical subjects, and *candiane*, from the place near Padua, characterized by a thick paste and oriental decorations. The technical secrets of the amalgam of porcelain and hard-paste were established in Dresden in 1709–10 by the German alchemist Bottger. In fact, the existence of this material, discovered by the Chinese during the Tang dynasty

[225]

A pair of molded mirrors, 18th century. Private collection. They are in ceramic, and from the Bassana del Grappo factory of the Antonibon. The mirror is engraved with a character dressed in the fashions of the very early 18th century. The frame is decorated with gilt foliage and polychrome enameled flowers, culminating in a palmette pediment. The two sconces, in gilt wrought iron, are a later addition.

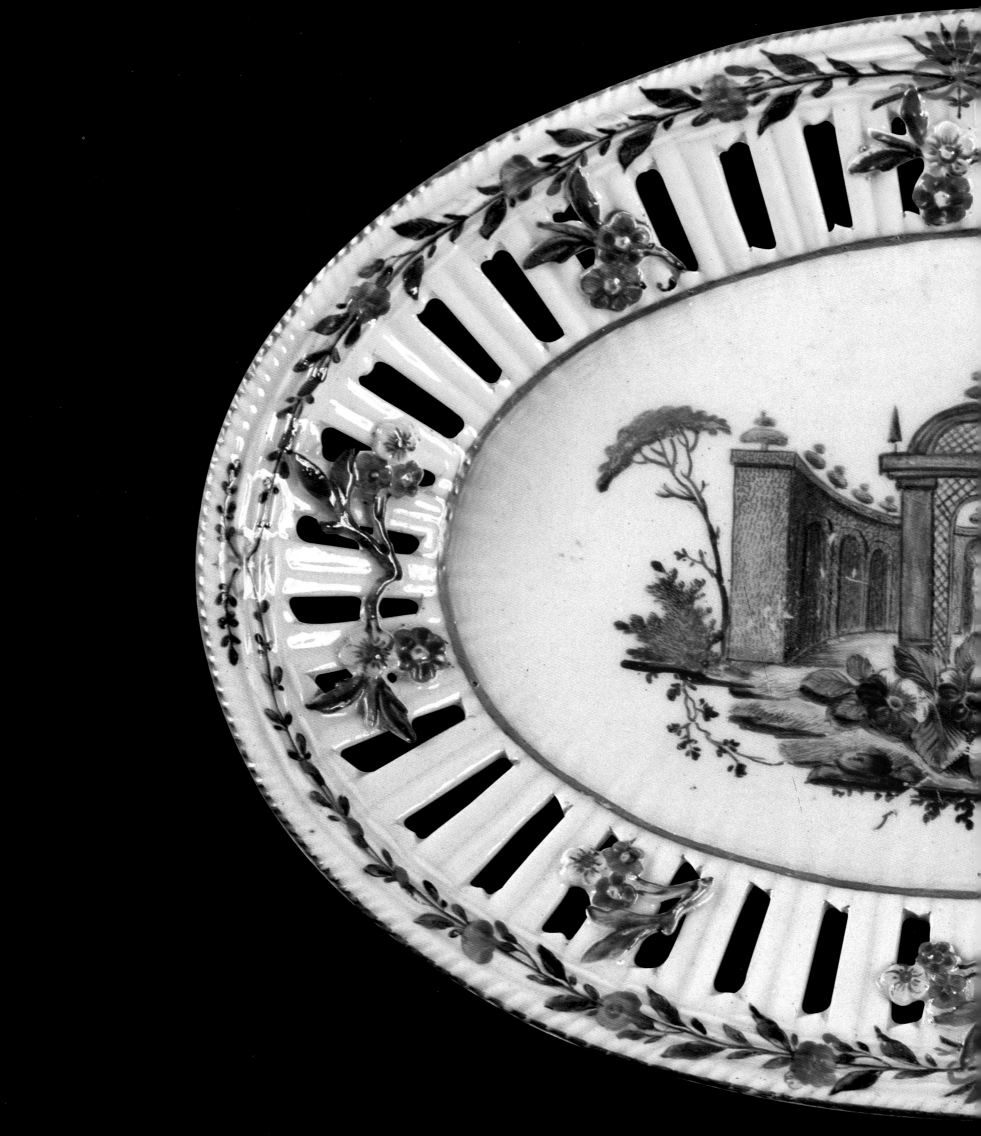

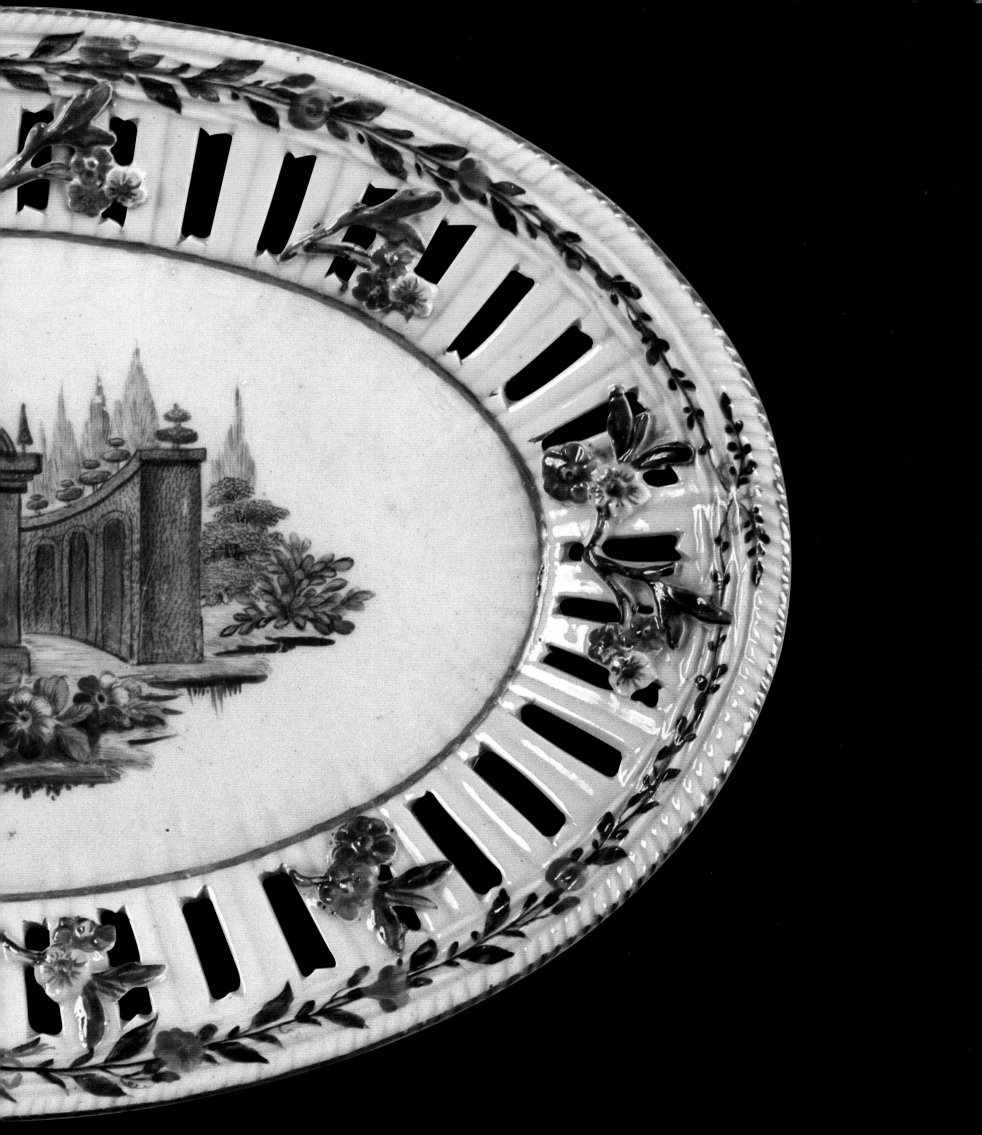

The small porcelain serving dish of the preceding pages has as its decorative motif slender flower sprays which surround a box topiary pavilion with portico and arched doorway, and a posy of purple primroses.

Oriental subjects in iron red decorate this earthenware fireplace tile. Both are datable to the middle of the 18th century and are from the Cozzi factory.

The porcelain vase with handles, however, is marked "Venia" and therefore made by Francesco Vezzi. It dates from the beginning of the 18th century and is now in the collection of the Fondazione Querini Stampalia. The low relief decoration of the sides is of various leaf forms. The central section bears a goldfinch surrounded by flowers in polychrome enamel.

(AD 616–907) had already been attested by Marco Polo, to whom we owe the lemma, a synonym of mother-of-pearl, which sets it apart. Porcelain is a white, hard, light, translucent, compact, sonorous substance, resistant to acids and heat. It is derived from kaolin, feldspar, and quartz, fired at extremely high temperatures.

Purchases of local porcelain are recorded from the beginning of the 16th century. In 1518 Leonardo Peringer, who was also a mirror maker, asked the *Proveditori de Comun* (the officials who looked after public goods) for the exclusive right to produce a formula he had invented, perhaps soft-paste, similar to the Persian type.

In 1720 hard-paste porcelain did, however, arrive in Venice, thanks to a German decorator familiar with the technique. This same year Francesco Vezzi opened his factory on the Giudecca. The workshop, which moved in 1724 to the building known now as the *casin degli spiriti* in Canareggio, closed in 1727, because of the difficulty of obtaining primary materials—kaolin was contraband from Saxony—and because of the high cost of slag . When it closed, it had 30 000 pieces in its warehouses, ready to be fired—cups, plates, vases, and tea, coffee, and chocolate sets, marked "Venia," "Via," or "Venezia," with animal decorations, mythological scenes, arms, and Chinoiseries.

Among the most important of these items are the great vase, again with plant reliefs, in the Fondazione Querini Stampale in Venice and the cup in the Museo Civico di

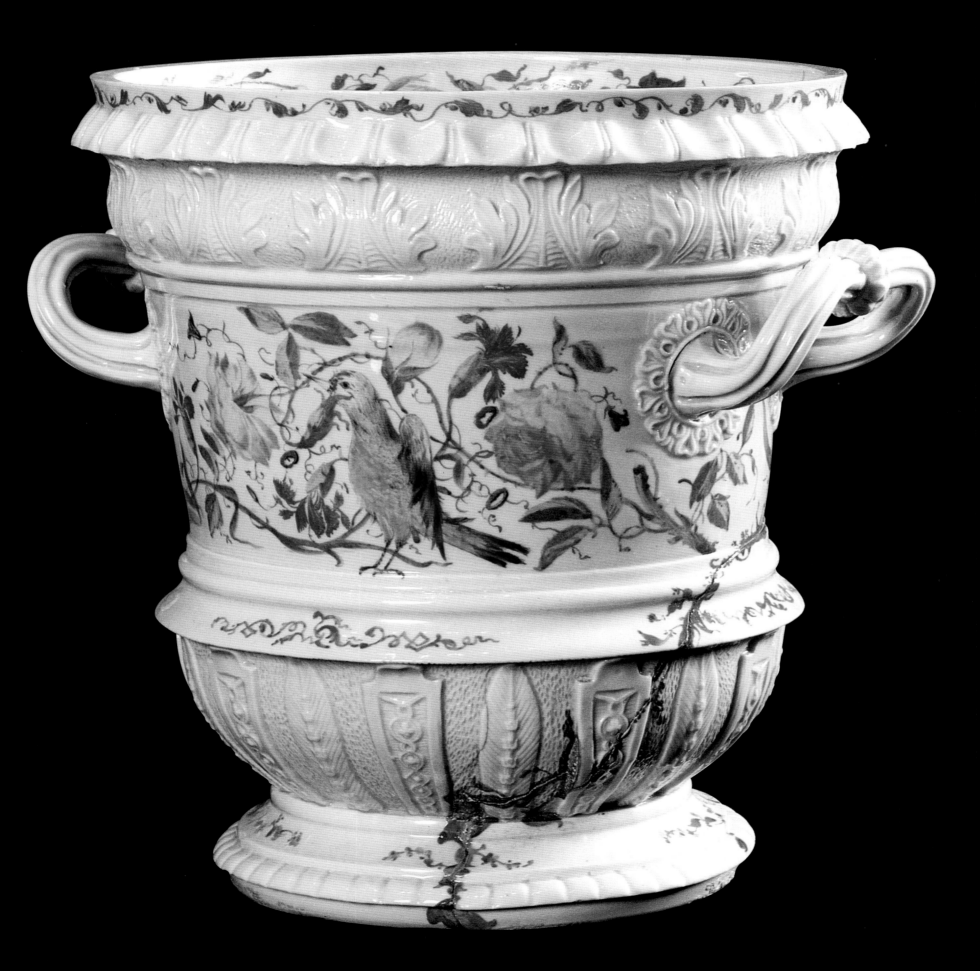

Feltre with bas reliefs and polychrome floral motifs. From 1761 to 1763 the Hewelckes also made porcelain in the city. They were natives of Saxony, perhaps from Meissen. From 1764 Geminiano Cozzi, from Modena, became prominent. He produced both high quality porcelain and more modest objects for everyday use, utilizing kaolin from the Schio quarries. From 1769 he manufactured majolica, too, and from 1782 the simplest earthenware. His mark was a red or gold anchor. From his eleven small furnaces, or "muffle kilns," of which three were for majolica, "came forth table services, in which under the purest glaze, the colors gracefully accompany the reliefs and the most elegant of designs weave in and out." Soup tureens, salad bowls, plates painted with little flowers and pale roses graced tables, together with little groups of white and polychrome decorated porcelain *amorini* and Arcadian shepherdesses. Cozzi also produced services with classico-mythological, bucolic, or galant themes, often in red haematite; among the pieces he produced there are 70 types of centerpiece, including ladies and gallants, Chinamen and blackamoors, maskers and peasants, and grotesque figures, sometimes in ridiculous or even erotic poses. The range of his output is enormous, including mirrors, fancy trays, candlesticks, clock stands, inkstands, perfume bottles, cane handles, snuffboxes and buttons.

Finally, we must not forget the manufacture of tiles for hearths, decorated "in the Raphaelesque style"—that is, with grotesques—in *trofei* or imitation marble. Despite the death of Geminiano in 1797 and that of his brother Vincenzo in 1799, the workshop carried on until 1812.

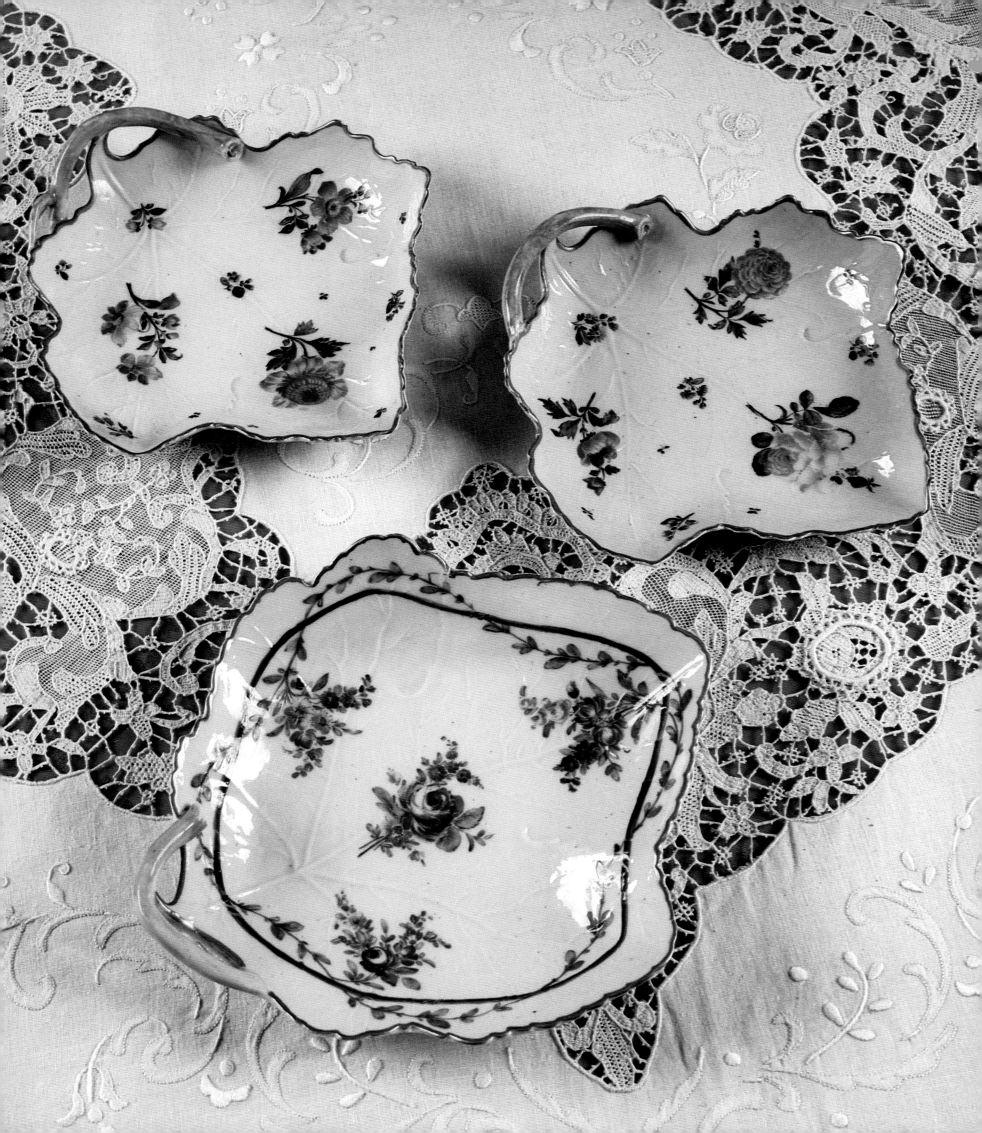

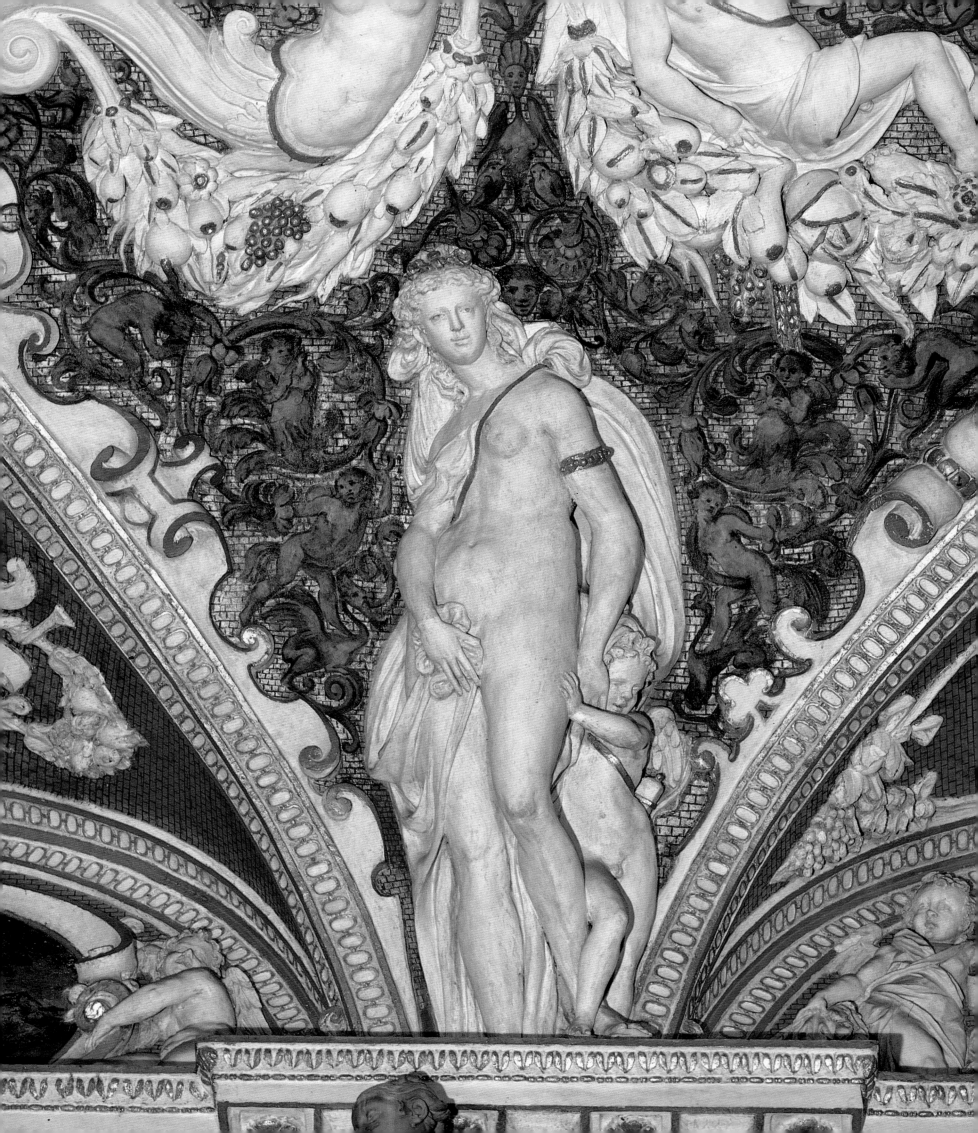

Stucco

In Venice there are stuccoes everywhere: from the most sumptuous showy residence to the most intimate domestic environment, and yet the Guild of *stucadori* was never included in any school. The reason for this was that it was difficult to limit it to just one sector, given that it played "second lead" sometimes to the major arts like architecture, sculpture, and painting, and at other times to the minor arts in the building trade, for example that of the stonemason.

A stucco worker produces *marmorino* plaster, creates architectural frames and overhangs, paints frescoes on marble and plaster, and decorates walls and ceilings with plant, animal, and human motifs in low, medium, and high relief. However, Tommaso Garzoni in his *Piazza universale de tutte le professioni del mondo* numbers stucco workers among "sculptors and cutters in stone, wood, copper, or ivory" or in any other material, including wax. He writes that the different ways of working stucco, laid out by Vannuccio in the eighth book of the *Pirotecnia* consist in mixing flour and chalk with wax, white lead, tallow, rubber, pitch, size, soap, sulfur, bricks, or other such things.

Sala delle quattro porte in the Doge's Palace, also known as the "sala degli stucchi" because of its superb decorations in white gilded stucco which cover the vaulted ceiling and frame the painted and frescoed images. It was built in 1574 by Antonio Da Ponte on plans by Andrea Palladio and Antonio Rusconi, and decorated by Giovanni Battista Cambi, known as il Bombarda. Allegorical figures in high relief alternate with jutting ogival niches from which plumed branches, garlands, floral wreaths, and putti emerge.

[233]

The rediscovery of the art of modeling in Venice can be traced to Giovanni da Udine, who worked in Palazzo Grimani in about 1540. He was an original artist who also dedicated himself to the art of embroidery, which his descendants also practiced "with such skill that their house was no longer called de' Nani, but of the Embroiders." His father, Francesco, brought him to Venice "to learn the art of drawing with Giorgione da Castelfranco," as Vasari tells us. He was then Raphael's pupil and helper in Rome. He visited the Domus Aurea with him, as well as the other archaeological sites which came to light in that period. He was struck by the stucco decorations of those underground rooms (called "grotesque" precisely because they had been discovered in environments similar to grottoes) and tried to copy them using "slaked lime and pozzuolana." After repeated unsuccessful attempts, he discovered how to create "real antique stucco" by crushing chips of the whitest marble he could find, reducing them to dust, and mixing them with slaked lime of the whitest travertine.

In fact, stucco is a paste of baked chalk and water to which can be added other substances like lime, casein, marble flour, pozzuolana, and sand. The resulting mush, which is easily modeled, solidifies very quickly, becoming harder than marble. It is therefore essential that the decorations be created quickly: improvizations may be called for, but there is no room for second thoughts. It is nevertheless possible, unlike when sculpting in stone or wood, to replace material that was removed in error, or to rework an unsuccessful detail. Stucco also lends itself to

The Scala d'Oro in the Doge's Palace is so called for the magnificence of its decorations. They are in a classical style, with white gilded stucco, and are the work of Antonio Scarpagnino from the middle of the 16th century. It was the staircase of honor by which one gained access to the dogal apartments, and has a ceiling covered with large panels in stucco by Alessandro Vittoria, which frame frescoes by Battista Franco. Putti in defensive poses hold open the central scroll with heraldic arms, dominated by a dogal horn which refers to Doge Priuli under whom the stairway was finished in 1559.

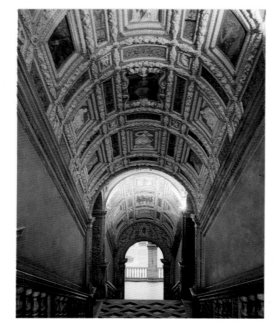

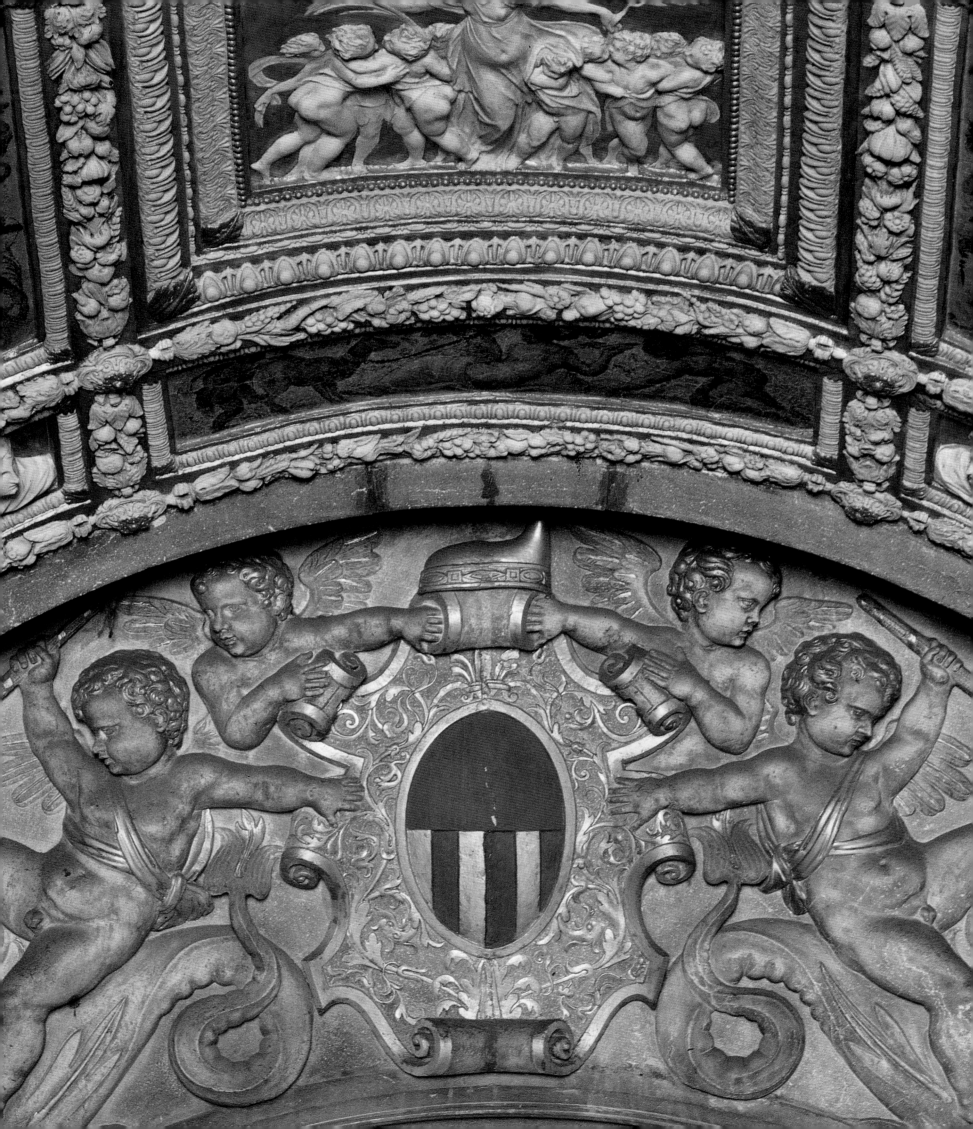

The great crowning part of the marble doorway of a noble Venetian palace has on the archivolt a putto holding up a balustered cornice, on which corbels and kneeling putti alternate; the putti hold dolphins by the tail. In the lower part of the doorway, on pillars which barely protrude, pilaster strips are linked by garlands of fruit and flowers which emerge from the jaws of anthropomorphic mascherons of great technical quality. This carefully considered insertion of stucco decorations in a marble context suggests that the doorway dates from either the end of the 16th century or the first half of the 17th.

Following pages

In Ca' Zenobio, on the modeled centering camber of the great mirror, which is contained within a mixtilinear frame and surrounded by flower shoots, putti appear. They hold floral festoons mixed up with flowers, which emerge from a shell-shaped cymatium with an allegorical woman's head in the center. This rich decoration, embellished by its proximity to the frescoes, may be dated to the first half of the 18th century. In the same room, on the sinuous, protruding tympanum of the transom, gilded relief medallions showing mythological scenes are framed by long fringed branches, garlands of fruit and flowers, putti lying on drapes and a shell pediment.

reproduction with molds using models prepared earlier in the workshop. Stucco was widely available, materials were cheap, and it was simple to prepare; it was therefore used in a great variety of ways, from simple *graffito* coverings of walls, to the decoration of specific architectural structures such as moldings, cornices, friezes, pediments, jambs, transoms, festoons, niches, and medallions, with bas-relief compositions in full round. Anything could be depicted, from clouds to flames, from drapes to flourishes, without placing any limit on the imagination.

Extraordinary creations are documented in the Sala delle quattro porte in the Doge's Palace. It is better known as the "Sala degli stucchi;" on it worked architects like Palladio and Sansovino, painters like Titian and Tintoretto and stucco workers like Giovanni Battista Cambi, known as il Bombarda. Alessandro Vittoria, the sculptor and medallist, obtained similar results. He was a pupil of Sansovino and noted for his soft pictorial plasticism in the decorations of the villa Barbaro in Maser (designed by Palladio and frescoed by Veronese), in the dogal

Scala d'Oro and the stairway of the Sansovinian library. These are stuccoes in the Roman style, white and gold, refined and sumptuous. Nevertheless, the harshness of critics with regard to the plastic works of Vittoria is perhaps due to his work in stucco and the widespread opinion that stucco, insofar as it is an applied art, is classified therefore as one of the "minor arts," not worthy

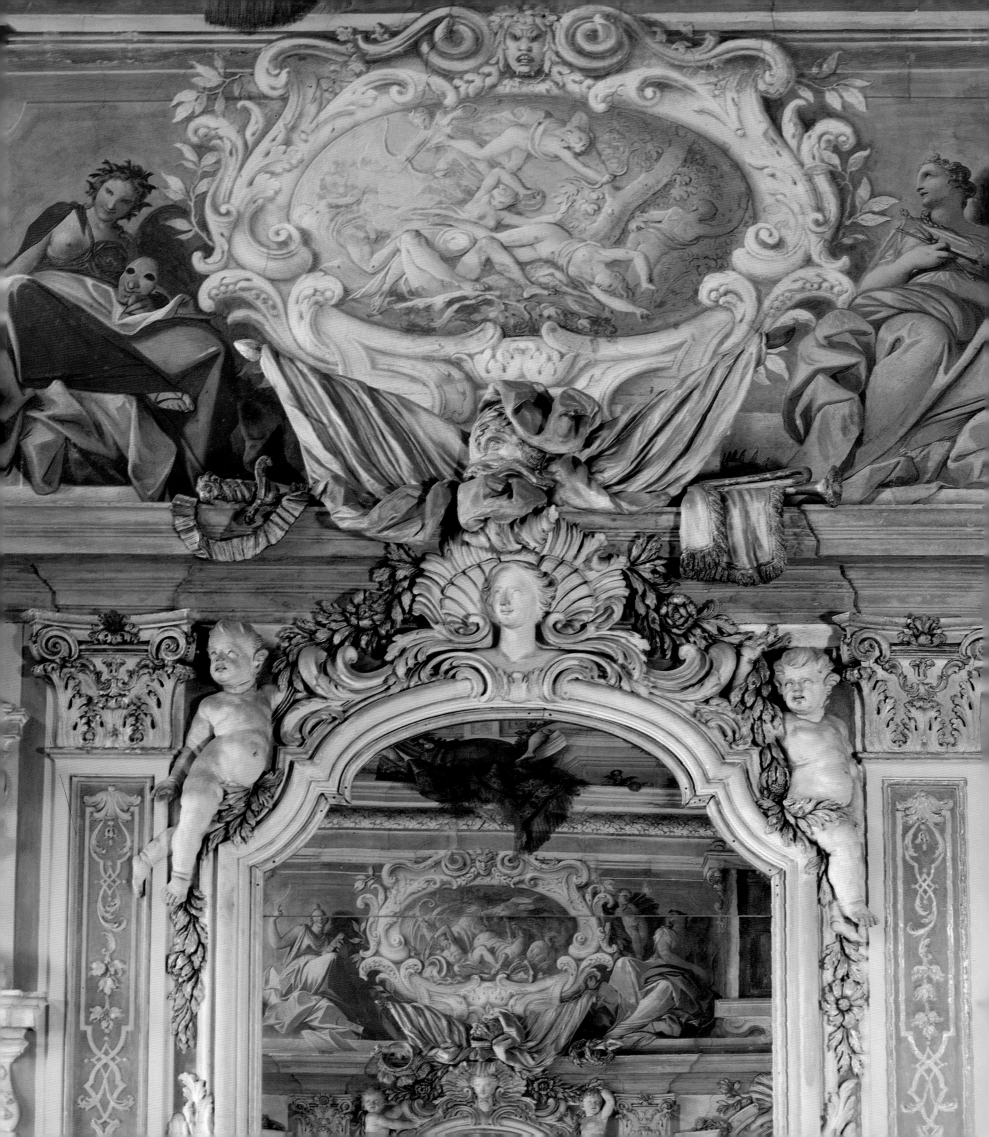

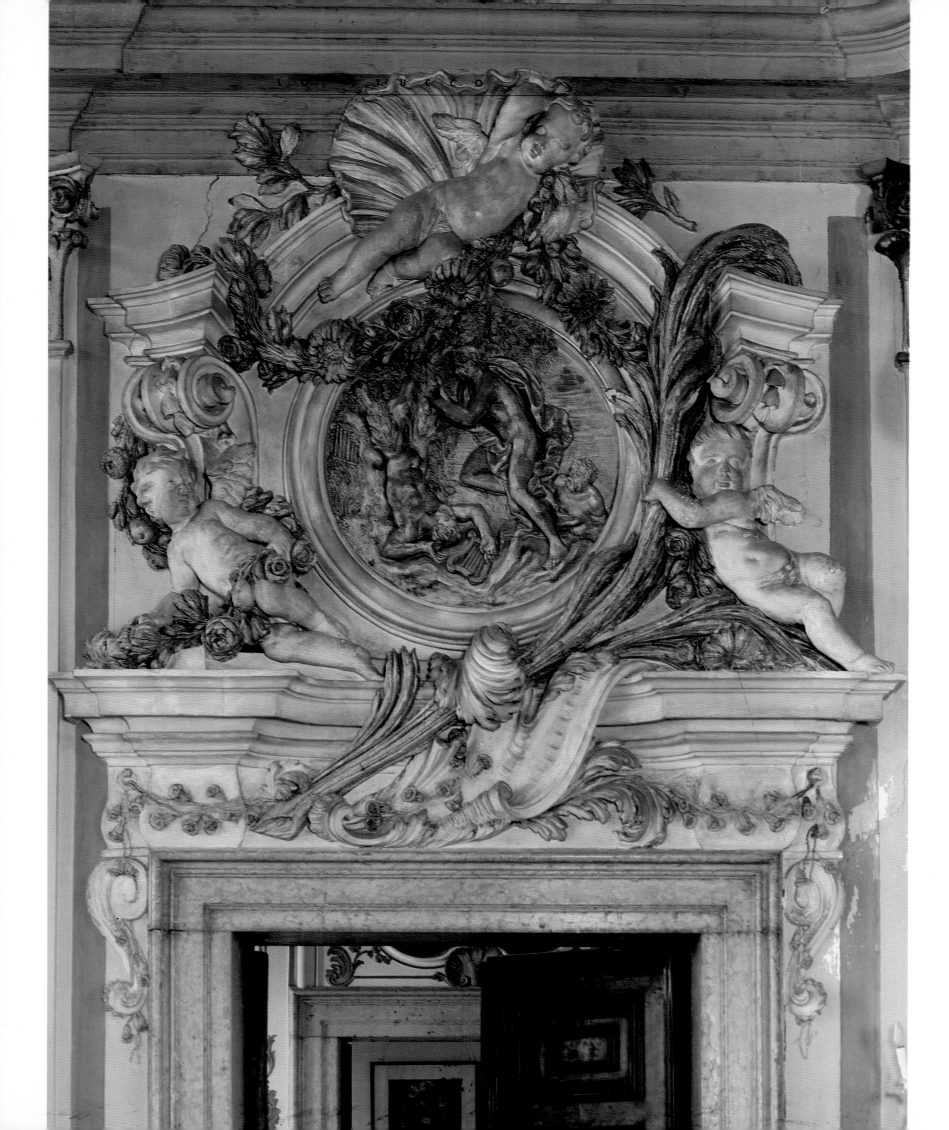

At the base of a great handled amphora or in the corners of mixtilinear cornices, gracious little animals stand on a background in delicate pastel tones. The depiction of the varieties of animals, rendered with lively naturalism, does not take account of their real dimensions, so a piglet ends up the same size as a turtle. They are very beautiful and original, and date from the middle of the 18th century. In the bedroom of the same palace (following pages) we see stuccoes from the middle of the 18th century by Carpoforo Mazzetti, known as il Tencalla. They are characterized by their rococo style, on delicately colored backgrounds. The two putti who hold up the Barbarigo arms are, however, Baroque. The arms are framed by a fanciful crowned scroll, from which cascades of flowers seem to tumble among fluttering drapes.

of great attention. In palace interiors, however, the work of the architect, assisted by painters and sculptors, was almost always finished off by that of upholsterers and stucco workers, who endeavored to perfect the scenographic effect. Caissons, panels, and lacunars on the ceiling were embellished with curls, turbans, and scrolls; cornices, jambs, and transoms adorned with a profusion of indentations, festoons, and volutes. Stucco was malleable, ready for the capricious inventions of the craftsman and abundant ornamentation. On the walls luxurious leaves and flowers framed gilded leathers, tapestries, damasks, portraits, and mirrors.

The baroque spirit is masterfully evoked in Palazzo Abrizzi, in the square saloon with a ceiling transformed into a bizarre draped baldachin, held up by a multitude of gracious putti or, for example, in S. Maria del Giglio, in the Cappella del Battistero, where Domenico Paternò, from Messina, and Stazio Abbondio, from Ticino, worked together. The latter settled in Venice after studying in Rome. Among his most important plastic works is the above-mentioned internal

covering of the walls of the church of S. Maria dei Gesuiti, in imitation of silk tapestry. This is not always rendered with white marble slabs inlaid in green but, in certain areas, in pictorial chased work in fresco on stucco. One of his pupils, Carpoforo Mazzetti worked with him on the decorations of Palazzo Albrizzi. He worked alongside Francesco Fontebasso and

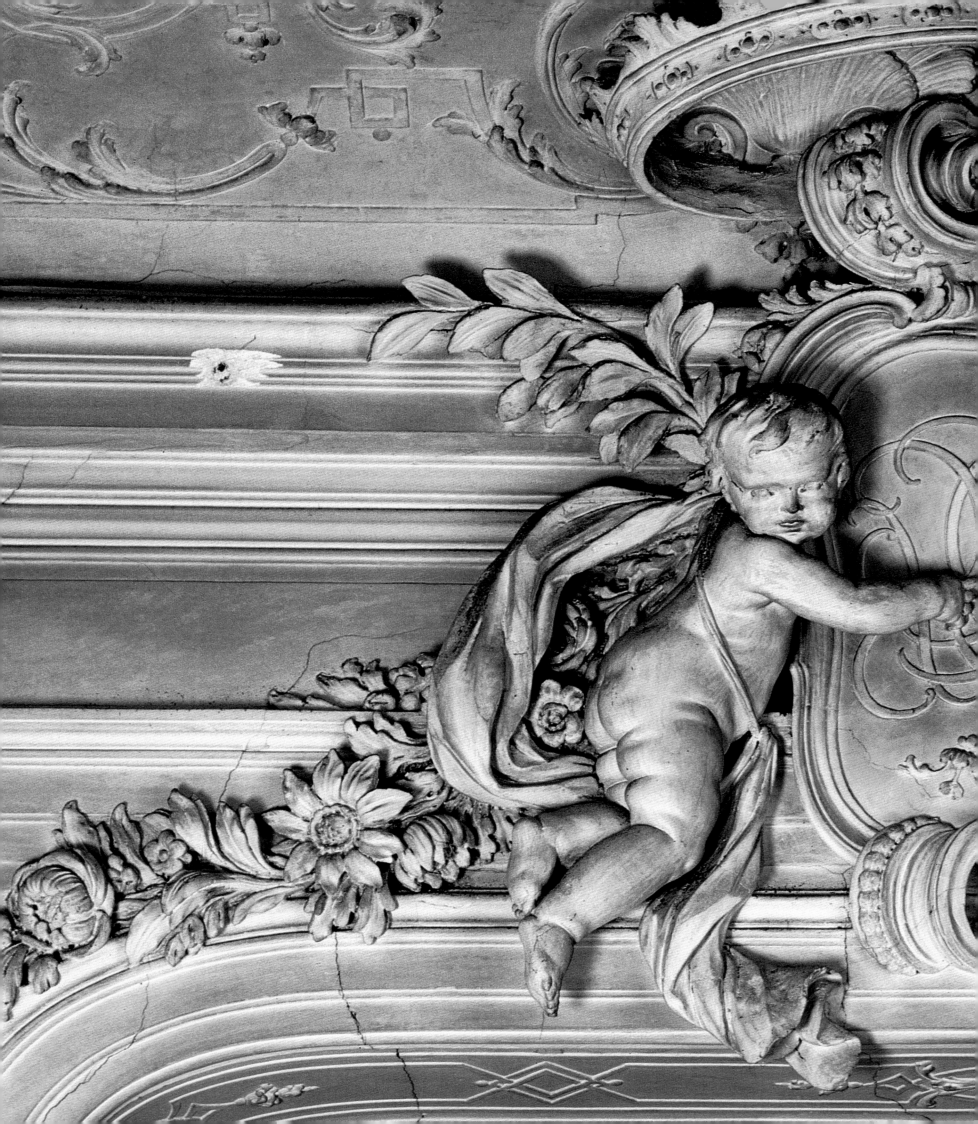

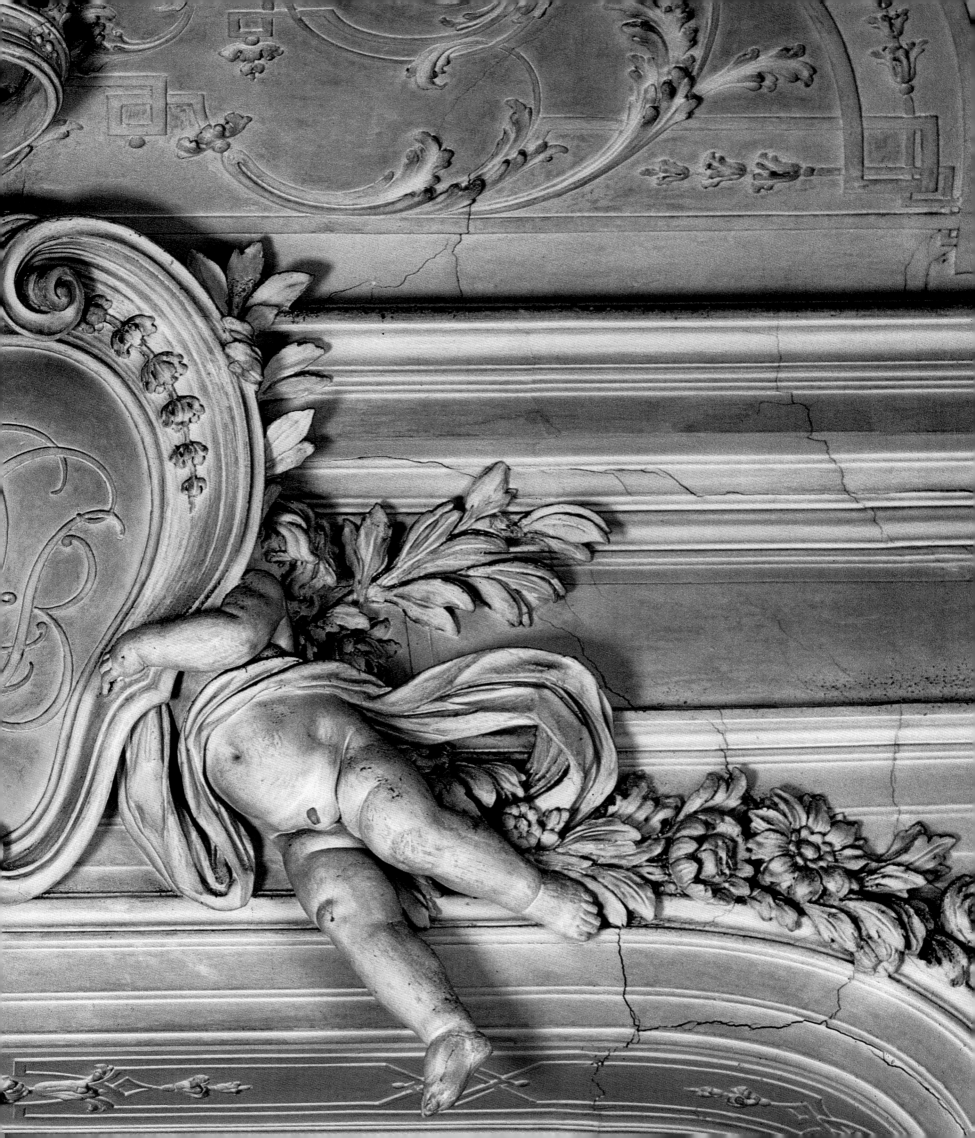

The ceiling of the "music room" in Palazzo Pisani Moretta (previous pages) dates from 1769 and is the work of Giuseppe Ferrari. A complex agglomeration of musical instruments stands out in white on a reticule in white stucco on a gilded background. There are oblong links with a rosette in the points of tangency and a central bead.
In the *portego* of the same palace, the pilaster is framed by striped strips and crossed by subtle plant volutes of acanthus interwoven with white trefoils on a green background. It separates the mirror from the pilaster in red *marmorino*. This work, and the candelabra with transparent jointed arms, dates from the second half of the 18th century.
In Palazzo Querini Stampale, in the library room, stuccoes of a neoclassical style are to be found. They are rigorously white on a pastel background, and become simpler where they form subtle indented volutes of acanthus with a Hellenistic face in the center.

Gaspare Diziani in making the ceilings of the saloons of Palazzo Contarini in San Beneto richer, lighter, and more festive. They were decorated with loggias, pergolas, garden gazebos, adorned with vases, flowery branches, drapes, animals, and Chinoiserie with white stucco on a polychrome background. We should also note the work of Giovanni Andrea Rossi who, sometimes aided by Giovanni Adami, decorated the rooms and mezzanines of Palazzo Pisani Moretta towards the middle of the 18th century. The "Leda con cigno" room is particularly refined in white stucco with polychrome Chinoiserie on a gold background. Giuseppe Ferrari, however, created (in 1769) the ceiling in white stucco on a gilded background, with a thick lace reticule and delightful musical instruments. These works were followed by others with a less pronounced overhang, less relief and in delicate pastel tones, sometimes inspired by Pompeian motifs; examples can be seen in the last decorations of Palazzo Zenobio and in the triumph of Bacchus among bunches of grapes and vine tendrils.

Gold, then used in little well-proportioned touches, was to be rediscovered with the return to decorative and chromatic essentials brought about by Neoclassicism. From that period we should note the works by Antonio Salva in La Fenice (no longer extant) and in Palazzo Guillon-Mangilli ai Santi Apostoli; by Giuseppe Borsato, helped by Giuseppe Castelli in Palazzo Cappello; and those of Davide Rossi in the family areas, now a library, of Palazzo Querini Stampalia.

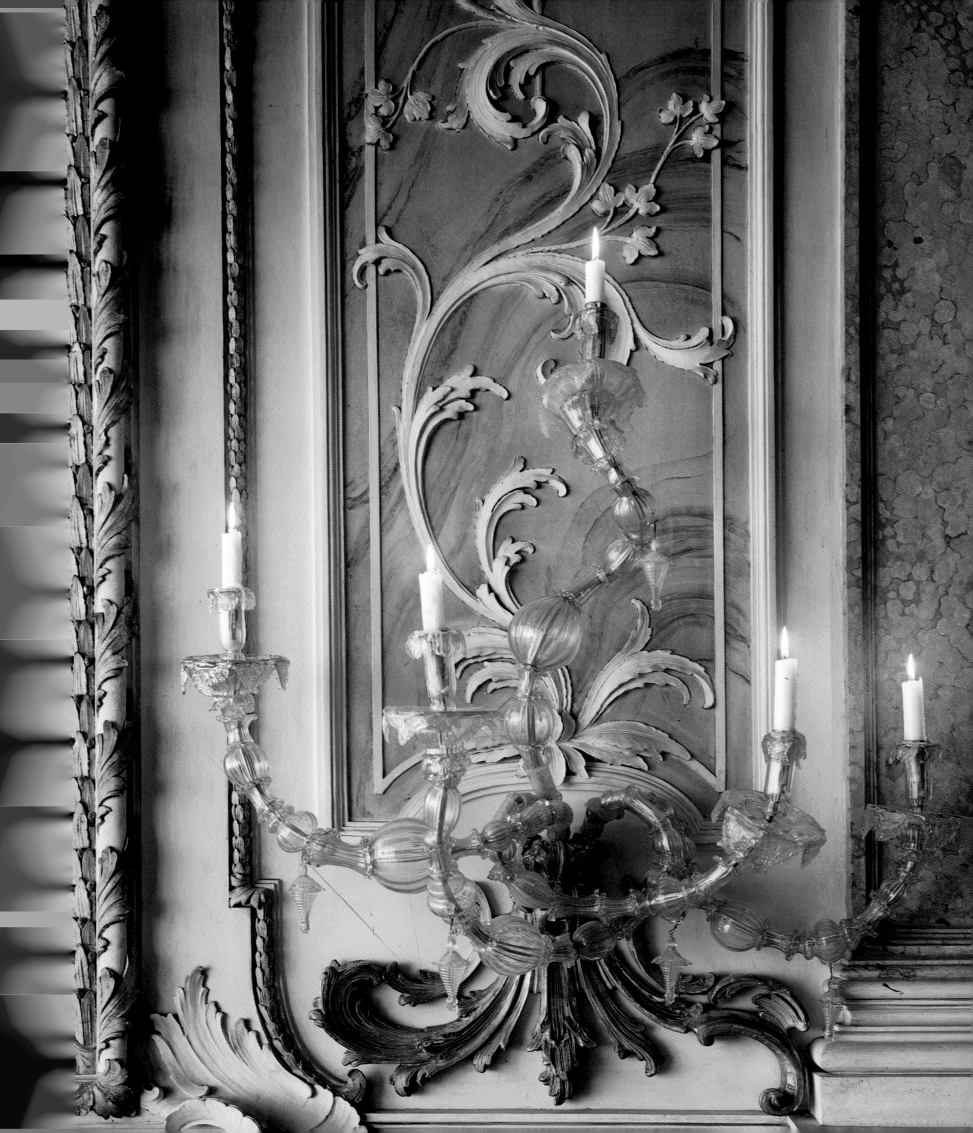

Soft Arts

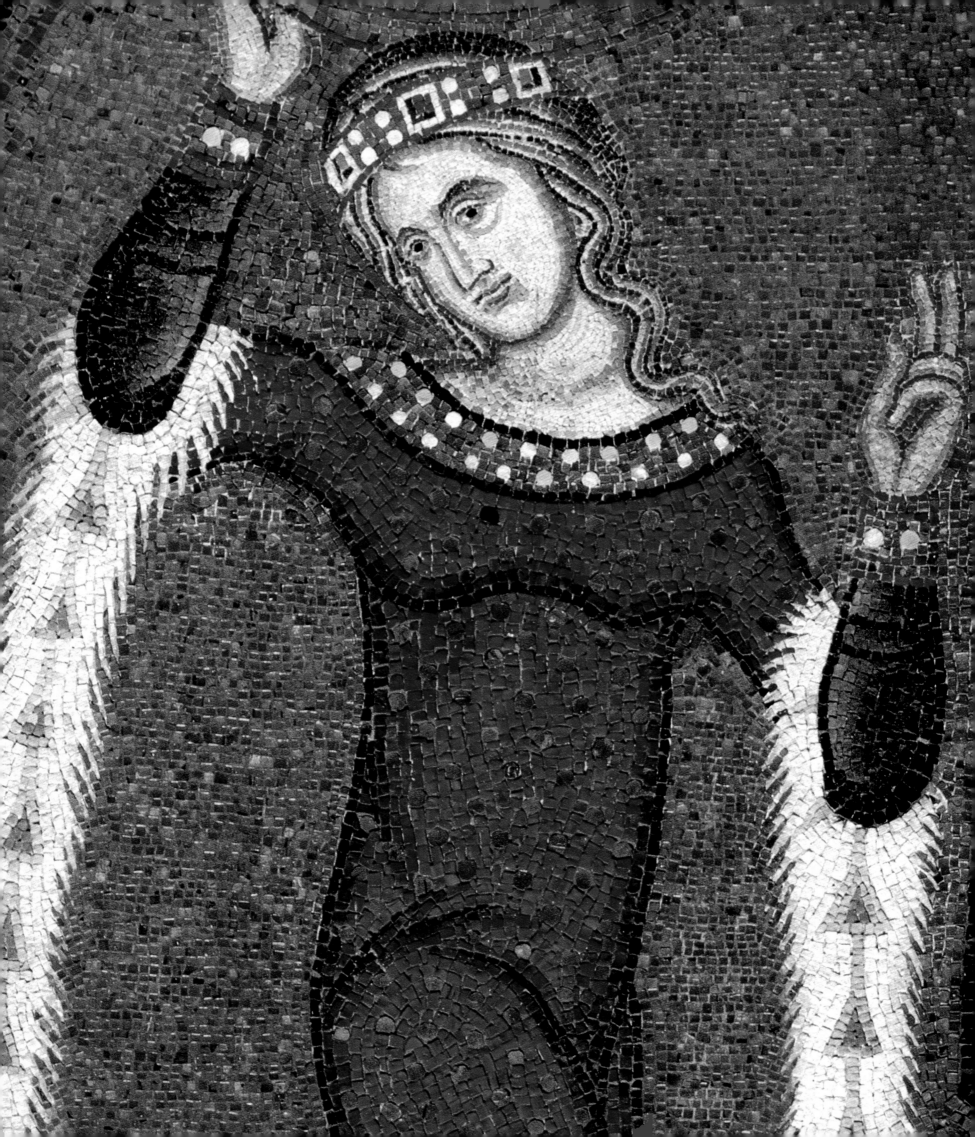

Silk

I tell you that I have seen on a loom a fabric,
of unrivalled beauty. A pattern
by sior Anzoletto, a real marvel.
Carlo Goldoni, *Una delle ultime sere di carnevale,*
Act I, scene XI, 1762

Though ancient manuscripts trace the weaving of Venetian silk and gold fabrics to Greek origins, datable to around the end of the 11th century, actually the art of silk in Venice certainly has more remote, Byzantine origins. Venetian merchants always had free access to Constantinople where they purchased silk garments and fabrics, as already documented in the 9th century, which ensured they had the exclusive right to sell their luxury goods at the two annual fairs organized by the French in Pavia. The *Cronaca* of Deacon Giovanni reports how, next to the production of raw silk, Venice also saw the development of silk weaving, though it was limited to simple patterns. Certainly more complex, not just for designs, but also for the frameworks, was the technique utilized by Antinope, "a masterly expert of the art of fabrics, silk brocades, both plain and woven with gold and silver, with arabesque designs." When Henry IV, emperor of the Western Empire visited Venice between 1084 and 1096, during the period of Doge Vitale Falier, Antinope was asked to weave a precious cloth for Polissena Michiel, a gentlewoman the emperor was in love

In the 14th-century mosaic from S. Marco, the biblical character of Salome wears a *guarnacca*, a fur-lined cloak, of red velvet decorated with gold sequins. An original fragment of this fabric whose decoration was obtained with extra wefts of yellow silk and gold thread can be seen at the Centro Studi di Storia del Tessuto e del Costume in the Palazzo Mocenigo.

Previous pages
Fabric for garments from the Cavenezia factory.

The *inferriata* brocade velvet, so called after the analogy of its design with the decorations of wrought iron gates, dates back to the second half of the 15th century. Of obvious oriental inspiration, it features tendrils seemingly engraved on the velvet pile, against a red background.
Of crimson high-low pile and relief velvet on gold weave is the cloth from the Collection of the Cassa di Risparmio di Venezia. The decoration of the vertical evolving of a spiral-shaped trunk that supports a large thistle flower is typical of the second half of the 15th century.

with. The preparations involved in setting up the appropriate loom, the warp, and the actual weaving all revealed to the local artisans who assisted him a set of techniques until then unknown and which obviously resulted in positive developments for the Venetian art of silk. The fabrics of the time are still characterized by the use of purple dyestuff, a sober chromatic range, the static rigidity of designs, in circles or rosettes, sometimes with the addition of new Sassanian motifs.

The *capitulare samiteriorum*, the charter of the *samiteri* in the Archivio di Stato di Venezia was revised in 1265, thus confirming its existence prior to that date. The *samiteri* were weavers of samite, a prestigious type of heavy silk fabric woven with six threads as the base of the framework. The charter, besides the usual guild regulations, contains numerous technical data related to other textile specialties, which obviously were fundamental at the time. It mentions widths, lengths, and total number of warp threads. In that time, combining various materials, such as linen and silk, was forbidden, and the penalty was the destruction of the cloth.

In 1269 the brothers Polo returned to Venice from their first journey to China, bringing with them goods and artifacts from those remote areas, among them certainly fabrics as well. Nicolò, Marco's father, was probably a merchant of silk fabrics, as he lived in the S. Giovanni Crisostomo district, which had a high concentration of artisans and merchants of silk who had an altar in the church of the same name. Therefore, if the motifs, whether botanical or zoomorphic, and maybe also Chinese techniques spread in the city from the second half of the 13th century, in the first quarter of the following century, the designs and new

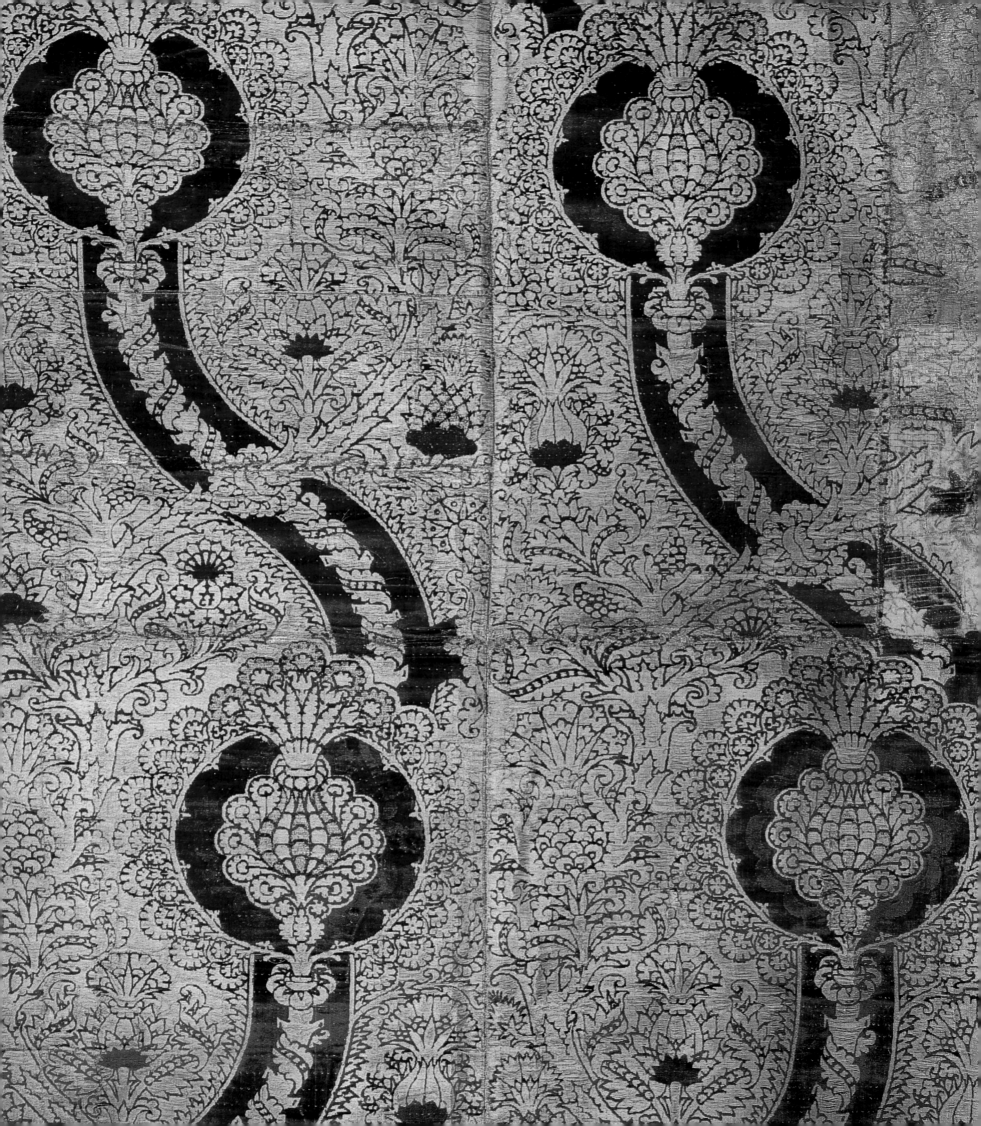

Ecclesiastical garments provide splendid examples of Venetian textile art. The tabernacle door cover, from the Collection of the Cassa di Risparmio di Venezia, shows a pattern with pomegranates and thistle flowers and leaves, emphasized by the high-low pile crimson red velvet brightened by the metal curls of the sparkles. Sparkles also enrich the crimson red relief velvet chasuble of Sixtus IV in the Musei Antoniani of the Basilica del Santo in Padua (following pages). Commissioned by the pope and manufactured between 1474 and 1483 by Pietro Bettino first and subsequently by Giovanni Antonio della Seta, this is all that is left of a whole piece of fabric measuring about 100 meters in length.

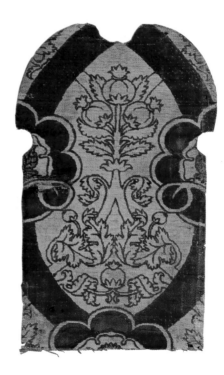

techniques of the weavers from Lucca were adopted instead. These artisans from Lucca arrived between 1307 and 1320 in large numbers and settled everywhere in the city, easily integrating themselves with the local artisans. They gave a substantial contribution to the flourishing of the art of silk in the city and perhaps their coming introduced the production of half-silk fabrics in Venice as well.

Organized in the four *colonelli* of the *filatoi*, *tintori*, *tira*, and *battioro*, *testori* or *samiteri*, from the latter in 1347 evolved the sector of the *veluderi*, evidence of the enormous expansion of this type of textile, which, though rarely mentioned in previous times, would become the luxury fabric most sought after in the century that followed. They went from the simple *samiti pillosi* to the delicate *zatanini velutadi* (samite and velvet satin), initially with very simple decorations such as stripes, squares, and series of golden rounds, like the ones on the sumptuous gowns of the dancing Salome in the mosaics of S. Marco.

In order to safeguard the quality of the fabrics, the *Corte del Parangon* was founded, an institution appointed to compare the fabrics produced, prior to their exhibition and sale, against swatches of various textiles—samite, lampas, and velvets—manufactured according to the rules and from the best materials. A special committee was appointed in 1366 to ensure the quality of the products of the art of silk, already largely spread and continuously evolving. The *Sazo* was established as well, an institution appointed to check dyed textiles and endorse the quality of the dying process with the lead hallmark of the lion of St. Mark. There were special norms that regulated the production of *chermes*, a pigment

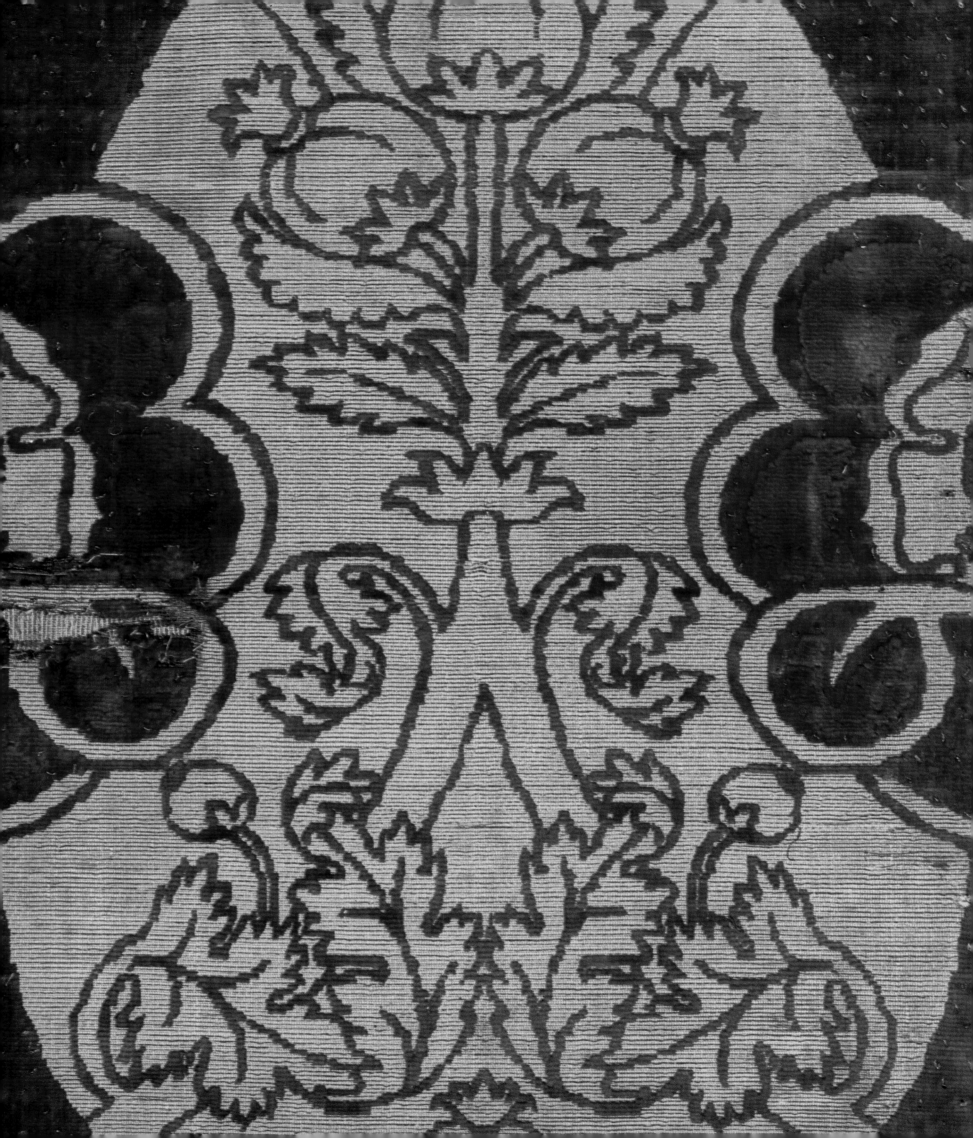

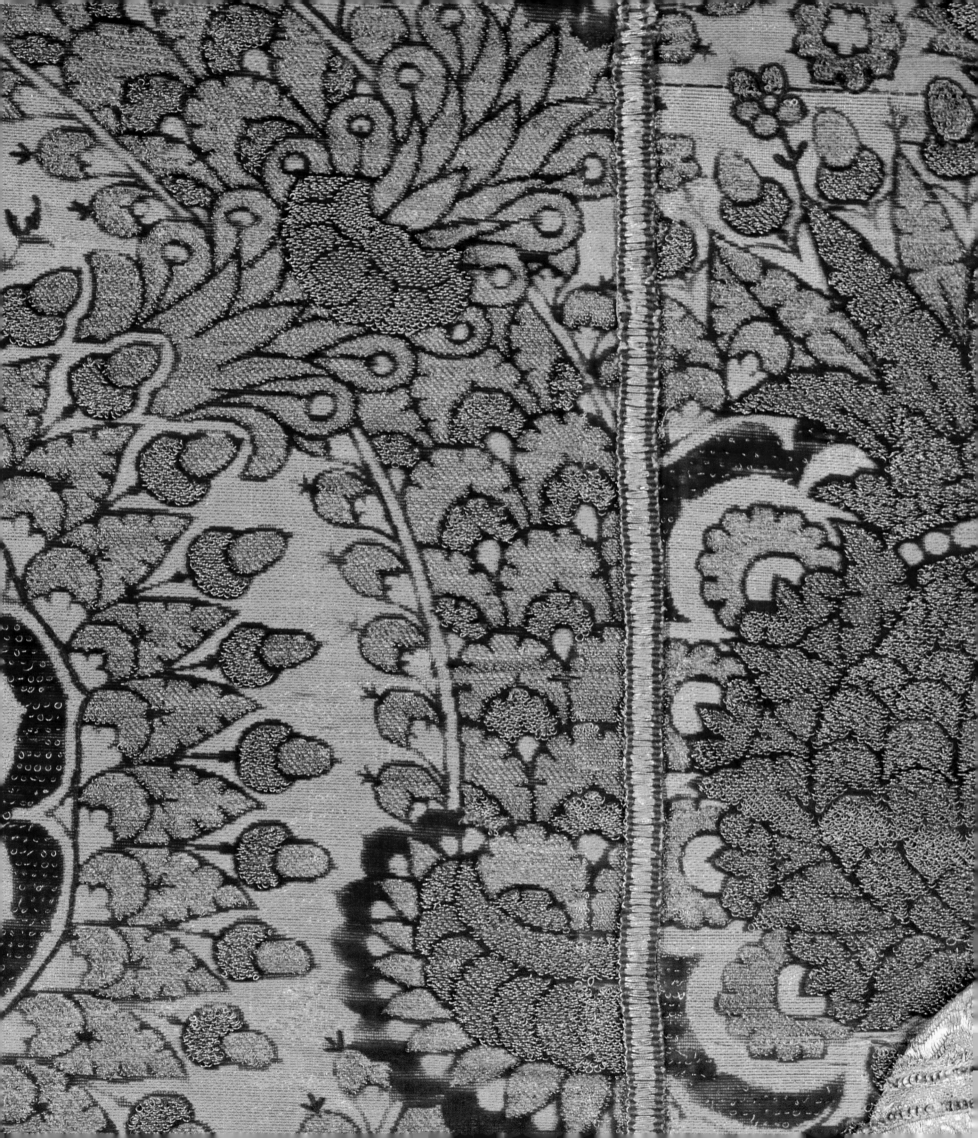

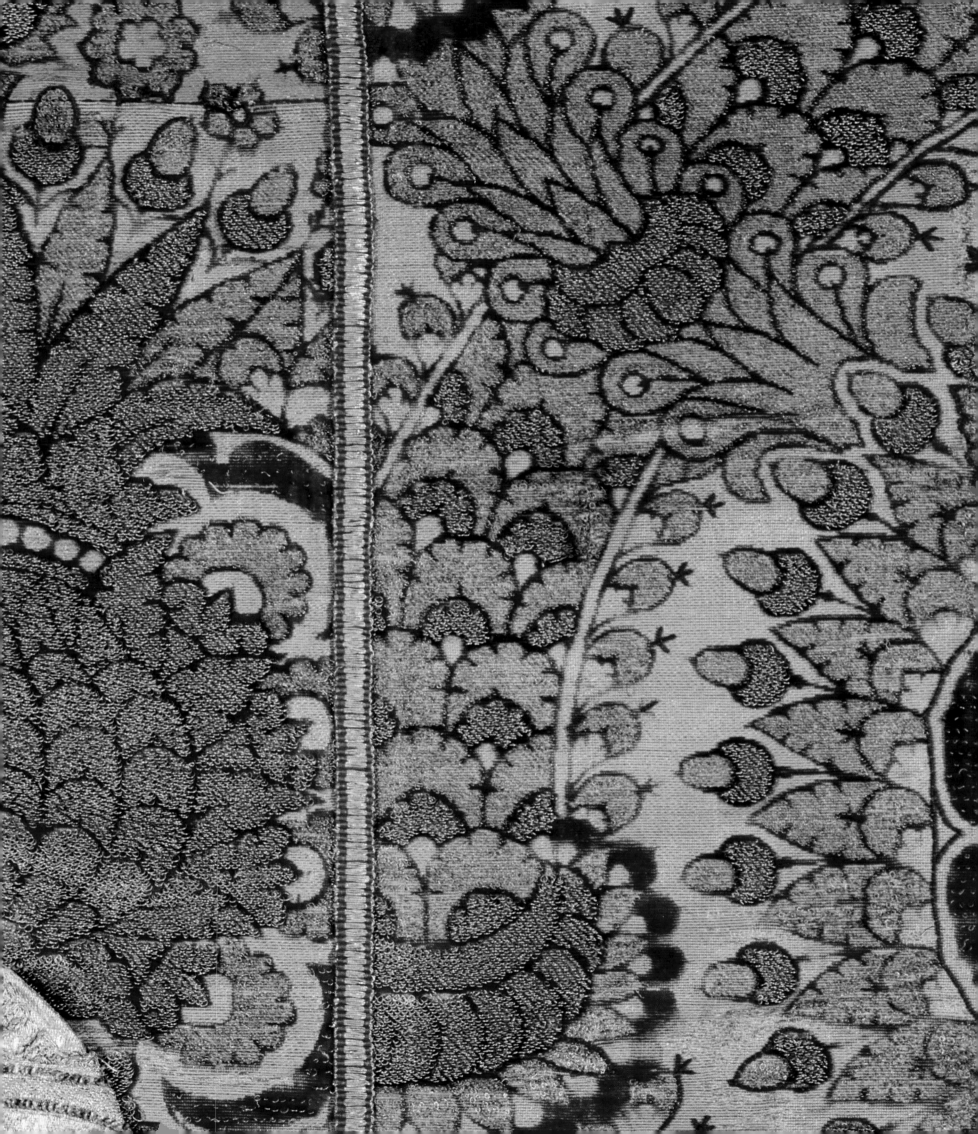

Inside the showcase of a collector some 17th-century togas and stoles are exhibited, which belonged to a procurator and other magistrates of the Serenissima.
The toga on the right-hand side is in red damask, decorated with a vegetal motif of large dimensions characterized by shoots of capers, while the stole is in high-low relief velvet. Due to the preciousness of the crimson dye and the complexity of weaving, this type of velvet was produced exclusively for the highest officers in the State. The cut of the velvet pile, with two or more various thicknesses, made its weaving particularly painstaking and slow. Though it was modified, the six-petal rosette remained a characteristic design throughout the centuries.

called "crimson" and later known as scarlet or Venetian red. The green selvedge with a gold thread in the center, would indicate immediately to the purchaser that the precious pigment had been used and in what percentage, the white stripe in the middle would signal its presence only in the warp.

At the beginning of the 14th century the decoration is still tied to an orderly structure, with repetitive schemes and decorative motifs; in the second half of the century, however, there is a progressive loss of the symmetry and balance to the advantage of a lively and realistic representation: animals are depicted flying or running as if they were to pounce on the prey or flee an ambush. Favorite connecting elements are twisted shoots, small wind-bent trees, and palm trees.

In 1450, reiterating the prohibition to the samite weavers to produce brocaded velvet, the combined techniques of the *pello taiado* and *pello riçado suso*, that is, cut and curly velvet, are mentioned, thus suggesting the combination of the two to produce the renowned *soprarizzo*. Only the *veluderi* were allowed to produce

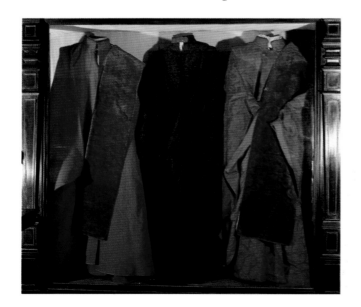

brocaded velvet, called *afigurado*, and the most popular design of the century seems to have been that of the *inferriata*, so called in the 19th century for the similarities with the ornamentations of wrought iron gates.

The decoration, to which collaborated renowned artists such as Jacopo Bellini and Pisanello as well as lesser known ones like Jacopo da Montagnana, was influenced by oriental stylistic elements, such as the curled serrated leaf and the

The *ganzo* is a typically Venetian type of textile, popular between the end of the 17th century and the first half of the following century. It is a lampas rendered spectacular through the heavy interweaving of extra gold and silver threads. The decoration with architectural fragments among exotic vegetation is highlighted only through a thin polychrome outline.
The brocaded red silk damask with vegetal shoots and gold rosettes is datable to between 1620 and 1640, and was intended exclusively for clothing.

small leafy palm tree, as well as bright chromatic combinations. The motif of the pinecone alternates with the pomegranate and the thistle, positioned in the center of cuspidate polylobate corollas, rendered in graphically linear manner and arranged in horizontal parallel rows. The design stands out of the velvet pile thinly outlined in satin. Besides this type of design, called *a camino*, that could be embellished with brocade and gold and silver sparkles, Venice is also home to the pattern called *a griccia*, red on a bright gold background, with a large sinuous trunk bearing a large polylobate corolla with a thistle flower or other similar element placed in the center.

Another Venetian specialty was the *alto-basso* or counter cut velvet technique. Usually of an intense crimson red color, the decoration, emphasized against the velvet background by the difference in pile thickness, consisted of concentric rosettes, subsequently vertically alternated with heraldic crowns supported by two joined twisting branches. This type of velvet, which apparently remained the same throughout four centuries, became a status symbol of the highest social and political classes; it was in fact used to make the stoles of the senators and procurators of the Republic. In the second half of the 16th century various types of fabrics became more favored: lampas, damasks, and light brocades, while among the velvets the *soprarizzo* was the preferred one.

Furnishing textiles, beginning to distinguish themselves from clothing fabrics, kept large-scale designs and were more dependent on the style of the other decorative arts, from which they drew inspiration in a variety of ways.

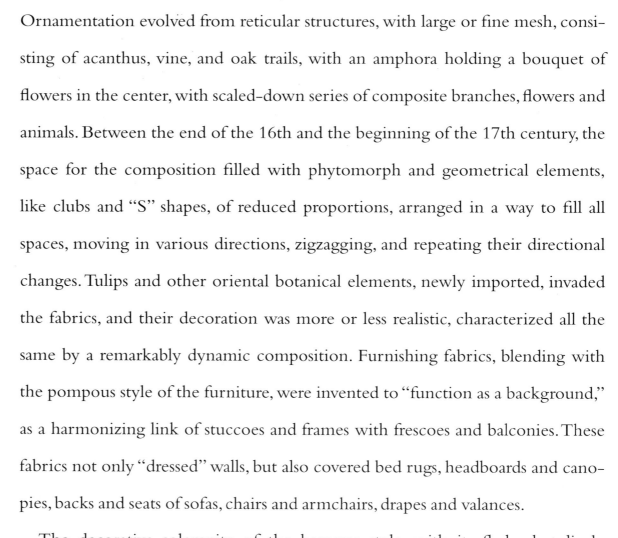

The red brocaded satin interwoven with extra straight and wavy silk wefts that covers the walls of the red sitting room in the Fondazione Querini Stampalia, shows a composition characterized by a large structure and natural elements such as corn poppies, berries, and peonies rendered with a certain realism. Datable to the early 18th century, it is coeval of the specimen in brocaded damask from a private collection, whose background decorations are barely noticeable. Clearly visible instead are the brocaded weave of polychrome silk, diagonally tied, in an "S" shape.

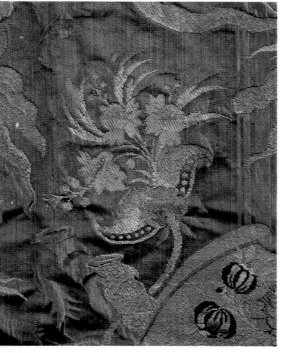

Ornamentation evolved from reticular structures, with large or fine mesh, consisting of acanthus, vine, and oak trails, with an amphora holding a bouquet of flowers in the center, with scaled-down series of composite branches, flowers and animals. Between the end of the 16th and the beginning of the 17th century, the space for the composition filled with phytomorph and geometrical elements, like clubs and "S" shapes, of reduced proportions, arranged in a way to fill all spaces, moving in various directions, zigzagging, and repeating their directional changes. Tulips and other oriental botanical elements, newly imported, invaded the fabrics, and their decoration was more or less realistic, characterized all the same by a remarkably dynamic composition. Furnishing fabrics, blending with the pompous style of the furniture, were invented to "function as a background," as a harmonizing link of stuccoes and frames with frescoes and balconies. These fabrics not only "dressed" walls, but also covered bed rugs, headboards and canopies, backs and seats of sofas, chairs and armchairs, drapes and valances.

The decorative solemnity of the baroque style, with its flashy but lively harmony of forms and colors, was well represented in the textiles' sophisticated polychromy, decorations with flowery volutes, foliate curls, and large plumes. Such furnishings bought in 1695 in the Venetian shop of Domenico Morandi, are now in the throne hall of the Castle Meli Lupi in Soragna. However, during the 17th century, the production of silk fabrics experienced a phase of decline, as the actual number of bolts produced halved, due to the disappearance of the ordinary types, while the elaborate ones, enriched with gold and silver, doubled.

Turquoise on a light yellow background, within square frames, two lions rampant are separated by a small tree of life. The Byzantine-like motif, in *soprarizzo* velvet on cloth, is still produced today on old semi-manual looms by the Bevilacqua weavers.
Of white cotton muslin printed in gold, silver, and blue with floral motif squares of Persian taste and with an edge of Murano beads, is the jacket created by Mariano Fortuny in the second quarter of the 20th century, from the collection of Liselotte Höhs.

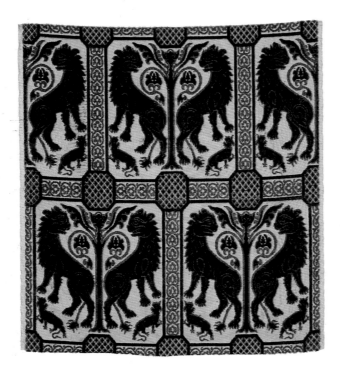

Therefore, though the quantity of fabrics decreased, the global annual revenues increased. This situation remained stable until 1712, when the decline became inexorable. The luxury textiles in question were the *ganzi*, silk fabrics identifiable for the heavy use of precious metals and a complex decoration in the alternating of architectural and botanical elements. In high demand were the so-called *bizarres*, characterized by the extravagance of the designs, almost psychedelic, for which the influence of drugs has been hypothesized.

The guarantee of quality at all costs enforced through the continuous promulgation of new, severe laws and controls in an era of innovations and consumerism, hindered the spirit of entrepreneurship, that found itself operating within such constraints that the market was opened to foreign competition. Worthy of mention is the work of the brothers Cavenezia, extraordinary weavers of whose output remain signed samples in the collections of the Civici Musei Veneziani, and of Pietro d'Avanzo, who in 1763 obtained the permit to open an academy of drawing and weaving.

The invention of the Jacquard loom in the early 19th century gave the art its final blow, though it managed to survive until the 20th century, thanks to the workshops of Mazorin, Martinoli, Trapolin, Rubelli, and Bevilacqua. The latter, along with Mariano Fortuny and his printed velvets at the beginning of the 20th century, would take the art of silk back to its ancient glories.

Tapestries

Venice never went overboard with tapestries, considered not sophisticated enough and almost crude for the prevalence of wool, though they were not totally given up, being utilized with great abundance in houses and churches, as documented in ancient inventories.

Tapestries are a type of cloth with a single warp, usually of raw linen, and numerous polychrome wool wefts, each of which is wound on special spools and woven exclusively in the type of weave required by the pattern; this type of work produces tiny gaps between the various colors, which are finished by hand stitching. This type of cloth can be produced without great differences in quality on high heddle looms with vertical framework or on low heddle looms, with horizontal framework. The cardboard with the drawing is placed underneath the warp and the fabric is woven on the wrong side, as a mirror image.

The first document alluding to this type of cloth dates back to 1313 and relates to the city of Arras, that would become so renowned for its specific textile production that it gave its name to this elaborate kind of tapestry.

Fragment of an arras, 16th century, Museo Correr.
A portion of a votive antependium commissioned on the occasion of the crowning of either Doge Leonardo Loredan (1501) or Doge Antonio Grimani (1521). The resolute profile of the doge, who wears the characteristic ecclesiastical headpiece, has not yet been identified with certainty. It was made of yellow silk warp and polychrome wool wefts. Traditionally the design, illuminated with metal threads, has been attributed to Titian.

This arras, of remarkable dimensions (177 x 458 cm) belongs to the series called *Stories of Jupiter* in Palazzo Ducale. It narrates in various sequences the episode of jealous Juno who assumes the appearance of the wet nurse of Semele—who was Jupiter's mistress and mother of Dionysus—in order to ask the god to show himself in his entire splendor, a sight which would then consume her with his lightning. Made with white wool warp and wefts of wool in several colors and yellow silk, it was originally framed within an elaborate fruits and flowers border. Attributed to the manufacture of St. Mark's artists, it is dated 1540.

Venice was among the first Italian cities, after Mantua, to welcome Flemish tapestry artists. A 17th-century chronicle records the arrival in Venice in 1421 of "Jehan di Bruggia" (Bruges) and "Valentin di Raz" (Arras), who, though continuing to be traveling artists, quite the norm at the time, established in Venice workshops in which they had tapestries made after their cardboard drawings while also restoring damaged ones.

The first testimonies of such artifacts in Venice date to 1431: the inventory of the Scuola di S. Ambrogio, in the Frari district, mentions an "illustrated tapestry or panel" with figures. It is also known that in 1450 the Zorzi family commissioned Alvise Pintor to produce tapestries to illustrate the life of S. Teodoro; the same motif is also found in an "altar tapestry" in the school dedicated to him. Furthermore, in 1489 Giorgio de Metelino asked Martino Arazziere to teach him *artem et exercitium razziorum* (the art and profession of tapestry).

Dating back to this time are the ten *Passion* cycle arrases in the Basilica of S. Marco which display the lion of St. Mark in the majestic pose called *in moleca*, believed by historians to have been produced in Venice by artisans from Arras.

Throughout the 16th century, tapestries with the name of *spalliere* (wall upholstery) or *bancali* (coverings for chairs and nuptial coffers) were frequently used in the aristocratic palaces, alternating with gilded leather. The art continued to be practiced by foreign artisans, often on cartoons by Venetian artists, notably the arrases bearing the family emblems of the Tiepolos, the Barbaros, the Grimanis, and the Giustinians—once in the Museo Vetrario di Murano— produced after drawings by Vivarini, Guariento Padovano, Nicolò di Semitecolo, or the upholstery and door coverings sold to the Da Mulas in 1572 by Girolamo di Nicolò from Corfu.

The yellow shield with the red lion of St. Mark in the majestic pose called by the Venetians *in moleca,* appears on the base of a column, a separating element between narrative sequences on the arras with the *Story of Semele* in the Palazzo Ducale.

The arrases with the *Stories of Jupiter* date back to 1540 and bear the emblem of St. Mark's lion in majestic pose, while the tapestries for the Collegio hall date back to 1576–77 and are based on drawings by Veronese. The arrases of St. Mark's miracles commissioned in 1550 to Giovanni Rost, who was at the Medicis' service, and based on cartoons by the Verona painter Giovanni Battista del Moro, but previously attributed to Sansovino, were produced outside Venice.

Of those tapestry antependia that each doge was required to donate to the basilica, only two remain: one based on a drawing by Jacopo Tintoretto, produced in 1571, of Florentine manufacture; the other, a gift of Doge Grimani, based on a project by Alessandro Allori (allegedly inspired by a work by Domenico Tintoretto) goes back to 1595 and is of Flemish manufacture. The Venetian government did nothing to entice local workers to engage in this form of art, contenting themselves with the promulgation of sumptuary laws that would limit its use. These textiles were used to decorate not only home interiors, but also boats furnished for special occasions, as for example the ones used to celebrate the arrival in Venice of Henry III of Valois in 1574 or the crowning of the doge's wife Morosina Grimani in 1597. Even a courtesan, Giulia Leoncini, bequeathed to her sister Angelica around the middle of the century four pieces of tapestry coverings decorated with birds and the family emblem measuring over 16 meters in total. The bequest also comprised tapestry *bancali,* bed furnishings and wall coverings illustrated with figures to cover the walls of a room measuring over 18 meters in total. In 1572, in order to provide a proper reception for the Duke of Ferrara on a visit to Venice, the halls of the palace

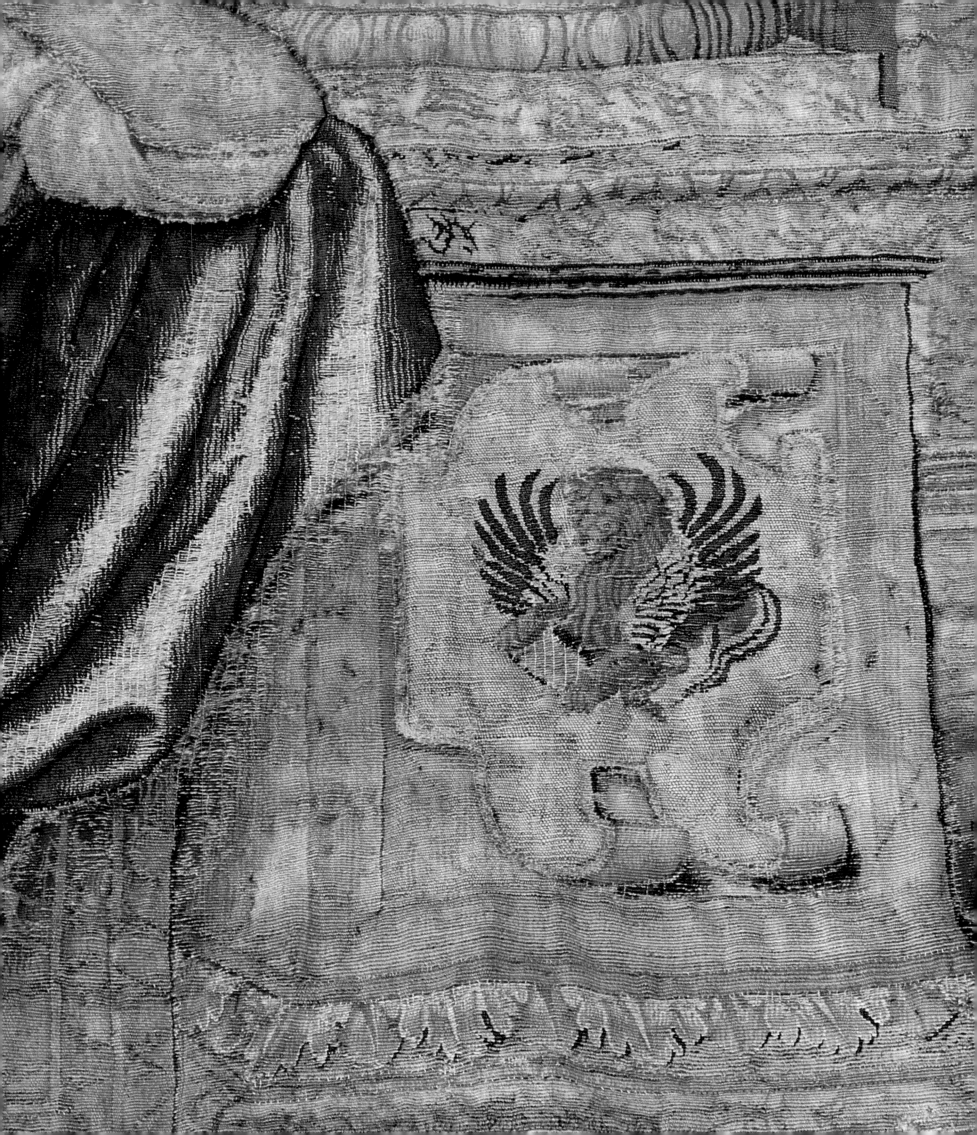

A banner created by Antonio Dini in 1762, on a drawing by Giambattista Tiepolo. The standard of the church of S. Maria Mater Domini, now in the Museo Diocesano, depicts the Virgin Mary and Child in glory on a golden background, framed by yellow floral elements on a red background. Made with a white silk warp and wefts of polychrome wool, silk and silver threads, it measures 186 x 114 centimeters. The Child's face appears marked by an inaccurate restoration.

where he stayed were embellished with whole cycles of arrases illustrating the months of the year, various animal species, Hercules' labors, and the gigantomachy.

Although in the first half of the 17th century the workshops of the previous century were still active, like those of the Zinquevies or the Clementes, in 1621 the permission to settle in Venice and open workshops requested by a group of artists from Flanders was refused. In 1625 Filippo Fevre (son of Pietro, headmaster of the Medicis' tapestry workshops) asked permission to open a workshop in the city for the production of arrases and carpets, with the promise of training local artisans in exchange for the *jus privativo* (the right to exclusivity with tax exemption). Upon evidence of his skills, he was conferred such privilege. Around 1650, the Zane family commissioned four Brussels' weavers to execute a series of eleven arrases— six of which are today in the Palazzo Labia—illustrating the stories of Scipio.

Also from Florence was Leonardo Bernini who, a century later, asked permission to open a tapestry factory in Rialto. We must remember also the already mentioned Pietro d'Avanzo, creator of the 1730 banner for the congregation of S. Salvador, and Antonio Dini with his daughters Lucia and Giuseppa. In his Venetian laboratory, in 1763, he produced coverings for benches, standards, antependia, panels to arrange on thrones and chairs, table or floor rugs, runners for boats, and twelve Turkish sofas sent to Constantinople and Egypt. At his death his daughters continued the activity of the factory in a commendable way and were cited in 1790 as being "extremely skilled makers of arrases" which were modestly priced.

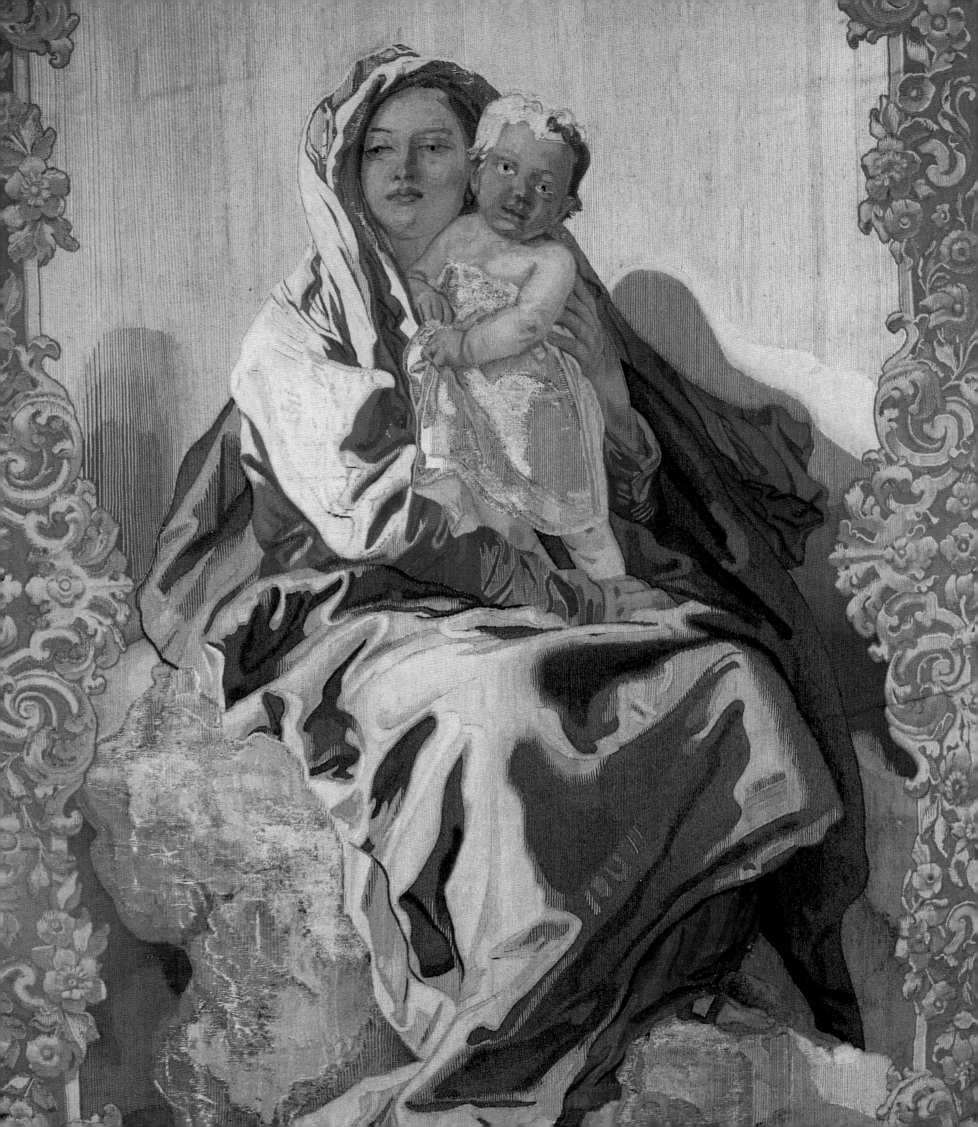

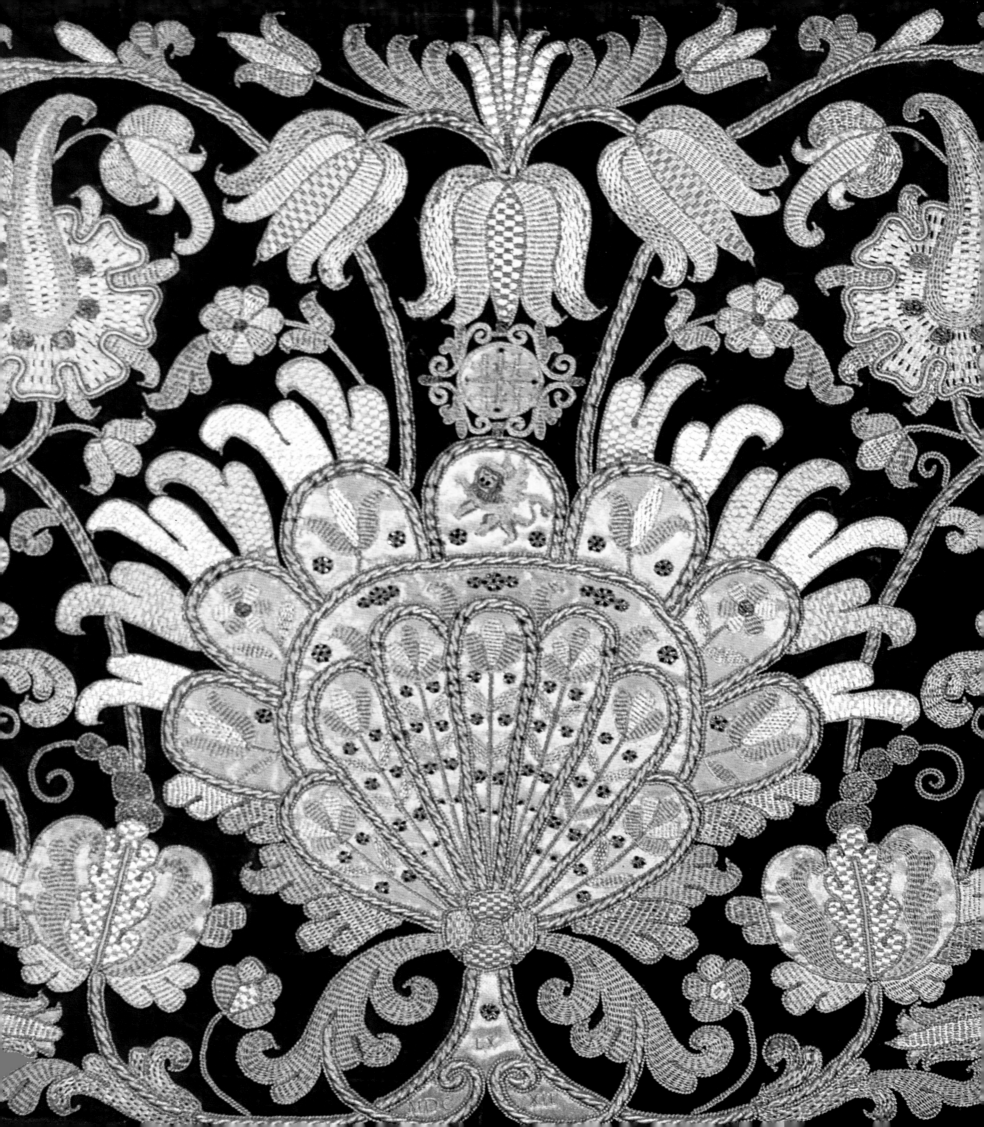

Lace and Embroidery

The Guild of embroiderers was included from 1272 on in the wider category of painters, though centuries later it would be comprised in that of the *marzeri* (haberdashers). Embroidery was believed to have been introduced in Sicily, and from here to the rest of Italy, around the year 1000 during the Saracenic domination of the island. Doubtless, however, Venice in its early stages was heavily influenced by the Byzantine style in this type of art as well. Among the oldest Venetian embroideries, the two panels in the Museo di S. Marco, dating back to the 12th century, are worthy of mention. They depict a *Lamentation on Christ with the Symbols of the Evangelists* and a *Couple of Archangels*, featuring polychrome silks, gold, and silver, and they were transferred onto plain cloth for conservation purposes. The gonfalon of the church of S. Fosca in Torcello dates back to 1336, and is defined as being *acu picto*, that is, painted with the needle, with the image of the Virgin and Child and the saints Maura and Fosca within Gothic niches framed by intricate golden swirls of Muslim inspiration. Despite the few remaining pieces from that time, embroidery is so

The crimson red velvet antependium, embroidered in gold and silver, belongs to a complete set with cope, chasuble, and tunicles crafted in 1672 in Venice and sent as a gift to the church of the Holy Sepulchre in Jerusalem.
The baroque decoration with large oriental-style flowers is enriched with the studded bullion, also by actual metal plates of remarkable thickness.

[275]

The 17th-century *meil* in gilt yellow lampas, from the *Museo di Arte Ebraica*, is embroidered with silver, polychrome silk threads and small baroque pearls in a curly scrollwork design with large stylized blossoms, colorful fruits and flowers, and Hebrew inscriptions.

The coverings of chair backs and seats of the 12 armchairs are by Brustolon, Ca' Rezzonico. They feature a combination of small stitch and cross-stitch with polychrome wool threads on canvas. Datable around the first half of the 18th century, they are decorated with male and female figures within a landscape framed by exotic-looking vegetation, dressed in the "heroic" manner, that is, wearing theatrical costumes allusive to a mythical classical age.

widespread that Cennino Cennini in the *Book of Art* in 1398 dedicates a whole chapter to "how to draw on cloth or sendal for embroiderers." We know that important artists collaborated in this field: well-known names like Giotto, Pollaiolo, and Botticelli, and lesser-known artists like Pordenone and Giovanni da Udine. In the second half of the 15th century were documented in Venice and Veneto workshops with skilled Lombard workers who embroidered the oak, symbol of the Della Rovere family, on the liturgical chasuble of the typical Venetian illuminated velvet that Sixtus IV gives to the Basilica of S. Antonio in Padua.

The oldest books of drawings for embroidery, published in Venice in 1527 are the *Burato Libro de' recami* by Alex Paganino and the *Esemplario novo* by Giovanni Antonio Tagliente. The succinct introduction to the first book explained how to transfer a design from paper to canvas, called *burato*, while in the second book drawing is taught as well. The most wanted publication, however, was Giovanni Ostaus' *The true perfection of drawings for various types of embroidery*, several editions of which were published between 1557 and 1591.

The writer Modesta da Pozzo (pseudonym: Moderata Fonte), was remembered by her biographer as an embroiderer "remarkably excellent for every type of stitch" and capable of creating any motif without the need for a preliminary trace. Male artists, however, were the creators of the illustrations of Christ, the

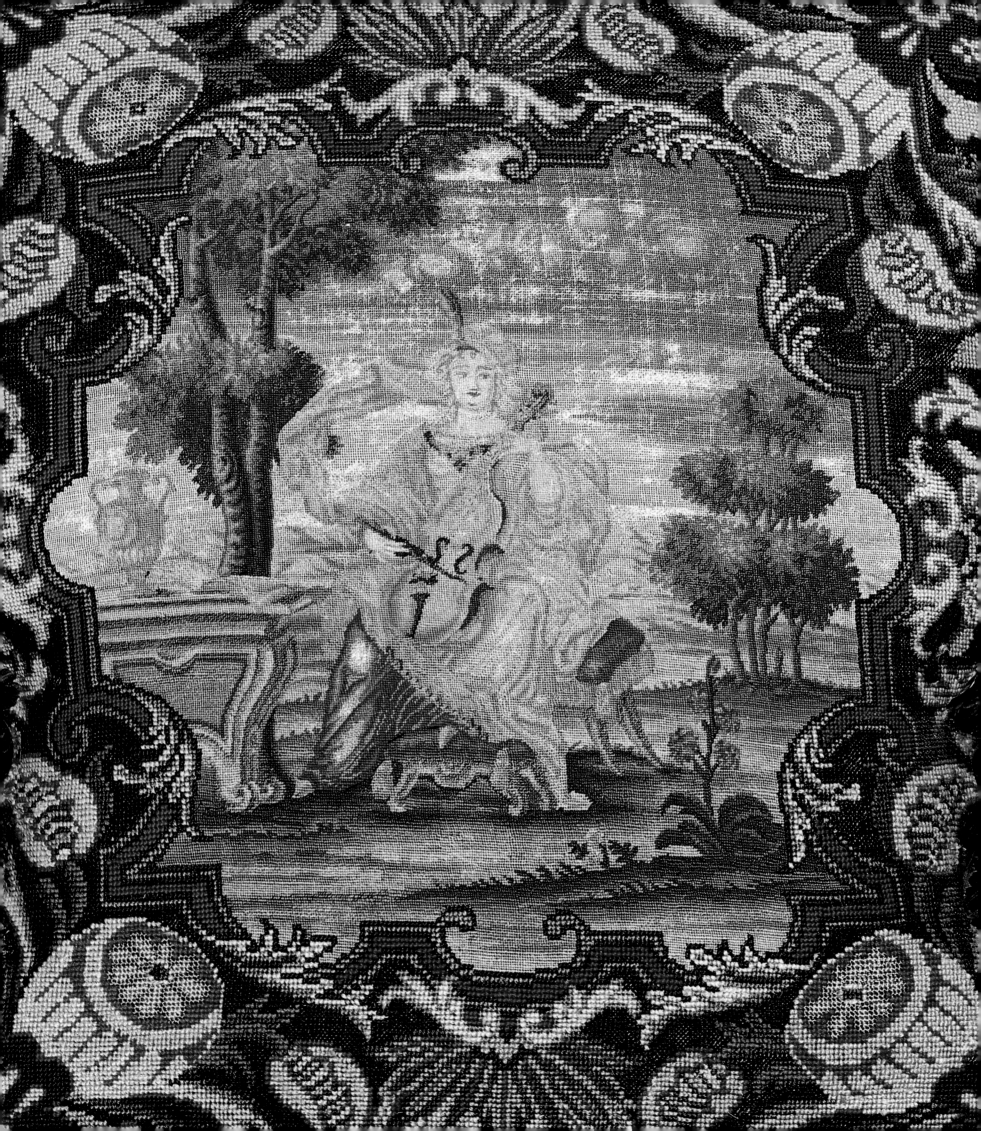

Missal cover, 1682, Museo Diocesano.
Originally from the church of S. Maria Formosa, it features a binding covered with white cloth embroidered with silver in "laid point," with polychrome silk painting stitching. On silver background with matting effect, the central medallion with the figure of S. Barbara is framed by two opposing bouquets of multicolored flowers tied with a ribbon.

Virgin, and saints, among whom the "St. George with dragon" among foliate volutes of the cope of Nese, near Bergamo. The artists, the Venetian masters Vivia' degli Acerbi and Santo Manzini were paid a total of 77 ducats in 1563: a fortune for that time. In his book *La piazza universale*, however, Tommaso Garzoni stated that embroidering was "better suited to women than to men," while the judgment of Nicolò d'Aristotile, called Zoppino, was more impartial, as he considered the genre well-suited to any "pilgrim ingenuity…both male and female." Among the most popular stitches were the *fili contati*, written, cross, flat, small cord, satin or painting, grass, chain, curly or knotted, laid, and veiled gold.

From the 17th century remain numerous pictorial testimonies of embroidery on both garments and accessories such as handbags, gloves, and shoes. In the ecclesiastical milieu, there are records of a whole vestment dated 1672, embroidered in gold and silver on crimson red velvet, created in Venice for the Jerusalem Committee, it was sent as a gift to the Holy Sepulchre.

Skilled in the needle technique, both in tailoring and embroidery, Hebrew women could afford to violate the Venetian laws that forbade their community to engage in gratifying artistic activities, engaging in the least noisy of all professions, in the quiet intimacy of the Ghetto. The Museo di Arte Ebraica contains sumptuous *parochet*, precious *meil*, lively *mappah*, embroidered sometimes not just with polychrome silk, gold, and silver, but also enriched with minute baroque pearls.

The first half of the 18th century was characterized by embroideries in relief obtained with paper or cotton wadding, rococo decorations or flower and foliate

[278]

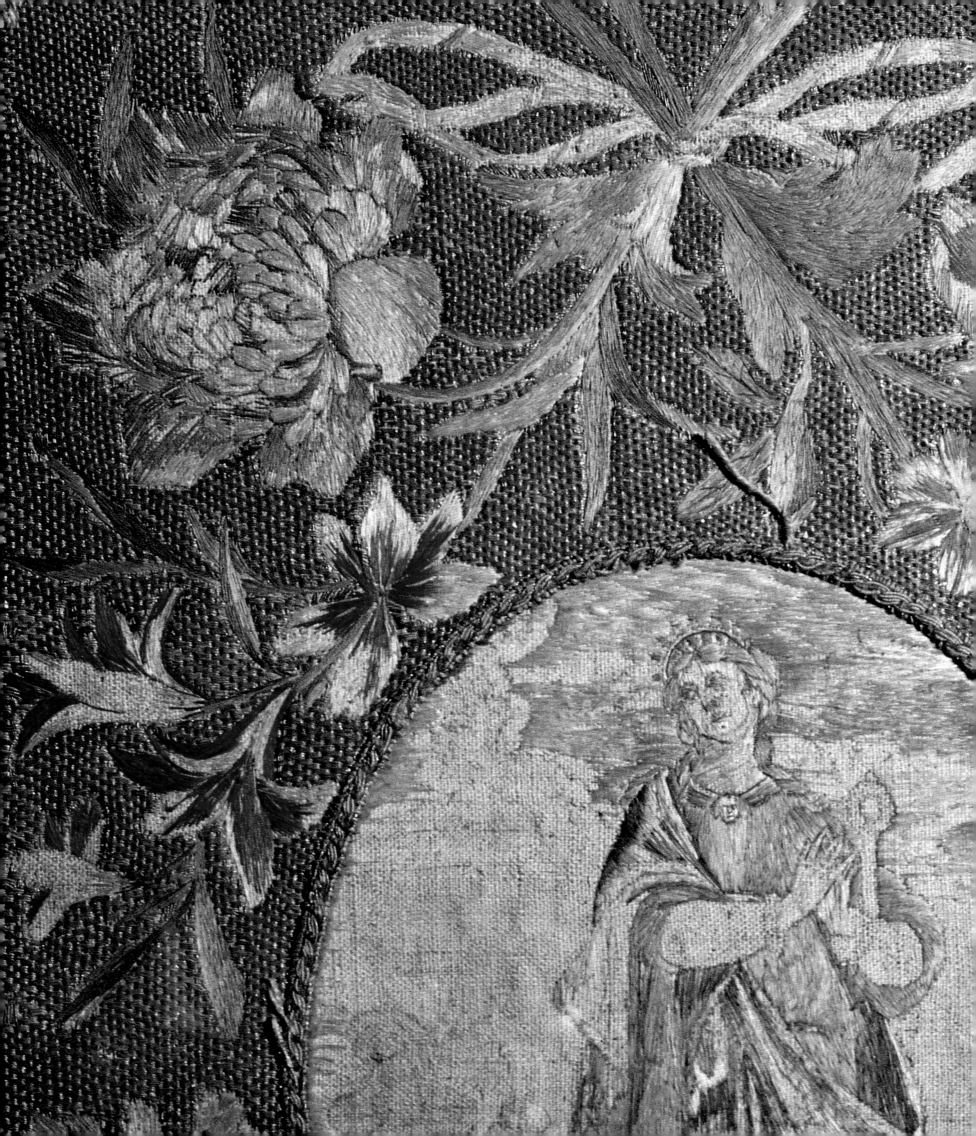

Various lace and embroidery techniques can be identified in this late-16th-century tablecloth from the Museo Diocesano. "Cut stitch" and "mesh stitch" square panels, with geometrical patterns and foliage alternate with other mesh designs with zoomorphic and allegorical motifs, called *filet*. The scalloped edge, on the other hand, is made with bobbin lace technique.

Following pages
Originally from the Pio Istituto delle Penitenti and now in the Istituto di Ricovero ed Educazione, the high lace border in flying stitch technique was created in the first half of the 17th century. The profusion of flowers and numerous botanical varieties, mainly oriental, is interpreted with baroque spirit.

motifs stuffed with chenille, or with the deft use of silk tracing. On the base fabrics such as taffeta, the composition was structured on a central axis and developed in a candelabrum shape, as in the gown of the Madonna del Rosario, dated 1704, or in the antependium of the Last Supper, both in the church of the Gesuati. Rococo style preferred small ornamentation, with sparse and light compositions, gracefully moving the sinuous meanders of ribbons and flowers that the neoclassic style would later simplify and stiffen into straight designs.

In the 19th century, despite industrial innovations, manual embroidery continues to be preferred, though mostly restricted to convent workshops or charitable congregations. In 1884 the Istituto delle Zitelle hired a teacher of embroidery, Maddalena Pelloni, who took the discipline to its highest developments and earned a gold medal at the Palermo exhibition of 1891. From that time also remains the artistic reproduction in "needle painting" of the Giudecca canal with the church and the Istituto delle Zitelle in the background.

A form of art that was entirely feminine was the art of lace making which boasts an exclusively Venetian origin. Even without knowing anything about Venetian history or art, simply walking around the city and observing its architecture, the pinnacles, and the numerous works of tracery explains the reason behind this claim. Although the geographical origins of the bobbin lace technique, derived from the weaving of trimmings, are not clear, on the other hand, the origins of needlepoint lace, developed from a type of drawn-thread work, are unanimously attributed to Venice, second half of the 15th century. It does not originate, as told

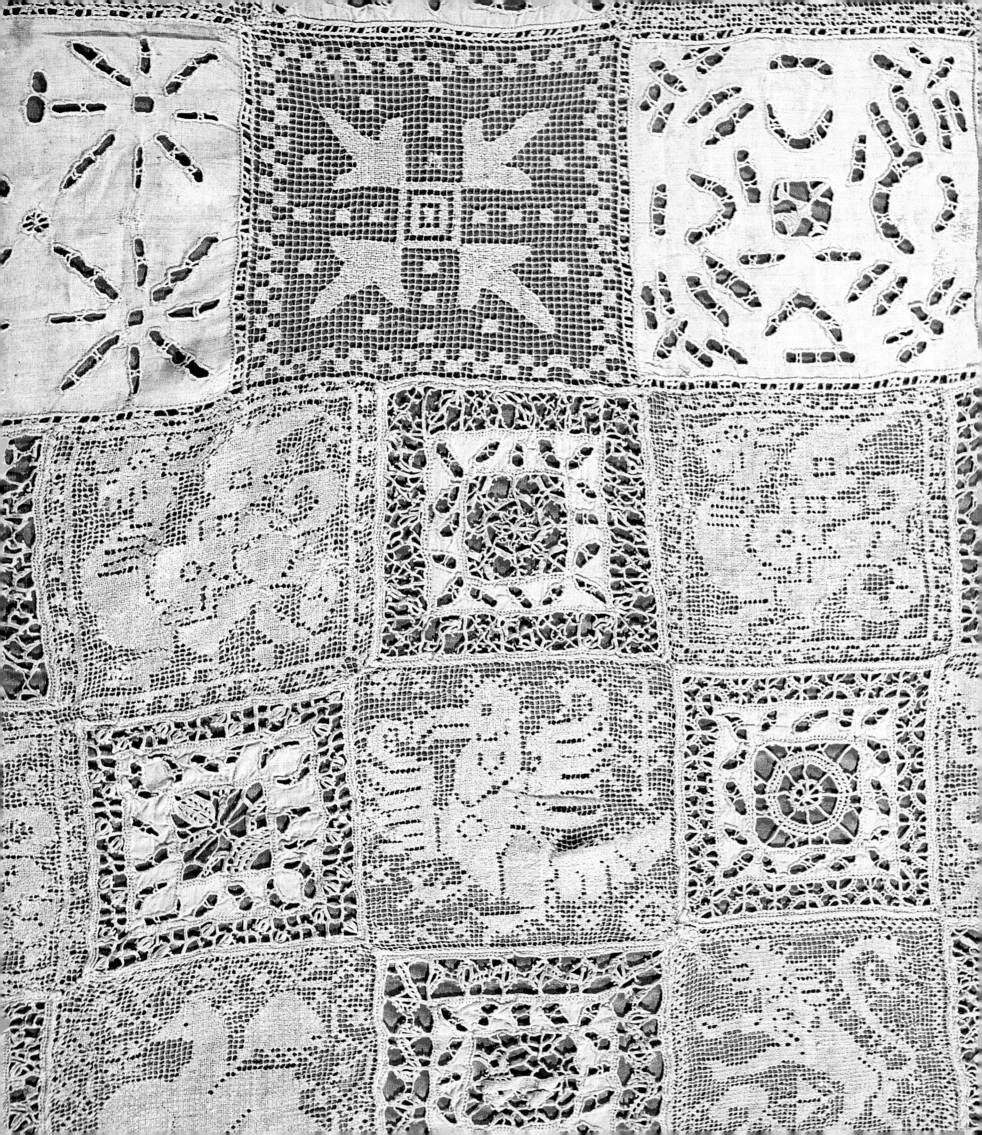

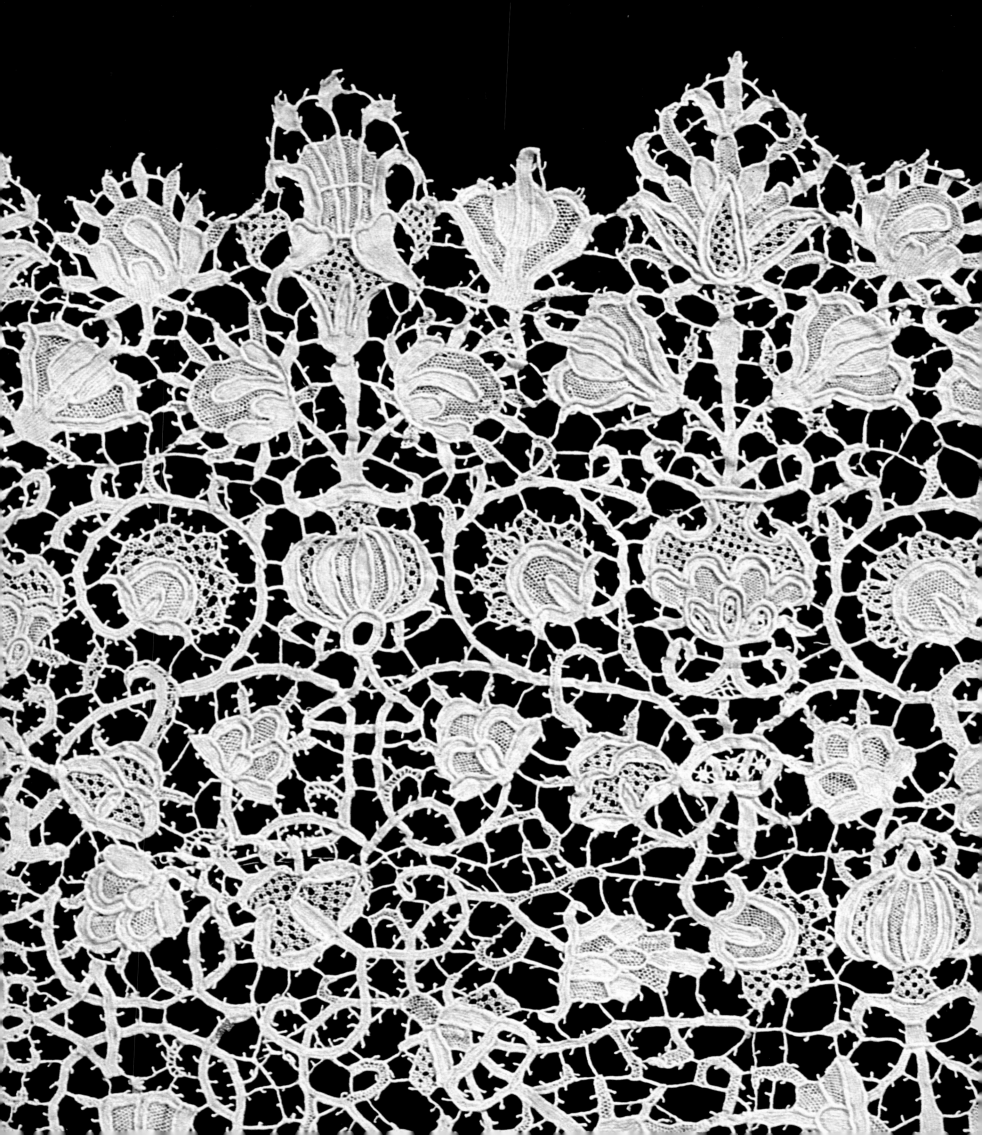

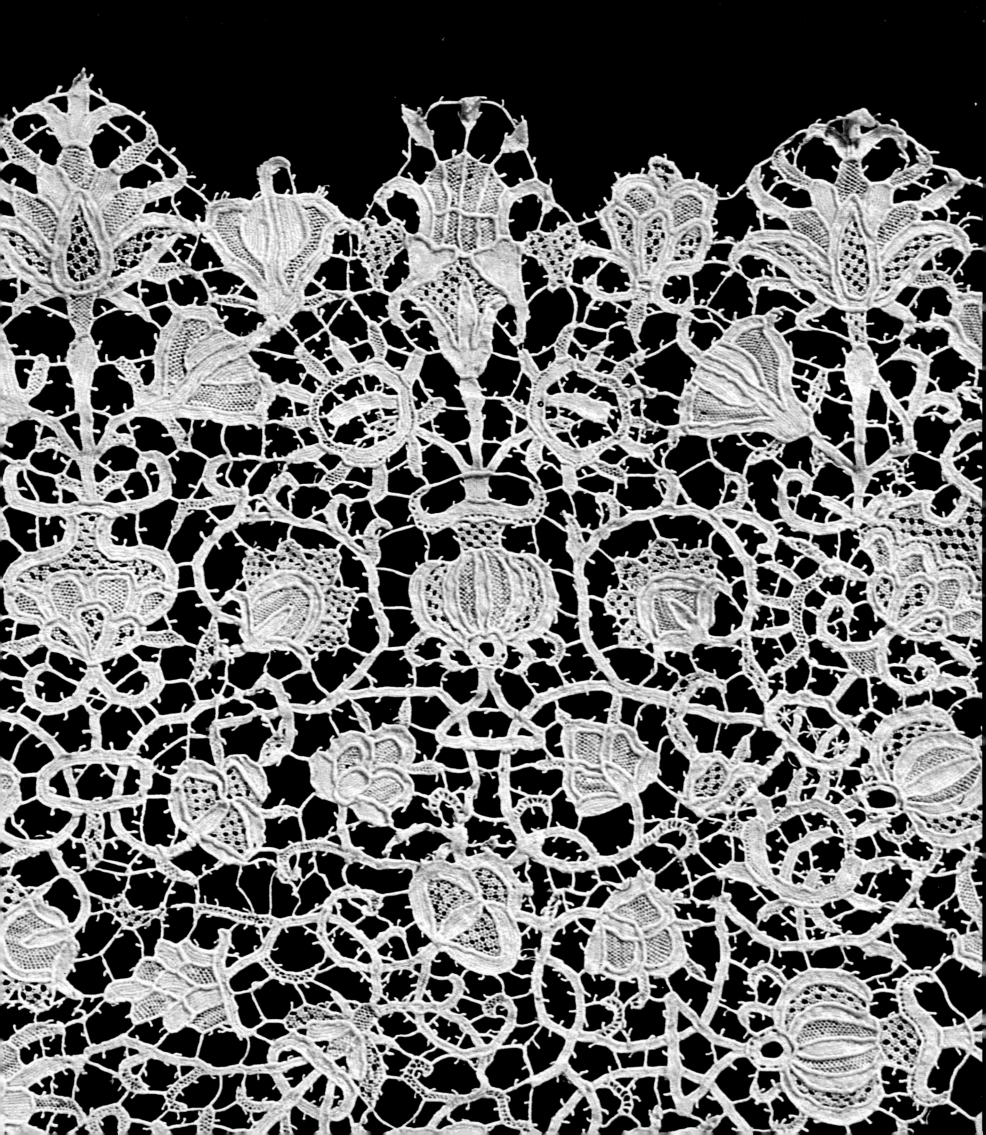

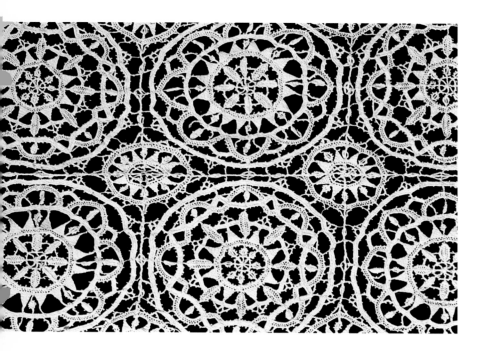

by some late-19th-century legends, in proletarian milieus as a development of fishing net crafting whose fantastic entangled seaweed would have originated the first decorations, rather, as artistic expression of aristocratic female sensitivity. To the "noble and virtuous women," educated from childhood to the feminine "graceful arts," were in fact dedicated countless volumes of pattern albums. These were collections of drawings for lace and embroidery, published in the 16th century, where the knowledge of various stitches' techniques is taken for granted and often indicated in Venetian dialect. Among the most important titles for pillow lace needlework (from the name of the stuffed cylindrical pillow used to work on with bobbins) is *Le pompe* published around 1550 and, for needlepoint lace, *Splendore delle virtuose giovani* by Jeronimo Calepino from 1563 and *Corona* by Cesare Vecellio from 1591.

Only later, when from sophisticated manifestation of creativity of cultivated and amiable gentlewomen, needlework became an indispensable accessory for both female and male fashion, the popularity of lace spread to lower economic classes as a source of income. The increased demand for lace required the organization of a large-scale production, which concentrated first in charitable institutions, hospices for the poor, and homes for orphans and penitents. The production of lace reached an early industrial stage and subsequently spread, from the beginning of the 17th century, to entire islands of the lagoon. The

Border, early 17th century.
Private collection.
The needlepoint lace, with diversified rosette pattern is crafted with thin linen thread; the same material is employed a century later to make the *barbola*, a type of small necktie worn by the ladies of the time.
This example, in the Museo di Palazzo Mocenigo, crafted in "snow stitch," a miniature variation of the "rose stitch," is characterized by a myriad elements in relief that reveal the outstanding mastery of Venetian lace artists.

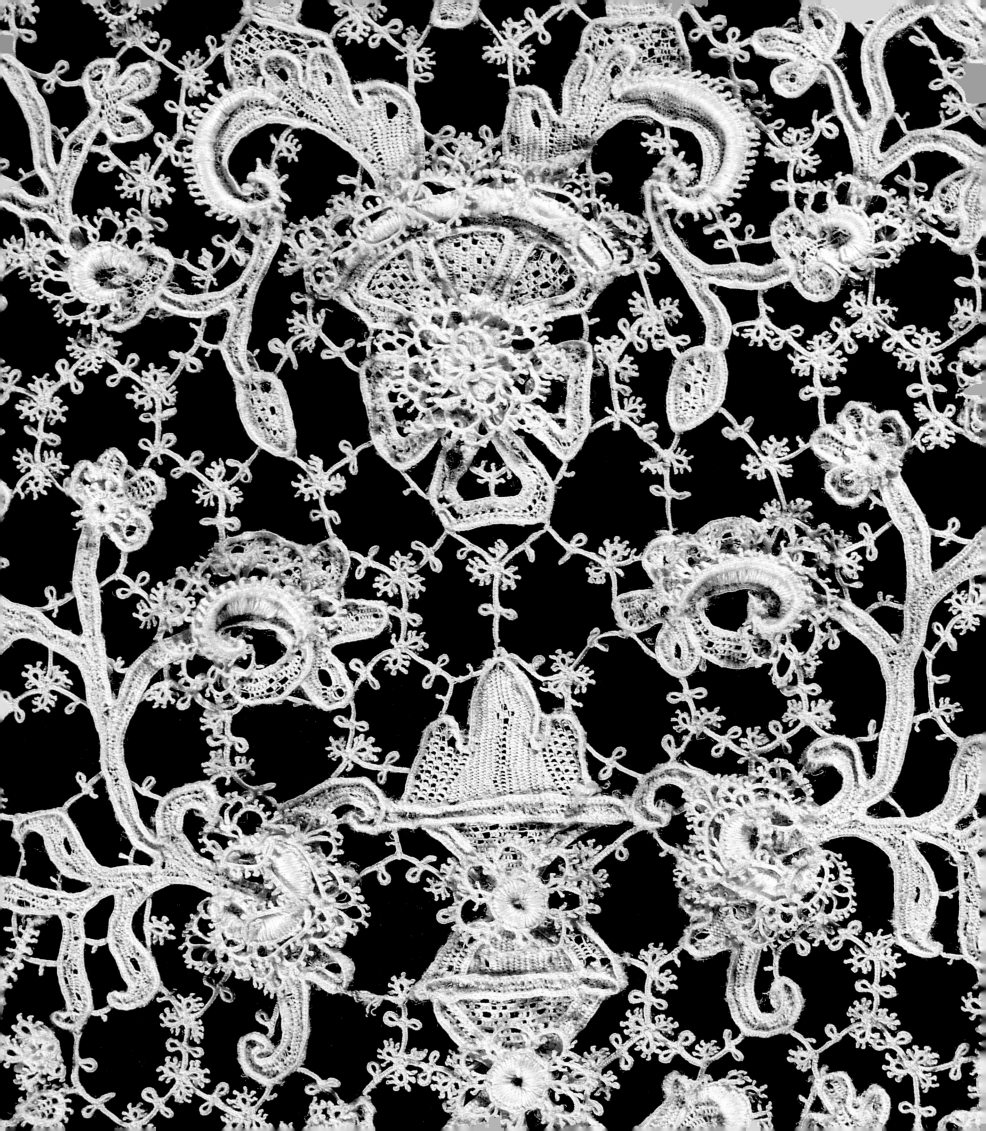

Commonly known as a *fisciù*, this small needle lace shawl in Burano stitch from the middle of the 18th century, in the Museo di Palazzo Mocenigo, is characterized by a background mesh on which evolves the pattern, with a ribbon intertwined with floral trails. Two needlepoint lace fans from a private collection. The top one is Venetian in Burano stitch, dating from around the second half of the 18th century, while the other is a 19th-century imitation of "rose stitch."

bobbin lace technique used in the island of Pellestrina is historically documented from 1609 in the *Relazioni* periodically presented by the podestas of Chioggia, as the island was under their jurisdiction. The *Buranelle's* skillful needlework was recorded in the middle of the 18th century by Grevembroch who, however, lamented the decline of its quality.

Despite the competition represented by the Flemish bobbin lace makers, Venetian silk, gold, silver, and black laces were exported throughout Europe, but it was the flying stitch that Venetian lace makers were famous for. The Venetian "cut stitch with high-relief foliage", three dimensional and rich with chiaroscuro effects, was very unusual and highly sought after at the court of Louis XIV. As a consequence of this huge popularity Minister Colbert requested, shortly after the middle of the 17th century, the presence of some Venetian masters in France,

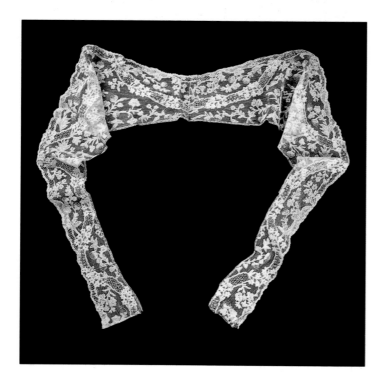

who taught the secrets of this type of art to their French colleagues. Although such an obvious act of artisan piracy, with its consequences for the Venetian economy, upset the Serenissima and led to the issue of death penalties for the relatives of the expatriated female artisans who did not make immediate return to Venice, still it would not cause the recognition of lace making as a proper profession. Despite the international demand, validated by remarkable economic advantages, lace makers would never be allowed to organize in a guild, but would instead

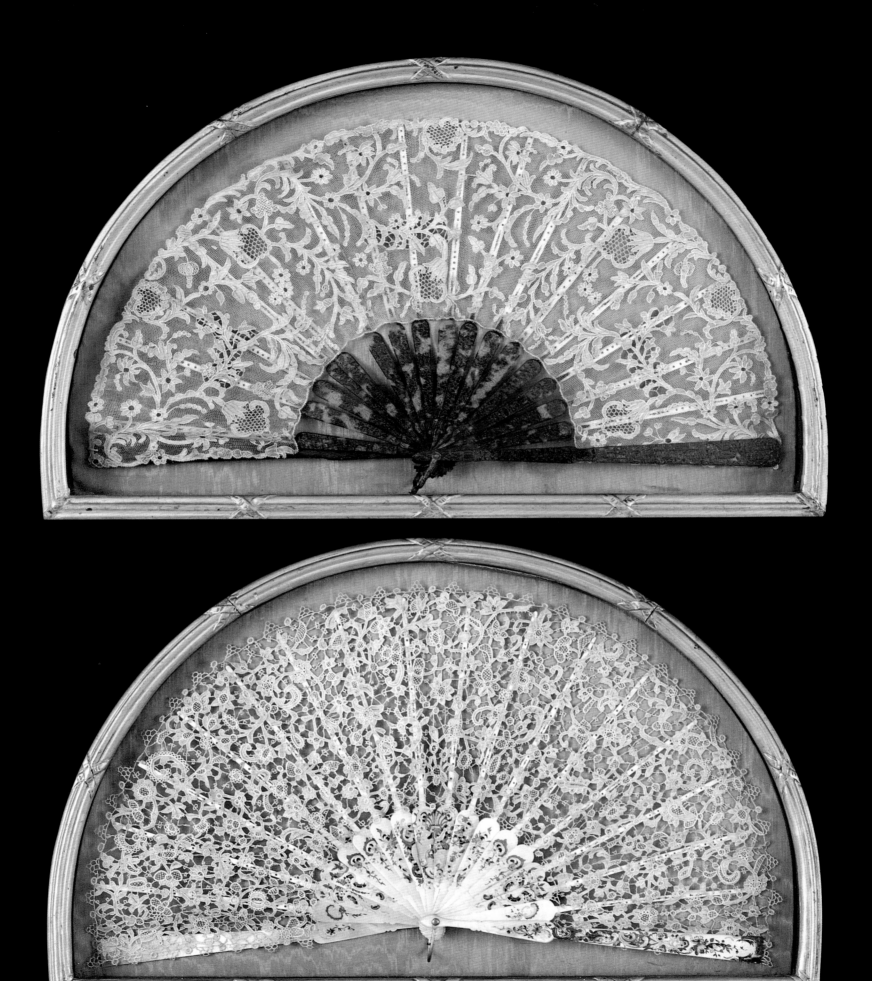

Tablecloth, Burano. Adriana
Marcello Foundation.
This large needlepoint lace artifact,
in Venice stitch with inserts of
Burano stitch, was crafted by the
pupils of the School of Lace, in the
first half of the 20th century. In the
decoration, the baroque patterns
alternate with rococo elements in a
new 20th-century stylistic context.

be included in the Guild of the *marzeri* who organized and delivered the raw materials, the yarn, the collection and resale of the finished products.

Women were not allowed to sell door to door, as it was reserved as an exclusively male selling profession. Meanwhile, fashion required new types of lace, sheerer and stylistically less pompous, designed to obtain frothy effects on garments. Venice launched the "rose stitch" derived from baroque patterns, which would then miniaturize them into a myriad of sprays of raised designs with the "snow stitch."

In the second quarter of the 18th century, the continuous demand for innovations caused the invention of the Burano stitch, where the prevailing background mesh on the design conferred to the lace exceptional lightness and frothiness, qualities that, however, remained unsurpassed in the so-called "blond" silk lace, both simple and mixed with gold and silver, both crafted with bobbin technique and filet. The critical phase of the lace industry began in the last quarter of the 18th century, due to the simplified fashion that from England spread throughout Europe, causing a drastic reduction in the use of lace and its total elimination with the advent of the French Revolution. Later replaced with industrial machine-made lace, the revival of Venetian lace did not occur until the diffusion of the *Arts and Crafts* movement in the second half of the 19th century.

Thanks to Senator Fambri and Countess Marcello, under the auspices of Queen Margherita, in 1872 Burano saw the opening, with artisans who had miraculously survived, of a school which would come to surpass the productions of the past in both quality and perfection.

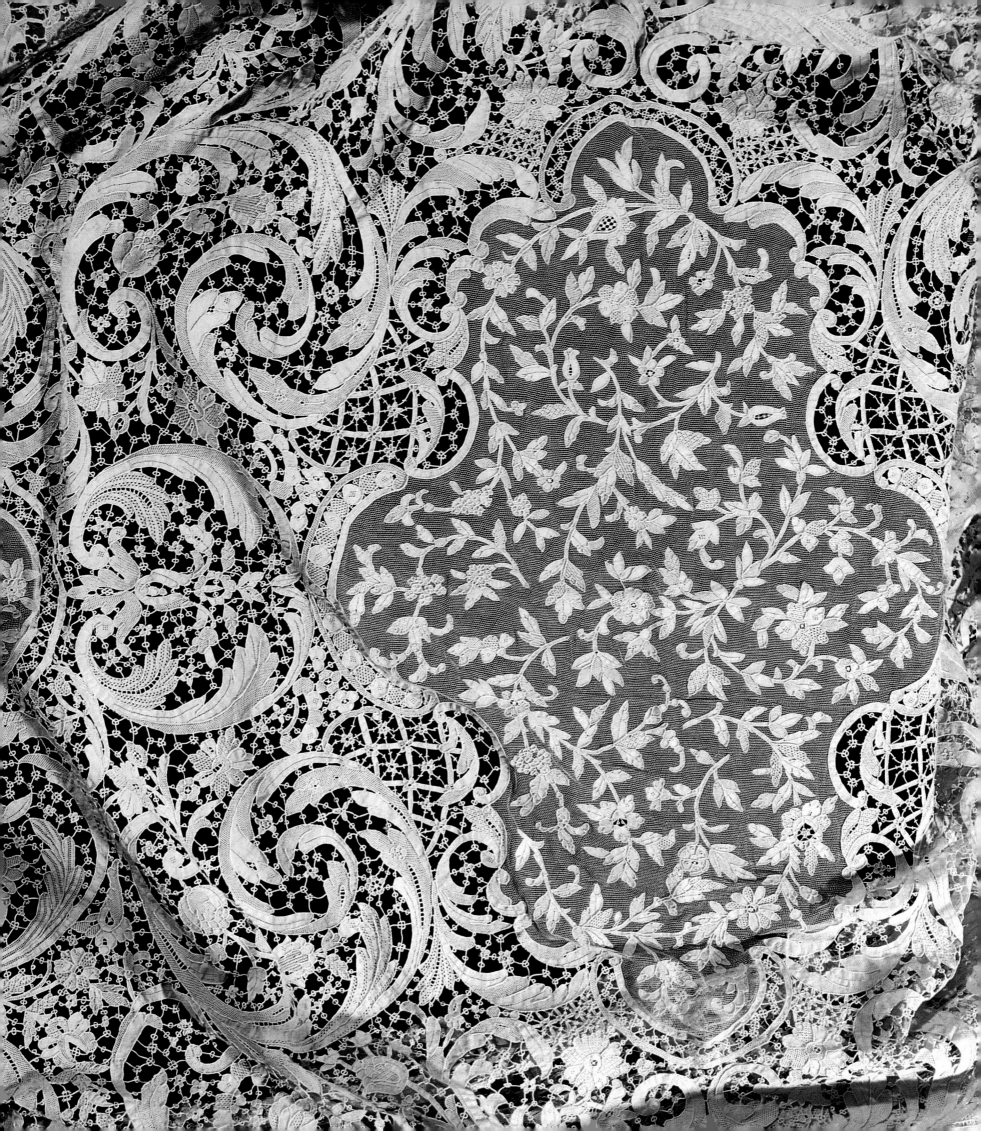

Leather

Venice also specialized in the industry of leather, tanned in a particular manner, embossed or engraved, printed, painted, silver plated or gilded, appropriately called *cuoridoro*, producing sophisticated pieces. This profession did not belong either to the Guild of the *conzacurame* (hide tanners) or to that of the *calegheri* and *zavatteri* (cobblers and slipper makers), but to that of the *depentori*, that is, painters and decorators. Their workshops were probably concentrated around S. Fantin, in the S. Marco district, where remain as testimonies a courtyard of the same name and portico of the *cuoridoro*.

In antiquity, the procedures involved in this type of work started with an engraved wooden mold, spread with large quantities of varnish and mineral spirits, on which the hides were laid. Once dried, they were nailed onto a board and varnished with a gold or silver substance obtained from mixing and boiling four parts of linseed oil, two of turpentine, and one of *aloe cavallino*.

Later, the procedure changed: the hides would first be covered with silver or gold foil, either hammered or rubbed onto the surface, then pressed onto a mold.

Detail of wall covering. Palazzo Ducale. In the doge's apartment, stripped of all the original furnishings, remains a room paneled with *cuoridoro*, with flashy baroque decoration. On a dark red background imposing golden volutes evolve, intertwined with foliate trails with berries, creating large compositions.

The wooden sedan chair covered with black painted leather, placed in the hall of a palace is datable to the second half of the 18th century. Garlands of polychrome flowers, among which roses, daisies, and daffodils are arranged on the lower portion and in the front, with dancing putti on the back, where, separated by wreaths of acanthus emerging from a shell, stands out a heraldic emblem, tripartite and crowned. A grotesque head of Mercury, crowned with flowers, represents the side decoration.

Drawings were then traced with black peach pit and painted, pricked with square irons shaped like rooster's eyes, fishbones, or other patterns; after being trimmed they were sewn together.

Already in the 15th century there was a vast production of panels for wall coverings—engraved with figures, arabesques, flowers, coats of arms—which grew in the 16th century with objects of common use like coffers, cases, table coverings, and book bindings. In 1562 the Senate prohibited the decoration of rooms for women in childbirth or any other room with elaborate leather wall coverings. Dating back to that period is the exemplar with golden grotesques on red background of the collection Mora of Milano, published by Molmenti, who remembers that in the 16th century the commerce of the *cuoridoro* yielded 100 000 ducats a year to Venice—while Zuan Paolo da Ponte in 1534 paid only 20 ducats to be portrayed by Titian!—and that there were over 70 workshops at that time. The *cuoridoro* were frequently mentioned in 17th-century inventories. For instance, Palazzo Cavalli in S. Vidal in 1677 contained six embroidered fabric door panels and two decorated leather door panels, and complete sets of decorated leather wall coverings; while the bedrooms were all paneled as well as the apartments on the mezzanines. The Vendramin Calergi renovated the décor of the palace of the same name after 1739; to that date can be traced back the gilding and painting that panel the walls of the hall dominated by the architectural fireplace.

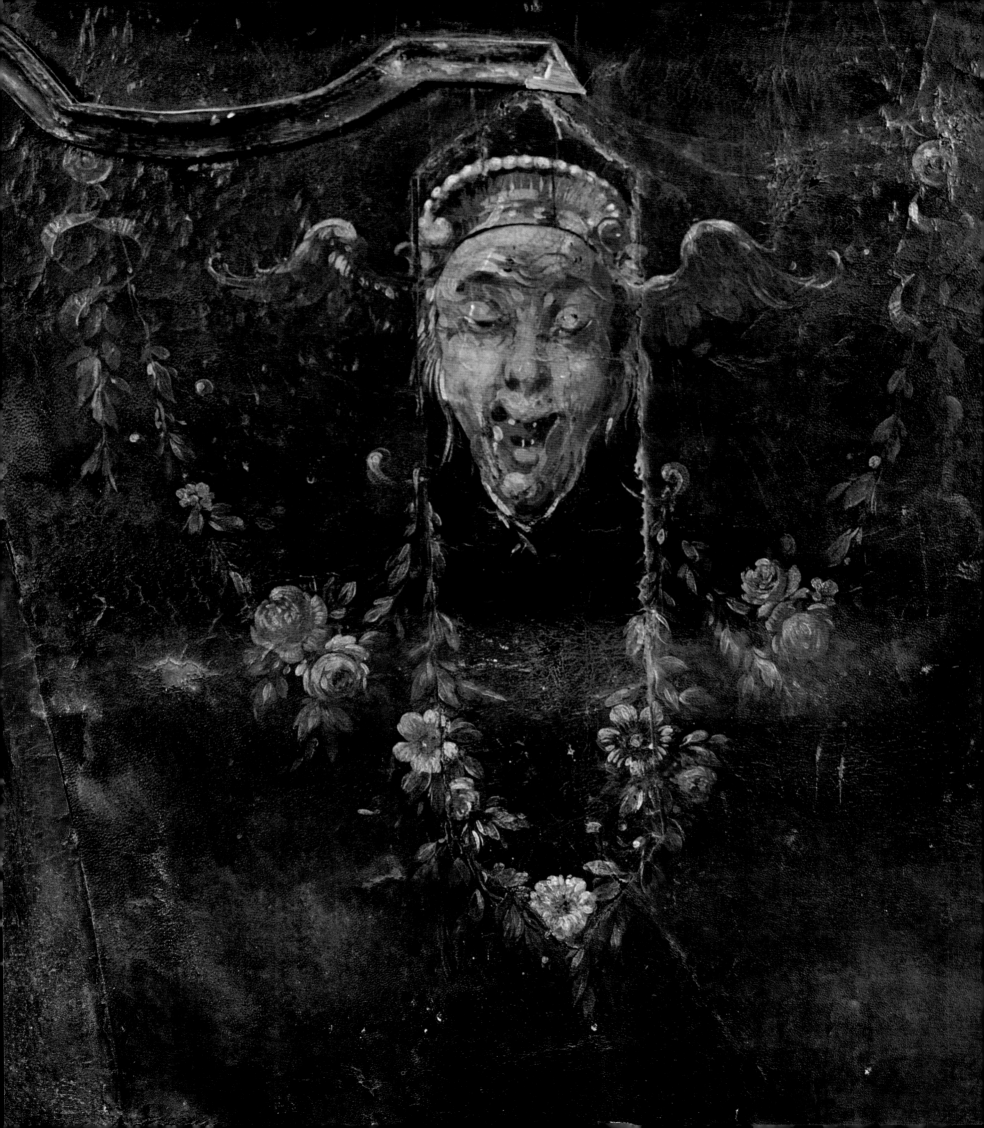

Antependium, 18th century, church of the Redentore. On gold background, climbing among the sinuous volutes of an imaginary baluster, trails of peonies, roses, buttercups, nasturtium, and other flowers, light blue, pink, and green, with palpitating corollas, seem to be overflowing from the composition. The six antependiums, all slightly different, are attributed to Francesco Guardi, "painter of flowers."

The polychrome floral motifs are a favorite decorative theme for leather. A significant example is this 18th-century locker, from the Museo Civico Ballo in Treviso, whose fir structure is completely covered with leather, painted, and lacquered. Decorated with metal friezes and internally lined with embroidered ivory silk, it was used to hold some of the nuptial dowry.

Trails of pink peonies and small yellow and light blue flowers climbing vertically with a light, wavy motion, decorate the tripartite screen in the Palazzo Pisani Moretta. Covered with silver raised pebble-grain leather, it dates back to the second half of the 18th century.

Gilded leathers remain also in one of the rooms of the private doge's apartment and in the six antependiums of the side altars of the church of the Redentore, datable to around 1747, attributed to Francesco Guardi, "painter of flowers." On a gilded silver foil background, hand engraved among the architectural volutes of a baroque baluster appear thin dark green wreaths with roses, peonies, buttercups, tulips, pomegranates, berries, dahlias, wild roses, and other flowers rendered with pink, orange, red, and light and dark blue. In the center stands out a bouquet of similar flowers. The botanical species, rendered with apparent naturalism but actually permeated with the fantastic inventions of the painter, never repeat themselves nor their composition structures. In 1773 the workshops left numbered only four, with eleven maestros, nine workers, and no apprentices; however, in 1790 they accepted a commission of one thousand gilded leather panels that would be exquisitely crafted.

Different, but somehow still tied with this art, is that of book binding. In the 15th century the binding of manuscripts still feature a rather simple, monastic style, as for instance the cover of the *commissione* of doge Foscari to Bartolomeo Donato, made with boards covered in red goatskin engraved with lozenges with nails and metal studs. In the second half of the 15th century oriental influences become more prevalent: morocco leather,

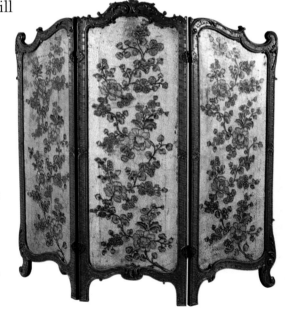

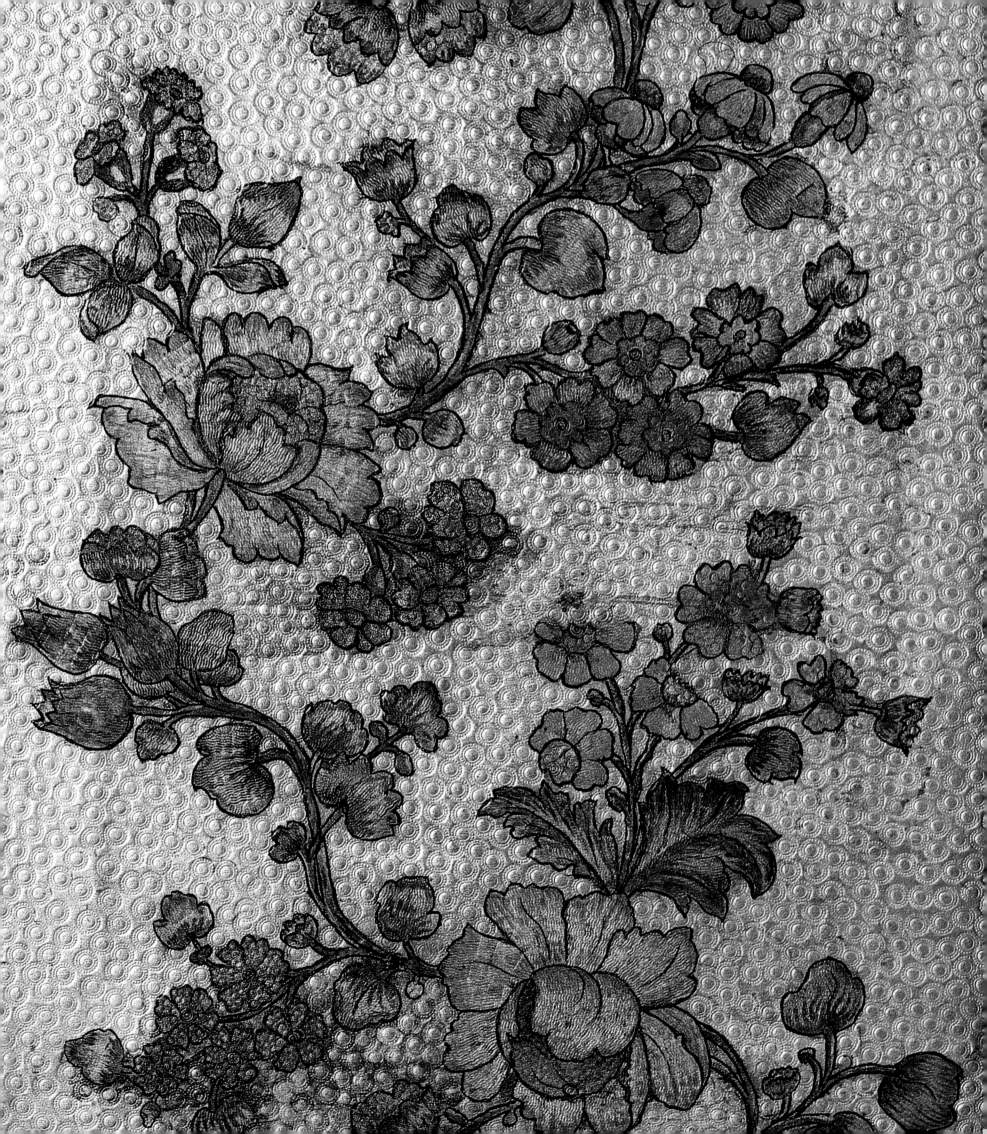

black, reddish brown, or greenish, engraved with geometrical linear decorations, small crosses, and circles, illuminated by embossed metal buckles and corners, or enriched with rosettes or gilded traced and painted arabesques.

In the first years of the 16th century, gold is glued onto the leather by the hot gilding technique: the leather would be pressed into a heated engraved mold. The Aldo Manuzio editions were so elegant that the bindings were attributed to his workshop as well, and they were crafted according to his precise directions. He allegedly also used for gilding little iron tools that were named after him, the *aldi.* After the arabesques on the covers of his editions, he proposed grotesques and stylized flowers with large designs on the whole width of the plates, with intertwined polychrome geometric profiles. The most elaborate and luxurious covers were the creation of specialized artisans among whom were the Torresani, whose workshop was opposite Manuzio's press.

The *commissioni* given by the Venetian government to its representatives, called captains, were bound in red morocco leather with a pattern similar to a coffered ceiling, with sunken compartments, richly decorated and colored, with the lion of St. Mark in the center. Even the cases of nautical maps were bound with leather decorated with golden arabesques and mosaics of polychrome enamels. Sometimes the edge and spine of the book were painted as well. No wonder then, that to define a book with an exceptionally beautiful binding it was sufficient to say "Venetian style."

[298]

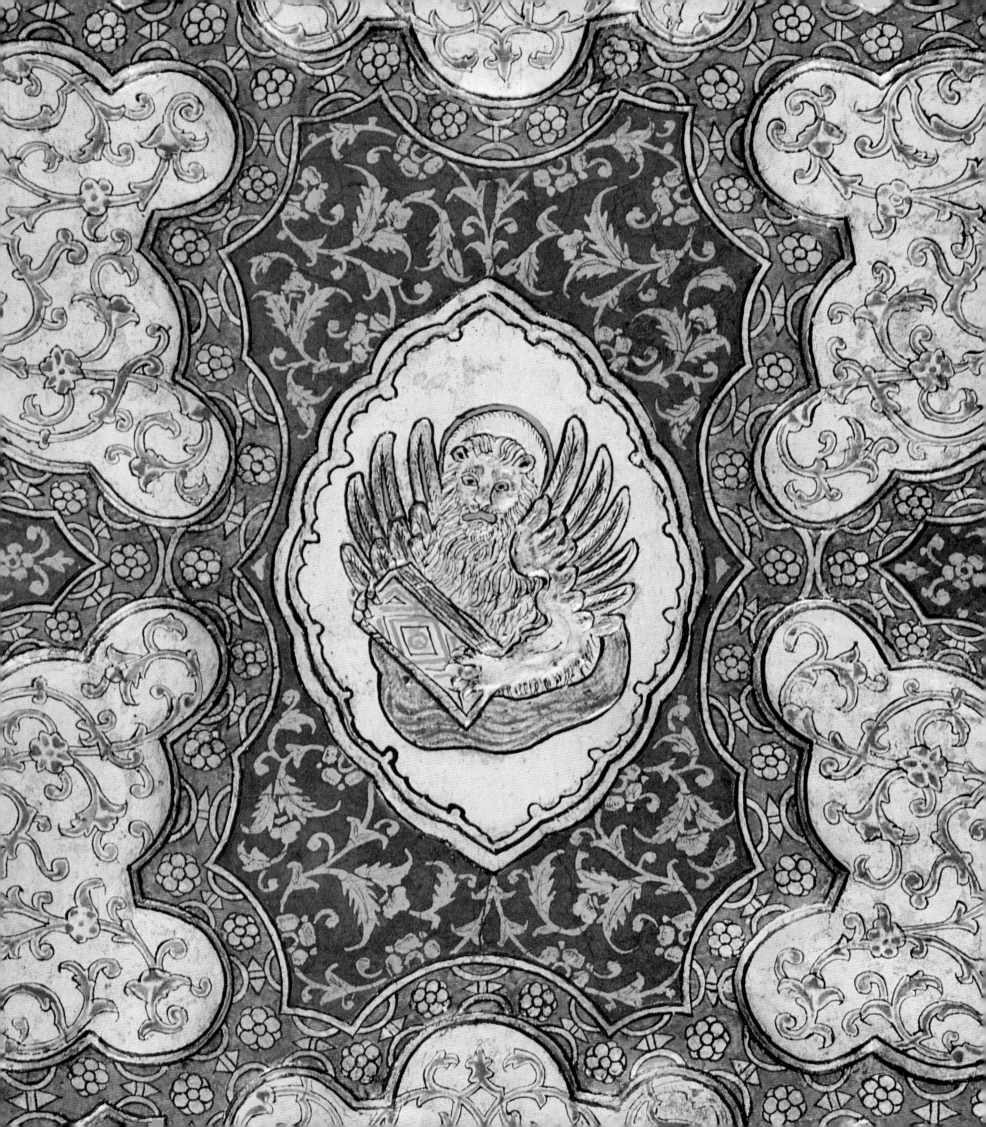

Bibliography

C. ALBERICI, *Il mobile veneto*, Milano 1980.

A. ALVERÀ BORTOLOTTO, *Storia della ceramica a Venezia dalle origini alla fine della Repubblica*, Firenze 1981.

ANTICHITÀ PIERO SCARPA, *Tiziano ritrovato. Il ritratto di messer Zuan Paulo da Ponte*, Venezia 1998.

Arti del Medio Evo e del Rinascimento. Omaggio ai Carrand, Firenze 1989.

Arti e mestieri in Venezia, Venezia 1989.

L'artigianato delle Venezie e la sua esportazione, Venezia 1947.

R. BAROVIER MENTASTI, *Il vetro veneziano dal Medioevo al Novecento*, Milano 1988.

R. BAROVIER MENTASTI, *Antonio Salviati e la rinascita del vetro artistico veneziano*, Vicenza 1982.

R. BAROVIER MENTASTI, A. DORIGATO, A. GASPARETTO (a cura di), *Mille anni di arte del vetro a Venezia*, Venezia 1982.

E. BASSI, *Architettura del Sei e Settecento a Venezia*, Napoli 1962.

E. BASSI, R. PALLUCCHINI, *Palazzo Loredan*, Venezia 1985.

A. BELLIENI (a cura di), *Ceramiche antiche a Treviso*, Treviso 1991.

M. T. BINAGHI OLIVARI, *Maestro Santo Manzini*, in "Osservatorio delle Arti" n. 2, Bergamo 1989.

G. BISTORT, *Il lusso nella vita e nelle leggi*, Bologna 1969.

G.G. BORRELLI, *Gli strumenti musicali*, Milano 1981.

G. BRAVO, *Storia del cuoio e dell'arte conciaria*, Torino 1964.

L. BRENNI, *L'arte del battiloro*, Milano 1930.

F. BRUNELLO, *Arti e mestieri a Venezia nel Medioevo e nel Rinascimento*, Vicenza 1981.

F. BRUNELLO, *Arti, mestieri e mode nella trattatistica e nell'iconografia*, in G. ARNALDI, M. PASTORE STOCCHI, *Il Seicento. Storia della cultura veneta*, vol. 4/1, Vicenza 1983.

G. BUTAZZI CHIESA, *Venezia e la sua gondola*, Milano 1974.

F. CAILLES, J. N. SALIT, *I gioielli*, Milano 1981.

G. CANIATO (a cura di), *Giovanni Giuponi. Arte di far gondole*, Venezia 1985.

G. CANIATO (a cura di), *Arte degli squeraroli*, Venezia 1985.

G. CANIATO, M. DAL BORGO, *Le arti edili a Venezia*, Roma 1990.

G. CARENA, *Vocabolario italiano d'arti e mestieri. Prontuario, parte II*, Napoli 1858.

C. CENNINI, *Libro dell'arte*, Vicenza 1971.

F.R. CHATEAUBRIAND, *Memoires d'autretombe*, in Y. HERSANT, *Italies*, Aylesbury 1988.

I. CHIAPPINI DI SORIO, *Palazzo Pisani Moretta*, Milano 1983.

S. COLOMBO, *L'arte del mobile in Italia*, Milano 1975.

F. COLONNA, *Hypnerotomachia Poliphili*, a cura di G. Pozzi e L.A. Capponi, Padova 1980.

M. COSTANTINI, *L'albero della libertà economica. Il processo di scioglimento delle corporazioni veneziane*, Venezia 1987.

U. DANIELE, C. SCHMIDT ARCANGELI, E. VIO, *Tarsie lignee della basilica di San Marco*, Milano 1998.

D. DAVANZO POLI, *Gli arazzi di Venezia*, in "Quaderno 2", Venezia 1990.

D. DAVANZO POLI, *Le conterie nella moda e nell'arredo*, in *Perle e impiraperle*, Venezia 1990.

D. DAVANZO POLI, *L'impiego dell'oro e dell'argento nei pizzi e ricami*, in P. PAZZI (a cura di), *Contributi per la storia dell'oreficeria*, Venezia 1996.

D. DAVANZO POLI, *Il merletto veneziano*, Novara 1998.

D. DAVANZO POLI, *I mestieri della moda a Venezia. Documenti*, 2 voll., Venezia 1984-86.

D. DAVANZO POLI, *Il ricamo con perline vitree. Storia*, in N. LOPEZ Y ROYO SAMMARTINI, *Fiori di perle a Venezia*, Venezia 1992.

D. DAVANZO POLI, *Il ricamo profano in Occidente*, in P. PERI (a cura di), *Per raffinare i sensi*, Firenze 1995.

D. DAVANZO POLI, *Il ricamo ecclesiastico e il museo diocesano di Brescia*, in *Indue me Domine*, Venezia 1998.

D. DAVANZO POLI, *Seta & oro*, Venezia 1997.

D. DAVANZO POLI, S. MORONATO, *Le stoffe dei veneziani*, Venezia 1994.

T. DE MARINIS, *Rilegature veneziane del XV e XVI secolo*, Venezia, 1955.

G. FERRARI, *Il ferro nell'arte italiana*, Milano s.d.

G. FERRARI, *Il legno nell'arte italiana*, Milano s.d.

J. FLEMMING, H. HONOUR, *Dizionario delle arti minori e decorative*, Milano 1980.

Y. FLORENT-GOUDOUNEIX, *I pavimenti in "opus sectile" nelle chiese di Venezia e della laguna*, in R. POLACCO (a cura di), *Storia dell'arte marciana. I mosaici*, Venezia 1997.

M. FOGLIATA, M.L. SARTOR, *L'arte dello stucco a Venezia*, Roma 1995.

O. FONTANARI, *Il mosaico*, in *Dal museo alla città*, Itinerari didattici 4, Venezia 1983.

R. GALLO, *Giuseppe Briati e l'arte del vetro a Murano nel XVIII secolo*, Venezia 1953.

B. GARZENA, *Dizionario delle arti figurative*, Bologna 1960.

T. GARZONI, *La piazza universale di tutte le professioni del mondo*, In Venezia 1638.

A. GASPARETTO, *Il vetro di Murano dalle origini fino ad oggi*, Venezia 1958.

E. GHITTINO, *Mosaico: dal passato un futuro possibile*, in *Venicemart '92*, Venezia 1992.

A. GONZALEZ-PALACIOS (a cura di), *Antiquariato. Enciclopedia delle arti decorative*, 8 voll., Milano 1981.

S. GRAMIGNA, A. PERISSA, *Scuole di arti e mestieri e devozione a Venezia*, Venezia 1981.

G. GREVEMBROCH, *Gli abiti de' Veneziani di quasi ogni età con diligenza raccolti e dipinti nel secolo XVIII*, a cura di G. Mariacher, 4 voll., Venezia 1981.

F. GRISELINI, *Dizionario delle arti e de' mestieri*, 18 voll., Venezia 1768-78.

Y. HERSANT, *Italies*, Aylesbury 1988.

Il museo storico navale di Venezia, Venezia, s.d.

Indue me Domine, Venezia 1998.

Le insegne delle arti veneziane al Museo Correr, Venezia 1982.

S. LEVEY, *Lace. A History*, London 1983.

S. LEVY, *Lacche veneziane settecentesche*, 2 voll., Milano 1967.

S. LEVY, *Le maioliche venete del XVIII secolo*, Novara 1980.

S. LEVY, *Il mobile veneziano del*

Settecento, testo con note di G. Morazzoni, 2 voll., Milano 1996.

A. MANNO, *I mestieri di Venezia*, Cittadella 1995.

P. MARANDEL, *I vetri*, Milano 1981.

G. MARANGONI, *Le associazioni di mestiere nella Repubblica Veneta*, Venezia 1974.

P. MARASCUTTO, M. STAINER, *Perle veneziane*, Verona 1991.

S. MARCHIORI, *L'impiego delle pietre dure e semipreziose negli altari veneziani*, in P. PAZZI (a cura di), *Contributi per la storia dell'oreficeria*, Venezia 1996.

G. MARIACHER, *L'intérieur vénitien*, in "Venise, l'amour de l'art", Venezia 1951.

G. MARIACHER, *L'oreficeria veneziana dalle origini alla caduta della Repubblica*, in *Oro di Venezia*, Venezia 1977.

Mestieri e arti a Venezia 1173-1806, Venezia 1986.

D. MICCONI, M. TODESCHINI, *Mestieri nella storia di Venezia*, in *Venicemart '90*, Venezia 1990.

D. MILANI VIANELLO, *El felze*, Venezia 1994.

E. MIOZZI, *Venezia nei secoli. La città*, 2 voll., Castelfranco 1957.

P. MOLMENTI, *La storia di Venezia nella vita privata*, 3 voll., Trieste 1973.

G. MONTICOLO, *I capitolari delle arti veneziane sottoposte alla Giustizia Vecchia*, 3 voll., Roma 1896-1914.

G. MORAZZONI, *Il mobile veneziano del '700*, Milano 1927.

G. MORAZZONI, *Mobili veneziani laccati*, Milano 1958.

G. MORAZZONI, *Il mobile veneziano del Settecento*, Milano 1958.

G. MORAZZONI, *Le porcellane italiane*,

Milano 1935.

G. MORAZZONI, M. PASQUATO, *Le conterie veneziane*, Venezia 1953.

A. MOTTOLA MOLFINO, *L'arte della porcellana in Italia*, Busto Arsizio 1976.

M. MURARO, *Palazzo Contarini a San Beneto. Gli stucchi di Carpoforo Mazzetti Tencalla*, Venezia 1970.

Oro di Venezia, Venezia 1981.

C. PAGGI COLUSSI, *Il ricamo*, in D. DAVANZO POLI, C. PAGGI COLUSSI, *Pizzi e ricami*, Milano 1991.

M. PASQUATO, *Il vetro muranese*, estratto da III Congresso internazionale del vetro, Venezia 1953.

P. PAZZI, *Il corno ducale*, Treviso 1996.

P. PAZZI (a cura di), *Contributi per la storia dell'oreficeria, argenteria e gioielleria*, Venezia 1996.

P. PAZZI, *I gioielli nella civiltà veneziana*, Treviso 1995.

P. PAZZI, *L'oro di Venezia*, Venezia 1996.

F. PEDROCCO, *La porcellana di Venezia nel Settecento*, Venezia 1998.

F. PEDROCCO, M. GEMIN, *Ca' Vendramin Calergi*, Milano 1990.

A. PENSO, *Camini di Venezia*, Venezia 1989.

Perle e impiraperle, Venezia 1990.

G.M. PILO, *Francesco Guardi. I paliotti*, Milano 1983.

R. POLACCO (a cura di), *Storia dell'arte marciana. I mosaici*, Venezia 1997.

R. POLACCO (a cura di), *Storia dell'arte marciana. Sculture, tesoro, arazzi*, Venezia 1997.

T. Presbiter, *Schedula diversarum artium*, Vienna 1874.

U. RAFFAELLI (a cura di), *Oltre la porta. Serrature, chiavi e forzieri*, Trento 1996.

G. RENIER MICHIEL, *Origine delle feste veneziane*, vol. I, Milano 1829.

E. RICCI, *Ricami italiani antichi e moderni*, Bergamo 1925.

A. RIZZI, *Vere da pozzo di Venezia*, Venezia 1881.

A. RIZZI, *Scultura esterna a Venezia*, Venezia 1987.

S. ROFFO, *Il ferro battuto*, Città di Castello 1998.

G. ROMANELLI, F. PEDROCCO, *Bissone, peote e galleggianti*, Venezia 1980.

J. RUSKIN, *Le pietre di Venezia*, Milano 1997.

F. SACCARDO, *Ceramica veneziana*, in *Dal museo alla città*, Itinerari didattici 8, Venezia 1990.

T. SAMMARTINI, *Fiori di perle*, in N. LOPEZ Y ROYO SAMMARTINI, *Fiori di perle a Venezia*, Venezia 1992.

T. SAMMARTINI, G. CROZZOLI, *Pavimenti a Venezia*, Treviso 1999.

P. SANTOSTEFANO, *Tagliapietra e proti nel monastero e nella chiesa di Ognissanti a Venezia*, in *Atti dell'Istituto Veneto di Scienze, Lettere e Arti*, Venezia 1993.

G. SARPELLON, *Miniature di vetro. Murrine 1838-1921*, Venezia 1990.

G.M. URBANI DE GHELTOF, *Degli arazzi in Venezia*, Venezia 1878.

G.M. URBANI DE GHELTOF, *Studi intorno alla ceramica veneziana*, Venezia 1876.

G. VASARI, *Le vite dei più eccellenti pittori, scultori e architetti*, Firenze 1550, ristampa anastatica Roma 1991.

C. VECELLIO, *Habiti antichi et moderni*, Venezia 1598.

Venicemart '86. Mostra dell'artigianato artistico veneziano, Venezia 1986.

Venicemart '90. Mostra dell'artigianato artistico veneziano, Venezia 1990.

Venicemart '91. Mostra dell'artigianato artistico veneziano, Venezia 1991.

Venicemart '92. Mostra dell'artigianato artistico veneziano, Venezia 1992.

G. ZANETTI, *Dell'origine di alcune arti principali appresso i Viniziani*, Venezia 1758.

L. ZECCHIN, *Sulla storia delle conterie veneziane*, Venezia 1955.

G. ZOMPINI, *Le arti che vanno per via...*, Venezia, ristampa anastatica 1990.

Photo credits
Archivio fotografico Scala, Florence, p. 61
Marino Barovier, Venice, p. 211
Biblioteca Nazionale Marciana, Venice, p. 152
Cameraphoto, Venice, pp. 20, 62–63, 126, 146, 213, 235, 250, 268
Centro Studi Anoniani, Padua, pp. 256–257
Consorzio Maestri Calzaturieri del Brenta, Stra (Venice), pp. 252, 259,
 260, 261, 262
Custodia Terrasanta, foto Garo Nalbandian, Jerusalem, p. 274
Musei Civici Veneziani, Venice, p. 171
Museo di Castelvecchio, Verona, p. 149
Procuratoria di San Marco, Venice, p. 89
Francesco Turio, Venice, pp. 206, 209

The editors would like to thank the following for permission to
reproduce their photos:
Albergo al Sole
Antichità Claudio Gianolla
Antichità Pietro Scarpa
Antichità V. Trois
Ca' Zenobio
Camera di Commercio Industria Artiginato e Agricoltura di Venezia
Cassa di Risparmio di Venezia
Curia Patriarcale
Fondazione Andriana Marcello
Fondazione Querini Stampalia
Galleria Marina Barovier
Galleria Rossella Junck
Gardini srl (Ravenna)
IRE – Istituzioni di Ricovero e di Educazione
Istituto Universitario di Architettura
Istituto Veneto di Scienze Lettere ed Arti
Musei Civici Veneziani
Museo Civico L. Bailo (Treviso)
Museo Diocesano
Museo Navale
Palazzo Pisani Moretta
Soprintendenza ai Beni Artistici e Storici di Venezia
Tessitoria Serica Luigi Bevilacqua
Ufficio Unesco di Venezia

The editors would like to thank the following people for their valuable
collaboration in allowing photographs to be taken of their houses:
Feliciano and Elena Benvenuti, Raimondo Blecich, Vittoria de
Buzzaccarini, Roberto Callegari, Attilio and Gabriella Codognato,
Alberto and Cecilia Falck, Alessandro Favaretto Rubelli, Maria Pia Ferri,
Maria Franchini Donà dalle Rose, Achille and Maria Grazia Gaggia,
Alberto and Giovanna Giol, Liselotte Höhs, Girolamo Marcello,
Gabriella Nani Mocenigo, Maurizio Sammartini, Nelly Sammartini Lopez y
Royo, Giovanni Sarpellon, Piero Pazzi, Filippo Pedrocco, Marco Tosa,
and the many more who preferred to remain anonymous.